PICTURING ⸱

IN

CHILDREN'S LITERATURE

PICTURING THE WOLF
IN
CHILDREN'S LITERATURE

DEBRA MITTS-SMITH

Routledge
Taylor & Francis Group
NEW YORK AND LONDON

First published 2010
by Routledge
711 Third Avenue, New York, NY 10017

Simultaneously published in the UK
by Routledge
2 Park Square, Milton Park, Abingdon, Oxon OX14 4RN

Routledge is an imprint of the Taylor & Francis Group, an informa business

First issued in paperback in 2012

Typeset in Minion by IBT Global.

Library of Congress Cataloging-in-Publication Data
Mitts-Smith, Debra.
 Picturing the wolf in children's literature / by Debra Mitts-Smith.
 p. cm.—(Children's literature and culture ; v. 69)
 Includes bibliographical references and index.
 1. Children's literature—History and criticism. 2. Wolves in literature. I. Title.
 PN1009.5.W65M57 2010
 810.9'3629773—dc22
 2009039237

ISBN13: 978-0-415-80117-1 (hbk)
ISBN13: 978-0-415-63666-7 (pbk)

To Chetan, for helping me see

Contents

Figures

Series Editor's Foreword

Dedicated to furthering original research in children's literature and culture, the Children's Literature and Culture series includes monographs on individual authors and illustrators, historical examinations of different periods, literary analyses of genres, and comparative studies on literature and the mass media. The series is international in scope and is intended to encourage innovative research in children's literature with a focus on interdisciplinary methodology.

Children's literature and culture are understood in the broadest sense of the term "children" to encompass the period of childhood through adolescence. Owing to the fact that the notion of childhood has changed so much since the origination of children's literature, this Routledge series is particularly concerned with transformations in children's culture and how they have affected the representation and socialization of children. While the emphasis of the series is on children's literature, all types of studies that deal with children's radio, film, television, and art are included in an endeavor to grasp the aesthetics and values of children's culture. Not only have there been momentous changes in children's culture in the last fifty years, but also there have been radical shifts in the scholarship that deals with these changes. In this regard, the goal of the Children's Literature and Culture series is to enhance research in this field and, at the same time, to point to new directions that bring together the best scholarly work throughout the world.

Jack Zipes

Acknowledgments

Books are never the work of just one individual. There are people who support and guide the research and writing process. There are others who read the manuscript, listen to ideas, and read revisions, again and again. Although my name appears on this work, it is the result of the encouragement, support, and thoughts of many people.

This book began life as a doctoral thesis under the guidance of Betsy Hearne at the University of Illinois. From the beginning she believed in this topic and encouraged me to explore not only images of wolves but also real wolves as visual images. Don Krummel helped me find my way to and through early illustrated editions of tales and fables, while Ron Toby pushed me to consider the wolf within a wider visual context. Through questions and suggestions Christine Jenkins helped focus my thoughts and writing. Susan Davis, who works in the area of eco-criticism, helped me in formulating my questions.

My sincerest thanks to Jack Zipes, whose work is an inspiration and whose support helped see this work to publication.

A special thanks to Janet Thompson who worked closely with me throughout the revision process.

I am grateful to the authors and illustrators who allowed their works to be reprinted in this book. I am also indebted to the librarians and curators of special collections who shared their knowledge, resources, and time with me. In particular, I would like to thank Andrea Immel, curator of the Cotsen Collection at Princeton University, Jenny Schwartzberg at the Newberry Library, Karen Hoyle, curator of the Kerlan Collection at the University of Minnesota, Sue Searing and Sandra Wolf at the University of Illinois, and Ken Orenic and Kitty Rhoades at Dominican University.

Thanks to Peggy Callahan, director of the Wildlife Science Center in Forest Lake, Minnesota, for giving me the opportunity to spend time with wolf pups. Thank you Napoleon, Templeton, and Tristan for letting me rub your tummies and scratch your ears.

I am grateful for the loving and constant support of my family and friends, especially Deanna Cinco and Tim Hogan. Most of all I am indebted to my husband, Marschall Smith. Thank you for welcoming the wolf into our home, our conversations, and our life.

Introduction

On a Saturday night in January 2004, I encountered a wolf. Over the previous year and a half, I had been searching for and studying visual images of wolves. I had seen wolves depicted in a wide range of media and in various states of wolfishness. There were folktale, fable, and storybook wolves. There were wolves in sheep's clothing, mobcaps, top hats, and overalls. Some were thinly disguised humans; others were thinly disguised wolves. Most played the roles assigned to them by the tales, whereas a few rebelled and insisted on telling their own side of the story. And some were recognizable as wolves only because of the accompanying text. But my momentary encounter with the wolf at a wolf park transformed even the most realistic of these images into mere shadows of their real-world counterparts. The difference between the visual representations and the actual animal took on a new clarity and raised the question: What is a wolf?

Over the next few weeks, as I realized that even "real" wolves in wolf parks and zoos were also only visual representations of the wolf, the importance of this simple question became clearer, even as answering it became more difficult. As a metaphor for human behaviors, traits, and beliefs, the wolf is ubiquitous. It is present not only in fables and folk and fairy tales but also in myths and everyday language. Sports teams, advertisers, and politicians also use its name and image.

The wolf is also a large mammal once common to the Northern Hemisphere, with a long-standing relationship to humans. Between fifteen thousand and one hundred thousand years ago, early humans began to tame wolves and dogs began to diverge from three wolf "Eves" in East Asia (Leonard et al. 2002, 1630). Solon of Greece established the first bounty on wolves during the sixth century BCE. From then until the mid-twentieth century, efforts aimed at ridding the land of wolves defined human–wolf relations in the West. Hunters', peasants', and travelers' stories have surrounded real wolves, especially the tracking down of outlaw wolves (Bernard 1981; Coleman 2004; Young 1970). This lore not only formed the basis of our knowledge about the species; it also described and prescribed the best ways to deal with it.

In the past sixty years the first scientific studies documenting life in the wolf pack began (Mech 1995, 271). Changes in our understandings of the wolf have led to changes in our interactions with it. What was once an animal slated for extermination has become, since the 1960s, a focal point of environmental campaigns. Far from assuring its future, however, attempts at saving and reintroducing the wolf to its former habitats have instead placed it at the center of controversy between competing views of nature and ways of life.

The survival of wolves as a species goes beyond the consideration of biological or ecological issues (Boitani 1986, 333–39; Kellert et al. 1996, 978; Mech 1995, 271–75; Nie 2003, 26; Rabb 2003, ix). In the conservation and management of wildlife, human values and attitudes become intertwined with concerns surrounding the biology of the animals (Nie 2003, 26–66). According to Fritts et al.: "Whether an animal population is lost, restored, or ignored usually reflects human decisions and actions" (2003, 312). Research by social ecologist Stephen Kellert and others on American and Canadian attitudes toward large North American carnivores suggests that several interacting factors play a role in shaping human attitudes, including human cultural and historical associations with a species as well as human knowledge and understanding of a species (Kellert et al. 1996, 978). This suggests an interconnectedness and interdependency of the symbolic and the real.

Children's picture books are one place where representations of wolves, symbolic and real, can be found. Tied to stories and information about wolves, the visual images in these books help impart social, cultural, and scientific information not only about wolves but also about humans and human behaviors. First encountered in childhood, these visual and textual images are a sort of training ground, providing their audience with the information necessary to decode the symbolic wolf across various contexts and, in the case of informational books and some fictional works, to make sense of real wolves. Illustrated versions of folktales, fairy tales, myths, and fables pass on cultural heritage along with more contemporary social values. Contemporary informational books, while educating their audience about real wolves, also reflect current environmental values.

And yet the visual representations of the wolf in children's books are not only the first but often also the only wolves some people will ever see. For this reason, we can learn much from the visual depiction of the wolf in children's books. This study identifies and analyzes the cultural, social, and scientific knowledge embedded in and imparted through the image of the wolf. Further, because the texts anchor the images, this analysis also takes into account the ways in which text helps focus our attention and guides our understanding of the images. At the center of the research are the pictures and stories featuring wolves in children's books published in Western Europe and North America from the later fifteenth century to the present. My sources include myths, legends and fables, fractured tales, fiction, and nonfiction. I have limited my focus to those works in which illustrations play a key role such as illustrated

anthologies, chapbooks, and picture books. Save for Rudyard Kipling's *The Jungle Book*, Jack London's *The Call of the Wild* and *White Fang*, and Jean Craighead George's series of novels featuring Julie and a wolf pack, novels, textbooks, and magazines are excluded from this study.

Research on the depiction of wolves in children's picture books stands at the intersection of the humanities, science, and social science. The boundaries between the symbolic and real are fluid, with references to the wolf of tales and myths appearing in scientific texts, while fictional wolves, even the traditional ones, bear elements of the real wolf. Further, authors and illustrators often imbue their depictions of the wolf with human attributes and values, creating characters who share our concerns and behaviors, which helps us to identify with them. In this way, the wolves of children's books mirror and model the lives of their audience. The research surrounding real and symbolic wolves is incredibly rich with interpretations, equally diverse and occasionally divisive. As such it constitutes a fitting place to begin our study of the wolf in children's books.

Symbolic Wolves

The American Heritage Dictionary defines symbol as "something that represents something else by association, resemblance, or convention; a material object used to represent something invisible" (2004, 1302). Ferdinand de Saussure and Roland Barthes describe signs and symbols as empty vessels into which humans pour values and meanings. In this way, "things do not mean in themselves but are invested with meanings by cultures and societies" (Barthes 1972, 113–15). Nature is "a rich taxonomy of species and forms [that] provides a vast metaphorical tapestry for the creation of diverse and complex differentiation" (Kellert 1993, 51). We often imbue the terms and phrases used to designate places, animals, and plants with meanings, concepts, and values beyond their physical referent. As William Cronon suggests, "We turn them into human symbols, using them as repositories for values and meanings to the sacred" (1983, 20). The myriad uses to which we put the term *wolf* exemplify our tendency to use aspects of nature to create and convey meaning.

Used as a metaphor for people, behaviors, and situations, the word *wolf* is found in the idiomatic expressions and proverbs of many Western European languages. While we either admire or fear the unconventional vision, actions, and talents of the "lone wolf," most other expressions are less ambiguous in their negative connotations. Wolfish behavior is typically perceived as cruel and untrustworthy. Therefore, we need to be leery of a "wolf in sheep's clothing," be it a false prophet or a womanizer. Someone "raised by wolves" lacks manners. And while, at all costs, we would like to keep away the "wolves at the door," we know that it is never good to "cry wolf." In French, *un jeune loup,* who uses any means to get ahead in life, may end up leading a dishonest,

criminal life (*mener une vie de loup*) to the point of notoriety (*être connu comme le loup blanc*). Risk takers often find themselves thrown into the wolf's mouth (*se jeter dans la gueule du loup*) while those who prefer to go along with the crowd tend to *hurler avec les loups*. And someone who follows in the footprints of those who have gone before is said to *marcher á la queue leu leu*. *Quand on parle du loup, on en voit la queue*, "speak of the devil" warns us to be careful lest the person about whom we are speaking walks in, especially if he or she sneaks in without making a noise (*à pas du loup*.) And when we are "hungry as a wolf" (*une grande faim de loup*), we are often tempted to wolf down our food. Similar metaphors are found in German, Italian, and other Western European languages.

In Western European folktales, the wolf represents human predation and gluttony. It is something to be feared. Wolves in Roman and Scandinavian myths are a more diverse lot. In the founding myth of Rome, the she-wolf's fierceness protects Mars's half-human offspring, but the wolves in Odin's realm are companions and devourers. On the other hand, for the Nootkan, Kyoquot, Makah, and Kwakiutl tribes of the Pacific Northwest, the wolf represents strength, stamina, and perseverance. Their folktales and rituals honor the wolf's prowess as a hunter (Ernst 1952, 82).

In the Judeo-Christian tradition, the wolf represents rapacious, dangerous behavior. For instance, in the Hebrew Bible, Jacob's blessing of his youngest son, Benjamin, uses the wolf to foretell the savagery of Benjamin and his descendants:

> Benjamin is a ravenous wolf;
> in the morning he devours the prey,
> in the evening he divides the plunder. (Gen. 49:27 NIV)

In the Christian Testament, the wolf signifies deception, as seen in Matthew's warning against false prophets who "come to you in sheep's clothing, but inwardly they are ferocious wolves" (Matt. 7:15 NIV). And if Jesus is both the Lamb of God and the Good Shepherd, then the devil, who tempts, deceives, and threatens the flock, is embodied in the wolf. As Saint Ambrose, the archbishop of Milan, wrote: "If a wolf threatens to jump on you, seize a rock: he will flee. Your rock is Christ. If you seek refuge in Christ, you will make the wolves flee, that is, you will also make the Devil flee" (qtd. in Ragache, 16).

Politicians have also used the wolf to enhance their virtues or darken their opponents' vices. In the 1940s, Hitler called himself Father Wolf, named his headquarters the Wolf's Lair, and referred to his U-boat fleets as Wolf Packs. In American war posters, the United States fought both German and Japanese wolves. More recently, Shadow Wolves is the self-appointed nickname of the all-Indian, United States Customs unit that patrols the border of the Tohono O'odham Nation reservation in Arizona and Mexico. The unit, which takes its name from the way it "hunts," is now part of the Department of Homeland Security (Wheeler 2003). During George W. Bush's 2004 campaign for

reelection, his committee ran a television ad using the wolf as a metaphor for liberals and terrorists.

Symbolic nature is used not only as a way of conveying meaning through language but also as a means of understanding and defining ourselves. Socio-logical and psychological research draws attention to the symbolic value of animals in human cognitive, emotional, and aesthetic development. Through reflection, projection, and integration, we use animals to understand, add meaning to, and cope with our lives (Freud 1958; Jung 1968; Melson 2001; Shepard 1993).

Several scholars argue that although the meanings and values we assign to these animal symbols are influenced by cultural, social, geographic, and economic factors, the inclination of humans to think and communicate in animal symbols is evidence of the biophilia hypothesis (Kellert 1996, 17–20; Lawrence 1993, 332; Shepard 1993, 279; Wilson 1993, 32). At the core of the hypothesis is the notion that human interest in and emotional connections to nature are part of our genetic and evolutionary heritage (Kellert 1996, 42–43; Wilson 1993, 31). The survival of hunter-gatherers depended on learned, practical knowledge of the animals and plants with which they lived (Shepard 1993, 277–78; Wilson 1993, 32). Within the predator/prey system, the ability to focus on other species in escape or pursuit was essential to survival (Shep-ard 1993, 277). As such, human interest in nature has proved a competitive advantage and represents part of our species' "genetic fitness."

The biophilia hypothesis also argues that the interest in other species led to a more meaningful existence and personal fulfillment (Kellert 1993, 52; 1996, 21). Plants and animals play an essential role in human intellectual, cognitive, and aesthetic development (Kellert 1996, 17–20; Lawrence 1993, 332; Melson 2001, 150; Shepard 1993, 279; Wilson 1993). In turn, plants and animals pos-sessing qualities deemed attractive to humans reinforce the human affiliative instinct. In the case of the wolf, the species' beauty, strength, and mimetic behavior appeal to us (Rabb 2003, ix).

Supporters of the biophilia hypothesis point to Lévi-Strauss's work on pri-mal peoples as evidence of the role animals play in human cognitive, personal, and social development. Or as Lévi-Strauss suggests, "animals are good to think with" (1962, 89). According to philosopher Paul Shepard, the attributes of other species as well as their interactions with each other provide a means to think about, describe, and justify human relationships. An example of this is the naming of clans after animals. Wild animals become the "concrete models of categorical forms, from which societies give names to their clans or other subgroups . . . people justify group relationships by such a poetic reference, giv-ing them expression in narration, art, fetes . . . all out of a kind of logic, not of emulation, but of parallels" (1993, 277). Shepard argues that humans during the Pleistocene Era must have acted in a similar way: hunting rituals did not reflect compassion for the animals killed but instead recognized kinship and "the genesis of self-consciousness as assimilation, an endless scrutiny that is both instrument and synonym of becoming—the eco-psychology of predator

and prey. Eating, in-taking, is the culmination of the holy hunt, a sacred meal in which not only the energy but [also the] qualities are internalized" (ibid., 279).

Shepard also argues that the scrutiny and recognition of animals as "other" during the Pleistocene Era was requisite to the development of speech as well as the emergence of self-awareness (ibid., 277–80). Even today, for infants and children, animals are a first vocabulary for many aspects of the self. Learning to talk is learning to name, and some of the first objects that children are taught to name are animals (Melson 2001, 150). First as nouns, then as verbs, there is identification of and with, as well as distancing from, animals in stories and play. "Having recognizable external parts resembling my own, animals are an invitation to think about my own visceral landscape, of our corresponding organs and behavior . . ." writes Shepard (1993, 280–81). Animals provide us with "the curved mirrors of ourselves" (ibid., 277); they become the "other" to whom we compare ourselves (Melson 2001, 50; Shepard 1993, 277–98). The incorporation of animals into story, play, and fantasy contributes to a child's development: "Rather than standing in for an already fully realized, self-aware self, animal characters are the raw material out of which children construct a sense of self" (Melson 2001, 19). Further, Gail Melson argues that a child's use of animals is comparable to Lévi-Strauss's descriptions of the use of animal totems among primal peoples where animals become visible manifestations of invisible human feelings and relationships (2001, 150).*

Animals are also the "other" with which we form relationships. Children learn to care for, nurture, empathize, and bond with animals. Both stuffed and real animals provide children with the opportunity to develop, maintain, and experience relationships, allowing them to care for and interact with another. Such relationships not only are real, but they also serve as models for human relationships.

Melson points to the prevalence of animals in children's books as reflecting the perceived belief that animals are useful in language acquisition and cognitive, emotional, and personal development. A random sampling of one hundred picture books published between 1988 and 1992 reveals that most feature animals as central characters while only eleven do not mention animals. In more than 40 percent of these works, animals wear human clothing

* Supporters of the biophilia hypothesis are not the first to draw a connection between children, animals, and "primitive" peoples. Psychoanalysts have also considered children, animals, and "primitive" peoples to be alike: untamed, unrefined, and uncivilized (Bettelheim 1989, 100; Freud 1950). Further: "The child does not yet show any trace of the pride which afterwards moves the adult civilized man to set a sharp dividing line between his own nature and that of all other animals. The child unhesitatingly attributes full equality to animals; he probably feels himself more closely related to the animal than to the undoubtedly mysterious adult, in the freedom with which he acknowledges his need" (Freud 1950). Children have been seen as more closely related to animals than to adults because, like animals, children lack control over their biological functions. As such, animals, as the untamed id, reflect "instinctual freedom—freedom to bite, to excrete in an uncontrolled way, and to indulge sexual need without restraints" (Bettelheim 1989, 100).

and live human lives (Black quoted in Melson 2001, 140). In these highly anthropomorphic works, animal characters are used to model human behavior (Melson 2001, 140).

For Freud and Jung, animals also play an important role in psychological development. According to Freud (1958, 79–80), animals become the objects onto which children could safely project anger, fear, and desire, feelings that, if aimed at adults, would be unacceptable. One of Freud's young patients, the Wolfman, dreamt of wolves: "Suddenly the window opened of its own accord, and I was terrified to see that some white wolves were sitting on the big walnut tree in front of the window. There were six or seven of them." According to Freud, the patient associated the wolves in his dream with the folktale "Little Red Riding Hood":

> He had always connected this dream with the recollection that during these years of his childhood he was most tremendously afraid of the picture of a wolf in a book of fairy tales. His elder sister, who was very much his superior, used to tease him by holding up this particular picture in front of him so that he was terrified and began to scream. In this picture the wolf was standing upright, striding out with one foot, with its claws stretched out and its ears pricked. He thought this picture must have been an illustration to the story of *Little Red Riding Hood*. (1958, 80)

Freud sees in these dreams an animal phobia, which he understands to represent the Wolfman's "fear of his father . . . and his ambivalent attitude toward every father surrogate" (ibid.). Furthermore, Freud theorizes, the young man was projecting his fears of his father onto the wolf of the tales:

> If in my patient's case the wolf was merely a first father-surrogate, the question arises whether the hidden content in the fairy tales of the wolf that ate up the little goats and of *Little Red Riding Hood* may not simply be infantile fear of the father. Moreover my patient's father had the characteristic, shown by so many people in relation to their children, of indulging in "affectionate abuse"; and it is possible that . . . his father (though he grew severe later on) may more than once, as he caressed the little boy or played with him, have threatened in fun to "gobble him up." (Ibid., 83)

Jung also stresses the role of animals in human psychological development. For Jung and his followers, integration of the "animal soul" is essential for wholeness. They consider the initiation rites of "primitive" peoples as the way in which the "animal being" is integrated into a person's life (Jaffe 1968, 264; Jung 1968, 120). Further: "Man is the only creature with the power to control instinct by his own will, but he is also able to suppress, distort, and wound it—and an animal, to speak metaphorically, is never so wild and dangerous as when it is wounded" (Jaffe 1968, 263–64). A dream in which an animal pursues the dreamer indicates that "instinct has been split off from the consciousness and

ought to be (or is trying to be) readmitted and integrated into life" (ibid., 264). Both the uninhibited and suppressed or wounded drives indicate a being "alienated from its true nature." To be whole, one must accept his or her animal soul (Jaffe 1968, 254; Jung 1968, 120).

Real Wolves

And what of real wolves and the representations of real wolves in books and other media? We catch glimpses of real wolves in natural histories, in the stories told by travelers, peasants, colonists, and hunters, and more recently, in scientific studies. From the earliest works to the present, the wolf's nature and fate are linked to its hunger and appetite. In some instances, what is known about wolves seems to be informed by observation of the wolf; at other times, the information is rooted in lore, legend, or myth. In many instances, however, the accounts contain both kinds of information. In each, what we see of the wolf remains limited by the human lens and entangled in human concerns.

Aristotle includes the wolf in *The History of Animals* (350 BCE), classifying the species as one of the untamable, savage animals. He describes wolves as having "thorough-bred and wild and treacherous" characters, explaining that "an animal is highbred if it comes from a noble stock, and an animal is thorough-bred if it does not deflect from its racial characteristics" (Aristotle 1952, 9). Of its physical attributes, wolves along with humans, dogs, pigs, lions, and bears have "teeth in both jaws and one stomach" (ibid., 30). He notes that the "wolf resembles the dog in regard to the time of conception and parturition, the number of the litter, and the blindness of the newborn pups. The sexes couple at one special period, and the female brings forth at the beginning of the summer" (ibid., 105). Aristotle also includes and questions some of his contemporaries' understanding of wolves:

> There is an account given of the parturition of the she-wolf that borders on the fabulous, to the effect that she confines her lying-in to within twelve particular days of the year. And they give the reason for this in the form of myth, viz. that when they transported Leto in so many days from the land of Hyperboreans to the island of Delos, she assumed the form of a she-wolf to escape the anger of Hera. Whether the account be correct or not has not yet been verified; I give it merely as it is currently told. There is no more truth in the current statement that the she-wolf bears once and only once in her lifetime. (Ibid., 105–6)

In *De natura animalium (On the Characteristics of Animals)*, the Roman rhetorician Aelian, writing in the second to third century CE, suggests that the wolf's wickedness depends on his hunger and is manifested by his tongue:

The wolf when gorged to satiety will not therefore taste the least morsel. For his belly is distended, his tongue swells, his mouth is blocked, and he is as gentle as a lamb to meet, and would have no designs on man or beast, even were he to walk through the middle of a flock. Gradually, however, and little by little his tongue shrinks and resumes its former shape, and he becomes once more a wolf. (1971, 229)

During the late fourteenth century, Gaston de Foix (Phébus) wrote a hunting manual, *Le livre de la chasse* (*The Book of Hunting*). In it, Phébus advises his audience on the care and use of hunting dogs and on baiting and capturing wolves with pitfalls, cages, jaw traps, poison, and needle traps. He provides brief sketches of the nature and habits of various animals including the wolf, which he describes as sly and cunning. He also stresses the wolf's ability to save its strength when being pursued. One of the pictures in Phébus's manuscript shows several wolves engaged in different activities. Save for a nursing she-wolf and her cub, most of their actions underscore their role as predator, highlighting lone wolves hunting and eating sheep, goats, and pigs. According to Phébus, wolves also pose a threat to humans: "they find the flesh of man so delicious that having once tasted it, they will eat no other beasts" (2002, 6). He attributes the wolf's penchant for eating humans to age (old wolves are too weak to attack and carry off other kinds of prey) and war (wolves acquire the taste of human flesh by feeding off the human corpses left on battlefields).

Travelers' and farmers' tales from both the Old and New Worlds also contain descriptions of wolves. Many of these stories refer to their struggles with wolves, portraying the animals as dangerous and the humans as vulnerable (Coleman 2004, 105). In *Ultime veillée: souvenirs et contes creusois au temps des loups* (*The Last Storytime: Remembrances and Stories from the Time of the Wolves*), Louis Dheron recounts family lore handed down by his peasant ancestors. For the most part these stories relate the family's efforts to protect their flocks from wolf packs. One story, in which a lone wolf in the woods attacks one of the family's female helpers, recalls "Little Red Riding Hood."

In 1907, the Bureau of Biological Survey, part of the United States Department of Agriculture, published a circular entitled *Directions for the Destruction of Wolves and Coyotes*. The purpose of this document was to help decrease the losses on livestock herds from wolf and coyote predation. It gives advice on the "best methods of hunting, trapping, and poisoning wolves and coyotes, of finding dens, and destroying the young, and of fencing to protect stock" (Bailey 1907, 1). In addition to specifying the traps needed and the most effective poison (strychnine), the manual also provides snippets of information about the size of wolf litters (six to ten pups), the breeding season (January and February), the gestation period (nine weeks), the physical appearance of pups (almost black at birth to "dullish yellow" and finally a light gray at three months), and the location of dens (valleys, foothills, or low mountains) (1907, 1–2).

As the U.S. government took on the task of predator control, the stories told by farmers and ranchers gave way to those told by government scientists and trappers. In contrast to the earlier stories, those told by the bureaucrats assigned to the task of tracking down the country's remaining wolves portray their prey as worthy adversaries, praising their ability to survive (Coleman 2004, 12). Unlike the more generalized depictions of wolves in earlier lore, the government hunters' stories name the outlaw wolves, which in turn helps to individualize them. As Coleman points out, the lore of the last wolves renders their lupine protagonists sympathetic, especially to a more industrialized and urban American audience (ibid.).

Just as the government was succeeding in exterminating the wolf from the United States, the first scientific study of wolves was undertaken. Adolph Murie's 1944 report on the wolves in Mount McKinley National Park (MMNP) marks the beginning of scientific research on wolves. In accordance with the National Park Service's policy "that no disturbance of the fauna of any given national park shall be made until a proper appraisal of the question has been made," Murie sought to determine whether it was "feasible to permit moderate representation of the wolf in the fauna of Mount McKinley National Park." In other words, he was attempting to understand the effect of wolf predation on the park's big game animals (specifically, Dall sheep) as well as on the park's other predators (golden eagles, foxes, grizzly bears, and so forth.) (1944, xiv).

From April 1939 to August 1941 Murie studied wolf–Dall sheep relationships inside the park. Using sheep skulls to identify the kinds of sheep killed by the wolves, Murie concluded that wolves "prey mainly on the weak classes of sheep, that is, the old, the diseased, and the young in their first year. Such predation would seem to benefit the species over a long period of time and indicates a normal prey-predator adjustment in Mount McKinley National Park" (ibid., 230). In addition, the remains revealed that the wolves provided the main check on the park's sheep populations. Murie's work also describes the rally that took place before the hunt: "Considerable ceremony often preceded the departure for the hunt. Usually there is a general get-together and much tail wagging" (ibid., 31).

At the center of Murie's research were three wolf packs, designated according to the location of their dens: Toklat River Den, Savage River Wolf Family, and the East Fork River Den. His chapter on wolves includes descriptions of their physical characteristics, diet, breeding, hunting range, pack life as well as their history in MMNP, the story of a captive wolf, and methods for trapping wolves. In these descriptions we can also see the beginnings of our understanding about the structure and makeup of the wolf pack. His observations begin to undermine the earlier held assumption that a pack consists of two adult parents and their pups: "So far as I am aware it has been taken for granted that a wolf family consists of a pair of adults and the pups. Perhaps that is the rule, although we

may not have enough information to really know" (ibid., 24). Puzzled by the presence of extra adult wolves within the packs, Murie admits to not understanding their relationship to the parent wolves or to the pack:

> The Savage River family was of special interest because of the presence of three adults, all concerned over the welfare of the pups. The sex and age of the extra adult was not known so its relationship was not determined. There could have been two families living together, but the uniformity in the appearance of the six pups indicates they were of one litter. The extra wolf may have been a pup of a previous year, but judging from the relationships at the East Fork den, where there were extra adults, it seems likely that extra wolf was not a yearling but was an adult living with the pair year after year. (ibid., 21)

At times, however, Murie's descriptions reflect long-held attitudes and behaviors. In talking about the wolf's threat to the livestock industry, he writes that the wolf is "a powerful animal, and a cunning one" (ibid., xiii). Later, in describing individual wolves, he assigns them names like Grandpa, Dandy, and Robber Mask. In this description of a black female wolf, Murie associates it with one of the most famous literary wolves, saying her "muzzle seemed exceptionally long, reminding me of the Little Red Riding Hood illustrations" (ibid., 28).

Although he supports the removal of the wolf from areas where livestock farming predominates, Murie also recognizes the desire to "retain the wolf somewhere in the North American fauna, perhaps in the more remote parts of the continent in wilderness areas where there will not be interference from economic interests" (ibid., xiv).

Since this first study, the wolf has been the object of scientific research. The longest-running study began fifty years ago on Isle Royale in Lake Superior. Initiated by biologist Durward Allen in 1958 and continued by biologists David Mech and Rolf Peterson, among others, it provides invaluable insights on wolf behavior. It is also the source for one of the first popular pro-wolf publications, the 1963 *National Geographic* article "Wolf Versus Moose on Isle Royale." One of the most significant contributions was a result of Mech's dissertation research, which found that wolves do not randomly kill moose. Instead, they test their prey to determine its strength and potential danger. Mech's work supports Murie's earlier findings that wolf predation's heaviest toll is on the young, the sick, and the old. Yet, in his recent work celebrating the fifty-year study on Isle Royale, Rolf Peterson suggests that more variables than the predator-prey relationship are at play in the size of the wolf-moose populations. Habitat, climate change, natural disasters, and disease, not to mention the presence or absence of humans, affect animal populations (Peterson 2007, 158–62).

Changes in the way in which predators and predation are understood have resulted in a change of legal status for wolves. Since the mid-1970s, the wolf's

legal status has changed from that of an animal to be exterminated to one worthy not only of protection but also of breeding programs to ensure its survival (Boitani 1986, 320–21; Mech 1995, 271). Even so, the wolf's status is complicated, varying from region to region, country to country, and from one wolf population to another. For instance, under the Endangered Species Act not all wolf populations are afforded equal protection. The act distinguishes between experimental groups reintroduced to an area by humans and non-experimental populations that wander into an area. The ways in which wolf biologists, ecologists, and government workers talk about saving wolves further obscure the role of wolves and of humans. "Wolf recovery," "reintroduction," "wolf management," "preservation," and "conservation" are samples of the complex and controversial terminology surrounding wolves. Further complicating the wolf's status are recent decisions by the federal government to remove "recovered" populations from the Endangered Species List and to turn over the "management" of these populations to the individual states.

The Interconnectedness of the Real and the Symbolic

While we use nature's various life forms to symbolize or represent human actions, traits, and beliefs, we also try to understand nature and our place and role within it. In *Saving America's Wildlife: Ecology and the American Mind, 1850–1990*, Thomas R. Dunlap describes the ways in which different cultures perceive and think about nature as nature myths: "descriptions of the world [that] every society provides to the people growing up in it, descriptions that locate them in the world and within their society" (1988, ix). Like symbols, nature myths are intellectual constructions that meld ideas and emotions into images (Nash 2001, 15). In this way "'nature' is a human idea, with a long and complicated cultural history, which has led different human beings to conceive of the natural world in very different ways" (Cronon 1983, 20). This suggests that there is not one single, definable, and identifiable nature but instead many different natures. Further, the ways in which people think about and value nature are shaped by the social and cultural contexts in which they live: "None of these natures is 'natural'; all are cultural constructions that reflect human judgments, human values, human choices" (ibid., 34).

This, however, does not mean that nature is unreal or that it does not exist. Rather, "the way we describe and understand the world is so entangled with our own values and assumptions that the two can never be fully separated" (ibid., 25). Further, "the material nature we inhabit and the ideal nature we carry in our heads exist always in complex relationships with each other" (ibid., 22). Elizabeth Atwood Lawrence suggests that whenever we meet another species "whether in actuality or by reflection, the 'real-life' animal is accompanied by an inseparable image of that animal's essence that is made up of, or influenced by preexisting individual, cultural, or societal conditioning" (1993, 302). As

such, nature myths do more than explain the natural world and humankind's relations to it: they can impact how humans treat it (Dunlap 1988, ix). As we use other species to represent various human concepts, traits, and values, these representations inform our perceptions of their real-life counterparts, which in turn influence our relations with them. Children's books impart not only stories and information about wolves but also cultural and social beliefs about wolves, nature, and ourselves. The ways in which authors and illustrators depict wolves, the roles and values they assign to them, potentially shape young readers' attitudes towards and treatment of the species.

Even within a single culture, symbols and myths are neither static nor universal. Histories tracing changes in the ways humans conceptualize nature point to the existence of views that challenge or contradict prevailing attitudes (Dunlap 1988; Merchant 1983; Thomas 1983). Social class, ethnicity, economics, geographical considerations, and educational background are several of the factors cited as influencing the ways in which people perceive nature and the natural world (Dunlap 1988; Nie 2003; Thomas 1983). Studies examining current controversies related to environmental issues show that while different people in different circumstances may construct the environment in different ways, they do so using similar or even the same images and terminology (Carbaugh 1996, 4; Fritts et al. 2003; Kellert et al. 1996; Mech 1995; Nie 2003).

Further, scientific understandings of nature are dynamic and biased, shaped and altered by ideological and political as well as technological and economic factors (Barbour 1983; Heise 1997, 5). In the 1940s, when biologists and ecologists began to focus on the effects of predation on a prey population instead of on the predator's diet, scientific understanding of wolves began to change (Dunlap 1988; Flader 1974). Changes in research methods along with changes in technology often displace or modify earlier "facts" and raise new questions. As wolf biologist Rolf Peterson has admitted, "the longer one studies a particular living system, the less one can say with certainty about its behavior" (2007, 162–63). Finally, as Barry Lopez in *Men and Wolves* reminds us, even the depiction of wolves in scientific studies is a construction: "The methodology of science creates a wolf just as surely as does the metaphysical vision of a Native American, or the enmity of a cattle baron of the nineteenth century. It is only by convention that the first is considered enlightened observation, the second fanciful anthropomorphism, and the third agricultural necessity" (Lopez 1995, 203).

The dissemination of scientific ideas and findings through popular works and by environmental groups helped to transform the wolf from a nefarious, cowardly creature into a noble, social animal worthy of saving from extinction (Dunlap 1988, 19–33; Greenleaf 1992, 50; Mech 1995, 271; Rahn 1995, 157–64). As Mech argues, however, environmental groups and animal-rights organizations tend to be selective in how they present scientific understandings of wolves (1995, 271).

The debate over the reintroduction and control of wolf populations provides a specific example of the ways in which the survival of a species is tied to people's perceptions of the animal. The fate of wolves is intertwined with the social, cultural, economic, and political concerns of differing groups that construct and use competing images of the wolf to promote their agendas (Mech 1995, 271; Nie 2003): "Wolf management is especially challenging, not only because wolves cause socio-economic problems but also because of the universally contrasting viewpoints about wolves" (Fritts et al. 2003, 312).

In the past, the eradication of wolves and other large predators was not contested because most people supported their removal or were indifferent to their survival (ibid., 313). In the current controversy surrounding wolf recovery in the United States, wolves embody intangible values expressed in terms of their role in the ecosystem and their "enrichment" of nature (ibid., 298). In 1974, the *Canis lupus,* or gray wolf, became one of the first animals to be listed under the Endangered Species Act and thus the *cause célèbre* for animal-rights and environmental groups. At the time, the remaining wolf populations were found only in "the most pristine wilderness of North America and the least developed parts of the world . . . Thus both laypeople and resource managers widely believed that wolves preferred wilderness" (Mech 1995, 271). For environmentalists and animal-interests groups, the wolf came to symbolize the disappearing wilderness (Mech 1995, 271; Nie 2003).

Wolf biologists like David Mech, however, have been critical of the tendency to associate the wolf with remote wilderness (1995, 271). He and other biologists have insisted that wolves are highly adaptable animals that can live almost anywhere (Boitani 1986, 340; Mech 1995, 272–74; Mech & Boitani 2003, xv). As a way to ensure the wolf's recovery not only in "wilderness" areas but also in their former habitats, wolf biologists advocate managing wolf populations, for example, the removal and disposal of wolves preying on livestock and pets (Boitani 1986, 339). This is a practice that many environmental and animal-rights groups find abhorrent (Boitani 1986, 335; Mech 1995, 275).

For ranchers and farmers, the wolf represents more than a threat to livestock and family pets: it represents the eastern establishment and urban dwellers interfering with the Old West (Nie 2003, 52). For this reason, "the wolf is often seen by ranchers and other Old Westerners as the symbol of everything that has gone awry in the New West . . . and some ranchers interpret the wolf as being its most loathsome mascot" (ibid., 129). According to this viewpoint, the wolf is the federal government preempting individuals' and states' rights, while ranchers represent rugged individualism and self-reliance, the very essence of the Old West (ibid., 52). As Nie suggests, "The only species that carries more symbolic baggage than the wolf is the western rancher" (ibid.). In this way the controversy surrounding wolf reintroduction and management can be understood as the clash between two distinct cultural views.

In contrast, the Nez Perce tribe sees parallels between the return of the wolf to Idaho and an elevation of the tribe's status. As leaders in Idaho's wolf

management program, the Nez Perce have become a valued source of information on wolves (ibid., 109). The tribe sees a connection between its survival and that of the wolves: "If the tribe is removed from wolf management, what is going to be the fate of the tribe, and what is going to be the fate of the wolf?" (Pinkham, qtd. in Nie, 109). Not all Native American tribes, however, embrace the wolf's return. In Arizona, previous efforts to reintroduce the Mexican gray wolf have been met with resistance by the San Carlos Apache, who see the wolf as a threat not only to their livestock but also to their game herds (ibid., 107–8).

The range and contradictory nature of these images indicate that the most vexing challenges surrounding wolf recovery stem from human beliefs, fears, and economic concerns and not from biological or ecological issues (ibid., 26). They also suggest that distinctions between the symbolic wolf and the "real" wolf tend to blur and even collapse. For wolves, this means that what "people choose to believe about wolves can be more important than the objective truth, or at least those beliefs can have a greater effect. Whether looking at the past, the present, or the future, people's beliefs and perceptions that primarily affect the survival of wolves" (Fritts et al. 2003, 290).

Wolves and Children's Literature

Several studies argue that folktales and mythology affect people's views of real wolves (Fritts et al. 2003, 292–93; Kellert et al. 1996, 978–79; Lopez 1995, 250–70). Most of the research on the wolf in traditional narratives focuses on the role of the wolf in one particular tale: "Little Red Riding Hood." As Sandra Beckett notes in her introduction to *Recycling Red Riding Hood*, "No folk tale has been so relentlessly reinterpreted, recontextualized, and retold over the centuries as *Little Red Riding Hood*" (2002, xv). "Little Red Riding Hood" has not only been the subject of numerous retellings but also the object of study by folklorists, psychoanalysts, psychologists, sociologists, educators, historians, and literary scholars. Our understanding of the story, the wolf, and the wolf's role varies according to the researcher's discipline, theoretical approach, and sources. Yet the wolf, as the villain, remains the same: dangerous. What changes is the type of danger he represents.

Literary scholars Arthur Arnold, Sean Kipling Robisch, and Sarah Greenleaf support the view that a child's understanding of wolves depends on what the child reads (Arnold 1986, 101; Greenleaf 1992, 58; Robisch 1998, 256–95). So if a child reads *Aesop's Fables* or the Brer Wolf tales, the child will understand the wolf to be dull, slow-witted, and gluttonous, but if a child reads Rudyard Kipling's *The Jungle Book*, then he or she will see the wolf as friendly to boys as well as courageous (Arnold 1986, 102–3). Arnold and Greenleaf examine the image of the wolf in fictional works, focusing on the link between stereotyping animals and racial and gender stereotyping and the ways in which the

presence or absence of real wolves influences how authors write about them. Negative stereotyping of the wolf in nineteenth-century children's fiction and magazines validated the extermination of the wolf while fostering the "process which encourages the same easy acceptance of other stereotypes, including racist and sexist ones" (ibid., 107). Sarah Greenleaf agrees, stating that "the use of wolves as symbols of wickedness has undoubtedly led young children to a later and easy acceptance of racial and sexist stereotypes" (1992, 56).

As Greenleaf and Suzanne Rahn have shown, however, not all images of the wolf in nineteenth- and early-twentieth-century children's publications are negative. In "The Beast Within," Greenleaf traces the influence of scientific thought on the depiction of wolves in children's books and argues that "the changing image of the wolf in children's books over the last two centuries affords a clear view of the major stages of growth in our biological think-ing, from a nature to be feared, to a nature to be controlled, to a nature to be respected" (ibid.). The dissemination of Darwin's evolutionary theory and the struggle for survival in realistic and fantastic animal stories during the 1890s and early 1900s resulted in more sympathetic images of wolves in chil-dren's books (Dunlap 1988, 19–33; Greenleaf 1992, 50; Rahn 1995, 161). Fur-ther, "whereas the traditional boys' adventure stories pitted the protagonist against nature (and against peoples who lived close to nature, such as Ameri-can Indians and African tribesmen), one could now find a significant number of stories in which the protagonist lived close to nature and in harmony with it" (Rahn 1995, 158). Rahn points out, however, that while scientists, hunters, and nature lovers were beginning to view most predators in a more sympa-thetic light, positive attitudes towards wolves lagged: "Even the environmen-talists of the late nineteenth and early twentieth centuries had no use for the wolf, when Yellowstone and the other national parks were established, gov-ernment hunters systematically exterminated every wolf and mountain lion within their borders" (ibid., 161). For this reason, Rahn calls authors Ernest Thompson Seton and Rudyard Kipling revolutionaries: "Seton for writing stories such as 'Lobo, the King of the Currumpaw,' . . . about a heroic wolf's last stand against his human enemies, and Kipling for putting good wolves at the center of *The Jungle Book*" (ibid.).

Peter Hollindale stresses that the new image of the wolf in contemporary children's novels has "more to do with a re-visioning of humankind itself, in its own nature and in its relations with the animal world" (1999, 99). Hollin-dale examines British and American children's fiction featuring wolves arguing that the status of the wolf—extinct in Britain, recovering in the United States—impacts the way in which American and British authors treat their subject matter. Because wolves have been extinct in Britain since the late seventeenth century, British authors are free to "remodel" the stereotype (ibid., 104). This means that, in Britain, there is "no conservationist present to obscure their lines of communication with the past of legend, superstition, and historical record." And yet the presence of the wolf in children's books attests to its presence in

the human mind (ibid., 114). Hollindale credits the development of modern ecology with rewriting the image of the wolf in children's books and "showing us the living animal as admirable and precious." At the same time he criticizes those "routine stories" that keep the traditional wolf and humans' irrational fears alive. He concludes that "in this respect the wolves of children's literature are situated very much like those of the real world" (ibid.).

But wolves are present not only in the stories we tell; they are also part of our visual landscape. Visual representations of the wolf are used in environmental, political, and advertising campaigns, as corporate logos, and as mascots for sports teams. Their images adorn everyday items from clothing to dishes, linens, and calendars. Pictures of wolves are found in literary, historical, scientific, and popular works, including children's books. Further, biologists agree that part of the wolf's appeal and success as an environmental cause has to do with its physical appearance (its resemblance to dogs and its beauty) (Fritts et al. 2003, 300; Kellert et al. 1996, 978; Mech 1995, 271; Steinhart 1995, xvi). The widespread and varied use of the wolf's image suggests the need for a closer look at these visual documents. But, save for Jack Zipes's semiotic analysis of nineteenth- and early-twentieth-century illustrated editions of "Little Red Riding Hood" and Sandra L. Beckett's narrative analysis of the visual images in contemporary editions of the tale, the visual image of the wolf has gone unstudied.

Given the range of media in which these images appear, as well as their sheer number, a comprehensive study of them is beyond the scope of any one book. The images found in children's books make them a rich resource in which we can see many types of wolves, from realistic to humanlike. Children's books, containing common as well as unique depictions of the wolf, are invaluable resources. In addition to being the medium through which many people first encounter and learn about the wolf, many of the pictures of the wolf in children's books are found elsewhere, including on calendars, in coffee-table books, and in advertising and scientific reports. For instance, the photograph of a wolf pack chasing a moose through the snow is repeated across informational books for children, popular nonfiction, coffee-table books, and scientific works. Oftentimes, however, only the composition and subject matter are repeated. But the overall effect of the repetition of images and their content does more than render the scenes familiar and recognizable; it also imbues the image with authority, and by extension, truth. Further, images of the wolf and other characters from "Little Red Riding Hood" appear not only in picture books but on billboards, in magazines, and other places such as posters, adding another layer of meaning to the advertisement. Further, although convention seems to dictate which scenes are to be illustrated, most illustrators of contemporary picture-book versions of wolf tales create distinct renderings of the wolf, keeping the retellings fresh and the wolf dynamic.

The following questions frame this study: How are wolves depicted in and across particular works? What cultural, social, and scientific values and

attitudes inform the depiction of the wolf and wolf-human relations? How has the concept of the wolf changed over time? More simply stated, what is a wolf and how have our understanding, use, and depiction of the species changed over time?

In terms of subject matter and questions, my approach to the visual image of the wolf aligns with an ecocritical perspective. "Ecocriticism," like feminism, is an umbrella term, at times reflecting different and even conflicting approaches. At its core, however, ecocriticism considers "the role that the natural environment plays in the imagination of a cultural community at a specific historical moment, examining how the concept of 'nature' is defined, what values are assigned to it or denied it and why, and the way in which the relationship between humans and nature is envisioned" (Heise 1997, 4). Cheryll Glotfelty, editor of *The Ecocriticism Reader*, stresses that ecocritical inquiry "shares the fundamental premise that human culture is connected to the physical world, affecting it and affected by it" (1996, xix). Ecocritical researchers focus on the interconnectedness between nature and culture as expressed in language, literature, and art, studying the ways in which these cultural artifacts reflect, contribute to, and perpetuate cultural beliefs and understandings of nature and the natural.

Literature and works of art are not the only sources in which nature is depicted. Nature is also the focus of many scientific works which not only contribute to our understanding of nature but also, at times, shape the depictions of nature in fiction and art. Given the power of science in the West, scientific descriptions of nature also have a place in studies focusing on nature in literature and art (Heise 1997, 5). As Ursula Heise has argued, by comparing what scientists tell us to an author's or artist's use of this information in his or her work, we can assess the dissemination, reception, and transformation of scientific knowledge within a culture. Such an analysis helps to determine the ways in which authors or artists stray from the scientific. For instance, authors of many contemporary fictional and informational picture books base their characterizations of the wolf on scientific studies of the wolf. Although these works contain facts about wolves, they are not always comprehensive or objective in the ways they present them. Instead, the facts are used to support the author's, illustrator's, or publisher's particular ideological agenda. Further, aesthetic representations of nature are associated with scientific descriptions. For instance, the photographic images of the wolf in contemporary informational books for children, while depicting a sanitized, pristine view of the wolf and nature, are used as evidence of scientific "fact." This suggests that the text is "a place where different visions of nature and varying images of science, each with their cultural and political implications, are played out, rather than simply a site of resistance against science and its claims to truth, or a construct in which science is called upon merely to confirm the inherent beauty of nature" (ibid.).

Ecocriticism also calls for a proactive agenda. In this area, I depart from the theoretical framework. My purpose is not to condemn particular works.

Instead, my goal is to understand the ways in which wolves and nature are constructed and used to convey meaning in illustrated children's books. These books are more than a space in which children and adults encounter a wide range of wolves; they are also the space in which children first learn about symbolic and real wolves. My hope is that analysis of these works will provide insight on the ways in which symbolic and real wolves are described, used, and defined.

Further, although the ecocritical approach seems appropriate given this topic's cultural, literary, and scientific associations, it also poses potential problems. Adhering too closely to any theoretical framework threatens to limit and skew a researcher's analysis of the data. In turn, this can lead to making the data fit the theory. Throughout my research I have tried to remain open to what the data reveal.

Although both the time periods and the various genres covered in this study suggest either a chronological or a genre-based approach, I have chosen to arrange my findings according to the various ways in which we conceptualize the wolf. According to the *Concise Oxford English Dictionary,* the wolf is "a carnivorous mammal, which is the largest member of the dog family living and hunting in packs" (2004, 1658). In other words, the wolf is a predator, a social being, and a canine. Bounties as well as the Endangered Species Act assign the wolf legal status while reflecting our view of it as a predatory animal. These categories cut across time and genre as well as across the representation of symbolic and real wolves. They are also the sites where the changes in the ways in which we think about the wolf have occurred. Further, at the heart of these categories are human–wolf relations. As cultural constructs, these categories not only describe the wolf but also reflect us and our relationship with the wolf and, by extension, with nature. In literature as in life, the wolf is often defined by its relationship to humans and human concerns. As such, human-wolf relations provide yet another way in which to investigate the wolf. Within the context of children's literature, the main human-wolf relationship is the one between children and wolves.

In many traditional European and Euro-American narratives, the wolf is first and foremost a male predator, serving as a metaphor for dangerous human behavior. In most of these stories, the wolf's predatory nature forms the basis not only of his reputation but also his identity and conduct. Defined by his greedy mouth, his voracious hunger, and the threat that he poses to humans and domesticated animals, the wolf is a one-sided beast seeking to fill his belly. In "Little Red Riding Hood," "The Three Little Pigs," and "The Wolf and the Seven Kids," as well as numerous fables and saints' legends, the wolf's desire to eat motivates his actions while shaping his interactions with the other characters. As such, his predatory nature not only keeps him hungry but also renders him treacherous and immoral. By exaggerating his snout, teeth, or tongue, the illustrations accompanying these texts draw the viewer's attention to his mouth, the visible manifestation of his nature.

Contemporary informational books as well as fictional picture books also describe the wolf's carnivorous ways. Drawing on scientific research, these books recast the wolf's predation by reducing it to but one of the wolf's many traits. They also diminish and reconfigure predation by stressing its benefit to prey populations, the wolf pack's frequent lack of success in hunting, and the danger posed to wolves by large prey animals. Similarly, the images and photographs that illustrate these works provide a different view of the wolf and predation. Very few show the wolf hunting, killing, or eating his prey. Indeed, for the most part the illustrations labeled as hunting feature a wolf pack walking in single file after a not-to-be-seen prey. Photographs or pictures featuring wolves eating are typically blood free and sanitized. These contemporary images and text do more than lessen the danger of predation; they remove the moral connotations associated with it. In other words, the wolf may be a predator, but it is no longer evil.

Contemporary nonfiction and fiction redefine the wolf by emphasizing its social nature. Life in the pack, pack relations, and relationships with other creatures form the core of these works. Informational books describe wolf society, especially the importance of establishing and maintaining hierarchy in the pack. Pictures highlight the species' visual communication while the texts decode tail wagging, howling, and other gestures. Pack life also centers on nurturing, raising, and educating puppies. Images feature pups nursing, adult wolves feeding and interacting with young wolves, babysitter wolves protecting and training pups, and the pups playing with each other. Much of the text used to describe these activities reflects not only wolf behavior but also human behavior. The effect of these descriptions is twofold. By making wolves familiar as well as sympathetic, they help the audience to identify more closely with wolves. At the same time, by focusing on traits and conduct that humans value—caring for the young, social order, and teamwork—they show wolf behavior reflecting and modeling ideal human behavior.

No longer bound to the role of villain, the wolf of contemporary fictional picture books plays a range of roles. Many contemporary fictional picture books, like informational books, focus on the wolf's social nature. Life in the pack and the relationships between young and old, strangers and kin, form a large part of contemporary stories. Fiction, however, allows for varied and complex characterizations and plots. Neither fully human nor fully wolf, the wolves in many of these fictional stories find that their predatory ways complicate their attempts at friendships with other species. Sometimes, the prospect of love and companionship transforms the wolf from a potential predator to a friend. At other times, the wolf's carnivorous urges overpower him. Yet when the contemporary fictional wolf does what traditional or even real wolves do—eat other animals—the distinction between good and evil blurs. As such, it is not clear that the wolf in Claude Boujon's *L'apprenti loup* or the wolf pack in Emily Gravett's *Wolves* is wicked; rather wolves, like people, need to eat.

While contemporary fictional and informational books clearly establish the wolf as a social being, the wolf in many traditional narratives appears not only alone but as a lone male animal. This lone status places him outside of the social context, freeing him of social constraints and rendering him dangerous. The relationships that he seeks are self-serving. Deception, entrapment, and intimidation underlie his interactions with others, making him a threat to society.

In contrast, the lone wolves of contemporary fiction and nonfiction are not dangerous but endangered. As a social animal, the lone wolf would seem to be an anomaly. Yet according to wolf biologists, a wolf can become a lone wolf due to pack aggression (the wolf loses its status) or dispersal (when a wolf leaves to find a mate and form a new pack). Informational books stress the difficulties of being a lone wolf. From the threat of starvation (the pack is essential for hunting large prey) to the threat posed by other wolves and other animals including humans (lone wolves, in trying to feed and survive, tend to attack livestock and family pets), the lone wolf leads a hard and typically short life. In contemporary fictional books, the wolf's lone status is usually the result of one factor: humans. Human hunters kill or separate pack members, rendering the survivor alone, lonely, and vulnerable.

Parodies of traditional and contemporary works problematize and reconfigure not only the source texts but also the wolf. By exaggerating the wolf's appetite, the fractured stories render the wolf harmless by rendering him humorous. Some of these stories revise the wolf by placing him and his actions within the context of family and friends. No longer a lone animal, his actions often fall under the scrutiny of others. At least one work parodies the tendency of environmentalists, vegetarians, and other animal lovers to pick and choose aspects of the wolf that suit them, ignoring those that keep the wolf problematic and dangerous. These fractured stories, while humorous, are nonetheless important for the insights they provide on the concerns of contemporary European and Euro-American cultures.

The classification of the wolf as *Canis lupus* allows room for comparison with other canines such as foxes, coyotes, and dogs. Children's literature, like the world it reflects, contains examples of each of these canines. In Aesop's fables, the wolf often appears alongside the dog or fox, each animal serving as shorthand for different types of human behavior and foibles. Where the wolf's large size supports cruel and brutal intentions, the fox relies on wit to overcome small physical stature. And when the two meet, as they often do, the fox mainly outwits the wolf. The dog represents enslaved loyalty while the wolf stands for unfettered independence. Just as their roles in these stories have endowed them with specific character traits, so the conventions for illustrating these stories have helped to make each species readily identifiable. The wolf, known for size, greed, and hunger, is often the largest of the three. The fox is identifiable by a short stature and fluffy tail, while a collar distinguishes the dog.

Not only in traditional stories do these animals appear and oftentimes interact with each other. They are also present in contemporary informational books. For instance, nonfiction about wolves includes photographs not only of the wolf but also of other canines. While the pictures allow the audience to compare the animals based on their physical attributes, the texts compare their behavior. Most of these works emphasize the relationship between dogs and wolves, stressing their common genetic legacy as well as the behavioral traits they share. In this way, the dog becomes a window through which readers can understand and, more importantly, connect to the wolf. Comparisons of wolf and dog are also found in informational books on dogs. Where the message of informational books on wolves is that wolves are like dogs, in books on dogs, the message is that dogs are like wolves. In both cases, the dog mediates the human-wolf relationship.

The wolf is not only a hunter, but for centuries it has also been hunted. The violence on display in traditional and contemporary works is typically that done to the wolf. Dead and dying wolves litter the illustrations accompanying "Little Red Riding Hood," "The Three Little Pigs," "The Wolf and the Seven Kids," and many other fables. Similarly, contemporary nonfiction, along with some of the fictional stories, contains pictures of hunted, trapped, and dead wolves. The difference rests in the treatment and meaning assigned to these deaths. In the traditional stories, the wolf's behavior transgresses acceptable human conduct and poses a threat to society. Within this context, the wolf's death is a just act and a cause for celebration. In contrast, images of dead or dying wolves in contemporary works serve as an indictment not of wolves but of humans and the damage we have wrought on nature. What has changed is not the wolf but the ways in which we view ourselves and our role in the world.

The strongest evidence of this transformation is found in the literary relationship of wolves and children. From the wolves of Romulus and Remus and Rudyard Kipling's *The Jungle Book* to "Little Red Riding Hood" and *Where the Wild Things Are,* wolves and children share a long and complicated history. Where the wolves once nurtured or devoured children, now children shelter and nurture wolves. Further, in traditional tales adults are portrayed as wise and experienced as they try to protect their young from the predatory wolf. In many contemporary stories, a child attempts to protect a wolf from predatory adults. While parents and other caregivers used and still use traditional wolf tales to warn children of dangerous humans, so the authors of contemporary informational and fictional works urge their young audiences to preserve and save the wolves from human transgressions.

Finally, in another twist, several contemporary fictional stories feature children who take on the persona of a wolf. Whether releasing an inner beast, overcoming shyness through anonymity, or gaining strength and courage from the wolf's physical form, these children as wolves are among the fiercest of the fictional wolves.

As these images and texts suggest, the transformation of the wolf is rooted in our own transformation. We use the wolf to represent human values, beliefs, and concerns. In turn, we judge the wolf according to human standards and norms. In traditional European and Euro-American tales, the wolf's predatory nature is equated with human evil and wickedness. Currently, we find value in the wolf and reconfigure it in our image. Stressing the social aspects of wolf behavior, we diminish its skill as a hunter and emphasize the danger that large prey pose to the wolf. We applaud the wolf's role in keeping prey populations healthy while criticizing our own uncontrolled destruction of the wolf. Through various media, we advocate the need to preserve, protect, and restore wolf populations, urging the public to take up the call. In traditional stories we use the wolf to explain aspects of human behavior, while in nonfiction, as well as in some fictional picture books, we use human behavior to explain that of the wolf. In essence, we use the wolf to mirror the ways in which we see ourselves, our role in the world, and our relationships with other species. Our understanding of the wolf changes as our understanding of ourselves changes. Whether as lone sociopaths, lonely outcasts, or social beings who care for each other, we are the wolf and the wolf is us.

Chapter One
Wolf as Predator

Two wolves chase the sun and the moon. A wolf leaps at a holy man; another knocks on a door. Disguised as a sheep, a wolf feeds off a flock. A vagabond wolf charges at kid goats; an upper-class wolf doffs his top hat to a young girl. A wolf in overalls destroys the houses of porcine siblings. Bones of a wolf's victims pave the way to his lair. One wolf pack faces a herd of musk oxen while another chases unseen quarry. A pack feeds off the carcass of an unidentifiable animal, and a single wolf gnaws on a fallen moose's antlers. With a full belly, a wolf sleeps peacefully on his back.

From hunting to attacking and devouring, these images reflect not only the most dangerous aspect of the imaginary and the real wolf but one of the most basic ways in which we categorize the wolf: he is a predator. For the most part, traditional European and Euro-American narratives use the wolf's predatory nature as a metaphor for wicked or dangerous humans, behaviors, and situations. Designating the wolf as an alpha predator, scientists place the species at the top of the food chain, stressing its vital role within the ecosystem. In both the real and literary worlds, the wolf's carnivorous diet brings it into conflict with humans and other animals. And so we condemn the literary wolf to his role as a symbol for dangerous and deadly human behavior and the real wolf to extermination. The persistence of traditional images alongside more scientific ones has resulted in more than just competing characterizations of the wolf. It has made the wolf's predatory nature the aspect of wolfish behavior where the most fundamental changes in our understanding, depiction, and appropriation of this species have occurred.

In Norse myths as well as in stories such as "Little Red Riding Hood," "The Three Little Pigs," "The Wolf and the Seven Kids," and "Saint Francis and the Wolf of Gubbio," the predatory nature of the (almost always male) wolf drives the action of the plot as it defines his character and colors his interactions with others. It puts him in pursuit of celestial objects and divine beings, causes him

to terrorize domesticated animals and their keepers, and brings him to homes of pigs, goats, and grandmothers. At times it motivates him to don a sheep-skin, an old lady's nightgown, or even the habit of a religious pilgrim, whereas at other times it tempts him to lead a dog's life. The wolf in these stories is a predator threatening the way of life, the property, and the lives of other characters. Even though these depictions of the wolf are anthropomorphic, making him more human than wolf, the animals that he preys on—goats, sheep, pigs, and humans—reflect the threat that real wolves pose to humans and human property. This in turn renders his predatory behavior not only danger-ous but also criminal and immoral. Similar characterizations in early natural histories (works purporting to provide information about various aspects of nature) along with contemporary attitudes expressed by ranchers, farmers, hunters, and politicians suggest that these depictions, however inaccurate or humorous they may be, have nevertheless stuck to the real animal. As such, many of the tales and fables featuring the wolf not only serve as warnings about dangerous human conduct but also reflect views that cast both literary and real wolves as outlaws.

During the late nineteenth century, in the wake of Darwin's theory of evolution, a few authors such as Rudyard Kipling, Ernest Thompson Seton, and Thornton Burgess wrote short stories and novels that challenged the pre-vailing understanding of the wolf as a wicked predator and wolf predation as immoral. The authors of these works used anthropomorphic and sympathetic characterizations to argue that wolves had the right to eat too.

Yet save for these few exceptions, the wolf's predatory nature remained his predominant trait in the European and American imagination until the mid-twentieth century, when the first scientific studies of wolves were under-taken. In addition to revealing other characteristics about the wolf's way of life, this research began to undermine the Western stereotype of the wolf as a cunningly voracious predator. In 1963 two important pro-wolf publications appeared. In its April issue, *National Geographic* published Durward Allen and David Mech's article reporting on their study of wolf-moose predation on Isle Royale. The second work was Farley Mowat's *Never Cry Wolf*, in which the author, working for the Canadian Wildlife Service, studied wolf-caribou predation near Nueltin Lake in Manitoba. Mowat's results described the wolves' diet as mainly consisting of small rodents and not large prey animals. Although criticized for its lack of scientific integrity, Mowat's book sold more than one million copies and was later made into a documentary film by Dis-ney. These two publications are credited as having helped foster new depic-tions, understandings, and feelings towards wolves.

Many popular pro-wolf publications, including children's books, have fol-lowed. Informational as well as fictional works draw on scientific information to describe the species' habitat, diet, and physical and behavioral traits, recon-figuring the wolf as they redefine predation. No longer gluttonous, cunning, or wicked, the wolf in contemporary fiction and nonfiction hunts to survive. By

contrasting the wolf's dietary needs with the difficulties of the hunt and the dangers posed by large prey animals, these works diminish the threat posed by this species while directly and indirectly deconstructing the wolf of traditional European and Euro-American narratives. Further, contemporary authors have drawn on scientific research and point to the benefits of predation on prey populations; no longer immoral, predation is now understood to be a necessary element of a healthy ecosystem. Shaped by environmental concerns and values, contemporary informational and fictional picture books provide a more benign, if not always a more objective, view of the wolf as a predator.

By examining the ways in which these various genres characterize the wolf's hunger, hunting tactics, and prey, this chapter focuses on the ways in which our understanding of the wolf as predator has changed across time and place. The chapter begins with a discussion of the wolf as depicted in the images and texts associated with fables, tales, myths, and legends. Following this is an examination of late-nineteenth and early-twentieth-century works by Ernest Thompson Seton, Rudyard Kipling, and Thornton Burgess, whose sympathetic portrayals of wolves underscore their significance as precursors to twentieth-century environmental movements. Finally, this chapter closes with a consideration of the ways in which contemporary books, and even some retellings of traditional narratives, transform the traditional image of the wolf from a vicious predator into an invaluable, yet vulnerable, player in the ecosystem.

Devouring the World: The Wolf in Traditional Literature

Odin on his eight-legged steed rides into the giant wolf Fenrir's cavernous jaws. In another image from Norse mythology, a wolf leaps through the sky with the sun in his mouth (see Figure 1.1). With jaws agape, a medieval wolf greets Brother Francis. Across Western illustrations, the wolf's tongue, teeth, and drool predominate as he interacts with various prey. Another wolf licks his lips in anticipation of a meal. A wolf's mouth appears perilously close to a little pig (see Figure 1.2).

Looking at these and other visual images of wolves over time, the frequency with which illustrators and artists have depicted the wolf with his mouth open is striking, if not surprising. The myths, fables, tales, and legends that these images accompany emphasize the wolf's mouth as his most salient and deadly characteristic. In these stories, hunger stirs the wolf into action, driving his encounters with others. By stressing the wolf's mouth, illustrators focus attention on it, rendering it the visible manifestation of his predatory nature, synonymous with danger. From a wide-open mouth baring teeth, tongue, and even drool to more closed-mouth images revealing only the slightest indication of the threat within, images of the wolf's mouth serve to remind us of his primary intention.

Many stories do more than highlight the wolf's insatiable appetite; by equating it with danger, they make it the source of his actions and his reason for being. Aesop's fable of "The Mother and the Wolf" begins: "A famished wolf was prowling about in the morning in search of food" (Aesop 1909, 137). In La Fontaine's version of the fable, *Le loup et L'agneau* (*The Wolf and the Lamb*), the wolf's appetite draws him to the brook where a lone lamb drinks: "Un loup survient à jeune; qui cherchait aventure, et qui la faim en ces lieux attirait" ("A wolf, who was looking for adventure and whose hunger brought him to this place, spied a young one") (1867, 25). Perrault in *Le Petit Chaperon Rouge* introduces the wolf by alluding to his appetite: "Elle rencontra compère le Loup, qui eut bien envie de la manger" ("She met godfather Wolf, who desired to eat her") (1894, 28). According to Bedard, "And when hunger drew him [the wolf of Gubbio] from his den, so fierce was he that no living thing was safe from him" (2000, 6). The final refrain of the children's game *jouer au loup* (to play wolf) sums up the wolf's intentions: "Je vais vous manger!" ("I am going to eat you!") (*Loup y es-tu? Loup y es-tu?* 1993, 16).

Although allusions to the ravening jaws and bloodthirsty ways of wolves are found throughout the Scandinavian epics, the *Edda* and *Poetic Edda*, children's versions of the Norse myths typically focus on three wolves who, according to the prophecies, endanger the gods, time, and life itself. Illustrations accompanying these stories make clear the type of threat the wolf poses: he devours what he can. Two wolves with mouths open and tongues hanging out, Skoll and Hati, pursue the chariots conveying the sun and the moon, an act that not only sets time in motion but also keeps it moving at its brisk pace. When Skoll and Hati catch their prey, time will cease, the final battle will take place, and the enemies of the gods, including the Fenrirswolf, will be released.

Images of Fenrir make visible the reasons for which the gods fear this wolf. Not just his size but that of his mouth make him a threat. Ingri D'Aulaire pictures the binding of Fenrir on his back with his open mouth dangerously close to the wounded god Tyr. Bound, his mouth remains the one way he can lash out at his captors. In Neil Philip's more recent version of the stories, illustrator Maryclare Foá depicts the moment before the gods betray Fenrir. Foa's image places Tyr next to Fenrir, his hand in the wolf's blood-red mouth. Further, the prophecies link Fenrir to the final battle, Odin's death, and the end the world. Foa depicts the wolf capturing the sun while D'Aulaire features a two-page illustration of Fenrir, whose jaws span the distance between the sky and the ground, swallowing Odin and his eight-legged steed.

The texts recognize the threat posed by the wolf's mouth, linking it with danger. John Ogilby's 1651 edition of the Aesop fable, "The Wolf and the Fox," begins where the fable of the "Wolves and the Sheep" leaves off, with a description of the "wolfish crew [that] . . . fell on the guiltless flock, / And

satisfied their ravening jaws with blood!"(1651, 19). In another fable, a crane removes a bone from the wolf's throat and soon discovers that his reward for saving the wolf's life is being permitted to remove his "head in safety from the mouth and the jaws of a wolf'" (Aesop 1909, 3; see Figure 1.3). Indeed, Sergei Prokofiev's *Peter and the Wolf* equates the wolf with danger: "And then danger came. Out of the trees across the meadow, a big, hungry wolf crept through the tall grass" (Prokofiev/Malone 2004, 12). Open-mouthed, the wolf chased the duck, and "with one big gulp, he swallowed the duck whole." This story, filled with predator-prey interactions, centers on the wolf's predatory actions.

The danger posed by the wolf can also be felt in the reactions of his potential prey. In the Norse myths, Odin tries to prevent his fate by having the Fenrirswolf bound. When Little Red Cap arrives at her grandmother's house, she senses that something is wrong, even though she has not yet seen the threat. In "The Wolf and the Seven Kids," to escape the wolf, the kid goats scatter and hide, while in "The Three Pigs" the pigs refuse the wolf's demand to let him into their homes.

The medieval collections of the legends of Saint Francis, *I Fioretti* and the *Actus Beati*, describe the wolf as fearfully large and fierce with a hunger so rabid that he devours not only animals but also human beings (Brown 1958, 1348). Even though recent picture-book versions of "The Wolf of Gubbio" by Michael Bedard and Colony Elliott Santangelo differ from the source texts in a significant way—the wolf kills and devours livestock, not humans—both authors make clear the association of the wolf with fear. In Santangelo's retelling, when sheep, goats, and chickens begin to disappear, the townspeople first react with bravado and promise to hunt down the wolves. Even after their first sighting and interaction with the "old gray-haired and scrawny wolf," the people's hysteria magnifies his threat, rendering them "too fearful to leave their homes" (Santangelo 2000, 12–13).

Bedard's young narrator tells us: "At night we lay in bed and listened to the howl of the wolf on the hill. In sleep, we saw his shadow slink along the moonlit wall as the great beast circled the town" (Bedard 2000, 8). In Kimber's illustrations accompanying this text, the wolf's mythic proportions reflect the ways in which the people's imagination and fears amplify the wolf (see Figure 1.4). Further, Kimber's illustrations of Brother Francis walking into woods to meet with the wolf recall other tales of wolves waiting in the woods. The bone-strewn path to the wolf's lair serves as evidence of the wolf's guilt. Bedard's textual description and Kimber's visual depiction of Francis's meeting with the wolf unfolds as in the Italian and Latin sources: "With jaws agape, the great beast bounded toward him" (ibid., 16).

In these stories, the wolf's predatory nature defines not only the wolf's behavior but also his character. The wolf's tactics and choice of victims render him a dangerous and immoral predator. In most of these stories, the wolf is an outsider—a wild animal among domesticated animals. Using

lies, threats, and the power of his size, he preys on humans and livestock. In Aesop's fables, in particular, the wolf plays the role of a thief—stealing and devouring livestock that belong to someone else. In "Little Red Riding Hood" and "The Wolf of Gubbio," he also preys on humans. Francis, in more traditional tellings of the legend, makes clear that the wolf has sinned:

> Brother Wolf, you have done great harm in this region . . . You have been destroying not only irrational animals, but you even have the more detestable brazenness to kill and devour human beings made in the image of God. You therefore deserve to be put to death just like the worst robber and murderer. (Browne 2004, 1349)

The wolf in these stories is a metaphor for evil and sinfulness.

Hunting

Real wolves are social animals that hunt in packs. For the most part, the wolves in traditional European and Euro-American stories hunt alone. In nature, a lone wolf is the exception, and we must consider this exception in understanding the wolf in traditional stories. He is first and foremost a predator. Defined by his greedy mouth, his voracious hunger, and the threat that he poses to gods, humans, and domesticated animals, the wolf is a one-sided beast seeking to fill his belly. His method of achieving that takes many forms, but from the preternaturally large and fierce wolf of Norse mythology and Christian legends to the solicitous wolf of Charles Perrault or the Brothers Grimm and the deceptive wolf of Aesop and La Fontaine, he is always the same: he is hungry.

In traditional stories, not only the wolf's powerful jaws and sharp teeth but also his ability to talk render his mouth dangerous. The wolf's arsenal of weapons includes threats and entrapment, falsehood and treachery, flattery and enticement, disguise and deceit. In "The Three Little Pigs," when the pigs refuse to allow the wolf to enter, the wolf threatens: "Then I'll huff and I'll puff and blow your house in" (Jacobs 1894, 59). In Aesop's "The Wolf and the Lamb," the wolf's false reasoning reflects his heavy-handed and cruel ways: "A Wolf, meeting with a Lamb astray from the fold, resolved not to lay violent hands on him but to find some plea which should justify to the Lamb himself his right to eat him." Even after the lamb successfully denies the wolf's charges, the wolf seizes him and eats him, saying "Well! I won't remain supperless, even though you refute every one of my imputations" (Aesop 1909, 11). In another fable, "The Wolves and the Sheep," some wolves use false accusations and empty promises to persuade a flock of sheep to get

rid of the dogs guarding them. When the sheep agree, the wolves freely feed on the flock (ibid., 29).

At other times, as Perrault's moral to "Little Red Riding Hood" warns, the most dangerous wolf is the wolf with the best manners and the sweetest temperament: "Mais hélas! qui ne sait que ces loups doucereux, / De tous les loups sont les plus dangereux" ("But alas, as one knows, that the sweetest, gentlest wolves / Of all the wolves are the most dangerous") (1894, 32). With Little Red Riding Hood, the wolf politely extracts the information that will lead him to her grandmother's house: "'Good morning, Red Riding Hood. . . . Where are you off to so early in the day, my dear?' he asked" (Grimm/Hyman 1983, 8). And "he walked along with Little Red Riding Hood for a while, making polite conversation." Pointing out the beautiful flowers, he seduces by chiding her for being so intent on her tasks: "For goodness sake, why don't you relax a bit, look at the world, and see how lovely it is?" (ibid., 10). Distracting her from her journey, the wolf runs on ahead to her grandmother's house.

By exaggerating the wolf's attentive behavior, several contemporary illustrators show why Little Red Riding Hood fails to see him for what he is. For example, Nicoletta Ceccoli's illustrations liken the wolf's actions to those of a chivalrous medieval knight. Ceccoli's wolf kneels before Little Red Riding Hood, walks beside her, points out the beauty of the woods, and escorts her to the crossroads. Ceccoli's endpapers further develop their encounter. The wolf plays with Little Red Riding Hood. He encircles her. She chases him. He sneaks up on her. She stoops to pick a flower. He kneels and offers her a flower. By emphasizing his relationship with Little Red Riding Hood, Ceccoli's pictures show the wolf's appeal. He is more than civil; he entices her and pays attention to her. His seemingly innocent actions conceal his designs. Josephine Evetts-Secker's text, accompanying these images, presents a jarring note. Describing him as "teasing," "cunning," and "wily," she allows the audience to see beyond his outward display of civility.

In the Aesop's fable "The Wolf and the Sow," the wolf, hungry for one of Mrs. Sow's piglets, feigns kindness by offering to help out with her small charges: "Can I be of service to you, Mrs. Sow, in relation to your little family here? . . . I will take as much care of your pigs as you could yourself" (Aesop 1821, 26). Similarly, in the tale of the "Three Little Pigs," when the wolf fails to "blow down the house" of the third little pig, he changes his strategy and tries to lure her out of her house with invitations for apple picking, harvesting turnips, and a fair. Yet the pigs in both of these stories prove wiser than the wolf.

Sometimes illustrators play on the wolf's doglike traits, modifying the wolf's physical features and gestures to suggest a more tame nature. By softening the wolf's features and giving him doglike gestures, illustrators such as Trina Schart Hyman transform the wolf into a dog, concealing his deadly intentions under the guise of the domesticated animal known for its loyalty to humans.

The wolf's appetite often causes him to disguise more than his desires. In both "Little Red Riding Hood" and "The Wolf and the Kids," the wolf finds it expedient and even necessary to mask his voice and alter his appearance. Unseen by those inside the house, the wolf takes on the voice of an expected arrival. At the door of Little Red Riding Hood's grandmother's house, the wolf pretends to be Little Red Riding Hood: "'C'est votre fille le petit chaperon rouge,' dit le Loup, en contrefaisant sa voix" ("'It is your little girl, Little Red Riding Hood,' said the wolf, disguising his voice") (Perrault 1894, 29). Later when Little Red Riding Hood arrives and "hears the big voice of the wolf, she is at first afraid" ("la grosse voix du Loup, eût peur d'abord"). Realizing his mistake, the wolf sweetens his voice ("adoucissant sa voix") to sound more like that of the grandmother's, putting the girl at ease (ibid.).

The mother goat's warning to her children in "The Wolf and the Kids" implies that the wolf is recognizable by his voice and the color of his paws: "Der Bosewicht verstellt sich oft, aber seiner rauhen Stimme und an seinen schwarzwen Fussen werdet ihr ihn gleich erkennen" ("The villain often disguises himself, but you will easily recognize him because of his rough voice and his black paws") (Grimm/Hegenbarth 1984, 3). When the wolf arrives, he knocks on the door and says without changing his voice: "Macht auf, ihr lieben Kinder, euere Mutter ist da und hat jedem von euch etwas mitgebracht" ("Open the door, dear children, Mother's home, and she's brought something for each of you") (Grimm/Hegenbarth 1984, 5). The kids respond by denying him entrance on the grounds that their mother "hat eine feine und liebliche Stimme, aber deine Stimme ist rauh; du bist der Wolf" ("has a soft, sweet voice, but yours is rough; you are the wolf") (ibid.). Depending on the version, the wolf changes his voice by eating chocolate curd or chalk or by having his tongue filed.

Even with the wolf's voice disguised, the kids block his attempt to enter the house: "Aber der Wolf hatte seine schwarze Pfote in das Fenster gelegt, das sahen die Kinder und riefen: 'Wir machen nicht auf, unsere Mutter hat keinen schwarzen Fuss wie du; du bist der Wolf'" ("But the wolf placed his black paws on the window; seeing it, the kids cried: 'We're not opening the window, our mother doesn't have a black foot like you; you are the wolf!'") (ibid., 5). To remedy this, the wolf goes to a baker and a miller to whiten his paws. When the miller refuses, the wolf responds by threatening him: "If you don't, I'll eat you up!" (ibid., 11). With whitened paws the wolf's entrance is secured: "'Zeig uns erst deine Pfote, damit wir wissen, dass du unser liebes Mutterchen bist.' Da legte er die Pfote ins Fenster, und als sie sahen, das sie weiss war, so glaubten sie, es ware alles wahr, was er fragte, und machten sie die Tur auf" ("'Show us your paws so that we will know for sure that you are our mother.' The wolf put his paw on the window ledge, and when they saw that it was white, they believed they were hearing the truth and opened the door") (ibid., 6).

Sometimes the wolf uses clothing to conceal his identity and nature. In Aesop's "The Wolf in Sheep's Clothing," the "wolf resolved to disguise his nature by his habit, so that he might get food without stint. Encased in the

skin of a sheep, he pastured with the flock, beguiling the sheep with his artifice" (Aesop 1909, 18; see Figure 1.5). Illustrations of the wolf in a sheepskin express changes in both his outward physical appearance and behavior. In a similar way, Doré's illustrations for La Fontaine's "The Wolf and the Shepherd" dress the wolf in a shepherd's costume (see Figure 1.6). Yet the ludicrous appearance of the wolf in clothes that are too large for him points to the shepherd's foolishness as well as to the wolf's audacity.

Having devoured the grandmother, the wolf in "Little Red Riding Hood" uses her nightgown and bedclothes to hide his identity from the little girl. The traditional texts of Perrault and the Brothers Grimm deal somewhat differently with this visual transformation of the wolf. Perrault describes the wolf as hiding himself in the bedclothes but adds that Le Petit Chaperon Rouge, on seeing her grandmother, was "bien étonnée de voir comment sa mère-grand était faite en son déshabillé" ("well astonished at how her grandmother looked in her nightclothes") (1894, 30). The Grimms' "Little Red Cap" is more specific: the wolf "put on her clothes, and her nightcap, lay down in her bed, and drew the curtains" (Grimm/Zipes, 2001, 749).

Playing upon the absurdity of cross-species as well as cross-gender dressing, some illustrators of "Little Red Riding Hood" have relished the opportunity to dress the wolf in the grandmother's nightcap and gown. An early example of the wolf getting dressed appears in Walter Crane's 1898 edition of his toybook. This image of the wolf admiring himself in the dressing table mirror underscores the role he is about to play.

Lisbeth Zwerger's illustrations for *Little Red Cap* also feature the wolf getting dressed. Within a single frame, Zwerger depicts the wolf in a range of movements and gestures from putting on the grandmother's clothes to stopping to contemplate the best way to wear the bonnet: ears in or ears out. In the last gesture of this scene, the wolf becomes a coquette (see Figure 1.7). Seated on the stool, with his back to us, he looks out at us over his shoulder in a semi-pinup pose. The wolf plays not only at being human but also at being female. Zwerger's exaggeration of his gestures and behavior does more than add a humorous note to the wolf's deeds. As a caricature of the feminine, or of that which is perceived to be feminine, the wolf draws attention away from his maleness while rendering his wolfishness absurd. This breaks the tension by drawing the reader's attention away from the violence that precedes and follows this scene. The image is at once comical and disturbing, a wicked whimsical interlude that mocks the wolf's victims.

Most illustrators, however, do not show the wolf getting dressed but instead show the wolf as Little Red Riding Hood sees him when she reaches her grandmother's house: in bed, under the covers. Doré's famous illustration of this scene captures the farcical potential of the moment while reflecting Le Petit Chaperon Rouge's astonishment at seeing the way her "mère-grand" looks in her nightclothes. Like many other illustrators, Ceccoli places the wolf in bed, while the text describes his transformation: "He laughed as he dressed up in

her largest nightgown and tried to pull her nightcap over his head. Then he lay down in her bed, drew the curtains around him, and waited" (Grimm/ Evetts-Secker and Ceccoli 2004, 20). Ceccoli shows the wolf with the cover pulled up under his eyes, so when Little Red Riding Hood sees him, she sees only her grandmother's bonnet and glasses. Only after the wolf devours Little Red Riding Hood does Ceccoli reveal his enormous body straining the seams of granny's nightgown.

Not all illustrators use the wolf in grandmother's nightgown and cap as an opportunity to break the tension and distract the audience from the wolf's violence. Some use this scene to increase the threat posed by the wolf. In Christopher Coady's adaptation of Perrault's version, the wolf is more monstrous than humorous. Coady's juxtaposition of Little Red Riding Hood as a small, distant, dark figure on the left-hand page with the close-up of the wolf's head, his ferocious mouth open, on the right-hand page, hints at where the story ends: inside the wolf's angry mouth (see Figure 1.8). Further, by placing the wolf's head on the edge of the right-hand page, Coady puts the wolf's mouth in close proximity to the reader's hand, bringing the danger close to the reader. When the wolf finally moves to attack her, he leans in, his paws already touching her. To heighten the violence, Coady allows us to see the fear on Little Red Riding Hood's face as the wolf's disguise falls away.

Through deceit and falsehood, the wolf affects a multilayered transformation: from a wild animal to a domesticated one, from a predator to a prey species, from a hunter to a shepherd, and in several instances, from a male to a female. To catch his quarry he often needs to become it. Yet illustrations of the wolf in the grandmother's nightgown, a shepherd's costume or sheepskin, or with a whitened paw show how ill-suited the wolf is for each of these disguises.

From taking on female voices and dress to adopting more docile and refined behavior, the wolf uses aspects of the female and feminine (gentle, *gentile*, civilized, refined, and nurturing) to disguise not only his wolfishness but also his masculine traits. On one hand, these actions speak to the wolf's need to disguise himself as specific characters: the granddaughter, the grandmother, and the mother goat. On the other hand, they also suggest that the female and the feminine are less threatening, gentler, weaker, and perhaps even more civilized than the male and the masculine, aligning vulnerability with gender. Recent studies of real wolves betray this human stereotype; female wolves hunt alongside male wolves, and within several weeks of giving birth, the alpha female leaves her pups with a babysitter wolf to return to the hunt. Further, the babysitter wolf can often be a lower-ranking male wolf.

The Wolf's Prey

The traditional stories and images reveal attributes not only of the wolf but also of his prey. As these stories imply, much of the wolf's success depends on

the characterization of his intended victims. With few exceptions, the most vulnerable of these are naïve, lazy, or sick. At the same time, those who survive are those who know his ways.

The Grimms' "Little Red Cap" and "The Wolf and the Seven Kids" as well as some versions of "The Three Little Pigs" start with parental warnings. These admonitions reflect more than parental love; they characterize the young as inexperienced, unknowing, and innocent, suggesting that they need protection. Yet their parents' warnings fail to protect, and the young are left to fend for themselves.

Key to the wolf's ability to deceive Little Red Riding Hood, sheep, and kid goats is their naïveté: "Il lui demanda où elle allait; la pauvre enfant qui ne savait pas qu'il est dangereux de s'arrêter à écouter un Loup" ("He asked her where she was going; the unfortunate child didn't know that it was dangerous to stop to listen to a wolf") (Perrault 1894, 28). In Hyman's picture book based on the Grimms' version of "Little Red Cap," the narrator comments, "The little girl had no idea what a wicked animal he was, however, so she was not at all frightened of him" (Grimm/Hyman 1983, 8). And yet the wolf, while disguising his true nature, makes it clear to the girl what he plans to do with the information she has shared with him: "Je veux l'aller voir aussi; je m'y en vais par ce chemin ici, et toi par ce chemin-là, et nous verrons à qui plus tôt y sera" ("I want to visit her also; I will go by this path, and you will take that one, and we will see who gets there first") (Perrault 1894, 29). In a similar way, the kid goats, in rebuffing the wolf, unwittingly give him the means by which he can gain entrance to their house.

The illustrations of both the kid goats and Little Red Riding Hood show them as being smaller in stature than the adults, reflecting both their weaker physical states and their innocence. Clothing also underscores the difference between the mother goat and her kids. For the most part, the kid goats appear not only smaller than their mother but also unclothed and so perhaps less civilized and less domesticated than she. Images of Little Red Riding Hood range from that of a young child of four or five, as in Father Tuck's, Gustave Doré's, and Trina Schart Hyman's images, to an adolescent in her early teens, as depicted by Lisbeth Zwerger. Sometimes, as in Walter Crane's toybook edition, her physical maturity varies within the tale itself, taking on more "mature" features and gestures when alone in the woods, and reverting to more childlike behavior and traits when in the company of an adult.

As the presence of shepherds and dogs suggests, the sheep's small stature and docile nature make them particularly susceptible to the wolf's deceitful ways. Indeed, when either the dog or the shepherd fails to protect them—as happens in the fables "Wolves and Sheep" and "The Wolf and the Shepherd"—the wolf is free to harass and devour as many sheep as he desires. In the former, the sheep abide by the wolves' peace treaty and release the dogs from their duty. In the latter fable, however, it is not the sheep but their gullible shepherd who allows a wolf to graze among the flock.

Illness also affects a character's defense against the wolf, and in "Little Red Riding Hood," it plays a central role. In addition to providing a premise for the little girl's visit to her grandmother, illness renders the grandmother vulnerable while facilitating the wolf's plans. Without getting out of bed to answer the door, she invites the wolf in by telling him how to open the door: "The wolf pressed the latch, the door sprang open, and without a word he went right to the grandmother's bed and gobbled her up" (Grimm/Zwerger 1983, 10). Most illustrated editions include an image of the wolf at the door, making the viewer privy to the danger lurking on the outside. Some also include depictions of the grandmother in her bed as she realizes her mistake. Doré's illustration of this scene underscores the grandmother's helplessness against the wolf: he is mobile while she is trapped under the covers by his front paws.

In "The Three Little Pigs," the choice of building materials reflects the character traits that make the pigs easy targets for the wolf: laziness and foolishness. The house of hay and the house of twigs, while quickly erected, prove easy marks for the wolf. Images showing the ease with which the wolf blows down their houses point not only to the wolf's power and the flimsiness of the structures but also to the pigs' imprudent decisions and behavior. The third little pig's success in evading and ultimately conquering the wolf heightens the moral failings of her siblings. The third pig's choice of bricks withstands the wolf's assault and reflects her intelligence and willingness to work. Failing to blow down the house of bricks, the wolf falls back on trickery. Here, the third pig survives by outwitting the wolf, showing that industriousness and cleverness overcome brawn.

As demonstrated by the third pig, the wolf, skilled and devious as he may be, sometimes encounters opponents who, knowing him for what he is, successfully defy him. If ignorance and gullibility weaken a being's defense against the wolf, knowledge and cleverness strengthen it. Indeed, as several of Aesop's fables show, goats, even young ones, have enough guile to outwit the wolf. In "The Kid and the Wolf":

> A Kid, returning without protection from the pasture, was pursued by a Wolf. He turned round, and said to the wolf: "I know, friend Wolf, that I must be your prey; but, before I die I would ask of you one favour, that you play me a tune, to which I may dance." The Wolf complied, and while he was piping, and the Kid was dancing, the hounds hearing the sound, came up, and issuing forth, gave chase to the Wolf. The Wolf, turning to the Kid, said, "It is just what I deserve; for I, who am only a butcher, should not turn piper to please." (Aesop 1909, 92–93)

In another fable of the same name, the wolf sees through the bold taunts of a kid on a roof: "The wolf, looking up, said: 'Sirrah! I hear thee: yet it is not thou who mockest me but the roof on which thou art standing'" (Aesop 1909, 30). And when, in another fable, the wolf invites the goat to come down

from her summit and feed on the lower pasture, the goat is not so silly as to take him up on his invitation and replies: "No my friend, it is not me that you invite to the pasture, but you yourself are in want of food" (ibid., 72). In both of these fables, the goat and the kid are smart enough to stay outside of the wolf's reach.

Fearless and resourceful, Peter in Prokofiev's *Peter and the Wolf* sets out to trap the wolf. With characters similar to those found in "Little Red Riding Hood," this story mirrors it. Yet, in this story, the child's role and the repercussions of his choices are different. Instead of being punished for disregarding his grandfather's warnings about the wolf and the danger in leaving the garden, the boy ventures into the meadow and triumphs. When the wolf arrives, Peter, with the help of a bird, lures him into a trap. When two hunters arrive and see the wolf, they begin shooting. But instead of allowing the wolf to be killed, Peter stops the hunters and, depending on the edition, releases the wolf into the woods, brings him to a nearby village, or places him in a zoo. Peter's disobedience and trickery reflect the innovation and the forward thinking necessary to trap the wolf.

These stories suggest that intelligence, foreknowledge of, and prior experience with the wolf afford his would-be victims protection. And for the most part, the wolf's quarry recognizes his predatory nature. In *Pigweeney the Wise: Or the History of a Wolf & Three Pigs*, the earliest known print version (1830) of "The Three Little Pigs," a fairy warns the mother sow that after her death, "A wolf will come hither, and eat you like bread! / And two out of three he will have for his dinner, / But one he will keep for his supper—a Sinner!" (*Pigweeney* 1830, 4). The mother goat's warning to her kids in "The Wolf and the Seven Kids" echoes that of the fairy to the mother sow: "Beware of the Wolf! If once he gets into the house, he will eat you up—skin, and hair, and all" (Grimm 1958, 5).

With size, strength, and knowledge about the world on their side, adult figures in general fare better than young ones. Visual images of goats point to the potential physical threat that adult goats pose: not only are adult goats the same size as or larger than the wolf, but they also have horns. The horns in turn provide more than a physical defense; they serve as a sign of maturity and the wisdom that comes with it. Indeed, several versions of "The Wolf and the Kids" begin with the mother goat imparting her knowledge of the ways of the world and the ways of the wolf to her young. Her knowledge and size render her the wolf's equal. By placing mother goat against father wolf, two late-nineteenth-century French editions of the tale, in particular, make clear the adversarial yet equal nature of their relationship. In these versions of the tale, the mother goat returns home before the wolf succeeds in devouring her children. As in the ending to "The Three Little Pigs," the mother goat invites the wolf to his death when she invites him to enter her home by the chimney.

Although Little Red Riding Hood's and Little Red Cap's grandmothers fall prey to the wolf's tricks, a later, expanded version of the Grimms' tale

suggests that illness, not ignorance, renders her vulnerable. In this telling, in which Little Red Cap visits her grandmother a second time and meets a second wolf, the grandmother knows how to handle the wolf that has followed her granddaughter to her house: "Fetch the bucket Little Red Cap, I cooked sausages yesterday. Take the water they were boiled in and pour it into the trough" (Grimm/Zipes 2001, 749). As the grandmother predicted, the smell of sausages entices the wolf, who leans over, loses his balance, falls into the trough, and drowns. This ruse reflects the grandmother's knowledge of the wolves: they are hungry animals easily undone by the promise of food. The story also suggests that Little Red Cap's first encounter with the wolf has made her wiser: instead of stopping to talk to the wolf, she runs away from him.

In the Grimms' "Little Red Cap," a hunter or woodsman plays a role similar to that of the mother goat in "The Wolf and the Seven Kids." Aside from the wolf, he is the only male character in these tales. As the mother goat serves as the antithesis of the wolf's character, so the hunter mirrors the wolf; both are adult male hunters. Puzzled by the sounds of snoring from the grandmother's house, the hunter decides to investigate. His reaction to the wolf asleep in the grandmother's bed implies that he and the wolf know each other and have had previous encounters: "Here you are, you old sinner . . . I've been looking for you" (Grimm/Zwerger 1983, 16). It also suggests that until now, the wolf has been able to escape the hunter. Illustrations of the hunter's meeting with the wolf reflect the latter's vulnerability. Armed with a gun, scissors, or a knife, the hunter safely approaches the sleeping wolf. Zwerger's illustrations show a hunter with the scissors in his hands looking over at the wolf. Hyman's image of the scene features the hunter pointing his gun barrel at the wolf's belly. Crane's hunter shoots the wolf before it devours Little Red Riding Hood. These scenes, along with their counterparts in the Grimms' "The Wolf and the Seven Kids," speak to the vulnerability of the wolf. Unconscious, the wolf's fortune turns, his victory undone and his punishment secured.

Other factors also affect the wolf's prowess as a hunter. Injured, the wolf is off his game. As the Aesopian fable "The Wolf and the Sheep" demonstrates, injuries affect the wolf's ability to hunt. In this fable, a wolf "sorely wounded and bitten by dogs, lay sick and maimed in his lair" asks a passing sheep to bring him some water (Aesop 1909, 44). The sheep refuses: "If I should bring you the draught, you would doubtless make me provide the meat also." Wounded, the wolf lacks the strength to attack the sheep. At the same time, the sheep's reply suggests that it sees through the wolf's deception.

The wolf also tends to lose against those would-be victims who are bigger than he. In "The Ass and the Wolf," his encounter with an ass leaves him with his teeth kicked into his mouth. In an ending similar to that of "The Kid and the Wolf," the wolf bemoans his fate while admitting that he deserves it for trying to be anything but a butcher (Aesop 1909, 92–93, 103). As the story implies, his failure is due to stepping outside his normal role of predator.

The wolf's insatiable appetite may also be a liability. In La Fontaine's "Le loup et Le renard," the wolf's gluttony allows him to be ensnared by the fox's jest that the reflection of the moon at the bottom of a well is a piece of cheese (1867, 269). The fox may be small, but he is clever and quick; pitted against his canine cousin, the wolf appears brutish and slow-witted.

Finally, there is recognition in some of these tales that death, not by the wolf but by another predator, awaits these animals. The mother sow in *Pigweeney the Wise* admits as much to her children:

> The Wolf may as well lay his claw on your life,
> As be struck in the throat by a vile Butcher's knife;
> And then to be sing'd from the head to the tail,
> Til you look like a rusty, old tenpenny nail,
> And spitted—and greas'd—put down to roast—
> Then serv'd up in a dish like hot butter'd toast! (1830, 6)

In Aesop's fable "The Lamb and the Wolf," the wolf tells the lamb seeking refuge in a temple: "The priest will slay you in sacrifice if he should catch you." In this instance, the lamb chooses to be slain by humans rather than by wolves: "It would be better for me to be sacrificed in the temple than to be eaten by you" (1909, 141). It is, of course, the irony of most of these stories that the wolf is depicted as wicked for doing what humans do: kill and eat other animals. The wolf says as much to a group of shepherds he sees "eating for their dinner a haunch of mutton. Approaching them, he says, 'What a clamour you would raise if I were to do as you are doing!'" (Aesop 1909, 58).

Hungry as a Wolf

Many traditional narratives refer to the wolf's voracious appetite and gluttonous tendencies. Rarely satisfied by just one meal, the wolf, in many versions of "Little Red Riding Hood," "The Three Little Pigs," and "The Wolf and the Seven Little Kids," attempts to make, and sometimes succeeds in making, a meal of more than one victim. After meeting Little Red Cap, the wolf decides to get her and her grandmother (Grimm/Zipes 2001, 748). At the end of "The Boy Who Cried Wolf," when the wolf realizes that no one is coming to help the shepherd boy, it has "no cause for fear, took it easily, and lacerated or destroyed the whole flock" (Aesop 1909, 25). A similar event occurs in the fable of "The Wolf and the Shepherd." In this story, the shepherd, mistaking the wolf's patience for peacefulness, leaves his flock unattended: "The Wolf, now that he had the opportunity, fell upon the sheep, and destroyed the greater part of the flock" (ibid., 101). In most editions of "Little Red Riding Hood," "The Three Little Pigs," and "The Wolf and the Seven Kids," the wolf succeeds—at least momentarily—in devouring more

than one victim. Once inside the goats' house, despite their efforts at hiding from him, "der Wolf fand sie alle und machte nicht langes Federlesen: eins noch dem andern schlukte er in seinem Rauchen" ("the wolf found them all and made fast work of them: one after the other he gobbled them up") (Grimm/Hegenbarth 1984, 14).

The wolf eats up, swallows, gobbles, devours, or gulps down his victims. Their deaths, if indeed they are dead, are clean. There is no torture or mangling. He is hungry and he is fast. For the most part, however, the violence done by the wolf is not depicted but only implied. For instance, many of the illustrations for Aesop's fables feature the wolf chasing a sheep or carrying one off in his mouth. In "The Wolf and the Seven Kids," he is shown entering the house of the goats, causing them to scatter and hide. From disrupting the bedroom as he crawls into bed with the grandmother, to emerging from under the covers as he lunges towards Little Red Riding Hood, or to sitting next to Little Red Riding Hood in the bed while she looks at him, the prelude to their deaths is clear. At other times, illustrators like Suzanne Janssen use the black abyss of the wolf's open mouth and splashes of red spattered across the bed, floors, and walls to evoke what has taken place. And although we see the wolf as he blows down the houses of pig one and pig two, for the most part we do not see him devouring them—in fact, in some versions, the pigs escape to their siblings' houses.

These works rarely show the wolf killing his prey; instead, they focus on the aftereffects of his binge: a swollen abdomen. Typically when we first see the wolf, his body is normal or even thin. Gustave Doré's depiction of Le Petit Chaperon Rouge's first encounter with the wolf in the woods shows a large wolf whose rib cage serves as a visible reminder of his hunger. The thinness of this wolf, is even more prominently displayed in Doré's depiction of the wolf attacking the Le Petit Chaperon Rouge's grandmother. Perrault's text suggests the reason for his hunger as well as for his depleted condition: "car il y avait plus de trois jours qu'il n'avait mangé" ("because it was more than three days since he had eaten") (1894, 29).

Images depicting the wolf after his feasting contrast sharply with images of him at the beginning of the tales. Illustrations for "Little Red Riding Hood," "The Wolf and the Seven Kids," and "The Three Little Pigs" exaggerate the effects of the wolf's multiple meals on his body. As the wolf eats, his abdomen swells and becomes distended. Having had his fill, the wolf's first instinct is to sleep. The convention of depicting the wolf asleep on his back and with his belly protruding extends across editions of these tales. So in *Little Red Cap*, "Now that he had stilled his appetite, the wolf lay down in the bed again, fell asleep, and began to snore loudly" (Grimm/Zwerger 1983, 16). Similarly, in *The Wolf and the Seven Kids*, "Als der Wolf seine Lust gebusst hatte, trollte er sich fort, legte sich draussen auf der grunen Weise unter einen Baum und fing an zu schlafen" ("After the wolf satisfied his hunger, he strolled away, lay down in the green field under a tree, and fell asleep") (Grimm/Hegenbarth 1984, 14).

The sleeping wolf is typically depicted on his back, with his great mound of a belly unprotected. This is an especially vulnerable position made even more so by the wolf's unconscious state. Both the hunter and the mother goat are able to approach and cut open the wolf because he is asleep. The illustrations depicting the aftermath of the wolf's binge in "Little Red Cap" and "The Wolf and the Seven Kids" exaggerate, and thereby focus our attention on, the wolf's distended belly. Further, as Anne Sexton in her poem "Red Riding Hood" describes the wolf after gobbling down Red Riding Hood and her grandmother: "Now he was fat. / He appeared to be in his ninth month / and Red Riding Hood and her grandmother / rode like two Jonahs up and down with / his every breath" (1993, 245). In both "Little Red Cap" and "The Wolf and the Seven Kids" the emergence of the wolf's victims from his body gives credence to his resemblance to a pregnant woman.

The wolf's behavior in these two stories, as in "The Wolf of Gubbio," recalls Aelian's description of the wolf in his third-century work *De natura animalium*: having satiated his hunger, the wolf is no longer a threat (1971, 229). In Grimms' "Little Red Cap" and "The Wolf and the Seven Kids," the wolf's former victims, freed from his belly, keep the wolf sated by refilling his belly with stones: "Little Red Cap fetched large heavy stones and filled the wolf's body with them. When he awoke, he tried to run away, but the stones were too heavy so he fell down dead" (Grimm/Zipes 2001, 750). The mother goat and her kids do likewise: "Jetzt geht und sucht Wackersteine, damit wollen wir dem gottlosen Tier den Bauch fullen, solange es nach im Schlafe liegt" ("Now go and find some stones, so we can fill the godless beast's belly while he is still asleep") (Grimm/Hegenbarth 1984, 23). The wolf awakens, and because of the stones in his belly, he is overcome with thirst. As he makes his way to the well, the stones in his stomach knock against each other, and the wolf calls out: "Was rumpelt und pumpelt / In meinem Bauch herum? / Ich meinte, es waren sechs Geisslein / So find's lauter wachstein" ("What's rumbling and bumbling / down in my belly? / It must be all the six kids / But they feel heavy like stones") (Grimm/Hegenbarth 1984, 24). Leaning over to get a drink, the wolf, weighted down by the stones, falls in and drowns.

In the Norse myths, the prophecy calls for Odin's son Vidar to avenge his father's death. Significantly, Odin's son kills Fenrir by breaking the wolf's jaws, underscoring the way in which the wolf's predatory nature intertwines with his being: with his jaws broken, the wolf dies.

From tricking the wolf to enter the house through the chimney into a pot of boiling water, to breaking his teeth or jaw, to shooting or capturing him, most of these stories end with the wolf's death. Where the wolf's violence remains implied and unseen, as will be discussed later in this volume, the violence done to the wolf is on display. His misdeeds are punished, and his death is celebrated. As a metaphor for human relations, the story varies from a lesson about the dangers of being naïve and gullible to that of the victory of intelligence over brute force. If looked at in terms of human–wolf relations,

the message is clearer: human diligence and intelligence can overcome natural dangers such as the wolf. For peasants, shepherds, farmers, cattlemen, and ranchers—people whose lives, livestock, and livelihoods were threatened and destroyed by predators—stories in which humans succeed in taming or conquering nature offered hope. Although disguises speak to the wolf's cunning and sneakiness, generally, the wolf fails. Losing more than a meal, he loses his life.

Voices in the Wilderness

Exceptions to these traditional depictions of the wolf as predator and wolf predation began to appear towards the end of the nineteenth century. Three authors, Rudyard Kipling, Ernest Thompson Seton, and Thornton Burgess, in particular, wrote stories for young people featuring more sympathetic, if not more objective, portrayals of the wolf.

Like Romulus and Remus, the man child Mowgli in Kipling's *The Jungle Book* is taken in and raised by a wolf family. Save for some renegade wolves, most of the wolves accept Mowgli's presence in the pack, and instead of endangering his life, they save him. In Kipling's jungle world, the Law of the Jungle provides guidelines as to what can and cannot be undertaken. To take the life of humans or their animals is forbidden because it draws the attention of humans—making it dangerous for all who live in the jungle. Further, throughout his novel, Kipling acknowledges that the most dangerous animal of all is man.

Like the wolves of traditional European and Euro-American stories, the wolves in Seton's and Burgess's stories are primarily predators causing harm to livestock. In his preface, Seton states that his stories are "true histories of the animals described, and are intended to show how their lives are lived" (Seton 1899, "Note") Yet in them, he intertwines lore and observation, and attributes human emotions to his lupine characters. In "Lobo," one of his earliest stories featuring a wolf, Seton describes Lobo as a king and despotic ruler: "Old Lobo was a giant among wolves, and was cunning and strong in proportion to his size" (Seton 1903, 1). Lobo and his band of five wolves, well known to the ranchers of northern New Mexico, terrorize and feed on cattle and sheep. Seton credits Lobo's mate Blanca and a large yellow wolf for killing "two hundred and fifty sheep, apparently for the fun of it, and did not eat an ounce of their flesh" (ibid., 3). Badlands Billy, another of Seton's animal heroes, and his pack also feed off livestock.

What makes Kipling's, Burgess's, and Seton's stories different from the traditional depictions is their respect for the wolves. The wolf may still be best known for its role as a predator, threatening humans and human property, but it has become a worthy opponent. In both Seton's and Burgess's writings

the wolf has learned to avoid foothold traps and poisoned carcasses: "Man in his effort to destroy them has used poison, cleverly hiding it in pieces of meat left where Howler and his friends could find them. Howler soon found out that there was something wrong with the pieces of meat left about, and now it is seldom that any of his family come to harm that way. He is equally cunning in discovering traps buried in one of his trails. Sometimes he will dig them up and spring them without being caught" (Burgess 1920, 192). At the same time, these works recast the hunted wolves in the role of outlaw heroes who, for a time, have avoided capture. Dunlap and Coleman suggest that stories individualizing the wolf help render the species sympathetic. A recent *Nature* documentary credits Seton's story about Lobo with changing the attitude of the American public (especially eastern city dwellers) regarding wolves and, in turn, regarding ranchers' and bounty hunters' policy of eradicating the remaining wolves in the West. Seton, who wrote after a stint as a bounty hunter in 1893, changed his attitude about the hunting and killing of wolves. It also led to his help in founding two nature organizations for young people: The Woodcrafters League (1902) and the Boy Scouts of America (1910). "Lobo" later appeared in several collections of his stories, including *Wild Animals I Have Known: Being the Personal Histories of Lobo, Silverspot, Raggylug, Bingo, the Springfield Fox, the Pacing Mustang, Wully and Redruff* and *Lobo, Rag, and Vixen*.

Along with this respect for the wolf's ability to avoid its predators is the sense that wolves, like humans, have the right to eat. Seton points out in his story about Badlands Billy that wolves formerly followed the buffalo herds: "When the Buffalo were exterminated the Wolves were hard put for support, but the Cattle came and solved the question for them by taking the Buffaloes' place. This caused the wolf-war" (Seton 1905, 112). Implicit in Seton's comment is the recognition that humans—in killing the wolf's traditional prey—have forced the wolf to look elsewhere for its food supply. In the same story, Seton challenges the depiction of the wolf as man-eater. Quoting the wolfer King Ryder (an expert wolf killer) as saying that he had never "known a Gray-wolf to attack a human being," Seton begins to undo not only the stigma attached to wolves but also one of the main arguments used for eradicating wolves (ibid., 113).

These authors' implications about the way humans regard nature are significant. Kipling recognizes that human power was heightened by their use of weapons like guns and fire that could destroy not only the animals but also their environment. Burgess's description of the wolf's habitat shows how humans pushed the wolf into a few remaining places: "Howler the Gray Wolf—sometimes called Timber Wolf—is found now only in the forests of the North and the mountains of the Great West. Once he roamed over the greater part of this great country" (Burgess 1920, 191). Seton, by underscoring the tragedy of Lobo and Blanca and celebrating the victory of Badlands Billy,

criticizes what even he himself has been a part of: the eradication of the wolf, other predators, and nature, to protect livestock.

Redefining Predation, Redefining the Wolf

Under the 1974 Endangered Species Act, the wolf, hunted almost to extinction across most of the continental United States, was slated for protection. Although changes in the ways in which predators and predation were understood had begun to occur during the early twentieth century, not until the mid-twentieth century did biologists begin to question efforts aimed at the extermination of the wolf (Dunlap 1988). Until that time, most of what was known about wolves was based on folklore and anecdotal bounty hunters' tales recounting the tracking down of outlaw wolves (Mech 1995, 271). From the late 1930s through the 1950s, biologists Adolph Murie, Durward Allen, and David Mech conducted the first scientific studies of wolves. An increase in wolf research and a proliferation of popular pro-wolf books and movies followed the popularization of their work in magazines and books (ibid.).

Contemporary informational books, fictional picture books, and even some retellings of traditional stories for children are among the pro-wolf publications that disseminate current scientific thinking about wolves. In contrast with the ravening wolf of European and Euro-American fables and tales, these works present a more complicated view of the wolf and wolf predation. Although authors of contemporary informational books clearly state that wolves are carnivores, they remove the association of predation with cruelty and wrongdoing by stressing that wolves hunt not for pleasure, sport, or wickedness but to survive. Whereas traditional narratives highlight the predatory nature of wolves to represent the wickedness in humans, in contemporary fiction and nonfiction the wolfish characters do what real wolves do—eat other animals. The distinction between good and evil blurs, and the moral connotations surrounding predation disappear. Contemporary books also call attention to the challenges posed by hunting as well as the benefits of predation on prey populations, redefining the wolf as they reconfigure predation.

Authors of contemporary fictional picture books containing more realistic portrayals of wolves often incorporate scientific understandings of real wolves in their plots, characterizations, and descriptions. Jean Craighead George's *The Wounded Wolf* and *Look to the North*, Janni Howker's *Walk with a Wolf*, Jonathan London's *Eyes of Gray Wolf*, and Jim Murphy's *The Call of the Wolves* build stories around the life and experiences of wolves as revealed through scientific studies. In a similar way, Colony Elliott Santangelo's *Brother Wolf of Gubbio* provides a more ecological characterization of the wolf and wolf predation, updating and modifying both the medieval story's meaning and the wolf.

Visual images, especially photographs of real wolves, are powerful tools in the reconfiguration of the wolf and wolf predation. Like text, visual images

offer different kinds of experiences for the audience, from the intellectual to the emotional. Visual images reflect the text while providing additional information. The representational nature of photographs encourages the perception of them as visual proof that an event happened or that a place, thing, or person existed (Sontag 1977, 5). Not only do photographs afford readers the opportunity to see images of real wolves, but they also present and serve as evidence of wolves and wolf behavior in the real world.

Yet photography has always been a medium conducive to the manipulation of subject matter through choices in filters, exposure time, perspectives, or angles (Reich and Walker 1998, 29). Digital manipulation further complicates the understanding of photographic images as evidence of the real world. Computer programs allow photographers to touch up, insert, move, or remove objects within a scene. This means that images of nature, like images in fashion magazines, can be touched up and cleaned up to intensify and purify the beauty of their subjects. In addition, "the ability to alter a photograph digitally has undone the fundamental condition of photography—that something must have been in front of the lens when the shutter was opened, even if questions remained as to the authenticity of what was then recorded. It is now possible to create 'photographs' of scenes that never existed without fakery being directly observable" (Mirzeoff 1999, 88).

Photographing wild animals presents other challenges, which require yet other types of manipulation. As Mech points out, most "wild" wolves are shy of humans, making it hard to locate, observe, and photograph them (2000, 87, 126). Consequently, "almost all of the world's wolf photographs result from four approaches: opportunistic shots of wild wolves taken during wolf studies, close-ups of captive wolves in natural-looking surroundings, photos of wild wolves from afar, images of tame wolves temporarily released into the natural environment for the sake of photography" (ibid., 126). In Brandenburg's photographs of an Arctic wolf pack on Ellesmere Island or Weide and Tucker's photographs of Koani, the type of wolf featured is obvious. Save for Patent's and Otto's books, however, many of the works credit the photographers but fail to provide information as to whether the photographs are of wild, tame, or captive wolves.

Finally, the manipulation of images extends to decisions about subject content as well as about which images to include and exclude in a book. For instance, it is not coincidence that most photographs of adult wolves depict them against a snowy backdrop. By photographing adult wolves during the winter months, photographers capture wolves when their coats are their thickest and prettiest. Selection of images for inclusion means that certain physical features and behaviors are emphasized while others remain unseen and so, in a sense, are denied. Whereas photographs provide the audience with images of real wolves, the technology and techniques used in producing photographic images, as well as the difficulties inherent in photographing wild animals, complicate the meaning of photographic images as reliable evidence.

Although contemporary fictional picture books rely on media other than photography, their illustrations recall the content and themes expressed in

photographs. Sometimes illustrators present the same scene as in a photograph but from a different perspective. For instance, Sarah Fox-Davies's illustration of a wolf pack pursuing a moose seems to revisualize Rolf Peterson's photograph of a pack hunting a moose through the snow by depicting it from the point of view of the wolf. This similarity in and repetition of images across genres reinforce their value as evidence, essentially creating a truth-in-numbers effect.

Hunting

Drawing on findings from scientific studies of the wolf, contemporary informational books provide information about the wolf's diet, its skills as a hunter, and the effects of predation on prey populations. Authors point out that wolves need three to five pounds of food daily but may consume up to twenty pounds of food at a time and go without eating for up to two weeks. Unlike Teddy Roosevelt's "beast of waste and desolation," wolves as depicted in these texts are economic and efficient predators eating what they kill. Whereas individual wolves can hunt rodents, rabbits, birds, and other small animals, hunting and killing large ungulates, the species' main source of food, requires a pack. Texts depict the wolves as skilled hunters while underscoring that only one in ten hunts results in a kill. Several factors contribute to the pack's success or failure. Prey can escape by fleeing or fighting. As several works point out, large prey such as moose or bison can injure or kill the wolves.

Informational books also call attention to the benefits of predation on prey populations while stressing the danger large prey animals pose to the wolves. For the most part, authors stress that wolves test the prey, choosing the vulnerable ones, which are typically defined as the old, the sick, and the young. These are the same kinds of victims as found in the traditional tales and fables. Here the selectivity of what most authors present as vulnerable diverges from science, which reveals that wolves also prove successful in hunting healthy adult prey. A prey animal's vulnerability rests on a range of factors beyond its physical condition, including its habits, the weather, and other variables in the ecosystem. Only a few authors of contemporary nonfiction, such as Johnson and Aamodt and Patent, hint that factors other than age and physical condition may render an animal vulnerable or make a healthy animal a target (Johnson and Aamodt 1985, 64; Patent 1990, 26). The value placed on the wolf's role in the ecosystem recharacterizes predation in general and wolf predation in particular as it undoes the negative stigma associated with wolf predation in traditional narratives.

Textual depictions of the hunt range from vague accounts of wolves chasing prey to more in-depth and detailed descriptions of the mechanics of hunting:

> When a pack of wolves picks up the scent of prey, the animals become very excited and alert. They sniff the air and then set off in the direction of their

quarry, moving swiftly but cautiously. Their goal is to get close to the prey without revealing their presence, so silence and speed are essential. If they succeed in their quest, the wolves dash toward the animal, surround it, and bring it down by biting its rump, sides, neck, and head. In most cases, death comes quickly, and the predators begin to tear at the prey's flesh with their strong teeth, pulling off large pieces and bolting them down with very little chewing. (Johnson and Aamodt 1985, 59–61)

As this passage demonstrates, accounts of the ways a wolf pack takes its prey can be graphic. Yet most informational books do not include images of wolves attacking prey. One exception is found in Brandenburg's *To the Top of the World: Adventures with Arctic Wolves*. Brandenburg includes several photographs of the pack in the process of hunting (see Figure 1.9). More common hunting scenes are photographs of wolves walking single file or running through the snow as they pursue an unseen animal. As such, these images provide a benign view of the hunt and the kill. Even when a photograph of a wolf hunt includes the prey, the text does not always clarify the action of the image but instead renders it ambiguous. For instance, Simon's text opposite an image of a pack of wolves chasing a moose through the snow describes not only the way in which wolves hunt but also the dangers a moose poses to wolves: "One of the wolf's main prey is the moose. An adult moose may weigh over 1,000 pounds (450 kilograms) and stand over 6 feet (2 meters) tall at the shoulders. It has hoofs that can injure and even kill a wolf. It is also strong and a good runner" (Simon 1993, 24–25).

As Brandenburg's experience suggests, patience and chance play a major role in filming a hunt (1993, 29–34). Photographers must be in the right place at the right time, and they must be ready. But the lack of these scenes in other informational books also serves as a clue to the type of wolf featured. As suggested, wolves in the wild are hard to locate and observe. To get around this, photographers often use captive or tamed wolves, animals that do not hunt but instead are fed the remains of dead animals. In contrast, Brandenburg, by studying wild wolves that hunt to survive, was able to photograph them hunting.

Fictional picture books with more realistic depictions of wolves contain similar types of information but offer even more sanitized views of the hunt. In some instances, as in Daniel and Jill Pinkwater's *Wolf Christmas* and Jean George Craighead's *Look to the North,* hunting is merely mentioned; it takes place outside and offstage of the main story.

Although the wolves in *The Wounded Wolf, The Call of the Wolves,* and *The Eyes of Gray Wolf* hunt different prey, the author of each of these stories deals with hunting in a similar way. Each interrupts it. As the title *The Wounded Wolf* suggests, the main character in Craighead's story is wounded by the animal that the pack is hunting. In Murphy's *The Call of the Wolves,* human hunters in airplanes interfere with a pack's hunt, separating the pack members from each other, while an unknown wolf pack cuts short Gray Wolf's pursuit of a

white hare in *The Eyes of Gray Wolf*. Taken as a whole, these three stories reflect some of the challenges that individual wolves and wolf packs face not only while hunting but also in general. Finally, once interrupted, the plot's focus changes from wolves hunting to wolves struggling for their own survival—suggesting that the wolf is more threatened than it is a threat.

Unlike these works, Janni Howker's *Walk with a Wolf* features a successful hunt. Yet both Howker's text and Sarah Fox-Davies's illustrations provide a benign view of the fatal encounter between the wolves and a moose. Over four pages we follow the wolves as they chase after an unseen moose. The final scene of the hunt shows the moose standing and facing the wolves as they approach and begin to circle him. There is no physical contact between predators and prey and, in contrast to the text, there is no blood. In the first image the moose stands facing the wolf pack; in the next, the wolves stand near its fallen body (see Figure 1.10). The snow remains pristine throughout. Further, while the text suggests that at least one wolf has already eaten, the moose's body visually remains intact. Though the wolf in contemporary picture books must eat, images of the hunt reflect sanitized realism unlikely to scare or offend young readers.

Prey

Aside from Brandenburg's pictures of the hunt, contemporary informational books typically depict prey animals either in images separate from wolves or as an indeterminate mass on which a wolf or wolves feed. In the former type of illustration, the rabbit, deer, moose, or musk ox is alive and unthreatened. Snapshots of healthy prey separate prey animals from the actions of the predator. Munoz, Simon, Havard, Patent, Evert, and Johnson and Aamodt included photographs of wolves feeding on a dead carcass (see Figure 1.11). These images act as visual reminders that wolves kill to survive. Further, in these images the prey animal is nothing more than a faceless mass of blood, bones, and fur. By keeping the prey indistinct, these photographs also help keep the wolves' victims anonymous, preventing the viewer from identifying too closely with the prey.

In fictional picture books featuring more realistic depictions of wolves, authors also tend to separate the wolf from its prey. As discussed, most of these works feature unsuccessful hunts. In others, such as the Pinkwaters' *Wolf Christmas*, the authors conceal the wolf's diet by the use of obscure vocabulary: "We had all had a good meal of venison Poppa had caught earlier" (Pinkwater 2002, 3). From masking what it is that the wolves eat to keeping both the hunt and the devouring of the venison out of view, the Pinkwaters' text and images temper a potentially negative reaction from the audience.

Even Howker's story *Walk with a Wolf*, in which a wolf pack succeeds in killing a moose, provides a romanticized yet scientific depiction of the moose's death. Along with Fox-Davies's bloodless image of the wolves feeding off the

dead moose, Howker's comparison of the moose's blood to berries falling to the ground suggests beauty not gore. At the same time, Howker's description of the hunt draws on scientific research to validate the wolves' action: the moose is "old and limping. There are scars on his legs" (Howker 2002, 22). Left unsaid is the implication that by preying on an old, weak moose, the wolves are helping to keep the moose population healthy. Both scientists and authors of informational books stress the danger large prey can pose to the hunter; so does Howker but in a slightly different way. She attributes feelings and physical reactions to the wolves: "The wolves crouch on their bellies, their hearts beating fast. There's danger in hunting—a kick from a moose can break a wolf's ribs" (ibid., 19).

Livestock and Other Domesticated Animals

Wolves do not eat only wild animals; at times they attack and kill livestock and pets. Even though this behavior keeps the reintroduction and recovery of wolf populations controversial, images of cows, sheep, goats, and family pets with wolves are scarce. Havard's book contains two images of sheep, neither of which pictures the wolf and sheep together. One features a flock of sheep, while the other shows a Great Pyrenees mountain dog among the flock. Weide and Tucker's book *There's a Wolf in the Classroom!* contains a photograph of Koani, the diplomat wolf, face to face with a cow through a fence, rendering the encounter more comical than threatening.

Two other images provide more symbolic representations of the wolf-livestock threat. Otto's beginning reader on wolves includes a photograph of an empty farmyard. The text surrounding this image points out that as humans take up more land, prey and its habitats disappear, forcing wolves to look to domesticated animals as a food source (Otto 2000, 32–33). In *Once a Wolf*, Stephen Swinburne uses the photograph of Horatio Burns, a third-generation rancher, to underscore the ranchers' view of wolves: "I'm here to feed the people. It's not in my genes to see a wolf eat a cow" (Horatio Burns in Swinburne 1999, 23).

Contemporary retellings of "The Wolf of Gubbio" also diminish wolf predation. Colony Elliott Santangelo's, Michael Bedard's, and Jane Langton's versions of the legend of Saint Francis and the wolf differ from the source legends in their descriptions of the wolf's predation. According to source legends, the wolf devours both humans and livestock. In Santangelo's and Bedard's picture book editions, the wolf's transgressions are limited to preying on and devouring the town's livestock, whereas in Langton's version, it is the potential threat posed by the wolf that instills fear in the people. Santangelo's wolf is not the voracious beast of the legend or of fables and tales. According to Santangelo, only when a lamb strays near the sleeping wolf does the wolf awaken to the "rumbling of his empty belly" and devour the lamb (2000, 9–10).

Further, Santangelo's characterization of the wolf and his actions diverges from *I Fioretti* and the *Actus Beati*, the source texts for the legends, in other ways. Santangelo attributes the terror caused by the wolf's presence to the people's overreaction rather than to the wolf's actual threat to humans. On market day, a little girl's sighting of the wolf results in panic: "He was only one old wolf, gray haired and scrawny, but the people picked up sticks and stones and threw them shouting angrily. The wolf roared in pain, and the people shouted even louder. Then they ran into their homes, and the wolf ran out of Gubbio" (ibid., 16). Significantly, Santangelo shows us only human anger and violence, not the wolf's. Santangelo's Francis also deals more harshly with the people of Gubbio than with the wolf. When the town baker goes to Assisi to elicit Francis's help, Francis reprimands him, saying "Of course he roars. He is a wolf, and you threw stones at him" (ibid., 22). Before setting out to find the wolf, Francis makes it clear to the people that his sympathies are with the wolf: "My brothers and sisters, when Brother Wolf is hungry he must eat, just like you. But a wolf hunts whatever he can, even lambs and chickens and goats. He is only doing what wolves do" (ibid., 23).

As the next chapter shows, hunting is only one aspect of wolf behavior on display in contemporary fiction and nonfiction. The majority of images feature wolves engaged in behaviors related to life in the pack such as establishing and maintaining pack hierarchy, raising and caring for pups, and interacting and communicating with other wolves. In this way, contemporary informational and fictional picture books provide a favorable and even laudatory portrayal of the wolf.

Chapter Two
Wolf as Social Being

Two wolves nuzzle. A mother wolf carries her pup while another cleans her young. A young wolf plays with a rabbit. Several lone wolves mourn their loneliness. Three wolves arch back their necks as they howl. An alpha holds a lower-ranking pack member's snout between his jaws. The alpha pair run side by side through the snow. The pups of a litter wrestle with each other while adolescent wolves taunt adult pack members. A young female marks her pack's territory. A male wolf watches over his mate as she sleeps. Dr. Wolf cares for and heals the sick animals of the forest. As the descriptions of these images suggest, relationships in works featuring the wolf take two forms: those between wolves of the same or different packs and those between wolves and other species.

Wolf packs populate the landscapes of European and Euro-American literature. In Aesop and La Fontaine, groups of wolves attack flocks of sheep; in Daniel Defoe's *Robinson Crusoe*, they attack Crusoe as he makes his way across the Pyrenees; in Laura Ingles Wilder's *Little House in the Big Woods*, a pack's howls break the night's silence on the northern plains. Although the presence of wolf packs in these and other works suggests that the social nature of wolves was recognized if not understood, only since the late nineteenth and early twentieth centuries have several works looked beyond the predatory actions of packs to the relationships between pack members. In the wake of scientific studies conducted during the 1940s and 1950s, fiction and nonfiction began to focus on the social nature of wolves.

Traditional texts as well as contemporary stories portray the wolf in relation to other species. Across genres and time, the wolves in these stories share a trait: they are typically lone animals deriving status from their relationships with others. In other words, being a lone animal is a type of social status. Yet the implications of what it means to be a lone wolf have changed. In traditional stories the wolf is a lone and wild predator threatening the

lives of domesticated animals; in contemporary works the lone wolf is no longer a threat but is isolated, alone, and at risk. In fictional stories, in which the wolf is more human than wolf, his predatory nature is a complicating factor in his relationships with other species, often leaving him excluded and alone. In stories with more realistic wolves as well as in informational books, the wolf's lone status describes its relationship to other wolves but not to other species. Yet like the anthropomorphic wolves of contemporary fiction, these lone wolves are vulnerable, not dangerous. For a social animal, a life lived alone is difficult.

Beginning with a look at life in the pack, this chapter considers the wolf as a social being. Next, the wolf's relationship with other species as depicted in traditional narratives and some contemporary fiction is explored, focusing not only on what it means to be a predator among prey but also on what it means to be a social animal who is a predator. Within this context, the various characterizations of the wolf as a lone animal are considered. Finally, the conclusion offers reflections on the ways that contemporary works in particular try to foster relationships between the reader and the wolf.

Life in the Pack

Early examples of narratives that depict the wolf as a pack animal include the late-nineteenth- and early-twentieth-century works by Rudyard Kipling, Thornton W. Burgess, and Ernest Thompson Seton. Although these works are not notable for their realistic or objective depictions, they are important for their sympathetic portrayals. Where traditional stories isolate and generalize the wolf's behavior and physical appearance (large, fierce), later tales assign human names and emotions to wolves, describe wolf relations in human terms, and individualize wolves by giving them distinct characters, traits, and behaviors. Although the wolves do not tell their stories, the authors give voice, albeit a human voice, to the wolves' perspectives.

From the beginning of Kipling's *The Jungle Book*, the social order of the pack is central to the book's plot. Kipling's story opens with a glimpse of a wolf family. Father Wolf awakens while "Mother Wolf lay with her big gray nose dropped across her four tumbling, squealing cubs" (Kipling 1995, 3). The love that these wolf parents feel for their cubs is easily transferred to the human infant, Mowgli.

Kipling depicts the wolf pack as a law-abiding society, in which individual wolves have a voice: "The Law of the Jungle lays down very clearly that any wolf may, when he marries, withdraw from the pack he belongs to; but as soon as his cubs are old enough to stand on their feet he must bring them to the pack council . . . in order that the other wolves may identify them. After that inspection the cubs are free to run where they please, and until they have killed their first buck, no excuse is accepted if a grown wolf of the pack kills one of them" (Kipling 1995, 8).

This ritual shows that although Kipling's wolves are pack animals, they are also individuals with rights. The pack leader is Akela, "the great gray Lone Wolf, who led all the pack by strength and cunning" (ibid.). Akela's lone status refers to his role of leader, which places him at the head of the pack yet also keeps him separate from them. Just as the pack accepts pups, the pack acts to depose leaders who have grown old and weak. Akela thinks "of the time that comes to every leader of every pack when his strength goes from him and he gets feebler and feebler, till at last he is killed by the wolves and a new leader comes up—to be killed in his turn" (ibid., 12).

Late-nineteenth- and early-twentieth-century naturalists Seton and Burgess wrote stories for young people that challenged the prevailing attitudes toward wolves. Although their stories contain some information on real wolf behavior, these authors are most significant for their sympathetic portrayals of wolves. By endowing the animals with feelings, personalities, and intelligence and making them heroic figures along the lines of Robin Hood, Seton and Burgess individualized the wolf. They are often credited as being early conservationists.

In writing of his experiences tracking the outlaw wolves Lobo and Blanca, Seton compares Lobo's rule to that of a king. Lobo leads and protects his pack members—showing them how to kill cattle and avoid traps and poison. Yet for all of Lobo's despotic behavior, the wolf risks his life when his consort Blanca is caught. Having failed in his attempts to poison, trap, and shoot Lobo, when Seton discovers that Lobo has a mate, he decides to use her as bait. Younger and less careful than Lobo, Blanca is easily captured. Caught, the she-wolf cries "the rallying cry of her race, sent a long howl rolling over the canyon. From far away upon the mesa came a deep response, the cry of Old Lobo" (Seton 1903, 20). Further, "At intervals during the tragedy, and afterward we heard the roar of Lobo as he wandered about on the distant mesas, where he seemed to be searching for Blanca. He had never really deserted her, but knowing he could not save her, his deep-rooted dread of firearms had been too much for him when we approached him. All that day we heard him wailing as he roamed in his quest, and I remarked at length to one of the boys, 'Now, indeed, I truly know that Blanca was his mate.'" By evening, there is "an unmistakable note of sorrow . . . no longer the loud defiant howl, but long, plaintive wails; 'Blanca! Blanca!'" (ibid., 20–21).

When Lobo comes to the spot where they killed Blanca, "his heartbreaking wailing was piteous to hear. It was sadder than I could possibly have believed." As Seton predicts, Lobo follows the scent of the horses carrying Blanca to the ranch. Seton drags Blanca's body over the ground to scent the traps. Two days later, Lobo, who has been so careful to avoid traps in the past, is held in four foothold traps. As Seton tells it, Lobo's grief makes him reckless and his defeat complete. With his freedom, strength, and love taken from him, Lobo dies of a broken heart: "Who will aver that this grim bandit could bear the three-fold brunt heart whole?" (ibid., 26).

Seton presents an even richer picture of life in a wolf pack in his story "Badlands Billy." The author claims to have become acquainted with Badlands Billy and his history while accompanying a wolfer in pursuit of this outlaw wolf. The actions of a human hunter leave Badlands Billy (Duskymane) an orphan. After killing a she-wolf exiting from her den, the wolfer

> found the litter, a most surprising one indeed, for it consisted not of the usual five or six Wolf-pups, but of eleven, and these, strange to say, were of two sizes, five of them larger and older than the other six. Here were two distinct families with one mother, and as he added their scalps to his string of trophies, the truth dawned on the hunter. One lot was surely the family of the She-wolf he had killed two weeks before. The case was clear: the little ones awaiting the mother that was never to come had whined piteously and more loudly as their hunger-pangs increased; the other mother passing had heard the Cubs; her heart was tender now, her own little ones had so recently come, and she cared for the orphans, carried them to her own den, and was providing for the double family when the rifleman had cut the gentle chapter short (Seton 1905, 115).

After scalping and stringing up the pups, the wolfer leaves, not knowing that he leaves one pup behind. When an old she-wolf discovers the surviving pup, the story repeats itself.

Throughout this story, Seton pits the heartless actions of the humans against the generous nature of the she-wolf and the loyalty of her adopted pup. Seton's descriptions of the interactions between the surviving pup and its foster mother focus on the pup's attempts to join her and her pack: "Suddenly there arose from the grass a big She-wolf, like his mother, yet different, a stranger, and instinctively the stray Cub sank to the earth, as the old Wolf bounded on him . . . She stood over him for an instant. He groveled at her feet. The impulse to kill him or at least give him a shake died away. He had the smell of a young Cub. Her own were about his age, her heart was touched" (Seton 1905, 117).

He describes the pup as groveling and "disarming [the she-wolf's] wrath each time by submission and his own cubhood" (ibid., 118). Eventually this she-wolf loses her litter to the same wolfer; left only with her adopted pup, Badlands Billy, the old she-wolf raises him, teaching him to avoid the traps set by humans.

Later, when Badlands Billy takes the lead of his own pack, Seton underscores the outlaw wolf's loyalty to his pack. "We heard him howl the long-drawn howl for help, and before we could reach the place King [the wolfer] saw the Dogs recoil and scatter. A minute later there sped from the far side of the thicket a small Gray-Wolf and a Black One of very much greater size. 'By golly, if he didn't yell for help, and Billy come back to help him; that's great!' exclaimed the wolfer. And my heart went out to the brave old Wolf that refused to escape by abandoning his friend" (Seton 1905, 154). From loyalty to love and grief, the wolves in Seton's stories display admirable human qualities—ones with which their audiences can identify and

sympathize. Depicting them in this manner individualizes and ennobles them.

As the season's wolf pups and packs grow, Badlands Billy and his foster mother, Yellow Wolf, are pushed out of the area. Seton describes the many lessons that Yellow Wolf imparted to Badlands Billy: how to communicate with other wolves; what to eat and what to avoid; how to hunt sheep, cows, and horses; and to "never, never attack a man at all, never even face him" (ibid., 124). Further:

> Wolves have no language in the sense that man has; their vocabulary is probably limited to a dozen howls, barks, and grunts expressing the simplest emotions; but they have several other modes of conveying ideas, and one very special method of spreading information—the Wolf-telephone. Scattered over their range are a number of recognized wolf 'centrals.' Sometimes these are stones, sometimes the angle of cross-trails, sometimes a Buffalo skull . . . A wolf calling here, as a Dog does at a telephone post . . . leaves his body-scent and learns what other visitors have been there to recently do the same. He learns also whence they came and where they went, as well as something about their condition, whether hunted, hungry, gorged, or sick (ibid.).

Burgess's story "Old Man Coyote and Howler the Wolf" also describes relations among the members of a wolf pack. Like Seton, Burgess portrays the parent wolves as loyal and loving to each other and to their children: "In summer when food is plentiful, Howler and Mrs. Wolf devote themselves to the bringing up of their family . . . Howler and Mrs. Wolf mate for life, and each is at all times loyal to the other. They are the best of parents, and the little Wolves are carefully trained in all that a Wolf should know."

He also describes wolf packs as having "a leader, usually the strongest or the smartest among them, and this leader they obey" (Burgess 1920, 251–52). Burgess, like Kipling, includes a darker side to social relations between wolves: the wolves "will not attack each other, but if one in the pack becomes injured, the others will turn upon him, and kill and eat him at once." (ibid.). Except for framing his information about different species with a story about individual animals, Burgess's narratives tend to be less anthropomorphic and more descriptive of various species' behaviors and habitats than do Seton's accounts.

Although Kipling, Seton, and Burgess depicted wolves living within packs, not until Adolph Murie's study of the wolf of Mount McKinley during the late 1930s did scientists begin to question long-held assumptions about wolf packs, their members, and social structure. Further, not until biologist Rudolph Schenkel's studies were published during the mid-twentieth century did terms such as alpha, beta, bider, and omega come to be used to describe the status and hierarchical relationships of wolves within a pack (Allen 1993, 262). Contemporary informational books and contemporary animal fiction draw on these scientific studies to describe and depict the social life of wolves.

Member of the Pack

In traditional Western European and Euro-American tales, fables, and legends, the wolf is a metaphor for human gluttony and predation. As suggested in the previous chapter, the illustrations accompanying these stories often focus the viewer's attention on the wolf's mouth by depicting the wolf with his mouth open and by making his muzzle disproportionately large. In this way the mouth, and by extension the wolf's predatory nature, become a defining attribute. In contrast, images in contemporary informational and fictional books show few wolves with their mouths open; of those shown in this way, most of them are howling or panting, not attacking or eating.

Photographs reduce the wolf's mouth to just one of many physical features, thereby downplaying the wolf's predatory nature by reducing it to just one of many aspects of wolf behavior. The majority of the images in contemporary nonfiction feature wolves engaged in behaviors related to pack life such as interacting and communicating with other wolves, establishing and maintaining pack hierarchy, and raising and caring for pups. Nestled among descriptions of pack life, the wolf's predatory nature is no longer its most distinguishing trait. Instead, the wolf's social nature predominates.

Across informational books, the howling wolf is perhaps the most common image. It is also an image that permeates and transcends lore, literature, and firsthand accounts of explorers and hunters. Contemporary informational books stress that howling, traditionally associated with unseen danger, is one of the ways in which wolves communicate with members of their own pack and with other packs: "Chorus howling often takes place before a wolf pack goes out to hunt. The ceremony of togetherness may encourage the pack members to cooperate with each other in the difficult job of finding and bringing down prey . . . the pack may also celebrate with a group howl" (Johnson and Aamodt 1985, 48). Howling also allows a wolf separated from its pack to remain in communication with it. The prevalence of images featuring howling wolves suggests that this is the only way they communicate verbally and fails to convey the range of vocalizations used by wolves.

Images of growling wolves, baring their teeth or raising or lowering their heads or tails, are also common and are interpreted as the ways by which wolves establish and maintain hierarchy within the pack (Johnson and Aamodt 1985, 48, 54, 55; Patent 1990, 29, 31). Texts and captions help viewers and readers understand the stances, gestures, and other visual cues that serve as communication between pack members and ways to identify a wolf's status in the pack. Unseen and rarely discussed are social interactions and behaviors such as challenges and battles for the lead position that might be construed as more dangerous, scary, or unpleasant.

Images of wolves defecating and urinating are also interpreted as ways in which different packs communicate with each other. As the captions explain,

defecation, urination, and howling are the means by which packs inform each other "about their location and their intentions" (Johnson and Aamodt 1985, 48).

Texts along with images of wolves portray the wolf as a social animal capable of forming strong bonds with its pack. Many authors define the wolf pack as a group or family of wolves that live together, hunt together, and raise pups together (Havard 2003, 4; Johnson and Aamodt 1985, 19; Patent 1990, 20). Images of wolf packs depict the wolves resting near one another, nuzzling, sniffing, or licking each other's faces. Further, photographs typically feature the actions and gestures of two wolves that the authors identify as the alpha or top wolves—the "breeding pair." Alpha wolves brush against each other, walk side by side, and nuzzle one another. By describing the wolves' behavior as affectionate, courting, and loving, the texts help to connect the reader with the wolf by associating wolf behavior with human behavior (Johnson and Aamodt 1985, 27; Patent 1990, 20).

Some of the most powerful images contributing to the recharacterization of the wolf as a social animal are those depicting the care and nurturing of pups. Images show and texts stress that raising pups is a pack effort. Just as the alpha female wolf is central to the pack's hunt, so the alpha male plays an active role in raising the wolf pups. When the female dens, her mate, although not allowed inside the den, ensures that the nursing female has food by depositing food outside of it. When the pups leave the den, the adults in the pack not only welcome them but also take part in feeding them. Several photographs feature pups greeting both parents and nonparental adult wolves by licking their muzzles, which triggers a regurgitation response in the adults, giving the pups easily digested food.

The discussion of wolf pups is typically accompanied by photographs or illustrations of a mother wolf nursing her pups, a litter of pups huddled next to or on top of each other, and a nonparental adult wolf surrounded by pups. Scientists as well as the authors of these books refer to this last behavior as babysitting and to the adult wolf as the "babysitter" wolf. Brandenburg's two works on Arctic wolves feature images of Scruffy (see Figure 2.1), the babysitter wolf. Brandenburg's photographs of Scruffy with the wolf pups show him displaying affection for, caring for, and teaching his young charges. Displayed alongside these more affectionate images, Brandenburg's picture of Scruffy reprimanding the pups seems jarring. Yet Brandenburg tempers Scruffy's aggressiveness by arguing that life in the Arctic can be harsh, so part of his role is to "toughen up" the pups (1996, 19).

Informational books also include images of wolf pups interacting with each other and with other adult wolves. Just as the wolf pack is equated with human families and communities, so the behavior of wolf pups is described and explained in terms that equate it with the behavior of human children. Typically, the pups are depicted wrestling with each other or with adult wolves. Authors describe this behavior as play and suggest that, as with human

children, play allows young wolves to try on different roles and learn, develop, and practice the skills essential to being an adult (Brandenburg 1993, 21; 1996, 15, 16, 17, 23, 25; Johnson and Aamodt 1985, 34; Patent 1990, 21–23).

Whereas wolf packs usually contain anywhere from two to twenty wolves, two of the packs depicted in these books reflect a more eclectic mix. When photographer Bruce Weide and biologist Patricia Tucker agree to raise the wolf pup Koani, they become her pack. Unable to fulfill Koani's need for constant companionship, Weide and Tucker extend Koani's pack by bringing in a dog (Weide 1995, 14–17). The Arctic wolf pack photographed by Brandenburg seemingly becomes so adjusted to his presence that the pack lets him near the pups: "I couldn't believe it! Not one adult stayed behind to bark at me and keep me away from the den. They trusted me with their precious pups" (Brandenburg 1993, 10). The experiences of Weide and Tucker and Brandenburg suggest that the social nature of wolves allows them to form interspecies bonds. At the same time, the photographs of human–wolf bonding help to dismantle the perception of the wolf as dangerous to humans.

Nurturing and caring for young wolves also occurs in fictional stories featuring the wolf as wolf. In *Wolf Christmas*, Stinkface's descriptions point to the active involvement of adult wolves in rearing the young ones. Janni Howker's *Walk with a Wolf* focuses on life in the pack. From the beginning this story breaks with traditional tales by featuring a female wolf. We first see her as she walks through the woods alone. Howker's explanations of the interactions between the members of the pack are similar to those found in informational books. Fox-Davies's pictures show the female returning to her pack. The young run to her while her mate, the alpha male, "greets her with a stare from his pale eyes" (Howker 2002, 15). In addition to images of the pack hunting and feeding are those of the family members, bellies full, sleeping curled up close to each other (ibid., 26–28).

George's *Look to the North: A Wolf Pup Diary* features the first year in the life of the pups Talus, Scree, and Boulder, comparing it with that of the young reader. From snuggling with their mother as the father watches beyond the den's entrance, to their first explorations of the outside world, playing, their first attempts at hunting, and finding their unique abilities, readers follow the young wolves through their first year (see Figure 2.2). Illustrations feature the bonds between the adults and their young as well as those between the littermates. Never leaving any wolf alone, the pack, particularly its three young members, is depicted as a group, which suggests that part of learning to be a wolf is learning to live with and interact with the others.

Interspecies Relations

The wolf, imaginary and real, often comes into contact with other species. In traditional stories as in more contemporary works, those relations are colored

by the wolf's role as predator. For the most part, the wolf in traditional narratives is a predator among prey, threatening the lives of other animals. In contemporary fictional picture books featuring anthropomorphic wolves, the wolf's predatory nature becomes a complicating factor in its attempts at interspecies friendships. In both instances, the wolf is a lone animal; yet the implications of this status are not the same.

Dangerous Outsiders

In many traditional tales and fables, the wolf appears as a lone animal, without home or family. This lone wolf simply appears outside a town's walls, at the crossroads, or at the door. Yet scenes of domesticity and family life precede the wolf's arrival. The first thing that the three pigs do upon leaving home is to gather the materials needed to build a house; they set up homes. The mother goat leaves her seven children at home while she goes out to gather food. Little Red Riding Hood also leaves home to bring food to her grandmother; she essentially leaves one home to go to another. The visual representations of these spaces reflect building materials from straw to stone, as well as a range of styles from barns or stable-like structures to cottages, log cabins, and solid-brick, middle-class houses. There is also a range of interior décor, from the simple rustic home of Galdone's third pig to the English country home of Brooke's third pig. Little Red Cap's home as depicted by Zwerger is sparsely decorated, whereas Little Red Riding Hood's home as rendered by Hyman has an iron stove, flowers, rugs, quilts, and cats. The mother goat's home usually contains a table, a bed, a cupboard, and a clock, all of which become the hiding places of her kids. While the details vary, these spaces represent stability, security, and orderliness.

Some views of the houses include the living room and, in the case of Little Red Riding Hood, the bedroom, but almost all include scenes of the kitchen—the space where food is prepared. Indeed, one way to consider these images is in terms of eating, being eaten, and not being eaten. Within this context, the wolf also differs from his prey. As we have seen, once he has his prey, he swallows it whole. His eating involves no preparation—no slicing, dicing, or boiling. In contrast, when the wolf becomes the meal, the pig cooks him first.

Differences in setting reflect the divide between the domesticated and the wild, the prey and the predator. For the most part, the texts imply the settings through the wolf's counterparts. The presence of sheep, pigs, and goats underscores the bucolic aspect of these narratives. In this context, the wolf is a wild animal in domesticated spheres among domesticated animals. His status as a wild animal and predator sets him apart from the other characters. He is an outsider, an interloper. The first image we see of the wolf in *Pigweeney the Wise* shows him walking in a farmyard with the skeletal remains of various

animals at his feet; the next time we see him, he has a pig in his mouth. In Aesop's fables, the wolf chasing or carrying a sheep disrupts the peaceful pastoral scenes.

The wolf in most tales and fables lacks a home, but in "Little Red Riding Hood," he is associated with a space. Indeed, it is in the woods that Little Red Riding Hood first encounters the wolf. When the heroine enters the woods or forest, she enters his space: "As Little Red Cap went into the forest, she was met by a wolf" (Grimm/Zwerger 1983, 4). The woods or forest carries strong symbolic meaning in folk and fairy tales. The forest, the European and North American equivalent of the biblical wilderness, is traditionally associated with the devil: "The forest is an obvious symbol for freedom from social conventions and restrictions, but also for risk and danger" (Ashliman 2004, 41). A space outside the reach of the law, it is the place of outlaws. So when Little Red Riding Hood enters the woods, her mother's warnings lose their power; she stops and talks to the wolf. The wolf represents not only the risk and danger of the forest but also, more importantly in his role as a metaphor, the risk and danger posed by humans with no social conventions or restrictions. The visual representation of the forest varies from the turbulent, chaotic forests of Doré to the dreamlike setting of Zwerger and the orderly, contained space of Crane. Sarah Moon's depiction of the forest as a city, the path as a cobblestone street, and the wolf as an unseen stranger in a car evokes the phrase "urban jungle." Like Perrault's version, Moon shows that even civilized behavior and populated spaces often conceal amoral people. Indeed, shadows and darkness pervade Moon's photographic images, hinting that the buildings and technology provide a cover for immoral acts. As such, Moon's *Little Red Riding Hood* suggests that the danger and risk once associated with sparsely populated forests can also be found in towns and cities.

In "Little Red Riding Hood," the heroine enters the wolf's space. But what happens when he enters the domesticated spaces of the grandmother, the goats, and the pigs? In the images associated with the wolf's visit we see that disorder and destruction follow in his wake. In "The Three Little Pigs," even if he does not succeed in eating the first two pigs, he does succeed in destroying their homes. When the mother goat returns home, the room's disarray is a visible reminder of the recent visitor: "Die Hausture stand sperrweit auf: Tisch, Stuhle und Banke waren umgeworfen, die Waschussel lag in Scherben, Decke und Kissen waren aus dem Bett gesogen" ("The door stood wide open: tables, chairs and benches were overturned, the water jug was in pieces, the blankets and pillows were pulled off the bed") (Grimm/Hegenbarth 1984, 20). Doré's depiction of the wolf's presence at the grandmother's house also emphasizes the mess he causes as he attacks her. Other illustrators, such as Hyman, reflect a similar effect in the scene depicting his attack on Little Red Riding Hood. These illustrations suggest that the physicality of the wolf is out of place. He is too wild and awkward for the space, and he is violent.

Not only the houses but also the bucolic settings contrast with the forest. Whereas the latter contain natural elements, they are not natural spaces. Pastures, farms, and the countryside are spaces that have been cleared, cultivated, and tamed. Unlike the overgrown woods or forest that keeps the darkness in, pastures and farms are open spaces that let in light and extend visibility. Further, the plants and animals that live and grow there are raised for human use and consumption. In this way, bucolic settings reflect the peace of control and order as compared to the chaotic freedom of woods.

There are exceptions to the lone wolf of European and Euro-American tales. In the Norse myths, Odin is often depicted with two companion wolves, Freki (the Devourer) and Greki (the Greedy One). As will be discussed later, in the founding myth of Rome, a she-wolf nurses and protects two human infants, Romulus and Remus. The legend of Saint Francis and the wolf of Gubbio also differs from most of the traditional stories. As we have seen, at the beginning of the legend a large and fierce wolf terrorizes the town of Gubbio; at the end, the wolf is transformed into a member of the community. In this saint's legend, the wolf becomes the site of a miracle—the wolf pledges to stop eating the livestock and the citizens of Gubbio, in exchange for Francis's promise that the townspeople will provide for him. This exchange transforms the wolf from a predator stalking the town's inhabitants to a member of the community. Tied to the socialization process, taming curbs the wolf's instincts while allowing him to become integrated into the fabric of the town's life.

In the source legends, the wolf's encounter and transformation with Brother Francis serve as a sign of God's power. Yet in Santangelo's picture book version of the story, the transformation begins before Francis arrives. From the title, cover illustrations, and opening pages, Santangelo's *Brother Wolf of Gubbio* foregrounds the wolf. By shifting the focus of the narrative from Francis to the wolf, Santangelo transforms it from a saint's legend to a wolf's legend. Santangelo's wolf is no longer the fierce wolf of the source narratives; instead, this wolf is an old wolf too tired to travel on with his pack (see Figure 2.3). In the opening pages, Santangelo explains the presence of the wolf near Gubbio: he is part of a pack of wolves looking for food and shelter. While the pack moves on, one wolf remains behind. "Old and tired," the wolf lies down and closes his eyes (Santangelo 2000, 8).

Santangelo's sympathetic portrayal of the wolf contradicts not only the source texts but also the lone wolf of other traditional tales such as "Little Red Riding Hood," "The Three Pigs," and "The Wolf and the Kids." Santangelo's wolf belongs to a pack; he becomes a lone wolf only because he is old and tired and ready to die.

When Francis goes out to meet the wolf, he does not speak to the wolf on God's behalf but simply says, "I have no sticks and stones to throw. I do not shout. I stand on the same ground as you, and the sun that warms me has light

enough for us both" (ibid., 25). The wolf is tamed not by God but by Francis's gentle treatment.

Absent in Santangelo's story is not only God but also the notion of sin. So although Francis tells the wolf that he has frightened the people of Gubbio, he confirms that the wolf is "no fearsome monster" and that the wolf has hunted out of hunger, "as wolves do" (ibid., 27). Consequently without sin, the wolf has no need for forgiveness or redemption, and the contract Francis offers the wolf lacks the underlying premise of the wolf's change of heart, his repentance. So while the pact remains, its nature has changed.

Santangelo's text diminishes the religious themes of the source texts, but her artwork evokes the stained-glass windows and illuminated manuscripts associated with the Middle Ages. Painting on basswood, Santangelo has recreated the effect of light shining through stained-glass windows. It is not only the visual style, however, that provides the religious context to the story, but also the subject matter, especially the images depicting Francis's life as we know it from his biographies and other legends: his freeing of a rabbit, preaching to birds, and serving the poor. In positioning the sun behind Francis's head, Santangelo suggests the halo common to the iconography of saints. Francis's gestures as he speaks to the wolf also reflect the religious nature of the wolf's transformation (ibid., 28). Santangelo's illustrations of the wolf are somewhat representational in that the wolf is identifiable as a wolf or at least as a canine. Even as a predator, Santangelo's wolf is never threatening. Old, thin, and small in stature, the wolf is frail not fierce. At the end, sated and tamed, he becomes doglike in his interactions with the people of Gubbio.

Michael Bedard retells the story through a young boy's perspective. Bedard's version ends where it begins, with the wolf making his daily rounds. Docile and tame, the wolf retains an aura as in Kimber's illustrations. Significantly, the wolf retains his size. He may be tame, but he is nevertheless supernaturally large. As the site of a living miracle, the wolf still looms large in the people's minds. He still casts a shadow, but this time the shadow is cast by the sun and not by the moon. Unlike the image of the wolf prowling the streets of the town at night, the closing image depicts the wolf stopping to eat at the narrator's house.

Social Predators

In several fictional picture books, the wolf's predatory nature leads to his being cast out—if only temporarily. The wolf seeks to cure the situation in several ways: by finding other wolves to befriend, by proving his usefulness to the other species, or by modifying his behavior. None of these stories condemns the wolf's predation. Instead, the stories use the wolf's predatory nature to explain and explore the wolf's loneliness.

In *L'apprenti loup*, Claude Boujon ties the wolf's predatory nature to his self-awareness. A young wolf, whose best friends are sheep and rabbits, is

unaware that he is different from them. Not recognizing himself as a wolf, he is also unaware that he is a predator: "Mais . . . le jeune loup grandissait et ses compagnons commençaient à le regarder d'un drôle d'oiel" ("But the young wolf grew up and his friends began to eye him suspiciously") (Boujon 1987, 4). Unfortunately for the wolf, his friends begin to see him for the predator he might be. Not only is he bigger than they are but he also has pointed teeth, a long snout, and sharp claws. Only when he drinks from a pond does the young wolf finally see the physical differences between himself and his friends. In turn, the wolf begins to find amusement in scaring his friends. Eventually, a wise old rabbit tells him to go find others like him: "Il faut maintenant que tu commences ta vraie vie. Va rejoindre les tiens au lieu de jouer à nous faire peur" ("It's time that you begin your true life. Go and join your own kind instead of playing at terrorizing us") (ibid., 18). Saddened, the wolf leaves to find his own kind. When he comes face to face with other wolves, "Il sait qu'il est un loup comme une autre. Il chasse avec ses compagnons et, croyez-moi, il est bien trop occupé pour regarder voler les mouche et les papillons" ("He knows that he is a wolf like any other wolf. He hunts with his friends and, believe me, he is much too busy to watch flies and butterflies") (ibid., 22). In the final illustration, the slyness of the wolf's smile as he spies on sheep grazing shows his transformed nature and suggests what the text never states: that he is busy hunting sheep. Still Boujon's wolf is neither good nor bad; he just is. Like the sheep who graze on grass, he grazes on sheep.

In other stories in which the wolf's diet threatens interspecies friendships, the wolf modifies his behavior. In Peter Nickl's *The Story of the Kind Wolf* and Olga Lecaye's *Docteur Loup*, the wolf plays a doctor who cares for and cures sick animals.* Yet in both of these stories, the wolf's reputation as a predator precedes him, and the animals fear him and come to trust him only when he proves himself to be trustworthy by helping to cure them. Whereas neither story explicitly states that the wolf is a vegetarian, Nickl implies it in the wolf's behavior as well as in the treatment he prescribes for the fox: "My friend you are much too greedy. You eat too much. I'm putting you on a vegetarian diet—that means no more meat—just porridge or maize, and apples, pears, plums, carrots, cherries" (Nickl 1988, 23). This is further implied by the contrast in the images of the wolf and the fox. Until the fox falls ill, he is typically shown chasing after small animals or carrying them in his mouth. There are no images, however, of the wolf chasing or eating other animals. Instead, the only physical contact shown between the wolf and other animals occurs in his role as doctor: he carries the unconscious rabbit in his arms, and he listens to the fox's heart with his stethoscope. These images suggest that the wolf

* The wolf as doctor or healer of the forest is an apt metaphor, especially if one considers that predation of real wolves is rendered more palatable by the theory that wolves, in killing only weak, old, or vulnerable prey, help to keep prey populations healthy.

has changed his behavior. Unlike Nickl's story, which implies a change in the wolf's diet, Lecaye's story simply dismisses it. Ignoring a mother rabbit's pleas not to eat her son, Doctor Loup laughs and asks the little rabbit whether he believes that he wants to eat him.

Several other stories focus on the loneliness and despair experienced by the outcast wolf. In Helen Hoover's *Great Wolf and the Good Woodsman*, "It was Christmas, and Great Wolf was very lonely. He was a mighty hunter, fleet of foot and sharp of tooth, and so he was feared by all the animals in the forest" (Hoover 2005, 5). From afar Great Wolf watches a group of animals gather in front of the Good Woodsman's house. When he overhears that the Good Woodsman is injured, Great Wolf offers to help: "I will run over the hills to the house of the man who lives beside the lake. The man is my enemy, but he has a dog—and the dog and I are cousins. I will tell the dog about the Good Woodsman, and he can make his master understand" (ibid., 18). The other animals fear his approach, and he tries to assure them that on "Christmas Day all animals are friends" (ibid., 16). The Good Woodsman rewards the wolf's behavior by inviting the wolf to join them and the other animals: "Come down, Great Wolf . . . Come down and have dinner with us" (ibid., 32).

Underlying Hoover's story is Isaiah's prophecy that the Messiah's birth will usher in peace among all species: "and the wolf shall dwell with the lamb." Read as a parable, the Good Woodsman is akin to God: he provides for and respects the animals. Significantly, the wolf recognizes the man as his enemy. He also describes him as the master of the dog. The slave-master relationship between the dog and the man contrasts with the mutual friendship of the Great Wolf and the Good Woodsman. The Good Woodsman cares for the animals; he welcomes them and feeds them, but he does not cage them or control them. So when the Good Woodsman is injured, the animals in turn care for him.

In *Loulou*, by Grégoire Solotareff, a young wolf's potential threat jeopardizes his friendship with a rabbit. Loulou the wolf and Tom the rabbit are "de vrais amis" ("true friends") (Solotareff 1994, 13). Tom teaches Loulou to read, count, and fish, while Loulou teaches Tom how to run more quickly than the other rabbits. They also play *peur-de-lapin* ("fear-of-the-rabbit") and *peur-de-loup* ("fear-of-the-wolf"). Whereas the former never scares Loulou, the latter always scares Tom: "Un jour, Loulou effraya tellement Tom que celui-ci se précipita dans son terrier et décida de ne plus en sortir" ("One day, Loulou scared Tom so much that he ran into his hutch and decided never to go out again") (ibid., 15). Though Loulou promises Tom that he will never eat him, Tom rejects Loulou's friendship.

Significantly, the two images of Loulou with his mouth open are related to *peur-de-loup*. In the first one, Loulou plays at being a scary wolf by opening his mouth, showing his teeth, and sticking out his tongue. The second image, which proves to be the pivotal moment in Tom and Loulou's relationship, originates in one of Tom's dreams: "La nuit venue, Tom rêva que

Loulou était énorme, noir, et rouge et qu'il le mangeait" ("The night came, Tom dreamed that Loulou was enormous, black, and red and that he was eating Tom") (ibid., 21). The image is a close-up of Loulou's head. In his mouth is Tom, who is trying to save himself by holding on to the sides of Loulou's tongue. The images and text make it clear that to Tom *peur-de-loup* is no longer a game but instead is representative of Loulou's true and potentially dangerous lupine nature.

Downcast, Loulou sets out to find another rabbit to befriend. In an ironic twist of fate, a pack of wolves mistakes Loulou for a rabbit and attacks him. Indeed, as the picture suggests, Loulou's distant silhouette resembles that of Tom's: "Cette nuit-là, Loulou connut la 'PEUR-DE-LOUP'" ("That night, Loulou understood the FEAR-OF-THE-WOLF") (ibid., 25). This life-changing experience reforms Loulou, who promises never again to play *peur-de-loup*. In the close-up of Loulou's head outside the entrance to Tom's rabbit hole, Loulou's mouth is closed. As the rounded lower jaw and lips suggest, Loulou has lost his bite and changed his nature (see Figure 2.4). No longer a predator, Loulou can be friends with Tom.

In *Patatras!* Philippe Corentin introduces the wolf Patatras by equating the wolf with hunger: "Il a qu'il a faim. C'est un loup!" ("It is he who is hungry. It is a wolf!") (Corentin 1997, 8). In addition, Patatras is "méchant, pas un gentil. Un gros méchant même" ("bad, not nice. Even a big bad one") (ibid.). But Patatras is also lonely and would like to be nice but to whom? "Personne ne l'aime. On se moque de lui, on lui fait des farces" ("No one likes him. People make fun of him, they play tricks on him") (ibid., 9). Like Aelian, Corentin ties the wolf's behavior to his hunger: "Il ne joue qu'au gros méchant que quand il a faim" ("He only plays the big bad wolf when he is hungry") (ibid., 11).

Patatras enters a rabbit hole in search of rabbits, but the rabbits play tricks on him and hide from him. The more Patatras searches, the hungrier, lonelier, and sadder he becomes. Alternating between description of the wolf as a glutton and the wolf in search of friends, Corentin intertwines Patatras's hunger with his loneliness, making it unclear as to why Patatras is looking for the rabbits. Even though the text is written in the third person, it reflects not so much the narrator's observations as the wolf's growing despair. He is hungry, but he is also lonely. Patatras laments that no one wants to play with him, no one loves him ("c'est un mal-aimé"), and no one remembers his birthday.

Unlike other texts that modify the wolf's diet and behavior, Corentin's story changes not the wolf's diet but also our perception of it. Rather than making the wolf stronger and impervious to the other animals, Patatras's predatory nature renders him vulnerable and isolates him. As such, the wolf's hunger is something to be pitied rather than feared. Further, the insistence that Patatras would like to be good and not eat other animals but that he cannot deny his nature reflects that he has no choice. In the end, the rabbits hide, not because they are afraid of Patatras but so as to lure him to his surprise party.

With a big red nose, red ears, scrawny legs, and an oversize head and torso, Corentin's unappealing visual characterization collides with the pathos of his text. Instead of making the wolf a sympathetic character, Corentin's illustrations endow him with a clownlike ambiguity: sad, lonely, but somewhat scary. Corentin's depiction of the wolf achieves what more charming or visually appealing depictions fail to do: he visualizes our ambiguous understanding of and relationship to the wolf. In human's eyes the predatory nature of the wolf is not only dangerous but also distasteful. It is an aspect of the wolf that even pro-wolf advocates prefer to ignore and diminish. Only from a safe distance can the wolf become an object of beauty.

The wolf's loneliness in Rascal's *Ami-ami* is equally profound. At the heart of Rascal's story are two lonely souls: a rabbit and a wolf. While the oppositional characterizations of the kind little white rabbit and the bad big black wolf are many, each is looking for a friend. The rabbit's description of his ideal friend makes it clear he is searching for someone like himself. In contrast, the wolf lists the ways in which he will love his friend: "Le jour où j'aurai un ami, je l'aimerai immensément . . . je l'aimerai tendrement . . . je l'aimerai avec talent!" ("The day when I have a friend, I will love him greatly . . . I will love him tenderly . . . I will love him with all my heart!") (Rascal 2004, 10–26).

In a similar manner, Stéphane Girel's images for *Ami-ami* (see Figure 2.5) contrast the self-satisfied rabbit with the desperately lonely wolf. Surrounding the round rabbit with bright, warm colors and natural objects suggests a life of comfort. In contrast, the wolf lives in a sparsely furnished, angular home of dark gray metal, steel, and glass. As he looks out of his windows, the long angular lines of his wolfish body cast long, angular shadows. Save for a red-and-white checked dishcloth, his home lacks color.

While the reason for the wolf's loneliness is not explicitly stated, his activities as depicted in the illustrations suggest the cause: in most images the wolf is engaged in food-related tasks. He washes a dinner plate, dries a jar, and carries a fork. Further, Girel plays with visual illusions and allusions. Is the white of his belly fur? Or is it an apron? Girel also makes visual associations between the wolf's loneliness and his hunger. Are those teeth or tears on his muzzle? The only textual reference to the wolf being a carnivore occurs when he and the rabbit meet. The rabbit rejects the wolf because the wolf eats meat; he, the rabbit, does not. The wolf, however, ignores the rabbit's protests, saying, "Moi, je t'aime comme tu es" ("I love you as you are") (Rascal 2004, 32).

True to his predatory nature, the wolf's actions in Keiko Kasza's *The Wolf's Chicken Stew* are intertwined with his desire to eat: "As soon as he finished one meal, he began to think of the next" (Kasza 1987, 5). Spotting a tasty chicken, he decides that she would be even better if she were fattened up. After leaving her a hundred pancakes, a hundred doughnuts, and a hundred-pound cake, he comes for her. As he peeps through the keyhole, the hen opens the door and

tells her chicks to thank "Uncle Wolf" for his tasty gifts. Overrun, the wolf is transformed by the love of the grateful baby chicks. The plot and the wolf's actions are tied to his hunger, but there is only one image of the wolf with his mouth open. From the soft lines of his mouth to his nearly invisible tongue and small teeth, the wolf is never dangerous, and the love of the cuddly chicks changes his nature.

Lone Wolves

Fictional picture books featuring more realistic representations of the wolf and life in the pack also explore what it means to be a wolf alone. By stressing the difficulties of wolves on their own, books like Jean Craighead George's *The Wounded Wolf*, Jim Murphy's *The Call of the Wolves*, and Jonathan London's *The Eyes of Gray Wolf* demonstrate that a pack is essential to the survival of individual wolves not only for hunting large prey but also as a source of companionship. These stories explore another dimension of the wolf's social nature—its vulnerability—while challenging the image of lone wolves as deadly animals.

In Murphy's book, an aerial attack by humans on a wolf pack injures a young wolf and separates him from his pack (see Figure 2.6): "He wanted to search for his pack immediately, but he was afraid of the hunters" (Murphy 1989, 16). Lost, wounded, and alone, the young wolf is vulnerable to other wolf packs and even to a team of sled dogs: "Suddenly, the snow next to him exploded and a sled dog leaped at him, its teeth bared and snapping" (ibid., 22). The hazy, shadow-filled illustrations of Mark Alan Weatherby emphasize the young wolf's plight while mirroring his inner confusion. Yet when the lost wolf returns to his pack, the sun breaks through the fog, and the wolves seemingly smile in their happiness at being reunited.

In Jonathan London's picture book *The Eyes of Gray Wolf*, Gray Wolf becomes a lone wolf when he loses "his mate to a man's steel trap" (London 1993, 8). As he wanders through the woods, he becomes aware of a wolf pack: "He sniffs the crisp air, sensing danger. The fur on his neck stands up. There in the shadow he sees a wolf pack" (ibid., 19). By placing the opposing wolves on opposite pages, Jon Van Zyle's illustration reflects the vulnerability of the lone wolf against a pack: "Suddenly a young white wolf, brilliant as the moonlight steps out from the pack" (ibid., 22). Her image intrudes on the unknown wolf pack's space, breaking and interrupting the challenge. The white wolf saves Gray Wolf not only from the challenge but also from his fate as a lone wolf. In the white wolf, Gray Wolf finds a new mate and the possibility of a new pack. In contrast to the emphasis on distance in the scenes between Gray Wolf and the unknown pack, the scenes of White Wolf and Gray Wolf stress their unity: Gray Wolf and White Wolf circle each other, walk side by side, and sleep near each other.

As the descriptions of these last two books suggest, human hunters are the cause of the loneliness, unease, and fear of the surviving wolves. These stories reverse the traditional European and Euro-American tales and fables in which the wolf represents danger to the social order; now humans threaten the social order of the pack. Further, by situating these stories in a snow-covered wilderness, the authors and illustrators suggest that the humans are trespassers in the wolf's world. In these spaces, humans are out of place. Indeed, in these works and others, the presence of humans becomes synonymous with danger. Where earlier humans and their property were the wolf's prey, now the humans are arrogant predators and the wolf is a victim. Ultimately, contemporary fictional picture books, along with informational books, recognize that the survival of real wolves in the wild depends on humans.

Although contemporary informational books contain many pictures of wolves alone, information regarding lone wolves associates them with social behavior. Evert, Johnson and Aamodt, and Patent include descriptions of disperser wolves—wolves that leave their packs to find a mate and form a new pack. They also attribute lone wolves to failed challenges within the pack. Most informational books include images of wolves submitting, but pictures of wolves battling for authority are absent. For the most part, the social interactions imaged and described are positive ones. Texts depicting the potentially deadly battles that ensue from challenges, along with photographs of wolves killing weaker pack members or wolves from other packs, are missing from these works.

Wolf–Human Relations

Contemporary informational books as well as some fictional picture books work to reconfigure the wolf's relationship to humans. Where traditional narratives hold up the wolf's predatory nature as an example and warning of dangerous human behavior, in contemporary works human behavior, emotions, and relationships serve as the basis for describing wolf behavior. In other words, where we once used the wolf's behavior to describe human behavior, we now use our behavior to describe the wolf.

Through comparisons of wolf and human behavior, these works stress the similarities between the two species. Both are social animals living within complex family and political structures. Descriptions and images depict behaviors and relationships that Europeans and Euro-Americans value: family life, education, and social order. In this way, photographs and other illustrations of adult wolves nurturing, interacting with, and educating pups, as well as images of young wolves learning and developing skills through play, do more than display wolf behavior: they reflect and model idealized human behaviors. Further, by depicting the life of a wolf in terms to which the reader

can relate, comparisons between wolves and humans also foster emotional bonds between the reader-viewer and the wolf.

Visual images provide more than information; they also offer aesthetic and emotional experiences. The physical qualities of the wolf—the wolf's eyes, thick coat, black nose, and overall doglike appearance and gestures—make the wolf a highly photogenic and appealing animal. Wide expanses of land, clear blue skies, rich green grasses, golden fields, and pure white snow provide more than dramatic backdrops. Details such as these help shape the ways in which we envision nature, creating a wilderness that is at once lush, untouched, and remote. The photographs both reflect and propagate cultural standards of beauty in nature.

The qualities that make images of the wolf visually pleasing also help to make the viewing experience emotional. By focusing the viewer's attention on the wolf's eyes, or by showing wolf pups playing, sleeping, or howling, photographs of wolves present the viewer not only with images of "real" wolves but also with aspects of the wolf with which viewers can sympathize. Indeed, the texts accompanying these images often make analogies between wolf and human behavior: "The way adult wolves are constantly caring for the young in their pack is only one of many similarities with human families" (Brandenburg 1993, 10). Just as the text invites wolf-human analogy, so it underscores the physical and behavioral similarities between the wolf and the dog. The doglike qualities of the wolf's body, behavior, and movements help viewers, especially those who live with or know dogs, to connect emotionally with the wolves in the images.

Unlike the illustrations accompanying the tales, fables, and legends (in which the wolf's mouth is its largest physical feature), in these photographs, particularly close-ups, the eyes of the wolves draw our attention. The wolves seem to look out at us, drawing us into their gaze, beckoning us to make eye contact, and inviting us to connect with them. In Euro-American culture, looking someone in the eye is read as a sign of honesty and integrity. Thus, the wolves in these photographs seem to acknowledge the viewer's presence while offering the viewer a chance to know them, if only second-hand, through the photographer's lens. Yet according to wolf biologists and researchers, when one wolf looks another wolf in the eye, the wolf is asserting its authority (Harrington and Asa 2003, 90–95). In this way, photographs of wolves looking out at us across the pages of a book are more reflective of our culture than of theirs.

Conclusion

The change in the wolf, then, reflects our changed world. In early Europe and on the American frontier, the wild was threatening. The wolf embodied

the threat of both wilderness and wildness. For the most part, contemporary Europe and North America have overcome the dangers of nearby wilderness. Yet the dangers and difficulties that arise from society and social relationships remain. New picture-book editions of traditional tales help keep the metaphor of the dangerous wolf a constant and familiar vehicle. At the same time, the wolf in contemporary fictional picture books has ceased to be only the dangerous other, threatening society. In many stories, the wolf, as the victim of intolerance and misunderstanding, becomes the means through which authors and illustrators explore the problems and difficulties of social animals. Social relationships and society can be hurtful. The fictional wolf longs for friends but is rejected for being different. He grieves the loss of a loved one. The postmodern wolf gives voice to the experiences of society's victims. Finally, in his role as young wolf, the wolf mirrors and models the actions, behavior, and world of his young reader, and so he reflects those aspects of society that we value most: childhood, family, socialization, and education.

Chapter Three
Wolf Undone

After eating a little girl and her grandmother, a wolf reclines in a chair. With a list of good things to eat, a young wolf sets out to make his way in the world. Three young wolves flee a big bad pig bent on destroying them. A wolf gives soup bones to his pups while another wolf sings to the deer. A young girl helps an old wolf find his way home. A young girl sneaks up on a sleeping wolf and blows her horn in his ear. A wolf buys the necessary accoutrements for his disguise as the mother goat. A wolf uses his victim's bandana as a napkin. A rabbit, three pigs, Little Red Riding Hood, Peter and his duck, and a mother goat and her seven kids sit down to dinner with a wolf.

Humorous revisions of fables and tales are a popular genre of children's picture books. Drawing on a range of textual and visual narrative techniques, including role reversal and changes in point of view, characterization, and setting, authors and illustrators provide new takes on traditional tales and fables. Wolf tales and fables offer robust subjects for such retellings; indeed, some of the most successful fractured tales are those based on traditional wolf tales, such as Eugene Trivizas and Helen Oxenbury's *The Three Little Wolves and the Big Bad Pig* or Jon Scieszka and Lane Smith's *The True Story of the Three Little Pigs by A. Wolf*. Through a web of humor, intertextuality, and hypertextuality, authors and illustrators conjure, disrupt, and undo not only the tales but also the wolf. Whereas some revisions retain the wolf as villain, others mirror the relatively recent rehabilitation of the wolf in ecology and society, transforming the wolf from a metaphor of human predation and gluttony to one of benign and even admirable behavior.

This chapter examines how revised fables and tales reflect our beliefs about the wolf and ourselves. The textual and visual recharacterizations of the wolf are analyzed first by discussing the narrative forms these retellings take and then by considering the varying roles played by the wolf in revised tales. Finally, the ways in which the fractured image of the wolf reflects contemporary beliefs and society are discussed.

Revising Tales and Fables

Many fractured tales such as James Marshall's *Little Red Riding Hood*, Barry Moser's *The Three Little Pigs*, and Geoffroy de Pennart's *Le loup, la chèvre, et les 7 chevreaux* and *Chapeau rond rouge* derive their plot lines from their traditional counterparts. They are explicit examples of what Gérard Genette describes as hypertexts or texts derived from preexisting texts (1982, 16). He identifies two types of hypertextuality: transformation and imitation. And he defines transformation as "saying the same thing differently" ("dire la même chose autrement"), whereas imitation is "saying something different in a similar manner" ("dire autre chose semblablement") (1982, 14–15). Genette's transformation is similar to Gianni Rodari's notion of a "new key" where one tells the same story in a different time or place or from a different point of view (Rodari 1996, 51–52). In Scieszka and Smith's work, the wolf tells his side of the story surrounding the events leading up to the death of the two pigs, while Trivizas and Oxenbury reverse the roles of the pig and the wolf. Pennart introduces several new keys in his updated versions of *Le loup, la chèvre, et les 7 chevreaux* and *Chapeau rond rouge*, including the survival of the wolf and recharacterization of Little Red Riding Hood, her grandmother, and the goats. As Genette's and Rodari's descriptions suggest, authors and illustrators of revisions and fractured tales assume that their audiences have knowledge of the traditional versions of these tales. In other words, for young readers to understand and enjoy these texts to their fullest, they must know the tales on which these stories are based.

Other stories such as Pennart's *Le loup sentimental*, *Le loup est revenu!* and *Je suis revenu*, Janet and Allan Ahlberg's *The Jolly Postman*, Sylvie Poillevé and Olivier Tallec's *Le plus féroce des loups*, Mario Ramos' *C'est moi le plus fort*, David Wiesner's *The Three Pigs*, and Jon Scieszka's and Lane Smith's *The Stinky Cheese Man* depend on characters and settings from several Western European fables and tales in addition to those about wolves. Each of these familiar characters or settings recalls and evokes the stories from which they are taken. In this way, the characters and settings act as intertextual elements or the presence of one text within another, giving voice to multiple texts within a story. Gianni Rodari describes such jumbles of fairy-tale characters as a "Fairy Tale Salad Mix" and suggests that in subjecting stories and characters "to this treatment, even the images that are most constantly used appear to take on a new life, to blossom again, and to bear fruit and flower in unexpected ways" (1996, 38). The mixed casts of characters evoke the traditional narratives from which they come. At the same time, new encounters with the wolf, outside the context of the traditional fables and tales, allow Little Red Riding Hood, the three pigs, and the goats to rewrite their relations with him and, in some instances, to transform the wolf himself. For example, in Pennart's *Le loup sentimental*, the wolf Lucas becomes a hero, whereas the wolf in *Je suis revenu* and *Le loup est revenu!* becomes the friend of his former victims. In *Le plus féroce*

des loups, Poillevé's wolf becomes a hero by devouring the farmer, hunter, and ogre—the would-be killers of the pigs, rabbits, and children (see Figure 3.1). In David Wiesner's *The Three Pigs,* the wolf blows the pigs and pages out of the story. Using a page from the story, the pigs make a paper airplane and fly beyond the white space into other nursery tales. As for the wolf, he is trapped in the pages of the story, including the one used by the pigs to construct their airplane. Accompanied by a dragon, the pigs return to their story. When the wolf huffs and puffs, he is greeted by the dragon. Last seen outside the pigs' house, the wolf is removed from the story. These hypertextual and intertextual allusions evoke the traditional tales while changing the wolf's role and identity.

"The salad mix" is only one type of story in which traditional folk- and fairy-tale characters encounter each other outside the confines of traditional narratives and their traditional roles. Misunderstandings as to who the wolf is and what he wants provide a humorous tone to many of these stories. In Lisa Wheeler and Frank Ansley's beginning reader series featuring a wolf and a pig, Chip, a young pig, tries to determine whether Fitch, his wolfish new classmate, is friend or foe. Chip's questions and his tendency to panic make it clear that Chip knows all about the Big Bad Wolf. Pennart's *Le déjeuner des loups* also features a wolf, Lucas, and a truffle-hunting pig, Maurice. At first, Maurice has reason to fear for his life. When Lucas kidnaps Maurice, it is clear from Lucas's conversation with his family that Maurice will be Sunday's dinner. Over the week, Maurice and Lucas bond; when it comes time to serve Maurice, Lucas, much to the dismay of his father, refuses to slaughter him.

Even retellings and mixes in which the wolf remains devious offer new takes on the tales and characters. Disney's three animated musical films from the 1930s, *Three Little Pigs, Big Bad Wolf,* and *Three Little Wolves,* rewrite the wolf and pigs and their interactions. Visual allusions to other fables and tales (the wolf disguised as a baby sheep, the Fairy Queen Goldilocks, and Little Bo Peep), as well as exaggerated character strengths and weaknesses of the cast (two incredibly silly and cowardly pigs, one overly serious, plan-ahead kind of pig, a naïve and dimwitted little girl, a sweet but tough granny, and a devious wolf), reduce the cautionary tales to comic mayhem. Although the wolf in these stories remains conniving and persistent in his attempts to secure a pork or human dinner, he is more of a fool than a threat. The cartoon format, the song "Who's Afraid of the Big Bad Wolf?" and its merry melody, the two silly pigs' insistence that the wolf is a "great big sissy," and the third pig's over-the-top responses to the wolf signal the lighthearted nature of these versions.

Embedded in Disney's characterizations and slapstick humor are racial and ethnic stereotypes. The wolf in *Three Little Pigs* and *Big Bad Wolf* appears to be a slow-witted Southerner, his black fur suggesting an African American background. Created in the late 1930s, *Three Little Wolves* mocks Germany's rising power while promoting American patriotism. In it, the wolf's German

accent along with the German-like words ("Ist das nicht ein pigsen feet?") and oompah-like melody of his song mock Germany. The film's ending, featuring the three pigs—one as a drummer, one bearing a standard, and one playing a pipe—marching off to victory, evokes the "Spirit of '76," an iconic image of the American Revolution.

In *The Mystery of Eatum Hall*, Mr. and Mrs. Pork-Fowler receive a mysterious invitation from Dr. Hunter to a weekend at Eatum Hall. The wolf, as Dr. A. Hunter, appears as a parody not only of his traditional self but also of cinematic and literary mad scientists (see Figure 3.2). Hunter's elaborate plan for a meal hinges on the presence of Mr. and Mrs. Pork-Fowler as the main course for his guests, the Wolfellas. Hunter invites the Pork-Fowlers to join him for a weekend of free gourmet food. Although the Pork-Fowlers never meet their host, Hunter sees to it that their needs are met. With the aid of complicated mechanical devices and surveillance equipment, Hunter fattens up his guests by keeping the refrigerator well-stocked and serving large multicourse meals. The devices, which help to fatten up the Pork-Fowlers, work too well. They gain too much weight and break the machine that is supposed to turn them into a pig and goose pie. The wolf shares the fate of mad scientists before him: the machine turns on the inventor when the wolf sets out to fix it. In the end, the Wolfellas sit down to enjoy a slice of wolf pie. Hunter remains a shadowy figure though visual clues to his identity are evident throughout the house. His portrait gallery contains images of his illustrious lupine heritage along with some of his most well-known victims through the ages, including a portrait of Little Red Riding Hood by Walter Crane. The tone, along with textual and visual references to earlier tales and popular icons including the Mafia, the English manor house, and the gothic genre of mysterious weekend invitations diminishes the wolf as a threat. Hunter may be conniving, but he is never dangerous.

Not all revisions are humorous. In *Into the Forest* and *Piggybook*, Anthony Browne uses the tales, their characters, and settings to create an ominous atmosphere. In the first story, a boy, whose father is gone, is sent to his grandmother's house. Taking the shorter way through the woods, the boy meets Jack of the Beanstalk and his milk cow, Goldilocks, and Hansel and Gretel. He also finds a red coat. In *Piggybook*, having had enough of cleaning and feeding her husband and sons, Mrs. Piggot leaves. The longer she is away, the more her husband, sons, and even the dog, resemble pigs. Images and shadows of pigs take over the house. In the background of one scene, the shadow of the wolf's head looms in the window.

In *Jean-Loup*, a mysterious old wolf kidnaps little wolves to eat. As he says to Marie-Loup: "Maintenant nous allons préparer le dîner et tu en seras le plat principal" ("Now we are going to make dinner, and you will be the main course") (Krings 1992, 19). This image of a cannibalistic adult wolf is offset by that of his prey, the two young wolves, Jean-Loup and Marie-Loup. These two play, run in the fields, tease each other, and scare each other with "des histoires horribles de méchant loups qui mangeaient les petits loups" ("horrifying tales of bad wolves who like to eat little wolves")

(ibid., 4). After Jean-Loup's rescue of Marie-Loup from the clutches of the old wolf, the focus of the book switches to Jean-Loup's love for his friend. Further, the absence of any reference to what the young wolves eat suggests that their innocence is tied not only to their youth but also to their behavior, specifically what they choose to eat.

Déjà-vu

In addition to deconstructing and reconstructing the wolf and his tales, hypertextual and intertextual allusions contribute to the feeling that these revisions take place in a narrative space and time outside that of the traditional stories. Indeed, in many of these revised tales, the characters demonstrate an awareness of the traditional folk and fairy tales on which they are based. Pennart, aside from situating the characters in a more contemporary context, hints that his characters know the tales. Unlike the wolf in more traditional renditions of *Le loup, la chèvre, et les 7 chevreaux*, the actions of Pennart's wolf suggest that he knows the routine. Instead of building his disguise based on the kid goats' responses to his various attempts to gain entrance into their home, Pennart's story begins with the wolf Igor buying the necessary items for his disguise as the mother goat. In this way, the story unfolds from the wolf's perspective. Similarly, Chapeau Rond Rouge's response to her mother's warning about wolves suggests that she too has heard it all before: "Oui, oui, je sais, il y a le loup. Ne t'en fais pas Maman, je connais la musique" ("Yeah, yeah, I know there is a wolf. Don't worry, Mom. I know all about it") (Pennart 2004, 9). As the titles *Le loup est revenu!* (*The Wolf Is Back!*) and *Je suis revenu!* (*I Am Back!*) suggest, the events in these new stories take place in a time after the traditional tales end.

By placing the story after the end of a tale, the author often provides the wolf opportunity to deliver his take on what has transpired. Recounting his side of the story from jail, Scieszka's wolf claims that he has been framed. In a similar way, Toby Forward's wolf tries to convince the audience that his troubles with Little Red Riding Hood and her grandmother are the result of a misunderstanding. Other stories pick up the action where the tale ends. For instance, the wolf in the Ahlbergs' *The Jolly Postman* receives a letter from Little Red Riding Hood's solicitors requesting he vacate her grandmother's cottage and cease wearing her grandmother's clothes without her permission. The lawyers also inform him: "Messrs. Three Little Pigs Ltd. are now firmly resolved to sue for damages" (Ahlberg 1986, 19).

Big Bad Wolf Revised

While the wolf in traditional versions of "Little Red Riding Hood," "The Three Little Pigs," "The Wolf and the Kids," *Peter and the Wolf*, and Aesopian fables

is cast as the villain, his role across the fractured retellings varies from villain to benign character and even to victim. In James Marshall's *Red Riding Hood* and *The Three Little Pigs*, William Wegman's *Little Red Riding Hood*, Barry Moser's *The Three Little Pigs*, Geoffroy de Pennart's *Le loup, la chèvre, et les 7 chevreaux*, Eric Kimmel and Janet Stevens's *Nanny Goat*, and Steven Kellogg's *The Three Little Pigs*, the wolf's villainous tendencies become the focal point of humor. As will be seen, exaggeration, sarcasm, and slapstick render the wolf humorous while diminishing him as a source of danger.

The wolf, however, does not always play the role of the villain. In some instances, such as Melissa Sweet's *Carmine: A Little More Red*, Claire Masurel and Melissa Wai's *Big Bad Wolf*, and Jackie Leigh Ross and Steve Ko's *The Wherewolf?*, the wolf plays a more benign character. In *Carmine: A Little More Red*, the wolf is interested in getting granny's soup bones to feed his pups. While Carmine's dog Rufus might be nervous because "it is no JOKE that a wolf could eat a dog in the blink of an eye," a text and image box assures the reader that wolves typically "eat mice and other small creatures" (Sweet 2005, 11). Masurel and Wai also dismantle the wolf's image as big and bad. Images of people exaggerating and fearing the wolf's pointy ears, shiny eyes, long snout, sharp teeth, and piercing howl are countered by images of a wolf reclining on a blanket in the woods, picking flowers from a bush, and serenading deer. At night when children read scary wolf tales in bed, the Big Bad Wolf goes home to his wife and kids where he tells stories and plays the Big Bad Wolf to get his pups to go to bed. The wolves in these books are still perceived as potentially dangerous by their fellow characters, but the wolf in Ross and Ko's story is old, lonely, and forgetful. His days of scaring people and animals are behind him. His chance encounter with a little girl in the woods ends with her helping him find his way home.

Change in perspective and role reversal recast the wolf as a victim. In *The True Story of the 3 Little Pigs* as well as *What Really Happened to Little Red Riding Hood: The Wolf's Story*, the wolf recasts himself as the victim of a series of regrettable events. As the wolf says, "Nobody knows the real story, because nobody has ever heard my side of the story" (Scieszka 1989, 5). Lane Smith's illustrations, which frame the wolf and his story, echo the wolf's claim that he was framed. Role reversal in *The Three Little Wolves and the Big Bad Pig* transforms the wolf from predator to prey and increases his number to three, while mistaken identity is at the core of Pennart's revised wolf in his updated version of "Le Petit Chaperon Rouge." In these last two stories, role reversal renders the wolf helpless against his traditional victims.

While the wolf in revised tales and fables often shares the fate of the wolf in traditional tales and fables, in many instances he suffers humiliation rather than harm. Throughout Disney's three cartoons, the wolf is the victim of verbal ridicule and physical battering. Insisting that the wolf is a sissy and threatening to punch, kick, and tie him up, the two silly pigs taunt him while mockingly labeling him the Big Bad Wolf. Their actions upon meeting

the wolf, however, speak more to their false bravado than to the emptiness of the wolf's threat: the two silly pigs flee and hide. Their brother, the serious pig, proves more than a match for the wolf. From adding turpentine to the kettle heating in the hearth to pouring unpopped popcorn and hot coals down the wolf's pants and constructing a "Wolf Pacifier," the third pig delivers blow after blow to the wolf. The wolf runs off howling in pain, but he never dies.

In Pennart's revision of *Le loup, la chèvre, et les 7 chevreaux*, Igor's disguise as the mother goat proves too clever for his own good. As he enters the goats' house for his much-awaited meal, Igor is tripped up by a broken heel and tight dress. He falls, hits his head, and knocks himself out. As Igor begins to regain consciousness, the father goat, who is conspicuously absent in the traditional versions of this tale, arrives home to deal with Igor. Mayhem and mistaken identity contribute to the farce as Madame Broutchou returns just in time to see her husband pick up Igor. Believing that she has caught her husband with another female, Madame Broutchou demands to know what this woman is doing in his arms. Henri, surprised by his wife's return, drops Igor, who hits his head yet another time. As Madame Broutchou continues to berate her husband, Igor, flees. Humiliated but alive, Igor returns home, never to speak of that "memorable day!" (Pennart 2005, 36).

In Lynn and David Roberts's *Little Red: A Fizzingly Good Yarn*, Little Red, realizing that the wolf has eaten his grandmother, rescues her by offering the wolf some of his family's famous homemade ginger ale. Upon drinking the ginger ale, the wolf belches granny up. In return for his promise not to eat anyone ever again, Little Red promises to supply him with ginger ale: "The wolf readily agreed. So from then on, each week on his way to Grandma's, Little Red left a keg of ginger ale in the forest for the wolf, who drank it down eagerly, in spite of its embarrassing aftereffects!" (Roberts 2005, 32).

In *Le loup est revenu!*, *Je suis revenu!*, and *Le loup sentimental*, the wolf's encounters with his traditional victims transform him from foe to friend. In the first two stories, the lamb, the goat and her kids, the rabbit, the three pigs, Peter, and Little Red Riding Hood act together to physically overpower the wolf, telling him: "LOUP, NOUS N'AVONS PLUS PEUR DE TOI!" ("WOLF, WE ARE NO LONGER AFRAID OF YOU!") (Pennart 1994, 32). Before releasing him, they make him promise "d'être gentil et de nous raconter des histoires de loup qui font peur, alors, nous t'invitons à dîner avec nous" ("to be nice and to tell us scary wolf stories, then we will invite you to dine with us") (ibid.). In Pennart's *Le loup sentimental*, Igor sends his son Lucas out into the world with a list of good things to eat. On the list are the three pigs, Peter, Little Red Riding Hood, and the goat and her seven kids. As Lucas makes his way through the woods, he meets the various food items on his list. Just as he is about to eat them, they say something that reminds him of his family, which stops him from acting. When he comes to Ogre's cottage, his hunger combined with Ogre's rude remarks prove too much for him, and he kills and

eats Ogre. Only then does he see and release Tom Thumb and his brothers. At the end of the story, Lucas is a hero.

In fractured tales in which the wolf is a benign character or a victim, his crimes are removed, transferred, or transformed. As discussed, Masurel and Wai's *Big Bad Wolf* undoes the wolf's bad reputation by showing him to be an innocent animal maligned by human imagination and fear. Melissa Sweet's wolf in *Carmine: A Little More Red* commits a lesser crime than his traditional counterpart; instead of going after Little Red Riding Hood or her granny, he takes their soup bones to feed his pups.

In Pennart's *Chapeau rond rouge*, the wolf has no opportunity to be bad. Chapeau rond rouge refuses to believe that the wolf is a wolf and not a dog. The wolf follows Chapeau rond rouge to her grandmother's house to prove to her that she is dealing with a wolf. He is thwarted, first by her grandmother, who hits him with her car, and then by Chapeau rond rouge, who clubs the injured wolf with a candlestick.

As the title of Trivizas and Oxenbury's book suggests, the pig is cast as villain in pursuit of the three little wolves and, as such, the crime has been transferred to the pig. When the wolves refuse to let the pig enter, the pig threatens to huff and puff and blow down their houses. The wolves' houses prove too strong for the pig, and so he resorts to various tools to destroy the homes of the three little wolves.

In telling his side of the story, Scieszka's wolf transforms his crime into an accident. He claims that he did not set out to kill the pigs; instead, he knocked on his neighbors' doors to borrow a cup of sugar. His bouts of sneezing blew down the pigs' houses, killing their occupants. As he says after the first accident, "It seemed like a shame to leave a perfectly good ham dinner lying there in the straw. So I ate it up" (Scieszka 1989, 19).

Recharacterization of the Wolf

These fractured tales not only reference specific source texts but also provide humorous rewritings and revisionings of those texts and their characters. Exaggeration, sarcasm, understatement, and slapstick recharacterize the wolf. Revisions tamper with more than the wolf's role or fate: the characterization of the wolf also undergoes change. Even in parodies that adhere closely to traditional plot lines, the characterization of the wolf becomes a focal point for humor, and the exaggeration of his villainous tendencies diminishes him as a potential threat.

Dinnertime!

Many, but not all, of the revisions rely on cartoonlike images to depict their characters and actions: "In art, exaggeration and distortion are the

characteristics of a specific form: caricature or cartooning" (Nodelman 1988, 96). Cartoonists simplify by eliminating unessential details and lines, keeping only those that "best evoke the object in question." Simplification of line and detail results in a distortion of certain features. For the wolf this means his mouth. As such, a caricature or cartoon does "not accurately depict the way things look and rarely excites our sense of beauty, but it always conveys attitudes towards its subjects" (ibid., 97). The style itself, while it is not always used to convey humor and humorous situations, connotes a certain light-hearted quality that signals to the viewer that what follows is meant to be funny. The text elaborates on the wolf's appetite and hunger, and the visual images exaggerate his mouth. Compared with the rest of the wolf's body, his mouth is out of proportion, his snout is longer and larger, his teeth are sharper and pointier, and his tongue is thicker, redder, and bigger than they appear in more traditional illustrations.

As in the source versions, the wolf's reputation and actions are tied to his appetite: "Everyone knew that a ferocious and hungry wolf prowled within the forest, and straying from the path would almost certainly mean being eaten!" (Roberts 2005, 6). In Tony Ross's *The Boy Who Cried Wolf*, people fear the wolf: "because the wolf liked dining on people, everybody on this side of the mountains was afraid of him" (1991, 7). In William Wegman's canine *Little Red Riding Hood*, the wolf's hunger fixates not only on Little Red Riding Hood and her grandmother but on the blueberry muffins in the girl's basket: "Overcoming his almost overpowering urge to eat her and the muffins on the spot, the wolf thought, if I can detour this young thing for a few precious moments, I can have the grandmother, too. Then I have the blueberry muffins, and for dessert I will eat sweet Little Red Riding Hood" (Wegman 1993, 14). As he waits for Little Red Riding Hood to arrive, he rehearses what he is going to say: "I'm so happy to see you. So good of you to come. Hello. Little Red, so glad you could bring me a little snack. Muffins are they? My little muffin, my little red muffin, my little red-hooded muffin" (ibid., 20). Disney's wolf, in his refrain with Little Red Riding Hood, makes explicit not only his carnivorous but also his lecherous ways. To her comment on the size of his eyes, he replies: "All the better to look you over."

Nonvillainous wolves also need to eat. In *Carmine: A Little More Red*, the wolf bypasses the granny's sheep and granny herself for the soup bones. While Forward and Cohen's wolf tries to convince us that he is a "new wolf" whose specialty is vegetarian cuisine, Scieszka's wolf defends his carnivorous ways by stressing that they are part of his nature. He also suggests that we think of rabbits as hamburgers.

Indeed, the wolf often thinks of his fellow characters in meal-like terms: "Now someone was watching from behind the big oak tree. It was the big bad wolf! And his mouth began to water at the thought of those nice, fat, tender, tasty, juicy little kids" (Grimm/Kimmel and Stevens 1990, 7). And after he has eaten all seven kids and the mother goat, the sleepy wolf exclaims, "What a delicious supper!" (ibid., 21). When the wolf catches sight of Little Red, he

drools just thinking about what a "tasty snack" Little Red would make (Roberts 2005, 8). And when Little Red announces that he is going to Grandma's, the wolf begins to fantasize about the possibility of having "two tasty snacks, instead of just one" (ibid., 9). James Marshall's wolf in *Red Riding Hood* calls the little girl a "sweet thing" (1987, 12). At the grandma's door, his hunger almost betrays him: "It is I, your delicious—darling granddaughter" (ibid., 16). After swallowing the grandmother, he pats his belly, commenting: "Tasty, so tasty" (ibid., 18). And hearing Red Riding Hood's footsteps, he exclaims, "Here comes dessert!" (ibid., 20). After Scieszka's wolf accidentally kills and devours the first little pig, a similar occurrence takes place at the home of the second little pig. The wolf, in an attempt to stay our qualms, tells us to think of the second pig as a second helping (Scieszka 1989, 20). Disney's *Three Little Wolves* opens with the Big Bad Wolf instructing his three sons in the different parts of and ways to prepare pig. With a butcher knife as a pointer, two wall charts ("Choice Cuts" and "Pig Products"), and a musical question-and-answer refrain, the wolf takes his sons through their predatory lessons.

Emily Gravett's *Wolves* parodies the tension that the wolf's predatory habits cause for some environmentalists, animal lovers, and vegetarians. In *Wolves*, Rabbit checks out a library book on wolves. As we read along with Rabbit, we find out that wolves live in packs and are adaptable to most environments. We also find out that an adult wolf has "42 teeth. Its jaws are twice as powerful as those of a large dog." Further, a wolf's diet consists "mainly of meat. They hunt large prey such as deer, bison, and moose. They also enjoy smaller mammals like beavers, voles and [much to the dismay of Rabbit] rabbits" (Gravett 2005, 23–25). As Rabbit reads, the wolves escape from the book and soon, unbeknownst to Rabbit, a rather large wolf fills the space behind him until nothing remains but a chewed, red book. After the demise of Rabbit, Gravett assures the reader "that no rabbits were eaten during the making of this book. It is a work of fiction" (ibid., 29). For sensitive readers, Gravett offers an alternative ending: "Luckily the wolf was a vegetarian, so they shared a jam sandwich, became the best of friends, and lived happily ever after" (ibid., 30). Significantly, in the image depicting the alternative ending, the wolf has lost his bite: he is toothless.

In Olivier Douzou's picture book *Loup*, a wolf systematically puts on his eyes, his ears, his nose, and his mouth. Using text drawing on both the dialogue between Little Red Riding Hood and the wolf and the refrain from the French children's game *jouer au loup* ("to play wolf"), Douzou conjures the frightening image of the predatory wolf of traditional European tales and fables. As in the tale and the game, Douzou's text and images build suspense as the wolf prepares to eat his victim. Yet the meal for which Douzou's wolf readies himself is not a child but a carrot. By placing a carrot before the wolf, Douzou plays on current environmental characterizations, deconstructing and replacing the dangerous carnivore of traditional European narratives with a more benign predator. The effectiveness of Douzou's surprise conclusion depends

on his reader's familiarity with the text and images found in the print editions of the traditional fables and tales.

The revisions bring to the fore a part of the wolf's hunger rarely depicted in traditional texts: they give us a glimpse of the wolf eating his victims. In Tony Ross's *The Boy Who Cried Wolf,* the narrator tells us and shows us that the wolf likes to dine on people. As the wolf chases the old man, he salts him. In the next image, with the old man conspicuously absent save for his clothes, the wolf, dining *en plein air,* cleans a bone. Still, Ross's wolf has "fine manners (for a wolf)": sometimes he dresses for dinner (1991, 5). Where Ross's wolf seasons his food with salt and pepper, Barry Moser's wolf, somewhat less refined, likes his pig with "Bubba's No-Cook BBQ Sauce" and "PIGA Pepper Sauce" (see Figure 3.3). Vivian French's text provides sound effects for Korky Paul's depiction of the wolf relishing some bones in Aesop's "The Wolf and the Crane":

Gobble gobble gobble gobble gobble gobble crunch!
Wolf was eating
Wolf was munching
Wolf was tearing
Wolf was crunching. (French 1997, 66)

The wolf, however, typically swallows his victims whole, and in *Little Red*, we see how this is done. As the text indicates, "as soon as the Grandmother turned, the wolf pounced on her, and in one second flat he had swallowed her whole!" (Roberts 2005, 14).

His appetite is as voracious as ever. Moser's wolf eats up the first little pig without leaving "so much as the tip of his curly tail" (2001, 8). When Ross's wolf hears the grown-ups reprimand Willy for crying wolf, the wolf changes "his mind about eating Willy" and eats "the grown-ups instead" (Ross 1991, 21–22). But then the wolf changes "his mind again and had Willy for dessert" (ibid., 23–24). In Kimmel and Steven's revision of "The Wolf and the Kids," after the wolf eats all seven kids he "still wasn't satisfied. He hid beneath the kitchen table, so that when the nanny goat returned from the market with her arms full of groceries, up jumped the big bad wolf and ate her up, too!" (Grimm/Kimmel and Stevens 1990, 20).

Caricature of Evil

In revisions where the wolf still functions as the villain, the elaboration or exaggeration of his wickedness becomes a source of humor rather than of danger. In James Marshall's *Little Red Riding Hood* and *The Three Little Pigs* and Barry Moser's *The Three Little Pigs*, textual descriptions, dialogue, and visual depiction render the wolf's villainous tendencies funny. The headline of the *Fairy Tale News* reads: "Nabbed! Big Bad Wolf Arrested in Nightgown!"

Sometimes, as in Eric Kimmel and Janet Stevens's *Nanny Goat and the Seven Little Kids* or Stephen Kellogg's *The Three Little Pigs*, there are visual clues that the wolf is bad. In the former he wears an eye-patch and a T-shirt that reads "Big and Bad," while in the latter he rides a motorcycle and wears a black leather jacket with a wolf's skull on the back. He is funny, not scary.

Cross-dressing, one of the wolf's traditional ruses, becomes more humorous as it becomes more elaborate. In Disney's films *Three Little Pigs*, *Big Bad Wolf*, and *Three Little Wolves*, part of the wolf's plans involve disguising himself as a baby sheep, the Fairy Queen Goldilocks, Little Red Riding Hood's grandmother, and Little Bo Peep. Beyond simply donning granny's nightgown, the wolf uses wigs, rouge, lipstick, and false eyelashes to effect his disguise. His clothing is also more convoluted. With ruffled pantaloons, bonnets, and full skirts, his Little Bo Peep resembles Scarlet O'Hara, while his ballet slippers give the Fairy Queen a ballerina effect. Yet his body—the long snout and big teeth, feet, and hands—parodies the parody.

In Pennart's *Le loup, la chèvre, et les 7 chevreaux*, Igor, the wolf, goes to great lengths to disguise himself as the mother goat, buying shoes, a dress, talcum powder, and eau de goat. The Jerry-Lewis-in-drag quality of Igor's appearance, however, combined with slapstick humor, prevents Igor from becoming a serious threat. The exaggerated actions of the wolf, rather than rendering him more dangerous, diminish him. Visual and textual exaggeration of the wolf as villain results in the wolf as a caricature of evil.

Richard Egielski's cartoonlike images, as well as his informal and humorous prose style, belie the religious nature of *Saint Francis and the Wolf of Gubbio*. Egielski's wolf is a "great wolf, fierce and terrible, [that] had come into the land. The wolf ate sheep and goats, and when there were no more sheep and goats to eat, he ate shepherds. The wolf ate chickens and cows, and when there were no more chickens and cows to eat, he ate farmers" (2005, 8). With yellow eyes, enormous paws, sharp claws, and big teeth, Egielski's wolf is familiar, evoking folk- and fairy-tale wolves. In the tradition of folk and fairy tales, the people of Gubbio make three attempts at subduing the wolf: first, with a knight; second, with an army; and third, with a war machine. These scenes elaborate on the source texts which describe the futility of the people's actions and their weapons against the beast and visually reference the wolf's actions in "Little Red Riding Hood" and "The Three Little Pigs." After eating the knight, the wolf, with a swollen abdomen, reclines on his back. Next, the wolf deals with the army in the same way as the wolf dealing with the houses of straw and sticks: he huffs and he puffs and he blows them away. The third attempt does not reflect any one tale but instead seems to draw on the lore that the wolf kills in rage.

Egielski's cartoonlike style relies on caricature and exaggeration, and as such, it suits the exaggerated qualities and attributes assigned to the wolf. The wolf is a comic counterpart to the good, compassionate Francis. Yet while the wolf wreaks havoc, none of it seems too serious. Further, the killing of the

knight, the scattering of the army, and the destruction of the war machine, from the wolf's point of view, are done in self-defense. Save for one illustration in which the wolf is depicted with a farmer slung over his shoulder, Egielski does not show us what his text describes: the wolf killing and eating sheep, goats, shepherds, chickens, cows, and farmers (8). Instead, he shows us the aftermath of the knight's visit, the army's arrival, and the war machine's appearance at the wolf's lair.

Through dialogue with other characters, asides to the audience, and comments by the narrator, the wolf often seems to relish his wicked ways. In Disney's *Big Bad Wolf,* the wolf interrupts his exchange with Little Red Riding Hood to ask the audience how he is doing. After finishing off his second meal, Marshall's wolf's in *Little Red Riding Hood* admits, "I'm so wicked, so wicked," while the narrator adds "but, really, the wolf was enormously pleased with himself" (1987, 26) (see Figure 3.4). In Pennart's *Le loup, la chèvre, et les 7 chevreaux*, as Igor sets out, he rubs his hands together, smiling in gleeful anticipation that "cette journée sera memorable" ("that day would be memorable") (Pennart 2005, 3). As he powders his face and body, dons the dress, pumps, and sprays on the perfume *Fleur de Chavignol* (Flower of Goat Cheese), Igor sings to himself (see Figure 3.5). In *Je suis revenu!*, the wolf (who resembles Igor) lifts weights and brags that he is even better than before: "encore plus costaud, encore plus intelligent. Un vrai grand méchant loup, quoi!" ("even stronger, smarter. Truly, a big bad wolf!") (Pennart 2001, 8). Eager to prove to his *vieux amis*, the three little pigs, Little Red Riding Hood, the goats, the lamb, and Peter that he is in top form, he contacts the newspapers "to plant the seeds of terror" (ibid., 11).

The narrator's sarcastic descriptions of the wolf render the wolf more comical than scary or dangerous. The narrator in James Marshall's *The Three Little Pigs* suggests that the wolf huffs and puffs "until he was quite blue in the face" (Marshall 1986, 18). Marshall's description of the wolf's growing frustration with his failure to nab the third little pig is equally sarcastic. After the pig foils his plan to get him at the turnip patch, the narrator describes the wolf as trying "not to show his displeasure" (ibid., 20). When his second rendezvous with the pig also fails to happen, the wolf is "really . . . quite put out" (ibid., 23). And when the third meeting goes the way of the first two, the wolf declares, "I've been nice long enough!" and heads for the chimney (ibid., 24). Tony Ross's wolf in the same story not only huffs and puffs but also coughs and wheezes and strains and roars before turning to trickery (Ross 1983, 21). When the third pig repeatedly outsmarts him, the wolf becomes furious and, "snarling and spluttering," he claws his way to the chimney (ibid., 26).

The Human Wolf

The simplification of detail and line in the images as well as the textual emphasis and elaboration of the wolf's thoughts and actions results in highly

anthropomorphic representations of the wolf. From Pennart's wolves, who wear clothes and drive cars, to Moser's sublime superimposition of the human on the wolf, the illustrations play a major role in revising the meaning of these tales and redefining the wolf. If traditional tales and fables use the wolf's predatory nature to represent dangerous human behaviors and situations, the wolf in the revised tales is even more human in his actions, thoughts, and gestures. In *The True Story of the Three Little Pigs by A. Wolf*, the boundaries between the wolf and his human audience dissolve as he reconfigures his actions and identity through collusion, familiarity, and sameness. First, he shares the secret that he is "the wolf. Alexander T. Wolf," the notorious wolf of tales. Next, complicity breeds familiarity when he tells us to call him Al. Further, as he equates his eating habits with those of the reader, it becomes clear that the line separating lupine behavior from human behavior is a thin one: "If cheeseburgers were cute, folks would probably think you were Big and Bad too" (Scieszka 1989, 7; see Figure 3.6).

Socialization

The recharacterization of the wolf extends beyond his new role as protagonist and is reflected in his social, physical, and animal attributes. Significantly, in many of these revisions the wolf is no longer a lone wolf. As seen, the benign wolf in *Carmine: A Little More Red* and *Big Bad Wolf* goes home to his family. In both, he is a father who takes an active role in rearing his pups. In the former he distributes Granny's soup bones to his pups, while in the latter he plays with his children. In *The Three Little Wolves and the Big Bad Pig*, the little wolves are also part of a family. At the beginning of the tale, we meet their mother, who tells them that it is time for them to leave and make their way in the world. She also warns them to "beware of the Big Bad Pig" (Trivizas/Oxenbury 1993, 3). Unlike the three pigs, the three wolves are a pack: they set out together, build houses together, live together, play together, and escape from the Big Bad Pig together. After the wolf in Poilleve and Tallec's *Le plus féroce des loups* rescues various hunted animals from their pursuers, the would-be victims invite the wolf to dinner.

All of Pennart's wolves have friends and family. Igor, in *Le loup, la chèvre, et les 7 chevreaux*, begins and ends his day by leaving and returning to his wife and home. *Le loup sentimental* begins with Lucas's tearful parting from various family members. Further, it is his family's parting words, repeated by the various fairy-tale characters, that cause him to release them instead of eating them. In *Le loup est revenu* and its sequel, *Je suis revenu*, the wolf is not only overpowered by his former victims but also, more importantly, is befriended by them. In *Chapeau rond rouge*, the wolf is alone when Chapeau rond rouge first sees him. Through a comedy of errors involving a trumpet, mistaken identity, and a car accident, the wolf is transported to the grandmother's

house and placed in her bed by the grandmother. After being struck with a candlestick and suffering a near miss by Chapeau rond rouge wielding a knife, the wolf is nursed back to health by the grandmother. When we last see the wolf, he is safely ensconced on a chair in the grandmother's living room, helping her with her knitting.

As in the legend on which it is based, Egielski's wolf in *Saint Francis and the Wolf* promises to stop preying on the people and livestock of Gubbio in return for their pledge to feed the wolf. Egielski concludes his retelling by depicting the wolf as a member of the community: "From that day on, the wolf wandered peacefully about the city. He would go to a different house every day for his meals" (30–31). And being in Italy, the wolf of course enjoys pasta (see Figure 3.7).

Gravett's *Wolves* stresses the social nature of real wolves. Her textual and visual depictions, which alternate between realism and anthropomorphism, blur the lines between humans and wolves, rendering her portrayal of a pack of wolves as a gang humorous yet disturbing. Gravett's analogy gets at aspects of pack life that are only lightly touched upon in information books and realistic fiction—the danger wolf packs pose to each other as well as the aggressive behavior among pack members—reminding us that not all social behavior is good or safe.

Lupine Demographics

Fractured tales also include a more varied wolf population broadened by age and gender. As discussed, Pennart's series of French picture books as well as Melissa Sweet's revision of Little Red Riding Hood, Claire Masurel and Melissa Wai's *Big Bad Wolf*, and Disney's *Three Little Wolves* include images of the wolf within family contexts. In the Sweet and Masurel/Wai texts, the wolves go home to their pups. Pennart's books *Le loup sentimental* and *Le déjeuner des loups* provide a glimpse of a multigenerational extended family including Lucas's parents Igor and Valentine, grandparents Auguste and Marie-Charlotte, brothers Alexis, Octave, and Emile, and cousin Chloe. And although Fitch has no brothers and sisters or parents, he does have a grandmother.

Aging wolves have problems similar to those of aging humans. In Jackie Leigh Ross's *The Wherewolf?* the old wolf struggles with forgetfulness, isolation, and stiff joints. The wolf no longer finds joy in scaring the other animals and spends his time pondering his spent life. Similarly, in Wheeler's *Who's Afraid of Granny Wolf?*, Fitch's grandmother struggles with her false teeth, which slip and interfere with her speech, resulting in humorous misunderstandings that conjure the dangerous wolves of the traditional tales.

In several of Pennart's stories as well as Masurel and Wai's, there are not only young wolves but also female wolves. The females are recognizable by their clothing (they wear dresses) but also by the traditional role they play. Valentine, in *Le loup, la chèvre, et les 7 chevreaux*, is in the midst of cooking

when Igor sets out on his *journée memorable,* and the Big Bad Wolf's wife serves the meal as he and his children are seated at the table. Yet female wolves, while present, are still relegated to minor roles.

Gender, especially in Pennart's books, reflects behavior in other ways. Valentine stays at home while Igor goes out; she may not seem to know what he is up to, but she also watches him as if she distrusts him. In this way she is a visual clue to the audience that Igor is up to no good. Further, in *Le déjeuner des loups,* when Lucas introduces the pig Maurice as his friend and announces a change in the menu, Igor responds in anger and denial: "Ton ami Maurice? Ai-je bien entendu? Mais il n'en est pas question! Les loups et les cochons ne peuvent pas être amis! Nous allons cuire ce cochon immédiatement" ("Your friend Maurice? Did I hear correctly? But it's out of the question! Wolves and pigs cannot be friends! We are going to cook this pig immediately") (Pennart 1998a, 27). In contrast, Valentine tries to stop Igor: "Calme-toi. Je suis sure que tu sauras expliquer à Lucas l'inconvenance de cette amitié pendant le déjeuner. Nous mangerons le cochon plus tard, passons à table, j'ai trop faim, moi" ("Calm down! I am sure that you know how to explain the inconvenience of this friendship to Lucas during lunch. We will eat the pig later, let's sit down and eat, as for me I'm famished") (ibid.).

Strength and Weaknesses

Exaggeration of the wolf's physical being extends beyond his mouth. He is often portrayed as bigger and stronger than his fellow characters. In *The True Story of the Three Little Pigs,* the wolf attributes the huffing and puffing to a cold or allergies, denying his intent—but not his ability—to destroy.

In fractured tales, like traditional tales, size does not always ensure victory. While some of these tales exaggerate the wolf's physical stature and strength, others reflect a wolf who, if not weaker, is at least vulnerable. Barry Moser's pigs are neither little nor cute. Their teeth are as sharp and menacing as those of the wolf. In *The Three Little Wolves and the Big Bad Pig* and *Chapeau rond rouge,* technology undermines the wolf's power. In the former story, despite hard work and planning, the wolves are sent running by the pig. After each encounter with the pig, the wolves try to build a stronger house. Yet save for their last effort, the houses they build cannot withstand the pig, who enhances his power with various tools like a sledgehammer, a pneumatic drill, and dynamite.

Technology in the form of a car and candlestick endangers the wolf's life in *Chapeau rond rouge,* but the heroine reduces the wolf's power in yet another way: she refuses to see him as a potentially dangerous wolf and instead insists that he is a dog. Chapeau rond rouge blows her horn into the ear of the sleeping wolf. As a way of apologizing, she offers the *chien* ("dog") a cake. The wolf tries to correct her: "Je . . . je . . . je ne suis pas un chien,

je . . . je . . . je suis le loup" ("I . . . I . . . I am not a dog, I . . . I . . . I am the wolf") (Pennart 2004, 14). But she refuses to believe him and insults him further by telling him that he has the face of a puppy. In this exchange, Pennart captures the visual confusion inherent in illustrations of wolves (is it a dog or a wolf?) as well as the tendency of people to conflate wolves with dogs and to think of wild animals as cute. The dog-wolf confusion also evokes the French word for wolfhounds, the large dogs bred to hunt wolves: *chien-loup*. Her disbelief, which reduces the wolf's status from a wild animal to a domesticated one, effectively removes him as a potential threat. In the more traditional versions of this tale, the wolf deceives Little Red Riding Hood by his well-mannered behavior. Little Red Riding Hood, who knows nothing of wolves, believes him to be polite and thus fails to see him as a threat. In contrast, Pennart's Chapeau rond rouge, as indicated by her response to her mother's warning about wolves, claims to know all about them. Yet she too fails to recognize him for what and who he is. Chapeau rond rouge's failure, however, does not render her vulnerable to the wolf but instead makes her dangerous to him.

In Wegman's *Little Red Riding Hood*, dogs play all the roles—human and wolf. His photographic medium, while highly representational, undermines the differences between the victims and the villain. The physical similarity between Little Red Riding Hood, her grandmother, and the wolf renders the famous dialogue comical. Like Moser's depiction of the three pigs, Wegman's use of similarly sized dogs to play all characters balances the visual playing field, effectively removing the wolf as a threat.

Domesticated Nature

Ultimately, the transformation of the wolf touches upon notions of the wild and domesticated. In traditional tales, the wolf represents the wild or nature, while Little Red Riding Hood, her grandmother, the goats, and the pigs represent the domesticated or civilized world. The verb "to domesticate" carries several meanings including to tame, to accustom to home life, or to breed for specific traits (*Oxford English Dictionary*, 424). In contrast, "wild" refers to animals or plants "living or growing in the natural environment; not domesticated or cultivated; (of a place) uninhabited, uncultivated, or inhospitable; (of people) not civilized, barbarous . . . uncontrolled, unrestrained . . . very enthusiastic or excited . . . very angry" (*Oxford English Dictionary*, 1650). As such, the wolf as wild animal represents danger in the form of unrestrained hunger and barbarous acts, while the humans, goats, and pigs are domesticated species that represent home and family. The revised tales do not so much reverse these associations as disrupt and blur the distinctions between the wild and domesticated. For instance, Scieszka's wolf reframes his account around his need to bake a cake for his grandmother's birthday.

Unlike the wolf of traditional tales, the revised wolves of these stories have not only a home but also a home life. As in "The Three Little Pigs," domesticity and security are important motifs in *The Three Little Wolves and the Big Bad Pig*. The first thing the three wolves do after leaving their mother's home is to acquire the materials needed to build a house. Over the course of the story, they build four different homes, three of which are destroyed by the pig. Further, the story begins and ends with them in a home setting. Unlike the traditional versions, in this story the pig, a domesticated animal, destroys the home. As the wolves use ever stronger manmade materials, the pig uses ever stronger tools of destruction. Further, as the wolves move from brick to concrete, to armor plate and Plexiglas,™ the color drains from the illustrations. After their third and strongest home is destroyed, they wonder whether something is wrong with their choice of building materials. Then, "at that moment they saw a flamingo with a wheelbarrow full of flowers," and so they decide to build a house of flowers. The tale goes on: "One wall was of marigolds, one of daffodils, one of pink roses, and one of cherry blossoms. The ceiling was made of sunflowers, and the floor was a carpet of daisies. They had water lilies in their bathtub, and buttercups on their refrigerator." As the pig begins to huff and puff, he inhales the "soft scent of the flowers." The more he inhales the more he is filled with the scent and his "heart grew tender, and he realized how horrible he had been. Right then he decided to become a good pig" (Trivizas 1993, 24–29). Trivizas and Oxenbury's story seems to associate the domesticated with the natural as reflected in the transformation of the pig and in the return of color with the return of natural building materials. If, however, we look more closely, we see that their story does not replace the concrete and Plexiglas™ with a wild, unrestrained nature. Instead, the natural environment that they promote is tamed and civilized. The wolves construct their home with cultivated flowers and furnish it with manmade items: a sofa, a bathtub, and a china teapot.

The teapot, as a visual motif throughout the story, warrants attention. It is the one item that the wolves save from their home before the pig can destroy it. Further, the teapot can be read as an icon associated with the genteel and civilized English ritual, where manners and restraint play an important role. Teatime as evidenced by the teapot is, however, only one of a repertoire of activities that render the wolves civilized: they also engage in such civilized activities as croquet, battledore and shuttlecock, and hopscotch. So while they may be good wolves, they are not natural wolves, and they do not represent what is good in nature but rather what is good about civilization and cultivated nature.

As seen in Pennart's revision of "Little Red Riding Hood," domesticated animals and technology threaten wildlife. The illustrations depict a landscape at the crossroads of nature and civilization. In *Chapeau rond rouge*, the wolf is not even in the woods when we first meet him; like Little Boy Blue, he is asleep next to a haystack. In addition, the woods are not free from human presence; a road runs through them, bringing with it contemporary perils such as a

car. But civilization and domestication are not all that bad: the grandmother brings the injured wolf to her house and goes for a doctor. Though the doctor informs Chapeau rond rouge and her grandmother that the animal in her bed is not a dog but "un énorme loup" ("an enormous wolf"), the grandmother nevertheless nurses him back to health with medicine and rare steak. As Pennart says, "His reputation as a ferocious wolf had taken a serious blow," and in the end the wolf resigns himself to his fate: he has literally been domesticated (2004, 33). As for Chapeau rond rouge, she becomes a world renowned wild-animal doctor.

Conclusion

Revisions of traditional European and Euro-American wolf tales expand the role and the characterization of the wolf. Though the wolf may retain his role as villain, in most instances humor diminishes his threat. Further, revisions dismantle and disrupt the traditional tale they evoke. This revised view of the traditional wolf parallels the revised view of real wolves that began in the mid-twentieth century.

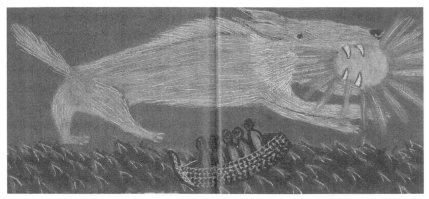

Figure 1.1 Fenrir swallows the sun by Maryclare Foá 1996, from *Odin's Family: Myths of the Vikings* by Neil Philip, illustrated by Maryclare Foá. Illustrations copyright © Maryclare Foá. Reproduced by permission of Scholastic, Inc.

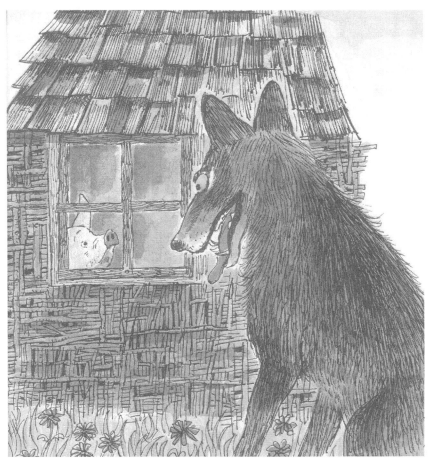

Figure 1.2 Wolf eyeing pig by Paul Galdone. Illustration from *The Three Little Pigs* by Paul Galdone. Copyright 1970 © Paul Galdone. Reprinted by permission of Clarion Books, an imprint of Houghton Mifflin Harcourt Publishing Company. All rights reserved.

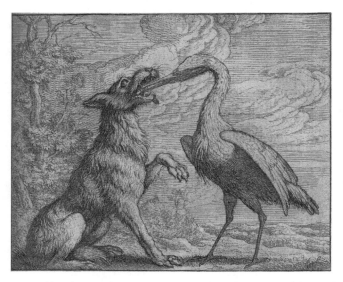

Figure 1.3 Wolf and crane by Francis Barlow from *Aesop's Fables with his Life in English,* illustrated by Francis Barlow. Photo courtesy of the Newberry Library, Chicago; Call No. Case fY642 A3068a.

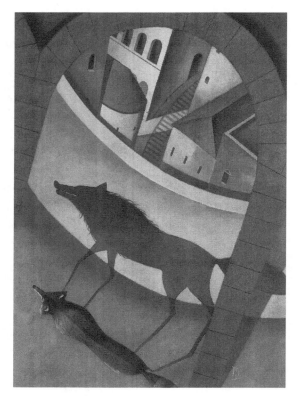

Figure 1.4 Wolf's shadow by Murray Kimber from *The Wolf of Gubbio,* retold by Michael Bedard and illustrated by Murray Kimber. Illustrations copyright © 2000 Murray Kimber, first published by Stoddart Kids, reprinted by permission of Fitzhenry & Whiteside, 195 Allstate Parkway, Markham, ON, L3R 4T8 Canada.

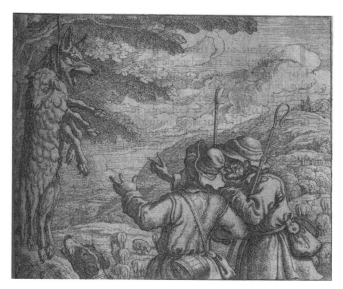

Figure 1.5 Wolf in sheep's clothing by Francis Barlow from *Aesop's Fables with his Life in English,* illustrated by Francis Barlow. Photo courtesy of the Newberry Library, Chicago; Call No. Case fY642 A3068a.

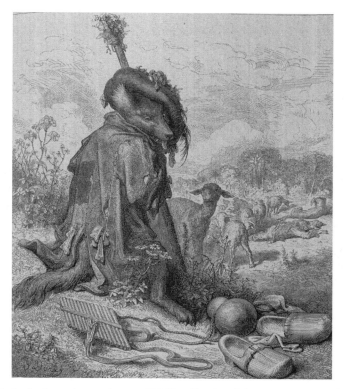

Figure 1.6 Le loup devenu berger (Wolf as Shepherd) by Gustave Doré from *Les Fables de la Fontaine* by Jean de la Fontaine, illustrated by Gustave Doré. Photo courtesy of the Newberry Library, Chicago; Call No. Case Y762 L1286 vol.1.

Figure 1.7 Wolf dressing by Lisbeth Zwerger from *Little Red Cap* by the Brothers Grimm, illustrated by Lisbeth Zwerger, copyright © 1987 Lisbeth Zwerger. Used by permission of Minedition, a Division of Penguin Young Readers Group, a Member of Penguin Group (U.S.A.) Inc., 345 Hudson Street, New York, NY 10014. All rights reserved.

Figure 1.8 Wolf attack by Christopher Coady from *Red Riding Hood* by Christopher Coady, copyright © 1991 Christopher Coady, illustrations. Used by permission of Dutton Children's Books, a Division of Penguin Young Reader's Group, a Member of Penguin Group (U.S.A.) Inc., 345 Hudson Street, New York, NY 10014. All rights reserved.

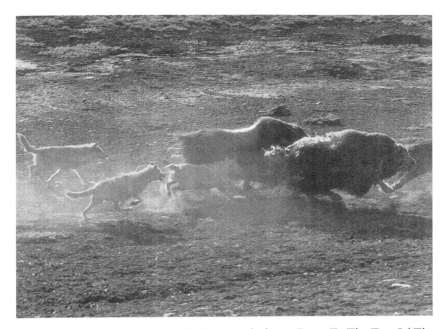

Figure 1.9 Wolf pack hunting by Jim Brandenburg. From *To The Top Of The World*. Copyright © 1993 Jim Brandenburg. Reprinted by permission of Walker Books.

Figure 1.10 Wolf pack eating by Sarah Fox-Davies from *Walk With A Wolf*. Text copyright © 1997 Janni Howker. Illustrations copyright © 1997 Sarah Fox-Davies. Reproduced by permission of the publisher Candlewick Press, Inc., Cambridge, MA, on behalf of Walker Books Ltd., London.

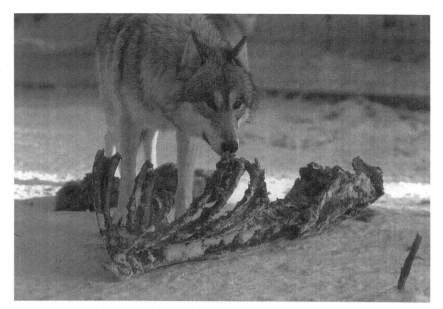

Figure 1.11 Wolf eating by William Munoz. Photographs from *Gray Wolf, Red Wolf* by Dorothy Hinshaw Patent, photographs by William Munoz. Photographs copyright © 1990 William Munoz. Reprinted by permission of Clarion Books, an imprint of Houghton Mifflin Harcourt Publishing Company. All rights reserved.

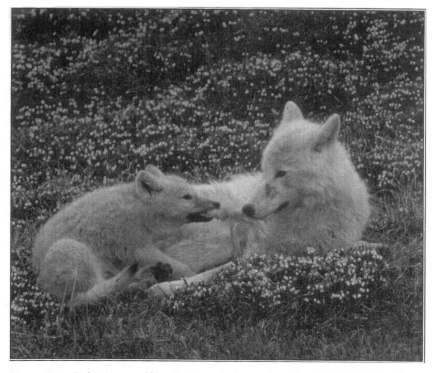

Figure 2.1 Babysitter wolf by Jim Brandenburg. from *Scruffy: A Wolf Finds His Place In The Pack*. Copyright © 1996 Jim Brandenburg. Reprinted by permission of Walker Books. All rights reserved.

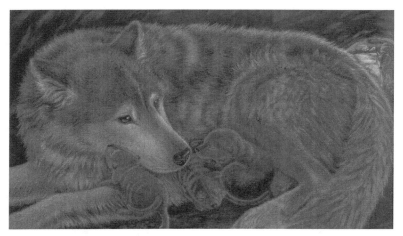

Figure 2.2 Wolf family by Lucia Washburn from *Look to the North: A Wolf Pup Diary* by Jean Craighead George, illustrated by Lucia Washburn. Illustrations copyright © 1997 Lucia Washburn. Used by permission of HarperCollins Publishers.

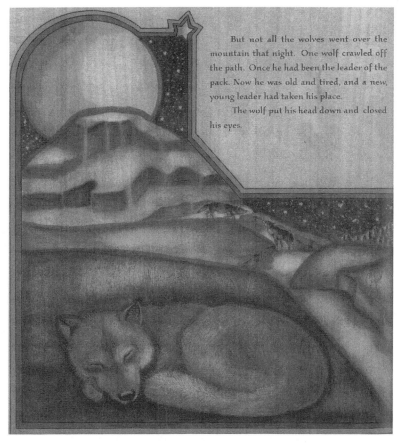

But not all the wolves went over the mountain that night. One wolf crawled off the path. Once he had been the leader of the pack. Now he was old and tired, and a new, young leader had taken his place.

The wolf put his head down and closed his eyes.

Figure 2.3 Old wolf by Colony Elliott Santangelo from *Brother Wolf of Gubbio: A Legend of Saint Francis* by Colony Elliott Santangelo. Used by permission of Colony Elliott Santangelo.

Après une terrible poursuite avec les loups où il faillit mourir de peur, Loulou revint voir Tom. «Tom», lui dit-il, «j'ai compris ce qu'est la vraie PEUR-DU-LOUP. Je ne recommencerai plus jamais à te faire peur. Je te le promets! Sors de ton trou, Tom, s'il te plaît!»

Figure 2.4 Loulou by Grégoire Solotareff. Illustration by Grégoire Solotareff from *Loulou* copyright © 1989 L'École des Loisirs, Paris.

Figure 2.5 Lonely wolf by Stéphane Girel. Illustration by Stéphane Girel from *Ami-ami* copyright © 2002 L'École des Loisirs, Paris.

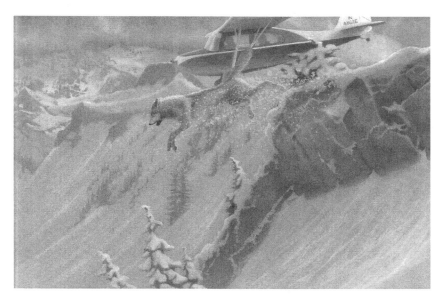

Figure 2.6 Aerial attack by Mark Alan Weatherby. Illustration copyright © 1989 Mark Alan Weatherby from *The Call Of The Wolves* by Jim Murphy. Reprinted by permission of Scholastic Inc.

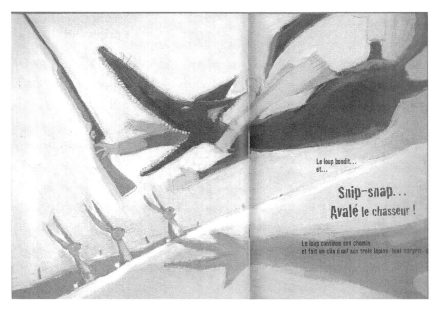

Figure 3.1 Wolf to the rescue by Olivier Tallec from *Le plus féroce des loups* by Sylvie Poillevé; illustrated by Olivier Tallec copyright © Flammarion, 2001.

Figure 3.2 Maniacal wolf by John Kelly and Cathy Tincknell from *The Mystery of Eatum Hall*. Copyright © 2004 John Kelly and Cathy Tincknell. Reproduced by permission of the publisher, Candlewick Press, Sommerville, MA.

Figure 3.3 Well-fed wolf by Barry Moser. From *The Three Little Pigs* by Barry Moser, copyright © 2001. By permission of Little Brown & Company.

Figure 3.4 After-dinner nap by James Marshall. From *Red Riding Hood* by James Marshall, copyright © 1987 James Marshall. Used by permission of Dial Books for Young Readers, a Division of Penguin Young Readers Group, a Member of Penguin Group (U.S.A.) Inc., 345 Hudson Street, New York, NY 10014. All rights reserved.

Figure 3.5 Wolf dressing by Geoffroy de Pennart. From *Le loup, la chèvre et les 7 chevreaux* by Geoffroy de Pennart copyright © 2005 Kaléidoscope.

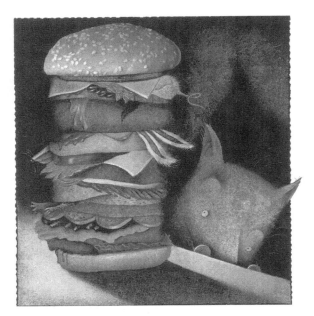

Figure 3.6 Wolf with rabbit burger by Lane Smith. From *The True Story of the Three Little Pigs* by Jon Scieszka, illustrated by Lane Smith, illustrations copyright © 1989 Lane Smith. Used by permission of Viking Penguin, a Division of Penguin Young Readers Group, a Member of Penguin Group (U.S.A.) Inc., 345 Hudson Street, New York, NY 10014. All rights reserved.

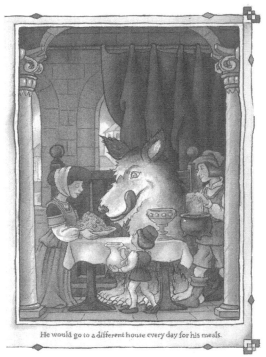

He would go to a different house every day for his meals.

Figure 3.7 Pasta wolf by Richard Egielski from *Saint Francis and the Wolf of Gubbio* written and illustrated by Richard Egielski, copyright © 2005 Richard Egleski. Used by permission of HarperCollins Publishers.

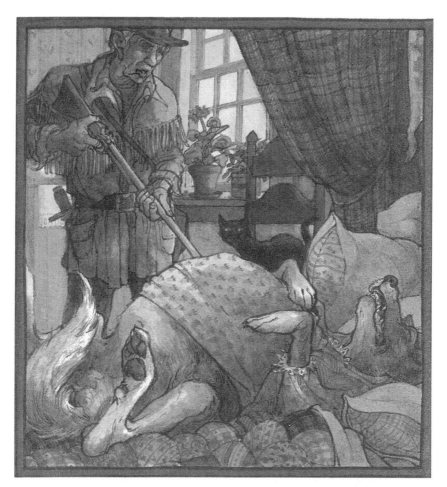

Figure 5.1 Hunter and wolf by Trina Schart Hyman from *Little Red Riding Hood* by the Brothers Grimm and illustrated by Trina Schart Hyman. Copyright © 1983 Trina Schart Hyman. Reprinted from *Little Red Riding Hood* by permission of Holiday House, Inc.

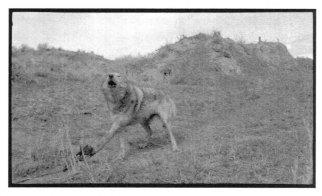

Figure 5.2 Wolf in trap photograph from *Once A Wolf* by Stephen R. Swinburne, with photographs by Jim Brandenburg. Photographs copyright © 1999 Jim Brandenburg. Reprinted by permission of Houghton Mifflin Harcourt Publishing Company. All rights reserved.

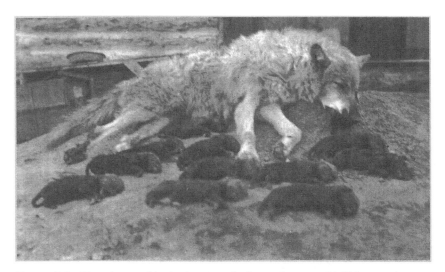

Figure 5.3 Denning archival photograph from *Once A Wolf* by Stephen R. Swinburne. Photograph by Jim Brandenburg. Photographs copyright © 1999 Jim Brandenburg. Reprinted by permission of Houghton Mifflin Harcourt Publishing Company.

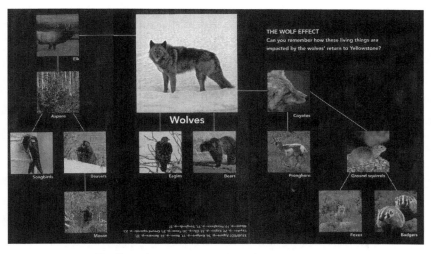

Figure 5.4 "Wolf Effect" by Dan Hartman and Cassie Hartman from *When the Wolves Returned* by Dorothy Hinshaw Patent. Photographs copyright © 2008 Dan Hartman and Cassie Hartman. Reprinted by permission of Walker Books.

Figure 5.5 Red wolf recovery by William Munoz. Photographs from *Gray Wolf, Red Wolf* by Dorothy Hinshaw Patent, photographs by William Munoz. Photographs copyright © 1990 William Munoz. Reprinted by permission of Clarion Books, an imprint of Houghton Mifflin Harcourt Publishing Company. All rights reserved.

Figure 6.1 Wolf at play by Claude Boujon from *La chaise bleue*, written and illustrated by Claude Boujon. Illustration by Claude Boujon from *La chaise bleue*, copyright © 1996 L'École des Loisirs, Paris.

Figure 6.2 Children as wolves by Grégoire Solotareff from *Le masque*, written and illustrated by Grégoire Solotareff. Illustration by Grégoire Solotareff from *Le masque*, copyright © 2001 L'École des Loisirs, Paris.

Figure 6.3 Nurturing child by Ted Rand from *Nutik the Wolf Pup* by Jean Craighead George and illustrated by Ted Rand. Illustrations copyright © 2001 Ted Rand. Used by permission of HarperCollins Publishers.

Chapter Four
Wolf as Canine

A hungry wolf walks alongside a well-fed and well-groomed dog. A fox tricks a wolf into believing that the moon reflected in the water at the bottom of the well is a block of cheese. A fox betrays a wolf to a shepherd while another fox accuses a wolf of stealing his property. A jackal taunts Mother and Father Wolf; later the man-cub Mowgli leads his wolf pack against the dholes, or wild red dogs. A kidnapped and abused dog escapes into the wilderness, reverting to his wild self. A young miner rescues and tames a wolf-dog hybrid with love and compassion. A rancher follows his hounds as they pursue an outlaw wolf. Julie uses wolf language to communicate with her father's team of sled dogs. A little girl reads a book about wolves to her dog. A sheepdog stands guard over his flock while a border collie herds her sheep. A dog's skeleton from 10,000 BCE lies in the dirt. Photographs and watercolor renderings feature fourteen different species of wild canids. A human bottle feeds a wolf pup. A wolf and dog wrestle. A wolf pups greet a black German Shepherd, trying to lick him through the chain link fence. A wolf-dog hybrid stands alone in a pen.

From *Aesop's Fables* to contemporary fiction and nonfiction, children's books feature various kinds of canines. In fables, illustrators through size, shape, and sometimes clothing render dogs, foxes, and wolves visually distinct from one another, whereas the texts which they accompany attribute particular human personalities to each of the canines and affix moral judgments to their actions. Similarly, contemporary informational books use images of various types of wild and domesticated canines to compare the different species, while the texts underscore the physical and behavioral qualities of each. The most in-depth comparisons—and the ones most often featured—are between two species that reflect the most physical variation but that are behaviorally and genetically the closest: the wolf and the dog. Linking these two animals is not only a common genetic ancestry but also their history with humans. The dog is a product of wolf DNA and human meddling. As descendant of the wolf, the dog inherits certain

physical traits and behavioral instincts from wolves. Yet more than 15,000 years ago, humans began to adopt and modify the wolf through unintentional (and later intentional) selective breeding into a new species, the dog.

From sources as diverse as hunting manuals, fables, natural histories, novels, and contemporary works, the wolf is often depicted with and compared to other canines. Through a close examination of the textual and visual characterizations of wolves and other canines, this chapter considers those features that help to distinguish one canine from another. Yet interbreeding among the various canines obscures the boundaries between the species and complicates attempts to classify them. Within this context, the issues and implications surrounding the identification and classification of species are also considered. Although it is only in the last several years that DNA testing has confirmed the genetic links between wolves and dogs, texts and images from Aesop to the present day have long recognized the relationship between these two canines. The chapter closes by exploring the various forms this relationship takes.

Imaging and Identifying Canines

In the late fourteenth century, Gaston de Foix (also known as Phébus) dictated *Le livre de la chasse* (*The Book of Hunting*). A hunting text from the 1380s is an unlikely but useful place to begin the examination of the visual images of the canines in children's literature. An early-fifteenth-century manuscript of Phébus's work contains images not only of wolves but also of dogs and foxes. As such, it can serve as a sort of Rosetta stone to help identify the types of canines found in illustrations across various types of works. This is not to say that every picture of a wolf or fox or dog resembles those found in this work; indeed, sometimes the artist's or illustrator's skill is so poor or the style is so abstract that the only way one knows for certain that the image is a wolf and not a dog or a fox is from the text that accompanies the images. Instead, this is to suggest that Phébus's visual distinctions of these three canines are present in later print editions of traditional narratives, natural histories, and contemporary fiction and nonfiction in which a wolf is portrayed alongside a dog or a fox.

According to Phébus, the dog is "the noblest, wisest, and most sensible beast in God's creation" (2002, 15). The dog is also the hunter's primary companion. In addition to showing dogs in hunting scenes, the manuscript includes images of different types of dogs (mastiffs, coursers, and greyhounds) and their uses, as well as illustrations of the ways to care for, handle, and feed them. Images depict young boys grooming, feeding, and readying their canine charges. They also show young servants applying dressings to dogs wounded in the hunt. These images suggest the role dogs played as well as the value placed on them.

Phébus's images show much of the dog's life as described earlier by Aesop in his fable "The Dog and the Wolf" and several centuries later in La Fontaine's fable "Le loup et le chien" ("The Wolf and the Dog"). In this story, a half-starved wolf, seeing a robust and well-fed dog, inquires as to how the dog manages to find sufficient food. The dog tells the wolf that if he follows the dog he too can enjoy regular meals and loving attention. Curious, the wolf asks what would be required of him. The dog describes his life as one of relative ease, where his only duties are to chase off thieves and beggars and show respect for his master. The wolf is about to follow when he catches sight of a mark on the dog's neck:

> . . . il vit le col du Chien pelé.
> Qu'est-ce la ? lui dit-il.—Rien.—Quoi ?rien ?—Peu de chose.
> —Mais encor ?–Le collier dont je suis attaché
> De ce que vous voyez est peut-être la cause.
> —Attaché ? dit le Loup: vous ne courez donc pas
> Où vous voulez ?—Pas toujours, mais qu'importe ?
> —Il importe si bien, que de tous vos repas
> Je ne veux pas même à ce prix un trésor.
> Cela dit, maître Loup s'enfui, et court encor.
>
> (. . . he saw the dog's hairless neck.
> What is this? he asked.—Nothing—What? Nothing?
> —A little thing.
> —Yes, but?—The collar to which I am attached
> Of which you see, is perhaps the cause.
> —Attached? Said the wolf: you don't run then
> Where you want?—Not always, but what does it matter?
> —It matters quite a bit, more than all your meals
> I would not want at this price even a treasure.
> That said, Master Wolf ran away, and ran some more.)
>
> (La Fontaine 1867, 15)

For the dog, the collar that binds him to a human is a small price to pay for his care, keep, and food. For the wolf, however, the collar signals the dog's enslaved status, with his food and his keep coming at the expense of his freedom. The collar symbolizes not only the dog's relationship to his human owner but also the major difference between the wolf and the dog: the dog's tamed and domesticated nature versus the wolf's wild one.

Yet the characterization of the dog by Aesop and La Fontaine also suggests that a dog's loyalty may be only as strong as the collar and chain. For the most part, the dog in the fables is lazy as in "The Dog and the Manger" or thieving as in "The Bitch and the Whelps." In other stories, dogs appear as stupid and cowardly. In "The Mischievous Dog," for instance, the owner

places a bell on his dog's collar as a warning to people that the dog bites. The dog, thinking the bell is an honor, proudly displays it until one of his canine friends tells him that the bell is a sign of notoriety, not celebrity. In "The Lion and the Dogs," a fox, seeing a group of dogs tear apart the body of a dead lion, cuts through their "courageous" façade by pointing out: "If this lion, were alive, you would soon find out that his claws were stronger than your teeth" (Aesop 1909, 113). Yet dogs, in fables as in life, are also used to hunt foxes and wolves.

Like that of his canine cousins the wolf and the fox, the dog's gluttony often leads to his undoing. In "The Dog and the Bone," a dog, carrying off his prized bone, sees his reflection in a river and mistakes it for a larger dog with a larger bone. Greed overcomes common sense, and the dog loses his bone as he lunges at his watery counterpart. Dogs may be devoted, but they are not generous. Instead, as the dogs in Aesop's "The Two Dogs" show, they are prone to selfishness and jealousy. Here a hunting dog complains when his master shares the day's bounty with the guard dog who, in the eyes of the hunting dog, has spent his day at home doing nothing.

In illustrations, physical characteristics differentiate the wolf, the dog, and the fox. Although Phébus includes different types of dogs (such as grey-hounds, mastiffs, and coursers) all dogs are mainly distinguishable by their ears, which are typically rounded and folded as compared to the upright, pointed ears of the wolf and the fox. This is true not only of Phébus's hunting and guard dogs but also of the dogs found in illustrated versions of fables as well as contemporary informational and fictional picture books. Indeed, authors of contemporary informational books point out that folded ears are a result of domestication.

The fox shares the wolf's ears, but he differs in size from both the wolf and the dog. The wolf is typically taller and heavier than the fox, who appears long-bodied, short-legged, and low to the ground. Whereas both the wolf and fox have bushy tails, the latter's ends in a white tip. In fables, the difference in size between the wolf and the fox reflects differences in their characters. Smaller and lighter, the fox must rely on his wits and not his physical prowess to survive. In contrast, the wolf's larger size renders him more powerful but less swift and less keen than the fox.

Although both the wolf and the fox are deceitful, the wolf tends to be heavy-handed and the fox, subtle. Their objectives as well as their means tend to diverge. The wolf in most cases is intent upon devouring his fellow characters, but the fox is just as likely to mock as to kill his victims. As suggested by the fox's long, lean, and flexible body, the fox's ability to adapt makes him devious and slippery, if not always dangerous. In "The Fox and the Crow," the fox plays on the crow's vanity to steal the bird's piece of cheese. In "The Fox and the Crane" (sometimes titled "The Fox and the Stork"), the fox invites the crane to dinner, finding amusement in serving her soup on a plate from which she cannot eat. The crane responds in kind by inviting the fox to dinner, which

she serves in a long-necked vase—a vessel from which the fox cannot eat. In another incident, the fox, who is stuck in a well, tricks a goat into helping him out of his plight. By praising the wondrous quality of the water, he tempts the goat to enter the well. The fox uses the goat's back to escape from the well, leaving the goat to fend for itself.

As trickster or prankster, the fox, when opposite a wolf or lion, uses his wit to outsmart or overcome these larger and stronger predators. At the beginning of his version of "Le loup et le renard" ("The Wolf and the Fox"), La Fontaine speculates on why the fox of Aesop excels "en tours pleins de matoiserie" ("in excessive cunning") (1966, 295). By the end of the fable, La Fontaine admits that the wolf is *un sot* or "a fool" to have believed the fox. Phébus may not have perceived real wolves as being fools, but his description of foxes as being "so malicious and cunning that neither man nor dog can outplay or overcome their ruses" matches that of the foxes found in the fables of Aesop and La Fontaine.

In "The Lion and the Fox," the fox sees through an old lion's invitation to join him in his lair, saying that while there are footprints of many animals entering the den, there are no traces of them leaving it (Aesop 1909, 16). The fox also knows when and how to sacrifice his own desires in favor of those more powerful than he. In "The Lion, the Ass and the Fox," the lion kills the ass for having equally divided the spoils; so when the lion asks the fox to divvy up their plunder, the fox, having learned from the ass's fate, survives by claiming the smallest portion for himself.

If the dog is a submissive, loyal servant as evidenced by his collar, and the fox is small but cunning, then what of the wolf? One of the pictures in Phébus's manuscript shows several wolves engaged in different activities. Save for a nursing she-wolf and her cub, the wolves' actions reflect their predatory nature. Most of the images focus our attention on the wolf's mouth, which is either open with teeth visible, wrapped around the body of its prey, or eating its victim. In it are images of lone wolves pursuing and eating sheep, goats, and pigs. The wolf's penchant for eating humans, while not visible in the images, is present in Phébus's text: "They find the flesh of man so delicious that having once tasted it, they will eat no other beasts" (2002, 6).

Although all three canines show an interest in food, the wolf's insatiable appetite makes him the most dangerous of the three. Unlike the fox, whose tricks display a certain level of cleverness and sophistication and whose use of flattery suggests that he knows the weaknesses of both his victims and his superiors, the wolf's false reasoning and promises tend toward the obvious and cruel. Just as the fox's lithe build expresses his nimble ways, the wolf's larger, heavier body signals his oppressive tendencies. As discussed earlier, for the most part, the wolf in Aesop's and La Fontaine's fables has one goal: to eat. As one of the larger predators, the wolf finds victims typically smaller than he. Yet the smartest of his potential prey recognize him for what he is and what he wants. Seeing the trap behind his words, a goat declines his invitations to

graze in greener yet lower meadows, while a sheep refuses to bring him water lest he should have to provide the meat too. When a crane responds to his plea for help in removing a bone from his throat, the wolf goes back on his word. And even a lamb's rational defense of its actions (drinking from the same stream as the wolf) does not save it from the wolf's jaws.

Untrustworthy, the wolf is also an opportunist, who, if he sees nothing to gain from helping another, easily turns his back on others' pleas for help. Further, the wolf, as in "The Lion, the Wolf, and the Fox," is quick to betray others when it benefits him. In this fable, the wolf, to win favor with the ailing lion, points an accusatory finger at the fox. Yet here the fox's quick response to a precarious predicament undoes the wolf's charges by asserting that the wolf's body is the cure for what ails the lion.

From remaining true to one's self to deceiving others and recognizing the deception of others, identity and appearance are major themes across many of these fables. "The Lion and the Fox," "The Crab and the Fox," "The Kid and the Wolf," and "The Ass and the Wolf" point to the perils of trying to be other than what one is. In each of these stories, a character suffers, even loses his or her life, for stepping outside of his or her role. When the wolf in pursuit of a kid goat agrees to the goat's request to play the flute, the wolf unwittingly draws the attention of the herd's guard dogs, which turn on the wolf (Aesop 1909, 92–93). In "The Ass and the Wolf," the wolf is brutally kicked by an ass when he falls for this beast's ruse to remove a thorn from his hoof so the wolf will not choke on it while devouring the ass. When the crab goes against his nature and feeds on grass, a fox feeds on him. In "The Lion and the Fox," the fox acts as the lion's hunting assistant, pointing out the prey for the lion to kill. Jealous of the larger animal's larger share, the fox announces that he will be the one to kill their quarry: "The next day he attempted to snatch a lamb from the fold but fell himself prey to the huntsmen and hound" (ibid., 133).

Just as the fables advise the readers to be true to themselves and their roles in life, they also caution against deceiving and deception. In "The Wolf in Sheep's Clothing," a wolf tries to make his task of feeding on sheep easier by using the hide of a dead sheep to conceal himself. Disguised as a sheep, he moves freely among the flock until the shepherd, with a penchant for a lamb dinner, mistakenly kills him. In a similar fable, "The Wolf and the Shepherd," the shepherd discovers the wolf's ruse and rewards him by hanging him.

Although these fables warn against deceiving, others warn against the danger of seeing things as they appear and not for what they are. Although the blind man in "The Blind Man and the Whelp" cannot identify the canine pup as wolf or fox, he nevertheless recognizes the danger the animal might pose: "I do not quite know whether it is the cub of a fox, or the whelp of a wolf; but this I know full well, that it would not be safe to admit him to the sheepfold" (Aesop 1909, 113). As discussed, the fox often cloaks his intentions in flattery, but the wolf often conceals his nature by acting tame. In "The Shepherd and

the Wolf," the docile behavior of a wolf blinds a shepherd to the wolf's predatory nature and intent; leaving the flock in the wolf's care, however, makes clear the shepherd's mistake—a wolf is always a wolf. The fox is clever, however, not only for disguising his intentions but also for seeing through the deceit of others. In "The Ass in the Lion's Skin," an ass, donning the hide of a dead lion, masquerades as the king of the beasts, scaring the animals. The fox, hearing the hee-haw in the lion's roar, undoes the ass's game.

Contemporary informational books about wolves contain pictures of dogs, foxes, coyote, jackals, and other wild canines. Photographs and drawings of the different canine species demonstrate their physical similarities and differences, providing means through which the reader may compare the species as well as learn to identify them. Although pictures of wolves, foxes, coyotes, jackals, and other canines appear next to each other, the animals are rarely, if ever, photographed together. The white space, borders, and frames that keep wolves and other canines separate from each other on the page inadvertently reflect reality. As similar as these canines may be, they compete with each other for territory and food, often resulting in the larger ones killing the smaller ones. The death and disappearance of Isle Royale's coyote population during the 1950s signaled the presence of wolves. Dorothy Hinshaw Patent in *When the Wolves Returned* notes a similar phenomenon: the reintroduction of wolves to Yellowstone has resulted in a reduction of the coyote population—the remaining coyotes have had to adapt to life with wolves. Just as wolves kill and drive off coyotes, coyotes drive and kill off foxes. Yet, as will be discussed, interbreeding between wolves and coyotes is not uncommon.

Some informational books, such as *Crafty Canines: Coyotes, Foxes, and Wolves* by Phyllis Perry, play on the traditional image of these three wild dogs as tricksters and deceivers, using this connection to underscore their adaptability. This information links these animals to each other and to a common ancestor, the dawn dog. Pictures and text also depict the habitats of the various canines as well as their relationship with humans.

Christiane Gunzi's *The Best Book of Wolves and Wild Dogs* connects wolves not only to foxes and coyotes but also to other wild canines found throughout the world. She begins with a portrait of the gray wolf, including diagrams explaining the purposes of various parts of the wolf's anatomy. She also includes images of the wolves interacting with each other, stressing that they are social animals that live in packs. Her next section features images of eleven species of wild dogs: the gray wolf, red fox, dingo, dhole, red wolf, maned wolf, bush dog, arctic fox, coyote, golden jackal, and African hunting dog. The captions to each of these include the dog's name, habitat, weight, height, and length, making it easy for the reader to compare and distinguish their specific physical traits. In the sections that follow, Gunzi uses the gray wolf as a point of comparison while focusing on the canines' common ancestry and the ways in which they share behaviors.

Dog into Wolf, Wolf into Dog

As the earlier discussion of Aesop demonstrates, the relationship of wolf and dog has long been in use as a literary metaphor. In the late nineteenth century, Seton calls the dog the wolf's cousin, and Mowgli in *The Jungle Books* insults the rebellious wolves by calling them dogs. The most famous examples of the wolf-dog connection are found in Jack London's novels *The Call of the Wild* and *White Fang*. As Aesop uses the wolf-dog difference to symbolize the difference between freedom and slavery, so London employs it to explore the divide between the wild and the civilized in the American West.

In *The Call of the Wild*, London traces the regression of Buck, a house dog, into a wild, wolflike creature. Kidnapped, beaten, sold, traded, and abandoned, Buck is reshaped physically, morally, and cognitively by mistreatment at the hands of his human handlers and fellow canines. Taken from his comfortable life in California and dumped into the harsh realities of life as a sled dog in the north, Buck's struggle for survival displaces his expectations of love, comfort, and food. Within days, the icy borderland between civilization and the wild takes hold of and transforms Buck. Meager rations and strenuous work make him stronger and the clubs wielded by his new masters and the teeth of his fellow dogs make him ferocious. Buck learns to survive by watching the behavior of the other dogs and the reactions of their masters. To supplement his scant meals, he begins to steal from other dogs and humans. So begins his moral decline.

Buck learns not only from experience but also from the reawakening of instincts long suppressed by civilization:

> In vague ways he remembered back to the youth of the breed, to the time the wild dogs ranged in packs, through the primeval forest and killed their meat as they ran it down. It was no task for him to learn to fight with cut and slash and the quick wolf snap. In this manner had fought forgotten ancestors. They quickened the old life within him, and the old tricks which they stamped into the heredity of the breed were his tricks. They came to him without effort or discovery, as though they had been his always. And when, on the still cold nights, he pointed his nose at a star and howled long and wolflike, it was his ancestors, dead and dust, pointing nose at star and howling down through the centuries and through him. (London 1981, 64)

Released from civilization's trappings of comfort, law, justice, and compassion, Buck begins to reconnect with his wild heritage.

As the story progresses the call becomes stronger. His dreams take him back to the beginning, when the wolf, not quite yet a dog, follows a short-legged hairy human along the coast and in the forest: "And closely akin to the visions of the hairy man was the call still sounding in the depths of the

forest. It filled him with a great unrest and strange desires" (ibid., 125). Buck begins to leave the campsite and wander in the forest. He hunts and lives off larger and more challenging prey: rabbits, then bear, then moose. One night, hearing a howl unlike that of any husky, he follows it to meet his unknown yet familiar wolf brother. The wolf and Buck finally exchange greetings by sniffing each other. The wolf invites Buck to follow him and he does, until he remembers John Thornton, his most recent master and the only one to show him compassion.

Buck remains torn between the two worlds—that of the wolf and that of the humans. Returning from a foray into the wild, Buck finds the campsite under attack by a group of Yeehat Indians. He responds by killing them. When he discovers Thornton's body, there is "a great void in him, somewhat akin to hunger, but a void which ached and ached, and which food could not fill." With Thornton's death nothing remains to keep Buck going into the wild. At the same time, "when he paused to contemplate the carcasses of the Yeehats . . . he was aware of a great pride in himself—a pride greater than any he had yet experienced. He had killed man, the noblest game of all, and he had killed in the face of the law of club and fang" (ibid., 137). By killing the Indians, Buck has crossed an unseen line. Yet instead of causing his moral degradation, killing the humans is a triumph for Buck. The ease with which he kills them takes away their power over him: "They were no match at all, were it not for their arrows and spears and club. Thenceforward he would be unafraid of them except when they bore in their hands their arrows, spears, and clubs." These deaths free him: "From far away drifted a faint sharp yelp, followed by a chorus of similar sharp yelps . . . It was the call . . . And as never before, he was ready to obey" (ibid.).

In contrast, White Fang, a wolf-dog hybrid, moves from the wild to the civilized. As in *The Call of the Wild*, the borderland between the wild and civilization is the Alaskan frontier. Born in the wild to a wolf-dog mother and wolf father, White Fang knows freedom only a short while. As London moves Buck from the civilized world of California to the increasingly desolate cold of the Alaskan territories, so he moves White Fang from the wild to more civilized (according to London's view) circumstances. The wild freedom of his birth is cut short when he is claimed by the Indian, Gray Beaver. While Gray Beaver breaks and tames White Fang with a club, the dogs of the other Indians, perceiving his wildness, ostracize him. An outsider not only to the humans but to the dogs, White Fang, like Buck, must learn not only his master's rules but also how to keep the other dogs at bay.

Life with Gray Beaver teaches him a harsh lesson: his survival depends on obeying his superiors and oppressing the weak. When Beauty Smith, a cook in the frontier town of Fort Yukon, tricks Gray Beaver into selling White Fang, the wolf-dog's plight goes from bad to worse. Seeing in White Fang the opportunity to make money through dog fights, Smith cages and beats White Fang to make the canine more vicious. The only time Smith frees him from his cage is to fight other dogs and wild wolves.

During one of these fights, just as a bulldog is about to sink his teeth into White Fang's neck, a young man from California, Weedon Scott, and his companion, Matt, break up the fight, saving White Fang's life. The wolf-dog's reaction to a club and rifle convinces Scott that affection and compassion, not physical violence, are the ways to retrain and save White Fang. For the first time in his life White Fang begins to trust and love another being. When Scott must return to California (civilization), he realizes that White Fang will die without him, and so he takes the wolf-dog with him.

In California, or Southland, White Fang must learn not only more rules but also to control his instincts. White Fang's time with the Indians and Beauty Smith has left him suspicious of humans and ferocious. The bullying he endured as a puppy and his employment as a dogfighter have taught him to kill other dogs. Further, his wolfish instinct to see other animals as prey makes him a threat to all tamed and domesticated animals. Through verbal reprimands and cuffs to the head, White Fang learns the rules of his new world.

In the characters of Buck and White Fang, as in his characterization of the Northland and Southland, London explores the divide between the wild and the civilized. Life on the Alaskan frontier—the harsh natural environment, the isolation, and the primitive living conditions—reduces men and dogs to lawlessness and savagery. The struggle for survival becomes paramount. In this world, dogs are not pets to be pampered but workers needed to haul cargo and people. Like slaves, they are harnessed and whipped to pull sleds through dangerous landscapes and weather. And like slaves, their lives retain value only as long as they can work. As the men fight each other, so do the dogs. Dogs fight for rations and humans fight for gold. Unlike the orderly, law-abiding wild of Rudyard Kipling's *The Jungle Book*, justice and fair play have no role in the Northland. Instead, London's depiction of the wild is a place without rule and order, a place where violence, ruthlessness, and power dominate.

For London, instinct and nature contribute the raw material, the clay as he called it, that makes up people and animals. The physical and social environments shape and mold the clay. London describes White Fang as a product of both his wolfish forebears and the environment—he is clay that has been molded by his early experiences with people and dogs. White Fang, three-quarters wolf and one-quarter dog is neither wolf nor dog. As a pup he is reared by humans, and even though they mistreat him, he becomes dependent on them. The more he is with humans, the more dependent he becomes upon them and the more silenced becomes the wild within him. Yet even though Gray Beaver's and Beauty Smith's treatment of him tames him, it also makes him ferocious.

Jack London's *White Fang* explores the freedom of wild animals versus the bondage of the tamed. White Fang is a wolf-dog hybrid who is at first tamed by mistreatment. London describes leaving the wild as "coming to the fire." A wild animal like White Fang remains torn between the call of the wild and the call of the fire. The canines in London's works suffer at the hands of humans. Although Buck experiences human love at the beginning of his life and White Fang encounters it only after years of beatings, they learn similar lessons: Buck

learns the "law of club and fang" while White Fang learns that to survive, one "oppresses the weak and obeys the strong."

London compares White Fang's perception of humans to human's perception of gods. Yet:

> Unlike man, whose gods are of the unseen . . . the wolf and the wild dog that have come to the fire find their gods in living flesh, solid to the touch, occupying earth-space . . . No effort of faith is necessary to believe in such a god; no effort of will can possibly induce disbelief in such a god . . . There it stands, on its two hind legs, club in hand, immensely potential, passionate, and wrathful and loving, god and mystery and power all wrapped up and around by flesh that bleeds when it is torn and that is good to eat like any flesh. (London 1981, 258)

London describes White Fang's taming as bondage and covenant: "He belonged to them as all dogs belonged to them. His actions were theirs to command. His body was theirs to maul, to stamp upon, to tolerate. Such was the lesson that was quickly born upon him . . . It was a placing of his destiny in another's hands, a shifting of the responsibilities of existence. This in itself was compensation, for it is always easier to lean upon another than to stand alone" (ibid., 259). White Fang's bondage and obedience are earned through beatings with club and whip, not caresses or love.

Although London's protagonists are canines, these animals serve as metaphors for humans. In the Northland, in the absence of refining and control mechanisms, humans revert to brutal behavior. At the end of *White Fang*, London introduces the character Jim Hall, an escaped convict seeking revenge on Scott's father, the judge who sentenced him. London's characterization of Hall and of the treatment that formed him mirrors those that shape White Fang: "He was a ferocious man. He had been ill-made in the making. He had not been born right, and he had not been helped any by the molding he had received at the hands of society. The hands of society are harsh, and this man was a striking sample of it. He was a beast—a human beast . . . that he can best be characterized as carnivorous" (ibid., 392). Like White Fang, the "more fiercely he fought, the more harshly society handled him, and the only effect of harshness was to make him fiercer. Straight jackets, starvation, and beatings and clubbings were the wrong treatment for Jim Hall; but it was the treatment he received" (ibid.). Prison is Hall's Northland, and his prison guards are the equivalent of Gray Beaver and Beauty Smith. Fittingly, when Hall arrives at the judge's house, he is greeted and killed by White Fang. London's placement of this scene at the end of White Fang does two things: it redeems him in the eyes of the judge's household; indeed, after he saves the judge's life, the judge's wife, daughters, and daughters-in-law rename him Blessed Wolf. It also sounds a warning that aspects of society—even in civilized settings—can be as harsh as any found in the wild.

White Fang's and Buck's moralizing and philosophizing reflect human perceptions—in particular, London's voice. James Dickey writes that London

"prided himself on his 'animality,' and identified with his chosen totem beast, the wolf" (Dickey 1981, 7). The wolf is not only part of London's identity but also a pervasive figure in his works. Dickey has suggested that even though London's wolf does not reflect its real-word counterpart, we as readers should accept London's "interpretation of the wolf, and conjure up in the guise of the mysterious, shadowy, and dangerous figment that London imagines it to be . . . the ultimate wild creature, supreme in savagery, mystery and beauty" (ibid., 8). Yet the ruthlessness and savagery of the wolves that Buck encounters and White Fang's brief time in the wild pale in comparison to their treatment by humans. Buck's quarrel is not with wolves but with humans and dogs. For White Fang, famine and survival from larger predators may have threatened his early life in the wild, but what he endures among humans and their dogs poses an equal if not greater danger.

Both humans and dogs recognize that White Fang is not a dog. His half-breed status marks him as different. Collie, Judge Scott's sheepdog, immediately sees the threat he poses: "Being a sheep-dog, her instinctive fear of the Wild, and especially of the wolf, was unusually keen. White Fang was to her a wolf, the hereditary marauder who had preyed upon her flocks from the time sheep were first herded and guarded by some dim ancestor of hers" (London 1981, 368). Just as Buck's long-silenced and repressed wolf instincts come to the fore in the North, so Collie's guard-dog ancestors warn of White Fang's potential threat. Slowly White Fang's behavior earns Collie's trust, and eventually Collie and White Fang mate. The story ends with their puppies crawling and climbing on him.

Nature as described in London's works is not a place of refuge or even of beauty. The cold, desolate, and isolated Northland threatens life. It also provides the backdrop against which the struggle for survival takes place. Shorn of society's civilizing influences, humans, like dogs, fall back on their most vicious instincts.

Classifying Canines: What Is a Wolf?

Contemporary informational books include diagrams featuring the anatomy of the wolf and other canines and charts displaying the scientific classification and ordering of each species. Wolves and other canines all belong to the canid family. Wolves are subdivided into species and subspecies. Most authors identify three species of wolves, *Canis lupus* or gray wolf, *Canis rufus* or red wolf, and *Canis simensis* the Ethiopian or Abyssian wolf, while others identify only the gray and red wolf. Yet the wolf most often depicted in photographs is the gray wolf. As such, it is the one that most people probably think of when they imagine wolves. Not only in books and photographs but also in the real world it is the most common—both the red and Ethiopian

wolves are highly endangered, with only a few remaining in the wild. Photographs and pictures also show several subspecies of the gray wolf: the eastern timber wolf, the tundra wolf, the buffalo wolf, the arctic wolf (featured in two of Jim Brandenburg's books, *To the Top of the World* and *Scruffy the Babysitter Wolf*), and the Mexican gray wolf. The texts accompanying these images emphasize the size and coloring of various species and subspecies of wolves, pointing out that wolves in northern and colder climates are typically larger than those in southern or warmer regions. Authors also stress and use images to show the range in coloring and markings underscoring variation in the gray wolf's coat.

Although these images make visible the differences between the species of wild canines, classifying them is not simple. Carl Zimmer's *Scientific American* article "What Is a Species?" uses the wolf as an example of the difficulties and significance in identifying species. In the eighteenth century, to distinguish the wolves of eastern regions of Canada from those of Europe (*Canis lupus*), naturalists assigned them the name *Canis lycaon*. During the early 1900s, scientists decided that *Canis lycaon* were the same as *Canis lupus* and renamed them accordingly. After analyzing wolf DNA, Canadian researchers have recently begun to assert that gray wolves are found only in western North America and that the wolves of eastern Canada comprise a distinct population, which these scientists are once again calling *Canis lycaon* (Zimmer 2008, 48). Other scientists, however, disagree, saying there is not enough proof to support splitting these two wolf populations into two species. To further complicate matters, the DNA of the eastern Canadian or Algonquin wolves reveals interbreeding with both coyotes and the western gray wolves. Scientists refer to this mixing of DNA as canine soup, admitting, "When it comes to wolves and coyotes, it is hard to say quite where one species stops and another starts" (ibid., 49).

The impact of species identification goes beyond assigning names or labels; it can determine whether a species is saved or lost. Dorothy Hinshaw Patent in *Gray Wolf, Red Wolf* discusses the controversy surrounding the efforts to save and reintroduce the red wolf to the southeastern United States. For some scientists, interbreeding among red wolves and coyotes, habitat loss, and earlier efforts to eradicate the red wolf have already rendered the species extinct. Other scientists disagree and are attempting to save what they identify as the remnant red-wolf population through DNA testing (to separate out coyotes and coyote-wolf hybrids) and breeding programs. But according to Zimmer, the debate about the Algonquin wolves threatens to further muddy the debate surrounding red wolves. Some Canadian scientists argue that *Canis lycaon* and *Canis rufus*, although geographically isolated from each other, are the same species. If true, the large number of *Canis lycaon* will affect red wolf status as an endangered species and the efforts to preserve, reintroduce, and protect it.

The Wolf and the Dog

Drawing on archaeological and scientific information, authors of contemporary information books stress the common genetic ancestry of the wolf and the dog. Since 2004, scientists using DNA testing have traced and confirmed that dogs are descendants of three female wolf Eves. Before this, as many earlier informational works reflect, it was unclear whether the dog was descended from wolves or from wolves and jackals. Before the development of DNA evidence, the strongest indicator that dogs descended from wolves and not other wild canines was the wolf's social nature, which allowed wolves to live and bond with humans, a key ingredient for domestication.

Several authors offer theories as to how and why humans and wolves first came together, emphasizing the similarities between the wolves and early humans. Jon Zeaman in *How the Wolf Became the Dog* argues that early humans and wolves lived in social groups and occupied many of the same regions. Dorothy Hinshaw Patent in *Dogs: The Wolf Within* suggests that early humans and wolves not only lived in groups but also hunted large prey, which required "cooperation among members of a hunting team," human or lupine (Patent 1993, 10). Zeaman conjectures that humans saw wolves hunting in packs and learned from them, even using what they learned from wolves to hunt wolves (Zeaman 1998, 11). Further, wolves "were probably drawn to human settlements by scraps and bones that humans threw away" (ibid., 9–11).

Extrapolating from archaeological sites as well as present-day practices of Inuits and other tribal cultures, who raise and tame wolves for dogsled teams, Zeaman proposes another scenario, in which early human hunters gave orphaned wolf pups to their children to raise (ibid., 11). Further: "When people first tamed wolves, a very strange and unexpected thing happened. Because wolves are instinctively social animals, they adapted quite readily to human communities. A young wolf cub bonded and identified with people who raised it and saw itself as part of the human pack" (ibid.). Although the wolf's social nature helped make domestication possible, as Zeaman, Patent, Bidner, and others hint, this was not the only factor at work.

For early humans to raise and keep wolf pups (and later dogs), they had to see value in the animal. Photographs of some of the oldest dog skeletons dating from 10,000 BCE, as well as images of dogs appearing on cave walls, tombs, or other structures, provide evidence not only of the long and intertwined history of canines and humans but also of the role played by these four-legged creatures: "Imagine the surprise of these people when they saw the wolf protecting them, guarding their camp from other predators or members of enemy tribes!" (Zeaman 1998, 12). In explaining how the presence and placement of canines' bones reflect the uses to which the animals were put, Patent does not shy away from their role as food. Not only did wolves, and

later dogs, stay with humans to be fed, but humans also used these canines as a food source.

Both Zeaman and Patent hypothesize that through unintentional breeding the dog emerged distinct from the wolf. Zeaman conjectures that "as people tamed and bred more wolves, the wolves began to change . . . The wolves who were the tamest, the most loyal, and the best guards were kept and valued" (1998, 13). Nevertheless, those who were too difficult or prone to biting and attacking people were killed: "The individuals with the most desirable behaviors would be the ones most likely to be kept and bred" (Patent 1993, 19).

Authors also stress and pictures show how domestication and selective breeding influence the behavior and the physical appearance of dogs, resulting in more than four hundred recognized breeds as well as countless mixed breeds and mutts. Further, photographs of wolves are not limited to books about wolves or even to books about the relationship of wolves and dogs. Just as images of dogs are found in books about wolves, so images of wolves are found in books about dogs and dog breeds. Statements such as "Wolves look similar to German Shepherd and husky dogs, but their legs are longer, their chests narrower, and their feet are bigger" compare particular breeds with wolves (Patent 1993, 8). As the pictures suggest, however, most dog breeds are physically distinct from the wolf. Looking at photographs of dogs and wolves makes it clear that even those breeds of dogs that most physically resemble the wolf—malamutes, German Shepherds, and huskies—do not really look like wolves. These dogs' floppy ears, curled tail, size, and the proportions of particular features serve as the visible signs of domestication. Patent suggests that variation in size, temperament, and coloring became useful in producing animals that could be "distinguished from wolves" (ibid., 21).

Although early humans may have sought to breed animals distinct from wolves, texts and images in contemporary informational books highlight the ways in which certain dog breeds reflect aspects of wolf behavior. For example, pictures of herding dogs, such as border collies separating, guiding, and moving sheep, are described as displaying the hunting techniques that wolves use to isolate vulnerable prey animals from their herds. Similarly, photographs of guard dogs barking and snarling at unseen intruders are said to exhibit the territorial qualities of wolves.

The story of wolf into dog reflects the connection that dogs have to both wolves and to humans: the dog has the genetic legacy of the wolf, and human interference has helped shape the wolf into the dog. The image of a dog morphed with a wolf on the cover of Jenni Bidner's book *Is My Dog a Wolf?* underscores the human technology behind the transformation of the wolf into the dog: through selective breeding and culling, humans created the dog out of the wolf. In this way the dog reflects both its wolfish ancestors and its human companions.

Wolf as Dog, Dog as Wolf

Comparisons of wolf and dog appear across informational books featuring various types of canines, as well as in some fictional picture books. Books about wolves typically compare wolves to dogs, whereas most books about dogs compare dogs to wolves. Gunzi, in *The Best Book of Wolves and Wild Dogs,* compares wild canines not only to each other but also to *Canis familiaris,* or the domesticated dog. Works such as John Zeaman's *How the Wolf Became the Dog,* Dorothy Hinshaw Patent's *Dogs: The Wolf Within,* and Jenni Bidner's *Is My Dog a Wolf?* focus specifically on the wolf–dog relationship.

Although some works compare the physical features of the wolf with specific dog breeds, for the most part the text and images emphasize their common genetic heritage as displayed through the similar behavioral traits of the dog and the wolf. Authors such as John Zeaman in *How the Wolf Became the Dog* use the characteristics of the wolf as a way to understand dog behavior: "The wolf is a very social animal and depends on pack cooperation for its survival . . . This ability to cooperate and accept leadership is what makes the descendant of wolves—dogs—such good pets" (Zeaman 1998, 12). Books such as *Why Do Dogs Bark?* tie specific behaviors to the dog's wolfish ancestors, stressing the ways in which a dog is like a wolf. Through juxtaposing photographs of dogs with those of wolves, Jenni Bidner's *Is My Dog a Wolf? How Your Pet Compares to Its Wild Cousin* makes visible the behaviors that wolves and dogs have in common. Pictures of dogs playing tug-of-war, licking people's faces, retrieving, wagging their tails, and howling are mirrored by images of wolves engaged in similar activities. Through close-ups of these animals' eyes, ears, noses, and teeth, Bidner also stresses the differences in the physical traits they share while evoking the refrain from "Little Red Riding Hood."

Informational books on wolves reverse the comparisons and stress that wolves are like dogs: "The more we know about wolves, the more obvious it becomes that the animals have the same strong social nature that dogs have. They too form deep attachments to their companions. . . . And if loyalty includes an instinct to work for the well-being and safety of other individuals, then wolves are among the most 'loyal' members of the animal kingdom" (Johnson and Aamodt 1985, 17). Seymour Simon in *Wolves* also stresses the social nature of wolves and dogs: "Like dogs, wolves are very loyal to other wolves in their family . . . Dogs are friendly and intelligent, and these traits too come from wolves" (1993, 7). Other authors compare the ways in which wolves and dogs communicate their intentions through barking, growling, howling, and visual cues (Patent 1993, 31; Bidner 2006).

Like other informational books on wolves, Weide and Tucker's book also compares the behavior of wolf and dog. They admit that Koani displays some of the social behavior we prize in dogs, but they also point out that those traits that make her a good wolf—her scent marking, curiosity, agility, and destructive capability—make her a bad dog (Weide and Tucker 1995, 27).

Bidner clearly states the difference between dogs and wolves: "Wolves are very smart animals, but because they are wild, they have much less interest in being trained" (2006, 13).

The comparison and association of wolf and dog play a significant and useful role. On the one hand, they help to explain wolf behavior to young children—by comparing the wolf to a dog, authors and illustrators reveal the traits and habits of an unknown animal through an animal that most children have at some point encountered and experienced. By drawing on what children know, these authors render the wolf familiar, diminish it as a danger, and make it more sympathetic. On the other hand, comparing a dog to a wolf does more than explain a dog's behavior; it ennobles the dog by imbuing it with a wild mystique.

Wolf—Dog—Human

The human and the role of the human, while present in these characterizations and descriptions of wolves, dogs, and other canines, is never so present as in the wolf-dog relationship. Early humans unknowingly domesticated wolves to dogs—dogs, according to the theories, that would help the humans with whom they lived to track, tree, and hunt prey. As hunting manuals, stories, and magazines reveal, the use of dogs as hunting companions continues to the present day. As in Phébus's descriptions, different dogs play different roles, depending on their size, temperament, and inclination. The wolfers or wolf-bounty hunters in Ernest Thompson Seton's accounts use packs of dogs to track and hunt wolves. Yet these wolves prove too smart for their canine pursuers: "Now all you who love the Dogs had better close the book—on—up and down—fifteen to one, they came, the swiftest first . . . In fifty seconds it was done. The rock had splashed the stream aside—the Penroof pack was all wiped out; and Badlands Billy stood there, alone again on his mountain" (Seton 1905, 163).

Since the transformation of hunter-gatherers into farmers, dogs have been used to herd and guard livestock. At the end of *Brave Dogs, Gentle Dogs*, Urbigkit writes that breeds used to protect livestock were recently imported to the Rocky Mountains. In return for their work, dogs receive food and shelter. Similarly, when the wolves returned to France, French herders had to retrain their dogs to protect their flocks.

The dog has another value as well. The social nature inherited from wolves has made it one of the favorite companion animals for humans. Photographs of people and dogs, and especially of children and dogs, interacting are common in books about dogs. Images of people and their dogs also appear in books about wolves. Included in Brandenburg's photographs of Ellesmere Island is a photograph of his friend and colleague Will Steger and Steger's dog team. In this instance, the dogs are "working dogs." While dogsledding

through the Arctic, Steger and his dogs had their own encounter with a wolf: "We woke up and this large white head was staring at us through the flap of our tent. An Arctic wolf, as close to me as you are now. He showed no fear. He followed us for days, played with our dogs" (Brandenburg 1993, 4).

Researchers and scientists also use dogs in their interactions with wolves. In socializing orphaned wolf pups, researchers often use dogs. When Weide and Tucker in *There's a Wolf in the Classroom!* agree to raise the wolf pup Koani, they become her pack. Unable to fulfill Koani's need for constant companionship, Weide and Tucker extend Koani's pack by bringing in a dog, Indy, to keep Koani company. Two other dogs, described as friends of Koani, appear in the photographs with her. These photographs show the canines interacting in ways similar to wolves in a pack. Yet the caption of a photograph in Bidner's book of a dog greeting wolf pups through a fence sounds a sobering note: "The black German shepherd puppy and the wolf puppies look to be getting along. But once grown, they would not be friends. In the wild, the wolves would attack the dog" (Bidner 2006, 15).

Another relationship on display in Brandenburg's and Weide and Tucker's works is that of the human and the wolf. Photographs of Tucker bottle-feeding the newborn pup and of Weide and Tucker playing with, walking, and interacting with Koani document Koani's interspecies pack. As discussed in an earlier chapter, the arctic wolf pack photographed by Brandenburg became so accustomed to his presence that the pack let him near their pups (Brandenburg 1993, 10). The experiences of Weide, Tucker, and Brandenburg provide evidence of the wolf's social nature allowing them to form bonds with humans. At the same time, the photographs of human-wolf bonding help to dismantle the perception of the wolf as dangerous to humans.

Statements such as "healthy wolves do not attack humans unless they have good reason" (Ling 1991, 10) and generalizations like "there have been no wolf attacks," also work to undo the legacy of "Little Red Riding Hood" and its portrayal of the wolf as a child-killer. At the same time, books about dogs and dog training warn that certain breeds have been known to attack children and advise children never to approach a dog without the owner's permission. Texts such as these render the wild less threatening while suggesting that the domesticated is not always hospitable.

Conclusion

The wolf-dog-human triangle is as intriguing as it is puzzling. The image of the dog as a companion animal to humans and wolves is a visible reminder of the dog's domesticated nature and wild heritage. As such, dogs have become not only a means by which to explain wolf behavior but also a link between humans and wolves.

At times, human hatred of the wolf is matched by human love for dogs. Yet humans over time have proven themselves poor companions to their dogs. From abandoning and beating to overbreeding and euthanizing excess dogs, our behavior towards this species reveals that human cruelty and viciousness are not limited to wild animals. Further, as the next chapter reveals, technology has produced an imbalance of power in nature, at once removing humans from nature while rendering humans all-powerful over the fate of other species.

Chapter Five
Hunted and Endangered

A wolf falls to a fiery death. A hunter shoots a wolf before he can attack a little girl; another points his rifle at a sleeping wolf's stomach. Using scissors, a mother goat cuts open the belly of a sleeping wolf, while a woodsman undertakes the same task with a knife. A little girl fills the sleeping wolf's belly with stones; kid goats do the same. A mother goat uses a pitchfork to prevent the wolf from escaping a pot of boiling oil. A wolf singed by hot water flees back up the chimney. As the wolf falls into a pot of boiling water, the pig places a lid on it. Odin's children trap and bind Loki's wolf-son Fenrir. A shepherd hangs the carcass of a wolf from a tree. Hunters pursue a wolf through the woods, while a young boy uses a bird to lure the wolf into his trap. The wolf's former victims celebrate his death. Jars of poison and steel traps reflect the bounty hunters' preferred means of hunting and killing wolves. Dogs and men on horseback pursue a pack of wolves. A wolf struggles in a foot-hold trap. Coyote Smith, a wolfer, displays the body of his quarry. Strings are used to display the scalps of a she-wolf and her pups. Outside a cabin, the remains of wolves and other predators hang from a clothesline. The dead bodies of a mother wolf and her newborn pups show the effects of "denning." Aerial hunters fire at a pack of wolves from a white-and-red Beecher plane while, in another plane, scientists track radio-collared wolves. A red helicopter circles over a pack as a gunner takes aim. A biologist sets a foot-hold trap. At another site scientists weigh, examine, and collar an unconscious wolf. A biologist examines a newborn pup, while another bottle-feeds a pup. A wildlife veterinarian displays one of the first wild pups born in Yellowstone.

From woodblock prints to photographs, pictures of trapped, unconscious, dying, and dead wolves litter literature and nonfiction across time and space. Although often disturbing, the images are not unusual or surprising. After all, both the imaginary and the real wolf represent danger; their actions, preying on other species, are often understood as immoral or unlawful behavior,

punishable by death. As mentioned earlier, sometimes the wolf in traditional narratives, such as Perrault's "Le Petit Chaperon Rouge" and several of the fables, succeeds and eats and lives to see another day. In many instances, however, punishment and death are the wolf's recompense. Taken as a whole, the images described do more than visually depict scenes in a story or scenes from history; these images document changes in human attitudes towards and treatment of wolves, revealing a change in understanding—from using and seeing the wolf as a marauding thief threatening humans and their property to a vital, yet vulnerable, part of the ecosystem. What has changed is not the wolf but human understanding of the wolf and its role. Changes in our treatment of the wolf accompany this new perspective. At the same time, it would be a mistake to think that the new understandings have replaced the traditional ones or represent a linear progression. As the traditional stories endure, so does human hatred of the wolf.

Since the sixth century BCE, governments have placed bounties on real wolves, paying the hunters in currency or kind. Wolves have been killed to eliminate the threat they pose to humans, their property, and their livelihood. They have also been hunted for their fur and for sport. Only in the last forty years have governments redirected their efforts from extermination to the protection and restoration of wolf populations.

Europeans and their North American descendants have a long and complicated relationship with wolves. In Great Britain and Ireland, the wolf has been extinct since 1684 and 1750, respectively. Wolves become extinct in France in the early 1920s, but wolves from Italy made their way across the Alps into southern France during the early 1990s. By the 1840s, wolves were extinct in Bavaria, and by 1899 there were no wolves left in the Rhineland (Boitani 1986, 318). Although wolf researcher Luigi Boitani has argued that "historical, geographical, and above all, cultural factors linked to the ecologies of the Mediterranean human populations have fostered relative tolerance towards wolves," by 1973 only about one hundred wild wolves remained in Italy (ibid., 319). Today, wolves live within twenty kilometers of Rome (ibid., 317).

Historians have noted, "European colonists brought to America a fear and hatred of the wolf based largely on Old World myth and folklore" (Fritts et al. 2003, 293). The Massachusetts Bay Colony set the first bounty on wolves in 1630. Beginning in the late nineteenth century and continuing through the mid-twentieth century, the United States federal government, through the Bureau of Biological Survey (later known as the U.S. Fish and Wildlife Service), took an active role in ridding the country of this "pest" (Dunlap 1988, 135–42). From that time until its listing as an endangered species in 1974, the wolf faced extinction in the contiguous United States. Research showing the beneficial role of predators in keeping prey populations in check, along with the American public's growing concern about environmental issues, contributed to a change in governmental policy, and the department that worked to exterminate the wolf turned its efforts toward protecting it. The reintroduction of

wolves to Yellowstone National Park in 1997, a place from which they had been completely eradicated by 1926, marks the culmination of scientific, political, legal, and environmental efforts. The Yellowstone initiative represents a success story of the Endangered Species Act, reflecting shifts in scientific research and understanding of predators, public attitudes, and government policy. Yet it may be a short-lived success. Current plans to reintroduce the wolf into its former habitats coexist with initiatives to remove its endangered status. Recently, the wolf was removed from the Endangered Species List in Idaho, Montana, and the Great Lakes area of Minnesota, Michigan, and Wisconsin; the *New York Times* (Robbins, March 7, 2009) quotes the governor of Idaho as vowing to reduce the wolf population in his state from eight hundred to one hundred. He also promised to be first in line to buy a wolf-hunting license. While the gray wolf, or *Canis lupus*, is perceived to have recovered, the southeastern red wolf and the southwestern Mexican gray wolf remain endangered. In Canada, where the hunting of wolves is allowed, there are approximately sixty thousand wolves. Recently, however, with the oil boom, the Canadian government has initiated a policy of lethal control.

As the Idaho governor's statement demonstrates, the belief that the wolf is a thief and threat best destroyed persists alongside the newer ecologically oriented perspective. This chapter considers the ways in which images of trapped, unconscious, and dead wolves reflect human attitudes towards wolves. The first section focuses on the ways in which literary and real wolves are hunted and killed. It also examines what these images say about the hunters. The second part considers the ways in which contemporary informational and fictional picture books reflect the wolf's changed status through the work of scientists, government agencies, and environmentalists. The influence of human perception on the definition of a wolf, reclassifying it as a vital yet vulnerable species rather than a fierce and dangerous predator, is explored. Environmental and scientific explanations of the wolf's role in the ecosystem as presented in modern children's literature may be the catalyst for changes in human attitudes and behavior towards wolves.

Killing Wolves

Traditional narratives offer several ways to kill a wolf. When going against a dangerous, fierce, and large wolf, the "hunters" in these stories draw on the wolf's vulnerabilities, sometimes employing the same tactics against the wolf that he formerly employed against them. Some, like the Norse gods, rely not only on magic but also on trickery and false promises. In several of Aesop's and La Fontaine's fables, the wolf's plans often backfire, leaving him flayed, skinned, hung, or killed outright. Others, like characters in "Little Red Cap," "The Wolf and the Kids," and "The Three Pigs," take advantage of the wolf's weaknesses.

Yet the ways in which these characters trap and kill the wolf differ from those used by the wolf in several ways. From ropes and cords to scissors and stones, pots and flames, and rifles and gunpowder, the characters rely on devices (natural, magical, or technological) to help them. Further, where the violence done by the wolf is often only implied, the violence inflicted upon the wolf is often depicted. Sometimes, as in Walter Crane's version of "Little Red Riding Hood," the hunter shoots the wolf, and the wolf dies a relatively easy death. For the most part, however, the wolf dies a painful death.

Except for one of Aesop's fables in which the shepherd hangs a wolf disguised as a sheep, ropes and cords are typically used to restrain, not kill, the wolf. To prevent the fulfillment of the prophecies, the Norse gods bring the half-god/half-giant Loki's three children—a serpent, an ogress, and a wolf— to Asgard, the realm of the gods. But because of his promises to Loki, Odin's honor does not permit the killing of the offspring. Instead, Odin banishes the serpent to the bottom of the Midgard sea, the ogress to Niflheim (the nether world), and the wolf to an island.

As the wolf Fenrir grows bigger and fiercer, Odin decides to chain him. When Fenrir breaks the two iron chains, the gods have the gnomes build a cord "made of things not in this world." By playing on the wolf's vanity and using deceit, broken promises, and a magical cord, the gods trap Fenrir: "Come, let us tie you with it to see how well you can do. If you can break it you will win great fame, and if you can't we give you our word that we shall untie you" (D'Aulaire and D'Aulaire 1967, 52). Fenrir agrees to their challenge on the condition that one of the gods places his hand between his jaws as a mark of good faith. Tyr places his hand in the wolf's mouth, and the other gods throw the magical cord around the wolf's legs: "The wolf howled and growled and threw himself this way and that, but the more he tore at the bond the stronger it became" (ibid.). Ingri D'Aulaire illustrates this scene with the wolf on his back being bound with the gnome's silken cord. In Foá's illustration, the wolf, with his legs tied, remains standing. Leaving him restrained, but alive, the Norse gods ridicule Fenrir by laughing at his plight.

Although the gods stop short of killing Fenrir and his siblings, the scene depicting the wolf's binding underscores his size, strength, and anger. Further, the gods' actions, rather than avoiding the fate prophesied, trigger the events that will lead to Odin's and Asgard's downfall. As described earlier, during the final battle, Fenrir fulfils his destiny by devouring Odin; in return, Odin's son Vidar avenges his father's death by killing Fenrir. Wearing a boot made of scraps of leather, Vidar drives his foot into Fenrir's mouth, tearing the wolf's "powerful jaws apart" and "splitting his head" (ibid., 147).

Peter in Sergei Prokofiev's *Peter and the Wolf* uses a rope to rescue his animal companions and trap the wolf. As described earlier, this tale contains several predatory relationships: cat and bird, wolf and duck, and human and wolf. The last of these features two sets of hunters: Peter and a bird, and a band of human hunters. When Peter discovers a wolf has eaten the duck and

is trying to eat the cat and the bird, he rushes to their rescue. Peter has the bird distract the wolf so he can lasso him. Just as Peter succeeds in immobilizing the wolf, a group of hunters firing rifles arrives. Peter tells them to stop shooting, showing them that he has already caught the wolf. The story ends with a victory procession of the hunters, Peter, his grandfather, the bird, and the wolf. Their destination varies according to the retelling: in several versions, acting upon the wolf's request, Peter and the hunters agree to return him to the woods; in some versions they bring the wolf to the village zoo. In other versions, ambiguity surrounds the wolf's fate with the final image depicting the wolf strung across a pole and the text simply describing the hunters and Peter as taking the wolf to a nearby village.

Prokofiev's tale introduces young people to the sounds of various orchestral instruments. The French horn signals the arrival and movements of the wolf. Significantly, the only animal represented by deeper, more ominous sounds are the human hunters, whose appearance and actions are expressed through the kettle drums. Prokofiev seems to indicate that the wolf is dangerous—to ducks, cats, birds—but that there is an even more dangerous predator—the humans.

In the Grimms' "Little Red Cap" and "The Wolf and the Seven Kids" the wolf, having eaten his fill, makes a fatal mistake: he falls asleep. The rescuers use the wolf's unconscious state to their advantage. Illustrators, by exaggerating the size of the wolf's abdomen, provide visual proof of the wolf's crimes while making it visually apparent to both the mother goat and the hunter that the wolf has recently eaten, giving them hope of rescuing his victims. Finding the wolf asleep under a tree, the mother goat "betrachtete ihn von allen seiten und sah, das in seinem angefullten Bauch sich etwas regte und zappelte" ("looked him over from all sides and saw that something in his full belly was turning and squirming") (Grimm/Hegenbarth 1984, 18). Taking "Schere, Nadel und Zwirn" ("scissors, needle and thread"), she opens the wolf's belly. As she cuts, her kids pop out, alive and unharmed "denn das Ungetum hatte sie in der Gier ganz hinunter geschluckt" ("because in his greed the monster had swallowed them whole") (ibid., 20).

The hunter (or woodsman) in the Grimms' "Little Red Cap" performs a similar deed. When he first sees the wolf asleep in the grandmother's bed, the hunter aims his rifle (see Figure 5.1). But then it occurs to him that the wolf has probably eaten her and that she might still be alive. Instead of shooting the wolf, he cuts open the wolf's belly. Just as the kid goats pop out, alive and unharmed, so do Little Red Cap and her grandmother.

To stave off the wolf's hunger, the wolf's former victims fill his belly with stones. In "Little Red Cap," the wolf upon waking tries to flee, but the weight of the stones kills him. In "The Wolf and the Seven Kids," the wolf wakes up thirsty. To quench his thirst he heads for a pond or a well. As he leans over to drink, he falls into the water, and the weight of the stones pulls him to a watery death.

In some versions of "The Wolf and the Kid Goats," the wolf's fate is similar to his fate in "The Three Little Pigs." Whether invited in or entering on his own volition, the wolf, in these stories, enters the house through the chimney, only to plunge into a kettle of boiling liquid or fall into the open flames. Pictures of the wolf's hot and fiery death are found across nineteenth-, twentieth-, and twenty-first-century editions of these tales. Sometimes illustrators show the wolf just before he falls into the pot; quite a few editions, such as *Pigweeney the Wise* (1830) and Paul Galdone's *The Three Little Pigs* (1970), feature the pig using the lid to push the wolf down into the pot. In a nineteenth-century French edition of "The Wolf and the Seven Kids," the mother goat uses a pitchfork to skewer the wolf, making sure he cannot escape. In another French version from the same time period, the wolf falls directly into the flames. Significantly, the anonymous illustrator of this edition gives the wolf a devil-like appearance by making his staff resemble a pitchfork and the flames near the wolf's head resemble horns.

For the most part, stories that end in the wolf's capture or death end on a happy if not a celebratory note. In the Grimms' "The Wolf and the Seven Kids," as the wolf drowns, the kid goats clap their hands, dance in a circle, and sing "The wolf is dead!" Little Red Cap and her grandmother celebrate both their rebirth and the wolf's death by eating the cake and drinking the wine that Little Red Cap brought with her. Sometimes, as in Lisbeth Zwerger's version, the hunter not only claims the wolf's hide as his trophy but also joins Little Red Cap and her grandmother in their celebration.

As in "Little Red Cap" and "The Wolf and the Seven Kids," the French editions of "The Wolf and the Kids" show the goats smiling and laughing at the wolf's plight. In several picture book versions of "The Three Little Pigs," the surviving pig is last seen reclining before her fireplace; her feet rest on the wolf's hide, which serves both as a hearth rug and as her reward. In editions where all the three pigs survive they also rejoice by building new homes to replace the ones destroyed by the wolf.

As these descriptions suggest, the wolf in these stories is hunted and punished for his actions. The wolf's role as a metaphor for a dangerous human justifies his death. In these stories, right belongs on the side of the domesticated animals, the wolf's potential prey. Tales and fables in particular attach moral judgments to the characters and the attributes they represent.* Smaller, innocent and domesticated, the wolf's prey may be guilty of being naïve or lazy; sometimes, as in Perrault's "Le Petit Chaperon Rouge," some versions of "The Three Little Pigs," and several fables by Aesop and La Fontaine, these failings contribute to the wolf's success. But the wolf's actions and choice of victims—preying on

* Significantly, natural histories intertwine lore and moral characterizations to describe and differentiate the various species. Entries on the wolf echo the themes found in these narratives, describing the wolf as cruel, cunning, wily, greedy, and so forth. He is killed for trying to kill others. The wolf of stories and fables shares the prey that at times the real wolf hunts: sheep and goats.

weaker creatures and threatening social bonds—are what render him evil and his behavior criminal. Capturing, binding, and killing the wolf reflect the triumph of good over evil and offer proof that justice has prevailed.

Further, unlike the wolf's killing of his prey, which remains hidden from view, the wolf's death is for the most part visible. We see him just as he falls into the pot and watch him as he boils or jumps to escape the flames. We see the effects of the stones on his body—the pain visible in his hunched posture and stumbling movements. Implicit in this contrast between what is visible (the wolf's punishment and pain) versus what is implied (the wolf's attack) is the attitude that the wolf's death, horrific as it may be, is nevertheless just. In this way, depictions of his plight serve as a form of public retribution.

The wolves on display in these images have fallen prey to the actions of the human or humanlike characters. In many traditional narratives, the wolf's desire to eat sets the plot in motion and his death marks the end. In literary or sociological terms, the wolf moves from being an agent acting upon others to an object of other characters' actions—the hunter has become hunted. In some works, part of this transition occurs through the use of humor. The slapstick depictions and descriptions of the wolf's demise lighten the stories' tone at the expense of the wolf and the wolf's reputation. Not only do his victims overcome him, but also his gullibility and laziness diminish if not remove the threat he poses, reducing him to a comical figure—the object of both his former victims' and the audience's ridicule.

Wolfers and Wolves

Wolves as depicted in the stories by Ernest Thompson Seton and Thornton Burgess share many of the characteristics of the wolf in traditional narratives. They are large, fierce, cunning, thieving, and wily. And like the wolf in those traditional stories, their incursions on human property must be halted and their predatory ways punished. But significant differences also exist.

Seton writes and illustrates the histories of real "outlaw" wolves, and although Burgess uses a fictional framework, he also provides information on real wolves and wolf–human relations. Unlike traditional narratives where the wolf's role is flatter, more stereotyped, Seton—and, to a lesser extent, Burgess—individualize their lupine protagonists through naming (Mr. and Mrs. Howler, Lobo, Badlands Billy, the Winnipeg Wolf, and Yellow Wolf) and by giving them complex emotions, perspectives, and motivations. Although these wolves share the predatory inclinations and drives of the wolf in traditional narratives, Howler, Lobo, Badlands Billy, and the Winnipeg Wolf display compassion and intelligence.

As discussed earlier, Seton and Burgess comment on the wolves' attachments to their pack mates. Burgess stresses Howler and Mrs. Howler's faithfulness,

describing them as loving and devoted parents. As Seton's stories of "Lobo," "Badlands Billy," and "The Winnipeg Wolf" show, the wolf's loyalty and devotion to pack members garner the esteem of their human pursuers. In "Badlands Billy," an old Yellow Wolf takes in an orphaned wolf pup, teaches him to hunt, and instills in him the knowledge (smells, sounds, visual cues) that will protect him. Later, when Badlands Billy leads his pack, he endangers his own life by helping a smaller and younger wolf besieged by a hunter's dogs. The Winnipeg Wolf shelters his human companion, Little Jimmy, from his drunken father's abusive behavior. Being loving and "tenderhearted" mean that these wolves also face heartache and grieve for other wolves in their pack or, as in the case of the Winnipeg Wolf, even for human children. His devotion to the boy continues after Jimmy's death; the wolf, to his peril, stay nears the graveyard. Seton counts on and uses Lobo's love for his mate to capture the old wolf, expecting that Lobo will come for her.

Seton and Burgess stress these wolves' instinctual traits, especially their sense of smell. Seton praises it, describing it as an information-gathering activity akin to humans reading the newspaper. He even includes a sketch of a wolf, sitting upright, with a newspaper in his "hands," legs crossed. His accounts include descriptions of wolves sniffing at the air or at the carcasses on the ground, of scenting and reading the scents left by other animals. In "Badlands Billy," he breaks down Yellow Wolf's inspection of a dead calf into a chemical analysis: "First, rich and racy smell of Calf, seventy-percent; smells of grass, bugs, wood, flowers, trees, sand and other uninteresting negations, fifteen percent; smell of her Cub and herself, positive but ignorable, ten percent; smell of human tracks, two percent; of sweaty leather smell, one percent; of human body scent (not discernable in some samples), one-half percent; smell of iron, a trace" (Seton 1905, 127). Seton especially admires the wolves' ability to differentiate and associate human scent with danger, a skill that gives wolves an advantage but makes the wolfers' task trickier and more delicate. In turn, Seton and other wolfers are careful about touching or holding the bait.

Wolves also learn and pass on their knowledge to their mates. In the story of Badlands Billy, an encounter with poison that left all but one of the nursing pups dead and the mother weakened, the survivors begin to avoid certain scents: "The reactions of smell are the greatest that a Wolf can feel, and thenceforth both Cub and foster-mother experienced a quick, unreasoning sense of fear and a hate the moment the smell of strychnine reached them" (Seton 1905, 123). Though the wolfers pursuing Lobo and his pack use "poison in a score of subtle forms," the wolf "never failed to detect and avoid it" (Seton 1903, 4). Iron, its smell and sound, also makes wolves suspicious and adept at evading the foot-hold traps. Even at night a wolf like Lobo can detect traps. Halting his pack, Lobo "cautiously scratched around it until he had disclosed the trap, the chain and the log, then left them wholly exposed to view with the trap still unsprung, and passing on he trotted over a dozen traps in the same fashion" (ibid., 16).

As these two quotes from Burgess and Seton suggest, it is not just instinct that safeguards the wolves; they also learn, from their own experiences as

well as from those of other wolves, how to detect traps set by their human hunters:

> Always the hand of man has been against them, and this fact has developed their wits and cunning to a wonderful degree. Man in his effort to destroy them has used poison, cleverly hiding it in pieces of meat left where Howler and his friends could find them. Howler soon found out that there was something wrong with pieces of meat left about, and now it is seldom that any of his family come to harm in that way. He is equally cunning in discovering traps buried in one of his trails. Sometimes he will dig them up and spring them without being caught. (Burgess 1920, 192)

Seton also notes this change in wolves: "I knew of the early days when anyone could trap or poison Wolves, of the passing of those days, with the passing of the simple Wolves; of the new race of Wolves with new cunning that were defying the methods of the ranchmen, and increasing steadily in numbers" (Seton 1905, 143). The ability to learn, recognize, and adapt to changes in their environment makes wolves worthy opponents and hunting wolves more challenging. Unlike the wolf in traditional narratives, these wolves are not the object of their hunters' ridicule but of their respect. Further, these passages suggest that Seton and Burgess evaluate wolf behavior in relation to the success of wolfers.

Descriptions of these wolves as large, fierce, and intelligent not only point to the wolf's strength, adaptability, and prowess but also underscore the cleverness, perseverance, and forethought required to be a successful wolfer. By making the wolf a skillful and gifted adversary, Seton heightens the stakes while leveling the playing field. He pits one hunter against another, turning the hunt into a match or duel. How much more interesting to pursue an intelligent, large, and ferocious animal than one easily caught! Tension builds as wolves outwit and seemingly mock the wolfers by avoiding poisoned carcasses and springing traps. All the various forms of technology in the human hunter's arsenal—dogs, poison, traps, guns, and ammunition—prove to be useless against Lobo, Badlands Billy, and Howler.

Seton contrasts the knowledge and techniques of novice wolfers with more experienced ones:

> A young trapper often fastens the bait on the trap; an experienced one does not. A good trapper will even put the bait at one place and the trap ten or twenty feet away, but at a spot that the Wolf is likely to cross in circling. A favorite plan is to hide three or four traps around an open place and scatter some scraps of meat in the middle. The traps are buried out of sight after being smoked to hide the taint of hands and iron. Sometimes no bait is used except a little piece of cotton or tuft of feathers that may catch the Wolf's eye or pique its curiosity and tempt it to circle on the fateful, treacherous ground. A good trapper varies his methods continually so that the Wolves cannot learn his ways. (1905, 134)

Just as wolves acquire the skills that will keep them free and alive, so wolfers must learn and adapt.

Seton's experience as one of the wolfers in pursuit of Lobo underscores the wolfers' methods and how they learn from each other. While waiting for the traps to arrives, Seton begins with poison, admitting, "There was no combination of strychnine, arsenic, cyanide, or prussic acid, that I did not essay; there was no manner of flesh that I did not try as to bait, but morning after morning, as I rode forth to learn the result, I found that all my efforts had been useless. The old king was too cunning for me" (Seton 1903, 11). His sketch of various bottles, one with fumes rising from it, reflects the dangerous concoctions he employs. He also includes a detailed account of one of his failed tactics:

> Acting on the hint of an old trapper, I melted some cheese together with the kidney fat of a freshly killed heifer, stewing it in a china dish, and cutting it with a bone knife to avoid the taint of metal. When the mixture was cool, I cut it into lumps, and making a hole in one side of each lump, I inserted a large dose of strychnine and cyanide, contained in a capsule that was impermeable by any odor; finally I sealed the holes up with pieces of cheese itself. During the whole process I wore a pair of gloves steeped in the hot blood of a heifer, and even avoided breathing on baits. When all was ready, I put them in a raw-hide bag rubbed all over with blood, and rode forth dragging the liver and kidneys of the beef at the end of a rope. With this I made a ten-mile circuit, dropping a bait at each quarter of a mile, taking the utmost care, always not to touch any with my hands. (Seton 1903, 11)

But the next day, instead of eating the baits, Lobo carries them in his mouth and then "having piled the three on the fourth, he scattered filth over them to express his utter contempt for my devices" (ibid., 12–13). Lobo is smart, and he goes out of his way to ridicule Seton.

In his preface to *Wild Animals I Have Known*, Seton writes, "The life of a wild animal always has a tragic end" (1903, iii). For the most part, no matter how skilled, smart, or learned these wolves are, they are doomed not only to die but to die horrific deaths from poison, traps, and lassos. From frothing at the mouth, to trembling and convulsions, Seton describes and makes visible the effects of strychnine poisoning on Yellow Wolf's body. Although she survives, the poison flows from her body to her nursing pups, killing all but one. Seton depicts the scene with an image of a wolf being strangled by a snake, whose thick body is coiled around the wolf's midsection. Although she escapes death by poison, eventually the old yellow she-wolf dies, caught in a trap. Seton describes her emotions as she struggles to free herself: "Fear and fury filled the old Wolf's heart." Tugging and straining "she chewed on the chains, she snarled and foamed . . . Struggling as she might, it only worked those relentless jaws more deeply into her feet." She snaps and barks the "roar of a crazy Wolf," attacking the traps, her pup, and herself. She tears at her legs and gnaws "in a frenzy at her flank, she chopped off her tail in her madness;

she splintered all her teeth on the steel, and filled her bleeding, foaming jaws with clay and sand" (Seton 1905, 138–39). By focusing on the wolf's emotional suffering and endowing her with human feelings and responses, Seton makes her suffering familiar—something to which the reader can relate. Her torment finally ends when the wolfer who set the trap shoots her.

Tragedy bounds the story of the Winnipeg Wolf. It begins with a wolfer killing a she-wolf and all her pups, save one. After collecting the bounty for the scalps, he gives the remaining wolf pup to the saloonkeeper, who ties the wolf to a post behind the saloon, keeping it for the amusement of his clientele. Drunk, they bait the pup by striking him with sticks or setting their dogs on him. In the end the wolf dies when he is punished for having "murdered" one of the worst of these tormentors. Seton's passages underscore the cruelty with which many humans attack the wolf, finding humor and sport in its suffering. In his story about Lobo, he expresses his later regret for having caught and put an end to that outlaw wolf. His later stories are even more critical of the humans, leaving him and the audience cheering for the wolf.

In "Lobo," Seton uses Blanca, Lobo's mate, to trap the King of the Currumpaw. From the tracks left by the pack, Seton determines that Blanca is not as careful as Lobo. Using his knowledge of wolves in general and of Blanca in particular, Seton sets up a series of foot-hold traps using the carcass of a heifer as the bait. He writes:

> During my operations I kept my hands, boots, and implements smeared with fresh blood, and afterward sprinkled the ground with the same, as though it had flowed from the head; and when the traps were buried in the dust I brushed the place over with the skin of a coyote, and a foot of the same animal made a number of tracks over the traps. The head was so placed that there was a narrow passage between it and some tussocks, and in this passage I buried two of my best traps, fastening them to the head itself. (Seton 1903, 18)

Seton's plan works and Blanca is caught: "We each threw a lasso over the neck of the doomed wolf, and strained our horses in opposite directions until the blood burst from her mouth, her eyes glazed, her limbs stiffened and then fell limp. Homeward then we rode, carrying the dead wolf, and exulting over this, the first deathblow we had been able to inflict on the Currumpaw pack" (ibid., 20). Seton illustrates this scene from Blanca's perspective. We see what she sees: a wolfer with lasso in hand. Blanca looks death in its face, and death is Seton. In an interesting aside, the *Nature* documentary featuring the story of Lobo and Seton offers a different, kinder death for Blanca. In the documentary, Seton simply shoots her.

As Seton's descriptions suggest, it is not just death but also capture that these wolves fear. As the descriptions of Yellow Wolf and Lobo indicate, the desire to remain free is paramount, and their struggle to survive embodies an

idealization of liberty. Killing the wolf is taming the land, and the remaining wolves are reminders of a disappearing wilderness.

From endowing the wolves with feeling and emotions and human perspectives to siding with the animal, Seton's stories, although true, lack objectivity. Seton, in his preface to *Wild Animals I Have Known*, defends his approach: "The real personality of the individual, and his view of life are my theme, rather than the ways of the race in general, as viewed by a casual and hostile human eye" (Seton 1903, i). He describes animals as "creatures with wants and feelings differing in degree only from our own," adding "they surely have their rights" (ibid., iv). Although beginning his career as a bounty hunter, Seton, like other early conservationists, starts to question the eradication of the wolf. Through his stories, in which the fate of animals remains inevitable, he advocates for the wolf and other species. Yet unlike later conservationists and biologists who focus on the necessary ecological niche that predators fill, Seton roots his arguments in his sympathy and respect for the wolf. In writing their stories he puts himself in their place, feeling their fear and anger at being caught. In turn, the emotional pain and physical cruelty they suffer render them sympathetic and their human pursuers cruel.

Both at the time he wrote as well as later, Seton was criticized for his anthropomorphic descriptions of his animal protagonists. As Doug Smith of Yellowstone National Park pointed out in the *Nature* documentary on Seton and Lobo, however, his stories contain elements of truth. Wolves, although they may not understand traps, poison, and bullets, are aware and suspicious of changes in their environment.

In addition to being a writer, Seton was a skilled artist. His illustrations range from anthropomorphic caricatures to representational renderings. Through these he captures the essence of human attitudes towards wolves and memorializes his wolf protagonists and their pursuers.

Seton's stories and images are significant not only for giving these wolves distinct personalities but also for questioning the actions of their human antagonists. In "Lobo," one of Seton's earliest works, he praises the King of the Currumpaw, at the same time stressing the need to hunt him down and to put an end to his livestock raids. Yet, in addition to recounting Lobo's story, Seton admits to having regrets—"not at the time, but afterwards." Before describing the means he used to kill Blanca, Seton writes: "Then followed the inevitable tragedy, the idea of which I shrank from afterward more than at the time" (1903, 20).

In his journal Seton ends his account of Lobo and Blanca with the simple question "Why?" His later stories, while still praising the skill of the bounty hunters, are even more critical of the humans. In "The Winnipeg Wolf," he expresses contempt for the men who bait the tied wolf, and in "Badlands Billy" he cheers the wolf on, rejoicing when the wolf escapes. Indeed, the story of Badlands Billy is one of the few stories by Seton that ends on a happy note—for the wolf, anyway. Seton's closing image features a triumphant Badlands Billy, a crown upon his head, cutting into a steak (a belly-up cow) dinner. This humorous tribute captures the underlying cause of the West's war against the wolf: livestock.

Trapped, Unconscious, or Dead Wolves

Images of trapped, unconscious, and dead wolves reflect as well as contribute to the recharacterization of the wolf. On the one hand, they reflect human efforts at exterminating the wolf when wolves were considered pests or, as Theodore Roosevelt described them, "beasts of waste and desolation" (Roosevelt 1927, 2:305). The black and white photos of wolfers as well as those of trapped, poisoned, or dead wolves represent the actions and attitudes of ranchers, wolfers, and early-twentieth-century government workers (see Figures 5.2 and 5.3). Indeed, they could easily illustrate Seton's and Burgess's stories. The presence of these images in texts advocating the preservation, recovery, and restoration of the wolf acts, however, as a visual indictment not of wolves as predators but of humans as predators. Underlying the recharacterization of the wolf as a social animal whose predation and existence are vital to the "balance of nature" is not a change in the nature of the wolf but rather a change in the ways we understand the wolf and ourselves. Photographs of wolf biologists and conservationists reflect this new perspective of humans and the human role in the preservation of other species. Oddly, without the text it would be difficult to distinguish between images of humans with dead wolves and images of humans with unconscious wolves. Indeed, both kinds of images are visible reminders of the power humans wield over other species.

Photographs of human hunters with dead wolves provide an interesting contrast to photographs of wolves with their dead prey. The wolves' prey appears as an indeterminate mass; yet when a human hunter or "wolfer" is depicted with his kill, the dead body of the wolf remains distinct. The disparity in content and presentation reflects differences in the reasons for which humans and wolves hunt. Wolves hunt and kill other animals to survive. The dead prey before a wolf or wolf pack is partly indeterminate because the wolf or wolves have eaten it. In contrast, humans hunt and kill wolves to protect livestock and game animals, for their coats, and for the thrill of hunting a large predator. In the latter case, photographs of "wolfers" with dead wolves function as visible evidence not only of the kill but also of the humans' prowess and bravery as hunters.

Text and image also stress the difference among various human actors. Eighteenth- and nineteenth-century colonists and pioneers are presented as fearful, prejudiced, and backward in their views and treatment of nature while twentieth-century scientists are presented as enlightened, rational, and objective. By contrasting the knowledge and work of contemporary scientists with the views and behaviors of the European colonists and Euro-American pioneers who cleared the land of its forests, prairies, and animals, these books do more than explain scientific techniques and contributions. They underscore the ways in which scientists and scientific research have helped to save wild animals. Johnson and Aamodt write that scientists "have conducted field research on the nature and habits of wolves. Thanks

to these scientists, legends of the 'big bad wolf' have been replaced by facts about real wolves and their way of life" (1985, 79). Absent from these histories, however, is the role of scientists in exterminating bears, mountain lions, wolves, and other species labeled as varmints during the later nineteenth and early twentieth centuries. Indeed, most fail to acknowledge that only since the 1950s and 1960s have scientists begun to work on behalf of predators.

In contemporary informational books and fictional picture books, humans endanger the wolf in several ways. Human hunters, by pursuing, trapping, and killing wolves, threaten the wolf packs. In *The Eyes of Gray Wolf*, a hunter's trap takes the life of Gray Wolf's mate, rendering him a lone wolf. In *The Call of the Wolves*, aerial hunters shooting from the air separate a young wolf from his pack.

In addition to hunters and wolfers, contemporary informational books cite habitat loss and resulting loss of prey as the cause of the wolf-livestock problem. Photographs of sheep, cattle, farmyards, and even a rancher symbolize the source of the wolf-human conflict. When settlers cleared the forest, they rid it not only of its trees and plants but also of the bison, deer, moose, elk, and other ungulates upon which wolves depend for their survival: "When the bison disappeared they turned their attention to livestock. On some ranches, wolves killed nearly half of the year's calves" (Swinburne 1999, 9). For cattlemen, the loss of livestock represents the loss of property and income and within this context the wolf is a criminal: "Cowmen, in return, attacked the predators with a vengeance, using leg-hold traps, bullets, and poison" (ibid.). As Swinburne states, "If the fight against the wolf in the East was a battle, the campaign in the West was all-out war" (ibid., 8).

Still, authors of contemporary informational books offset the damage caused by the wolf with the damage done to them. The inclusion of statistics on the number of wolves killed (80,000 in Montana between 1880 and 1890) and increases on bounties paid for dead wolves alongside images of dead or trapped wolves reflects the rancher's hatred and persecution of the wolf. Used within the context of texts advocating and celebrating the restoration of wolf population to former habitats, these documents and facts highlight the threat humans pose to these and other animals.

Photographs feature and record biologists, veterinarians, and government employees trapping, collaring, examining, releasing, and rereleasing wolves in the wild. These works do more than highlight the work of a scientist or person involved in saving and protecting other species—they celebrate and promote human behaviors that honor the environment. In this way scientists do interesting and valuable work that atones for earlier human arrogance and transgressions.

Contemporary images featuring scientists, National Park workers, and others caring for wolf pups, trapping wolves for preservation purposes, and reintroducing them to former habitats contrast with images of farmyards,

livestock, and a rancher, making clear that the wolf–human conflict continues. While farmers, ranchers, and hunters remain the enemies of the wolf, scientists and others working for the restoration of the species are praised. Further, the authors look to science and scientists not only to help us understand the various species of animals and plants and the roles they play in the ecosystem but also to restore the wild and the wilderness. As Swinburne has suggested, "Doug Smith and other wolf biologists believe that their work with wolves is about fixing what humans have destroyed in the past, righting a long standing wrong" (1999, 44). As such, images of biologists, vets, environmentalists, and park service workers symbolize hope and atonement. But as Johnson and Aamodt have pointed out, for most wolves the efforts to protect them are too late (1985, 78). And given the recent removal of the wolf from the Endangered Species List and the enthusiasm with which this decision has been received, the killing is likely to begin again.

Through images and texts, authors also compare the ways in which European colonists and Euro-American settlers and pioneers viewed, approached, and treated the wolf, nature, and wilderness with those of various American Indian tribes. Swinburne, Otto, and Johnson and Aamodt point to the reverence accorded the wolf by the Plains tribes—Lakhota, Blackfoot, and Shoshone—underscoring the role the wolf plays for these Indians as a model for hunting and a source of medicinal objects and treatments and religious symbols (Johnson and Aamodt 1985, 70; Otto 2000, 31; Swinburne 1999, 10). Pictures of the wolf mask used by the Makah tribe of the Northwest coast, as well as George Caitlin's nineteenth-century painting of Plains Indians wearing wolf skins to hunt bison, serve as evidence of these beliefs and attitudes (Johnson and Aamodt 1985, 71; Otto 2000, 31; Swinburne 1999, 10). Johnson and Aamodt also point to the coexistence of Eskimos and wolves; both are nomadic cultures. They note that the pastoral way of life and the introduction of livestock as food and property have made the wolf a threat.

Not only do authors depict American Indians as respecting the wolf; they also equate Indian life and the fate of the various tribes and cultures with that of the wolf. Both are victims whose way of life got in the way of European colonists and their descendants, the Euro-American pioneers, who cleared and took the land for farms, cities, and ranches. Indians and wolves were part of the world that had to be conquered and tamed.

Yet this depiction of the relationship of American Indians and the wolves is simplistic. As Swinburne gently states, from the first bounty in 1630, "Native Americans, who traditionally revered the wolf, were encouraged to kill them" and were paid in kind (three quarts of wine or a bushel of corn) for each dead wolf they delivered (1999, 9). According to historian Jon Coleman, American Indians played an important role in exterminating the wolf in the colonies. Further, the images and descriptions suggest yet another ambiguity: the wolf's role as a sacred and medicinal animal. Although American Indians did not hunt the wolf to near extinction, the lives of individual wolves were sacrificed

to provide the wolf skins, heads, and paws used in various religious, hunting, and medicinal rituals.

Wolf Recovery

Success stories abound along with accounts of the different ways in which scientists are working to restore wolves and other species to their former habitats. Although several authors allude to the economic and political factors at play, for the most part they focus on the scientific aspects. The work of wildlife biologists, the National Park Service, and employees of the U.S. Fish and Wildlife Service are central to reports. Scientists are lauded for their work, part of which remains unseen.

While works written before 1995 advocate the reintroduction of wolves to Yellowstone, those after that date celebrate the reintroduction and restoration of the gray wolf to this national park. The photographs and illustrations found in these works feature wolf biologists, National Park Service workers, and members of the public working to restore the wolf to Yellowstone. These images celebrate human intervention as much as the reintroduced wolves' ability to adapt and thrive in Yellowstone. Not everyone, however, welcomes the wolves back. Political, cultural, economic, and legal struggles continue.

Two recent works turn their focus on the wolf, stressing the wolf's role in the Yellowstone ecosystem. Both Dorothy Hinshaw Patent's *When the Wolves Returned* and Jean Craighead George's *The Wolves Are Back* tie the wolf's presence directly to the balance of nature within the park's ecosystem. With photographs featuring the various species of plants and animals found in Yellowstone, Patent explains the effects of the wolf's absence on the park's ecosystem. Without the wolf, the elk, moose, and bison populations remained unchecked, leading to overgrazing of grasses, plants, and trees. The loss of vegetation and trees threatened the survival of birds, beavers, and other animals. Further, without the wolf, the coyote population grew at the expense of smaller mammals such as beavers and pronghorn antelope. With the wolf's reintroduction, the tone and content of the images and text change, focusing not only on the wolf but also on the impact and benefits of its return. Not only does the wolf return and thrive, but so do the flora and fauna of Yellowstone. Patent presents the wolf as the missing link in the ecology of Yellowstone and the key to its health.

Written for a younger audience, George's work opens with a wolf pup and his father going to feed on an elk. So begins the refrain, "The wolves are back." By asking where they have gone, George takes us into the not so distant past when all the wolves were shot, and "peace" and silence came to Yellowstone. She describes the unchecked destruction caused by the overgrazing of the "gentle" elk, bison, and moose. Wendell Minor's illustrations complement the texts, moving from a wolf pup and his father to a wolf skull and scenes of

elk, moose, and bison grazing in green but empty spaces. She contrasts this with all the various species thriving after the wolf's return: songbirds, flowers, trees, and other large and small mammals. By featuring young wolves howling, watching vesper sparrows and flycatchers, and walking through the flower-filled meadows, Minor's illustrations focus on what was missing or lacking when the wolves were gone.

Patent's and George's works stress that predators play a necessary role in keeping nature healthy. George describes Yellowstone without wolves as broken and Yellowstone with wolves as having returned to a balanced state. The endpapers that close Patent's work contain a visual diagram demonstrating what she calls "The Wolf Effect" (see Figure 5.4) and a question: Do readers remember how the wolf impacts the lives and survival of elk, aspens, songbirds, beavers, moose, eagles, bears, coyotes, pronghorn, ground squirrels, foxes, and badgers? This simple yet powerful image highlights the critical and necessary role that the wolf fills in the ecosystem. Patent's and George's books visually and textually work to displace the long-held view that predators, in killing other animals for food, are cruel.

Not all efforts at reintroducing the wolf have been successful. The case of the Mexican gray wolf, extinct from its former ranges in Arizona, New Mexico, and western Texas since the 1970s, reveals the problems faced by biologists working to save and reintroduce this subspecies. Photographs of a caged adult Mexican gray and Mexican gray wolf pups record the success of biologists in breeding these animals in captivity. At the same time, the text, which accompanies these images, focuses on the political, economic, and cultural challenges that continue to frustrate the reintroduction of the Mexican gray wolf to Arizona and New Mexico.

In addition to human-directed reintroduction projects, several works point to packs of wolves returning to former habitats on their own. Swinburne and Patent have briefly described the Canadian wolves that crossed over Lake Superior onto Isle Royale in the late 1940s and the packs that repopulated parts of the Rockies in Montana during the late 1970s and early 1980s. Both texts stress that the presence of wolves on Isle Royale, a geographically isolated habitat, makes an ideal lab for wolf biologists to study wild wolves.

Finally, although these works link science to a better understanding and treatment of the environment, they also remain silent on unsavory aspects of species preservation. For example, Dorothy Hinshaw Patent's book *Gray Wolf, Red Wolf* describes the work behind saving the remnant red wolf population (see Figure 5.5). Some scientists believe the animal is already extinct due to interbreeding with coyotes, while others believe they can save it by isolating and breeding the remaining red wolves. Scientists caught animals they visually identified as red wolves. They then administered DNA tests to determine whether they were wolves, coyotes, or hybrids. Patent has explained that those animals identified as red wolves were sent to Oregon as a part of a breeding program. She, however, has been quiet about the fate of

those animals who "failed" the DNA test. The U.S. Fish and Wildlife Service's "Red Wolf Recovery Plan" provides the answer: coyotes and hybrids were euthanized. By omitting potentially disturbing methods, these works skew our understanding of the science behind saving endangered wildlife.

Wild Wolves

The appearance of a road, vehicles, houses, fences, farms, and other human-made structures clashes with the surrounding wilderness. Images of human artifacts such as these contrast with those of wolves running through open spaces under clear blue skies. Expanses of pristine and seemingly timeless mountains, valleys, forests, and meadows define the landscape. They also reflect and propagate the view that wolves require remote habitats to survive. Within this context, images of the technology that claims as well as saves nature keep us humans separate from it, and where before the wolf intruded upon and threatened human society, humans now intrude upon nature.

Still wildlife biologists point out that it is a misconception to identify or associate wolves with remote wilderness areas; instead they argue that wolves are highly adaptable animals capable of thriving near humans. For this reason, they advocate management measures that balance the needs of humans and other species. This insight is, however, absent from most contemporary informational books, which continue to associate the survival of these predators with a distant, isolated wilderness.

Conclusion

The images of wolves and humans define us through our treatment of the wolf. They point to past attitudes, fears, and hatred and to the more complicated present in which various sectors of the public contest or support efforts to preserve and restore the wolf. Contemporary informational books about threatened or endangered species such as wolves, grizzly bears, tigers, and mountain lions do more than provide information about wild animals. They tie scientific findings to environmental messages and to sympathetic and often anthropomorphic portrayals, influencing not only our understandings of other species but also our treatment of them. In these ways, contemporary informational books use the work of scientists to support, model, and foster environmental values and beliefs.

Chapter Six
Feral Children and Tame Wolves

A young wolf gets ready for bed while another leaves its den to explore. To reassure his son that nothing dangerous lurks in his bedroom, a father wolf checks under his son's bed. Gray Wolf dispels his littlest pup's feeling of inadequacy about his ability to jump, run, and roll. A wolf and dog find a blue chair and put it to different uses. A boy puts on a wolf suit; another dons a wolf head for the class production of "Little Red Riding Hood." After killing the wolf that swallows them, a boy and a girl hide beneath its skin and head, scaring the people of their town. A she-wolf nurses two young boys. A wolf stops a young girl at a crossroads. A wolf pack debates the fate of a human infant. A boy wraps his arms around a hunted wolf. A runaway girl seeks aid from a wolf pack. A wolf pushes a boy out of the way of a falling tree. A young girl cares for the wolf that she has injured. Schoolchildren form a barricade between a wolf and men with guns. A wolf pack seeks the help of a young girl in caring for two sickly pups.

As these images suggest, children and wolves, literary and real, have a long and complicated history. Like a kaleidoscope, the ever-shifting illustrations reflect the variations of their underlying textual narratives. Certain categories like "wolf as child" or "child as wolf" represent more recent trends, whereas those focusing on wolf-child relations reach back across time. Many contemporary fictional picture books use wolves or wolflike beings to depict aspects of human children's lives. Although the use of animals as humans is not a new literary device—fables, proverbs, and folk and fairy tales contain animals, plants, and other objects that are human in every aspect but their shapes— the use of wolves to depict human families in everyday situations is a more current phenomenon. Just as authors and illustrators reshape wolves in the form of children, so too they dress child protagonists in wolf skins. In both guises, however, it is the world of the human child, not of the wolf pup, that is revealed.

129

Relationships between children and wolves transcend time and culture. From the legend of *Lupa Romana* and the tale of "Little Red Riding Hood" to Rudyard Kipling's *The Jungle Book* and Jean Craighead George's *Julie of the Wolves* and *Nutik the Wolf Pup*, the span of wolf–human relations is reflected in the relations between children and wolves. The wolf as nurturer is part of legend, lore, and fiction, dating at least to ancient Rome. As discussed earlier in this volume, the antithesis of this image, the male wolf as the devourer of small children and other young animals, appears in three of the most frequently told tales for children—"Little Red Riding Hood," "The Three Little Pigs," and "The Wolf and the Seven Kids"—making it one of the most widespread images of the wolf. Between and within these categories exists a spectrum of lupine and human characters that redefine as they reconfigure the relationship between children and wolves, transitioning from the wolf as nurturer and devourer of children to children as the nurturers and protectors of wolves.

This chapter begins with a look at the wolf as child—in stories in which the lupine characters are human in every way but shape. Following is an examination of some of the most aggressive wolves in contemporary fictional picture books: children whose behavior and personalities transform when they don wolf hides or costumes. Finally, we consider the relationship between wolves and children, moving from wolf as nurturer to child as protector.

Wolf as Child

Some fictional picture books like *Wolf Christmas* and *Look to the North* offer more realistic characterizations of wolves, their way of life, and the challenges they face, while other fictional wolves live and behave like human children. Within this range of characterization, certain patterns across images emerge. In these stories, the wolf's predatory nature is typically obscured or ignored. Instead, as a young being, human or lupine, the wolf shows interests, actions, and concerns reflecting what we value most: family, parental love, and play. From nurturing, to building cognitive and social skills, to learning through play, the young wolves in these books model and mirror the behavior and situations of young readers.

Further, the authors and illustrators of these works blend, to varying degrees, elements of the animal and the human, resulting in settings and characters that are neither entirely wolflike nor entirely human but instead reflect morphed spaces and beings. Many illustrations depict wolves in human clothing, settings, and postures. Young wolves wear bow ties, ribbons, and pajamas. They sleep in beds, decorate Christmas trees, and play with toys. Although wolflike in shape, many walk upright on their hind legs, sit in chairs, and use utensils to eat. They talk, argue, and interact with each other, expressing human emotions including insecurities, fears, and disappointments. Although the wolves

in *Look to the North, Wolf Christmas, The Littlest Wolf,* and *Little Wolf and the Moon* live in the woods, run, and move like real wolves, they have names and they react to the world in humanlike ways. For all of these young wolves, family life and domestic scenes predominate, forming the center of their worlds. Finally, this blending—writing the wolf as the human and the human as the wolf—invites and encourages young readers to compare, connect, and identify with wolves.

Several texts highlight nurturing. Nadja's mini-board book for infants and toddlers, *Tout p'tit loup,* focuses on the world of a wolf pup. The sidebar tags of the sun, a squirrel, a bottle, and the moon frame the boundaries of the young wolf's day. In the morning, the pup ventures into the woods, where he asks a squirrel to play with him. They find berries and nuts. At the end of the day, the pup returns to the security of his mother: "Un grand coup de langue de mamman loup: 'Bonne nuit, tout p'tit loup!'" ("With a big lick from mommy wolf: 'Good night, little wolf!'") (Nadja 1997, 8). Nadja's simple text and images capture the limits of the young wolf's world, mixing the human with the wolf. The physical context of the story is the forest, but the friendship between different species is more human than lupine. And save for his coloring, tout p'tit loup resembles the young squirrel whom he befriends. Further, they find nuts and berries, yet the page's sidebar image featuring a baby bottle full of milk speaks more to the world of the book's intended audience than it does to the book's protagonist. In the final scene, tout p'tit loup returns home—home being not only the den but also and more important, his mother.

Routines also bring security and order to a child's world. In Marilyn Janovitz's *Is It Time?* (1994) a young wolf gets ready for bed. With the help of a caring adult wolf, the young wolf bathes, brushes his hair, puts on a nightshirt, and is tucked into bed. The young wolf's actions reflect those of a human child, though Janovitz includes some "wolfish" twists: the young wolf brushes his fangs, howls, and even dreams of sheep. These wolfish references prove useful in identifying the canines on display as wolves and not huskies; they do not detract from the human behavior on display. Reflected in Janovitz's story of a young wolf getting ready for bed is also the role of the nurturing and caring parent. While Janovitz's illustrations and text tend to blur rather than clarify the parent wolf's gender, the actions are those of a human parent.

For young wolves as for young children, bedtime is not always easy. In Elsa Devernois's *Grosse peur pour Bébé-Loup,* when a young wolf has trouble falling asleep, his father comes to the rescue, checking under the bed and looking for a missing stuffed animal. In a reversal of roles, Bébé-Loup has nightmares of an *enfant terrible* (a hairless, pink little boy with nails instead of claws) hiding beneath his bed, waiting to leap out and attack him. Bébé-Loup envisions the boy pulling and swinging him around by his tail. Papa-Loup finds the beloved toy, assuring Bébé-Loup that there is no boy lurking under the bed.

Christmas anxieties and expectations keep Loulou Petit Loup awake in Sylvie Auzary-Luton's *Noël chez Papy Loup*. Even before his family leaves to spend Christmas Eve with grandfather Papy Loup, Loulou begins to fret and tries to speed the arrival of Père Noël by rushing through the holiday rituals of trimming the tree, eating dinner, and going to bed. Once in bed, however, Loulou sets out to look for Père Noël. When he sees the Fox family stockings hanging by the fireplace, he realizes he has forgotten to hang his stocking. By the time he returns home, Père Noël has already been there to fill the stocking; weeping, Loulou goes to bed with his empty stocking.

In Larry Brimmer's *The Littlest Wolf*, Genevieve Noel's *Timide le loup*, and Anne Ferrier's *Les chaussettes d'Oskar*, young wolves must deal with insecurities brought on by peers teasing them and making fun of their differences. Each of these stories focuses on young wolves whose size, abilities, and interests render them different from their siblings and friends. Insecurities are resolved by adult figures, by finding others who are like them, or by circumstances that transform their perceived weakness into a valued asset. When his siblings criticize his running, jumping, and rolling skills, the title character in *The Littlest Wolf* seeks solace from his father, Big Gray. After Little One demonstrates each of these skills, Big Gray assures him that everything is as it should be. The story ends with Big Gray reminding Little One that the oak tree under which they are lying began life as an acorn.

Timide le loup's fellow wolves reject him because he prefers cabbage to meat, does not like to wrestle, and cries when they pull his ears. After meeting a bear getting ready to hibernate, Timide decides he will hibernate too. But as he crawls into bed, a snowstorm brings cold and weary visitors to his door: an owl, a rabbit and her twelve offspring, and finally a young female wolf. Timide's plans for sleep and solitude give way to a house full of guests who, like him, are not hibernating animals and so cannot fall asleep. One final knock on the door introduces Mimosa, a young female wolf, who like Timide prefers cabbage to meat and is fleeing pack mates who torment her. The story ends with Timide finding a group of friends who enjoy the same things he does.

Les chaussettes d'Oskar presents a third variation on this theme. As in the other two stories, Oskar's inadequacies—his small size, absent-mindedness, and dislike of hunting—make him the target of the other young wolves. Worst of all, unlike the other pups, Oskar gets cold feet in the snow. To help him, his grandmother knits him red socks, and although they keep his feet warm, they also provide another reason for his oldest brother, Yvan, to ridicule him. Things change for Oskar when, during a hunting trip, a grizzly attacks Yvan, leaving him unconscious in the snow. To keep his injured pack mate warm while he goes for help, Oskar puts his socks on his brother's paws. As Oskar leads the pack to Yvan, it begins to snow. The red socks save Yvan's life by keeping him warm and acting as a marker in the snow. In the end, the pack leader pays tribute to Oskar and makes his red socks, once the object of ridicule, a badge of honor to be awarded to wolves who perform brave deeds.

As their plots and characterizations suggest, these stories focus on identity, specifically identity in relation to others. Each of the characters worries about and is affected by what others think of him. Perceived differences in size, ability, and behavior cause social problems for the protagonist. Yet except for Oskar, the message that lies within the happy ending does not ensure the young wolf's acceptance by others; instead, it reflects changes in self-perception. The message for young readers centers on acceptance of one's self and valuing one's differences.

Play is an important part of childhood and, according to wolf biologists, of puppyhood. The play demonstrated by the wolf in his role as a child in fictional picture books mirrors, and even models, the behavior of young children. The presence of a wolf as a child playing reflects not only the behavior associated with children but also the value placed on play as the means of developing imagination, skills, and experience. Seen in this way, play is a learning process in European and Euro-American cultures. Imagination, exploration, games and other activities are parts of this process.

Play, along with nurturing and caring for young wolves, also occurs in stories that feature wolves as wolves. In *Wolf Christmas*, Stinkface's descriptions point to the active involvement of the adult wolves in rearing the young. Poppa watches the young wolves sleep and brings them food to eat. According to Stinkface, sometimes the young are "able to get the grown-up wolves to join us and play too" (Pinkwater 2002, 7). Sometimes the big wolf responds by nuzzling, not playing (ibid.). When Uncle Louis arrives, the pups stop playing and run to greet him: "We did not approach him with respect the way we approached Poppa. We flew at him, jumped all over him, and rolled in the snow. Uncle Louis laughed and batted us with his paws" (ibid., 10). Like a human uncle, Uncle Louis roughhouses with his niece and nephews. By overlapping wolf and human family relationships, the Pinkwaters have created a family structure that is at once foreign and familiar. So although Stinkface's pack resembles wolves physically and lives outside, sleeps in the snow, and runs through the woods, the relationships within the family reflect those of young readers. Stinkface also talks and views the world like a human.

As suggested by the description in the Pinkwaters' story, play can be physical. In *Look to the North*, as the pups grow they play "king of the hill, tug-of-war, and football. When they are bored with these games, they play 'jump on the babysitter'" (George 1997, 19). In *Wolf Christmas*, Stinkface describes wolf pups "wrestling, and tumbling on one another; laughing and biting and pushing" (Pinkwater 2002, 4). As in informational books, applying the terminology used to describe human behavior to wolf behavior blurs the distinction between human and wolf, furthering young readers' identification with the wolf.

Imaginative play is at the heart of Claude Boujon's *La chaise bleue*. Escarbille and Chaboudo, *Canis lupus* and *Canis familiarus* respectively, find a blue chair in the middle of the desert: "'C'est une chaise', dit Escarbille. 'C'est une chaise

bleue', completa Chaboudo" ("'It is a chair,' said Escarbille. 'It is a blue chair,' added Chaboudo") (Boujon 2000, 8). Testing and pushing the possibilities held in a chair, Boujon's visual and textual narratives reflect the ways in which children use their imagination to transform their world. With it they imagine all the things one can do with a chair: one can hide under it or use it as different modes of transportation, "tout ce qui role et vole et flotte" ("all that goes on wheels and flies and floats") (ibid., 12–13; see Figure 6.1). In a change of position, the chair becomes a counter or a desk. As Chaboudo suggests, it also has its practical uses: "Si tu montes dessus, tu deviens aussi grand que le plus grand de tes amis" ("If you stand on it, you become as tall your tallest friends") (ibid., 18). Their imaginations re-create not only the chair but also the texture and context of their world. Their play ends abruptly with the arrival of an overserious camel who, like an adult, declares: "Une chaise . . . est faite pour s'asseoir dessus" ("A chair . . . is made to sit on") (ibid., 31). As Escarbille says, "Partons . . . ce chameau n'a aucune imagination." ("Let's go . . . this camel has no imagination") (ibid., 35).

Play and discovery are intertwined in Marjorie Dennis Murray and Stacy Schuett's *Little Wolf and the Moon*. Every night Little Wolf comes out of the forest to look at the moon. He wonders: "How does the moon stay up in the sky? . . . Why does it not fall?" Later, when he sees the moon climb above the stars, he asks, "How does the moon climb over the stars? . . . Why is the moon so large?" (Murray 2002, 8). Little Wolf resembles a wolf pup, but his questions and feelings are those of a human child. The questions reflect the curiosity of children and may prompt the child reader and viewer to wonder and ask those same questions. In this way, picture books like *Little Wolf and the Moon* mirror and model valued behavior.

As the Pinkwaters' wolf pack runs, howls, and plays, so does Little Wolf's. Notably, as Little Wolf and his pack mates run through the fields, forest, and snow, they pay no attention to the deer, rabbits, or mice. Indeed, one night when the sky is particularly wondrous, Little Wolf decides that the moon lights up the stars so that "the forest grows so little mice can play in it . . . the earth is wide so elk can leap through the snow . . . the wind blows so owls can fly past the stars" (Murray 2002, 31). Instead of showing a more natural predator instinct, this passage reveals Little Wolf's wondrous admiration for creation while his curiosity and questioning reflect the human manner of learning and discovery.

Jean Craighead George, in *Look to the North: A Wolf Pup Diary*, has made the connection between wolf pups and children explicit by comparing the events of her readers' world with that of a litter of pups. Beginning with the pups' birth, George uses seasonal changes to mark the passage of time. She precedes descriptions of the young wolves with directives to her audience: "When you see dandelions turning silver, look to the north. Wolf pups are being born" (George 1997, 5). She describes the pups as being in a nursery. As they grow and change, their mother watches over them, reprimanding them with growls when needed. Like the young readers, the wolf pups learn as they grow.

Toys, especially stuffed animals, are present in many of the stories discussed. To sleep, Bébé-Loup requires the security of his stuffed duck and Timide snuggles with a stuffed sheep. Loulou has toys and eagerly awaits the arrival of more. Like *Gros peur pour Bébé-Loup*, Isabelle Bonameau's *Amélie-le-grand-méchant loup* explores the nighttime fears of a small child. In this story, Amélie, an anthropomorphic hedgehog, projects her fear onto her stuffed bear Boubou Nounours. In an enemy-of-my-enemy manner, Amélie dons the disguise of the Big Bad Wolf to take on the monster who lives in the drawer. As a wolf with pointy teeth and sharp claws, Amélie commands the monster to return to the drawer. The monster acquiesces after retrieving her own stuffed toy. Amélie's stuffed bear, Boubou Nounours, however, relaxes only after Amélie removes her Big Bad Wolf disguise. The final surrealistic image pictures Amélie in bed with her teddy bear; the empty wolf suit seemingly watches them both from the foot of the bed.

In *Good Little Wolf*, Kristina Andres introduces another dimension to both wolf as child and the role of stuffed animals. An opening image, which features a wolf, a bear, a giraffe, a sheep, and a rabbit in a box, suggests that the characters in this story are toys and that the voice of the wolf narrator is actually the voice of the child who owns these stuffed animals and gives them life. Through the wolf toy's adventures, from taking baths to getting left outside in the rain, the wolf narrator takes us through the child's day. The wolf also reads bedtime stories and sings lullabies to his friends, dresses as Little Red Riding Hood, and even pretends to be a Big Bad Wolf. The wolf's movements from the real world to make-believe express the permeable boundaries of the child narrator's world. Andres's images depict the wolf in these various contexts—in the box, on the shelf with other toys, on the edge of the bathtub, drying on the clothesline, and so on. Her illustrations, which lack movement, reflect the inanimate nature of the wolf and the other toys. In contrast, her text gives movement to the images, reflecting the world imagined by the child.

Playing Wolf

The fiercest and most assertive wolves in fictional picture books are young children in wolf suits. From allowing a child to lose his inhibitions and give free rein to his emotions to bolstering his courage, wolf skins and wolf costumes allow child protagonists to redefine themselves and their worlds. In two of these stories, the costume breaks down the young protagonists' inhibitions. In the third story, a boy finds that a wolf skin and head empowers him while it protects him against the town's "other wolves."

In Maurice Sendak's *Where the Wild Things Are*, when Max puts on his wolf suit, he unleashes his inner beast. Significantly, Max's face remains uncovered and so acts as a visual reminder of the young boy beneath the wild façade. Images show Max pounding on the wall with a hammer, suspending his teddy

bear from a hanger, and leaping down the stairs after a white dog. When his mother calls him "WILD THING!," Max retorts in a traditionally wolfish manner: "'I'LL EAT YOU UP!'" (Sendak, 6). His mother sends him to his room, effectively casting him out until he calms down. Max can return only when his inner beast is subdued. Pacified, he pulls off the hood of his wolf suit and emerges to find his dinner.

In Yvonne Jagtenberg's *Jack the Wolf*, a wolf mask enables the new boy at school to interact with the other children. The wolf's head rests ominously on a shelf above the lockers—as if waiting and watching the room full of children. It comes alive only when the teacher asks Jack to play the wolf in the class play: "Little Red Riding Hood." Until that moment, Jack remains withdrawn. With the wolf mask on, Jack loses his shyness and is finally able to participate in the class's activities. Even though Jack as the wolf scares the other children, in scaring them Jack finally interacts with them, becoming part of their world.

The wolf's physical form allows Max and Jack to express themselves, but in Grégoire Solotareff's *Le masque*, the fear caused by the costume to others offers protection to the young protagonists. Solotareff's story begins in a traditional manner: a wolf devours two children, Lila and Ulysses. The children fight their way out, killing the wolf. Ulysses makes a mask out of the wolf's ears, and Lila makes a coat from its body: "Les gens eurent peur de ces deux enfants si effrayants qui se promenaient bien tranquillement" ("People were afraid of the terrifying children who calmly walked along") (Solotareff 2001, 21; see Figure 6.2). Even after Lila quits out of boredom and hunger, Ulysses, like his namesake, wanders through the night. Approaching a darkened house, he howls:

Je suis le loup
Hou! Hou!
Qui ne dort pas!
Ha ! Ha !
Je n'ai pas peur
DE VOUS !
Vous avez peur
DE MOI !

(I am the wolf
Hou! Hou!
Who doesn't sleep!
HA! HA!
I am not afraid
OF YOU!
You are afraid
OF ME!) (Ibid., 25)

When he returns home the next morning, he tells Lila that he is keeping the mask: "C'est pour nous proteger au cas un autre loup voudrait manger" ("To protect us in case another wolf wants to eat us") (ibid., 28). Although a wolf-like figure eats the children at the beginning of Solotareff's story, Ulysses's actions—howling and singing outside humans' houses during the night—suggest that the wolf from which they need protection is a human wolf. When Lila asks to borrow the mask, Ulysses refuses her request, implying that the outer form shapes the inner character: "Parce que c'est un masque de loup et un masque de loup, ça peut rendre méchant" ("Because it is a wolf's mask and a wolf's mask can make you bad") (ibid., 31). When Lila asks her brother whether he fears that he will become bad by wearing the mask, Ulysses responds: "Pas si nous restons ensemble" ("Not if we stay together") (ibid.). Their relationship will protect him from becoming that which he is trying to protect them from: the human wolves who threaten children.

Though children in these books take on the shape of a wolf, they do not lose their humanity; their actions are more human than wolflike. The wolf's shape, rather than transforming the child into a wolf, becomes the visible means through which the child expresses or deals with human emotions such as anger, frustration, and fear—emotions typically construed as negative or potentially dangerous. Just as the wolf costume releases Max's inner human beast, so the wolf masks empower Jack and Ulysses to deal with threatening human situations.

Wolves and Children

The only image of the wolf perhaps equally as well known as Little Red Riding Hood's devouring wolf is that of a she-wolf suckling two human children. From the mythic beginnings of Rome, the motifs of the wolf as nurturer and of children raised by wolves recur across literature and art. Variations (children rescued by wolves) as well as reversals (wolves raised and rescued by children) on the themes also abound; rumors, lore, and "evidence" of real feral children push this phenomenon beyond the imaginative realm into the real world.

The final sections of this study explore texts and images reflecting these more positive relationships between wolves and children. The first parts focus on the depiction of the wolf as nurturer in the myth of Romulus and Remus, Rudyard Kipling's *The Jungle Book*, Jean Craighead George's series *Julie of the Wolves*, *Julie*, and *Julie's Wolf Pack*, and Jane Yolen's picture book account of "real" wolf-children, *The Wolf Girls: An Unsolved Mystery from History*. Included are a review of how the children and wolves in these narratives are brought together, an examination of the ways in which these works characterize the wolf and the human children raised or rescued by them, and a discussion of the divide between the wild and the civilized. The chapter closes with consideration of the works that offer variation and reversals of these themes.

Coming Together

The children in these narratives come to be nurtured by wolves in various ways. In the myth of Romulus and Remus, several generations after Aeneas makes his way to the Lavinium, two of his descendants, the infant twin sons of the Vestal Virgin Rhea Silvia and the god Mars, are condemned to death by his uncle, the King of Alba. The king orders one of his servants to drown them, but as the servant approaches the river, it begins to rise and grow turbulent. The servant flees, leaving the infants in a trough on the riverbank. As the river rises, it carries the trough away, depositing it on a shore under a fig tree. Abandoned on the banks of the Tiber River, Romulus and Remus are rescued by "a she-wolf coming down from the hills to quench her thirst, [who] heard them crying and fed them with her own milk; the king's herdsman, Faustulus, found her licking the babies" (Grant 1962, 307). In most traditional versions, Faustulus takes the babies and raises them as his own sons.

Anne Rockwell's beginning-reader version differs from the source versions in several ways. With both Mars and the Vestal Virgin Rhea Silvia absent in this retelling, Rockwell removes the twins' divine heritage. Instead of being condemned to death, the infants are separated from their mother as she washes laundry in the river. The babies in their basket wash ashore under a fig tree where a she-wolf lives. Hearing them cry, she thinks, "They sound like her little furry hungry wolf cubs, so she fed them" (Rockwell 1997, 11). In the illustration, Romulus and Remus nurse alongside the she-wolf's two cubs.

Rudyard Kipling's *The Jungle Book* begins when an infant man cub, separated from his parents during a tiger attack, strays near the den of a nursing she-wolf and her family. Father Wolf, hearing a noise in a nearby thicket, lunges at a "beast" only to discover an infant: "A wolf, accustomed to moving his own cubs, can, if necessary, mouth an egg without breaking it, and though Father Wolf's jaws closed tight on the child's back, not a tooth even scratched the skin, as he laid it down among the cubs" (Kipling 1995, 5). The boldness of the man cub as he pushes the wolf cubs aside to nurse charms Mother Wolf. As she says, "Now was there ever a wolf that could boast of a man's cub among her children?" (ibid., 6). Even though Mother and Father Wolf accept the human infant Mowgli into their family and raise him alongside their wolf cubs, other wolves and the tiger Shere Khan challenge the human's place in the pack and in the jungle.

Jean Craighead George's *Julie of the Wolves* offers a variation on the theme. In her novel, Julie, a young Eskimo fleeing from an abusive arranged marriage, finds help from a wolf pack. Hungry, cold, frightened, alone, and lost in the Alaskan wilderness, Julie recalls her father's story of how a wolf pack helped save his life. George's story opens with texts and illustrations depicting Julie as she tries to get the pack's attention by mimicking the gestures and postures of a wolf. Following the submissive postures of the young wolves, she conveys her friendliness and her need for help. Accepted by all but one member—an

omega wolf who eventually turns on her—Julie shares in the food of the pack. Although Julie's need to find shelter and the arrival of aerial hunters cut short her life with the pack, her relationship with the wolves continues even after she returns to human society.

The fourth work, Jane Yolen and Heidi Elisabet Yolen Stemple's *The Wolf Girls: An Unsolved Mystery from History*, explores the real-life story of two girls in India said to have been raised by wolves. The work contains several narratives including excerpts and summaries from the journal and letters of Joseph Singh, the missionary who found the girls, scientific views of feral children, definitions, and Yolen's story of Singh and the girls. Roger Roth's illustrations depict the story as found in Singh's journals and reports; text-filled notepaper and sticky tabs provide further and contradictory information—on feral children, autism, and so on—that bring into question Singh's narrative and purpose in publicizing the wolf girls' story.

Yolen's account begins when the missionary Joseph Singh and his wife reveal to the doctor treating two girls at Singh's orphanage that the girls were found "living with jungle wolves. The villagers who found them brought them here" (Yolen 2001, 9). In Singh's report from 1923, he writes: "We have rescued two wolf-girls . . . secured from wolf dens by villagers in the jungle" (ibid., 10). Word of the two girls spreads, and visitors pay to view them. As time goes by, Singh embellishes and changes the story: from the girls being left on the doorstep and villagers finding the girls in a wolf's den to Singh discovering and rescuing the girls during a missionary trip to the jungle. In this latter version Singh, looking for a ghost man, finds instead three adult wolves, two wolf cubs, and two human children. When the wolves see him, they disappear into the jungle. Singh returns with a helper to enter the wolf's den—a large mound. As they dig, two wolves flee, but the workers kill the mother wolf. When they enter the mound, they find four shapes: "Two were wolf cubs. The other two were human girls. All four lay curled up together, clearly terrified" (ibid., 19). Singh gives the cubs to the workers and takes the girls to the orphanage.

Nurturing Wolves

The wolves in these stories differ in several ways from the wolf of fables and tales. First, they are clearly social animals. Though Lupa Romana is alone when she finds Romulus and Remus, she is inclined to feed them and in Rockwell's version raises them with her other cubs. Kipling's and George's wolves, and even the wolves in the story of the wolf girls, live and appear in packs. Within the context of the source legends of Romulus and Remus, the wolf represents more than a wolf. Sent by Mars to save his royal heirs, the Lupa Romana becomes a sign of divine intervention. In turn, the wolf's presence becomes a symbol not only of the god's intervention but also of the special fate awaiting the twins (Dulière 1979, 14).

Although Kipling's wolf pack includes a few untrustworthy wolves (followers of the lame tiger, Shere Khan), for the most part the wolves, like the jungle where they live, are orderly, living by convention and codes. Father Wolf, as well as the four wolf cubs who grow up with Mowgli, offer loyalty and companionship to the man cub. At the head of the Seownee wolf pack stands Akela, the Lone Wolf. Unlike the wolf of traditional tales, Akela is lone because of his status as pack leader, not because he is without a pack, family, or alliances. To remain fair and just, Akela, like a good king, must remain separate and above the other pack members. Akela is an honorable leader, putting duty and service before himself and never fearing to fight for his Free People, as the wolf pack is known.

Whereas Kipling's characterization of the wolf pack reflects an idealized view of human society, George, in *Julie of the Wolves* and related works, uses Eskimo attitudes and scientific understandings of wolf behavior to characterize the wolf pack. In George's book, Julie's wolf pack does not speak of laws, rules, and codes of conduct as in Mowgli's pack. Yet it is nevertheless an orderly and ordered pack as exhibited by the respect they show one another, especially their leader, whom Julie names Amaroq. When Amaroq summons them, the two adult wolves "Silver and Nails glided to him, spanked the ground with their forepaws, and bit him gently under the chin. He wagged his tail furiously and took Silver's slender nose in his mouth. She crouched before him, licked his cheek, and lovingly bit his lower jaw" (George 1972, 18). By studying the interactions between the wolves, Julie learns the visual cues to communicate her needs and intentions to the pack, especially to Amaroq.

Perhaps the most distinctive element of all these stories is the presence and significance of female wolves. Each of these works builds on the image of the female as nurturer and protector of her young. In *The Jungle Book* as in the founding myth of Rome, a female wolf takes in, protects, and nurtures human children. Sent by Mars to protect his half-human offspring from their uncle, Lupa Romana cares for the infants. Although descriptions of the she-wolf's protective side are lacking in the source versions, visual images of the she-wolf nursing the children typically depict her with her mouth open, suggesting her fierce and protective nature.

Anne Rockwell's *Romulus and Remus* offers a sanitized version of the myth, at the same time giving the she-wolf a more prominent role. Rockwell's she-wolf raises the children to adulthood, rearing them with her pups, making sure they are well fed and well cared for. And like any human mother, when the boys' wrestling and quarreling get out of control, she reprimands them.

Although Father Wolf finds the man-cub and deposits him among his wolf cubs in *The Jungle Book*, Mother Wolf is the one who claims him. On two occasions she defends his life: first against Shere Khan when the tiger comes looking for the human cub that has escaped. "And it is I, Raksha [the Demon], who answer. The man's cub is mine, Lungri—mine to me! He shall not be killed. He shall live to run with the pack and to hunt with the pack; and in the

end, look you, hunter of little naked cubs—frog-eater—fish-killer—he shall hunt thee!" (Kipling 1995, 7). Father Wolf's reaction to his mate's response reveals the threat behind her words: he would not want to tangle with her. The second instance occurs during the presentation of Mowgli to the larger pack at Council Rock. Like Lupa Romana, Mother Wolf's nurturing role brings out her fierce and protective side. Rather than breaking with more traditional female roles, both she-wolves, in displaying their power and aggressiveness, reflect their maternal instincts. Their willingness to kill or be killed to safeguard the lives of their young is inherent to their role as nurturers.

In *Julie of the Wolves*, the she-wolf is Silver, the alpha female and mother of the wolf pups. Silver cares for her pups in several ways: when she hunts with the rest of the pack, she leaves them in the care of a babysitter wolf; later, when the pups are old enough, she takes them out on their first nighttime hunt. Yet as Julie begins to befriend the wolf pups, Silver displays no possessive maternal instincts and remains unbothered by Julie's presence and close physical proximity to her pups.

In general, Silver plays a minor role both in the story and in Julie's attempts to enter into the pack. Indeed, Julie, instead of looking to Silver for acceptance, looks to the alpha male, Amaroq: "Propped on her elbows with her chin in her fists, she stared at the black wolf, trying to catch his eye. She had chosen him because he was much larger than the others, and because he walked like her father, Kapugen, with his head high and his chest out . . . The pack looked to him . . . If he was alarmed, they were alarmed. If he was calm, they were calm" (George 1972, 7). For this reason, Julie understands that before the pack will accept her, Amaroq must do so. Julie's interest in forming a relationship with Amaroq shows a reversal of Lupa Romana's relationship with the male infants. At the same time, it suggests differences in cross-gender bonding, age, and expectations—a prepubescent daughter seeking acceptance, approval, and help from her father while the infant son receives unconditional love from his mother. Julie, like the male infants, is hungry, yet unlike them, she must work at being recognized and accepted. Her relationship with Amaroq reflects her relationship with her human father; just as Julie uses the knowledge imparted to her by her father to guide her, so she begins to look to Amaroq to guide and provide for her. Amaroq becomes Julie's wolf father.

Within the context of nurturing and feeding, milk, specifically mother's milk, is a motif cutting across these three stories. In each, human children nurse on she-wolves. In Plutarch's biography of Romulus, he says that a basket containing two children landed on a shore, under a wild fig tree. The tree is called *Ruminalis*. Plutarch gives several explanations for this name, including its association with "the suckling of these children there, for the ancients called the dug or teat of any creature *ruma*; and there is a tutelary goddess of the rearing of children whom they still call Rumilia, in sacrificing to whom they use no wine but make libations of milk" (Plutarch 1952, 16). The most famous image of Romulus and Remus is that of the infant boys nursing on

the standing she-wolf. In Rockwell's reader, Romulus and Remus are pictured nursing alongside the she-wolf's two cubs. Rockwell's text explains that the wolf feeds them whenever they are hungry, and the boys grow big and strong.

Almost as soon as Father Wolf places Mowgli among the cubs, the infant pushes the cubs away so he can nurse. Similarly, when Mowgli first meets his foster human mother, Messau, she gives him warm milk. Seven years later, when Mowgli returns to her, she again gives him milk to calm him. When we first meet the pack, Julie observes that some of the pups are still trying to suckle: "Zing, the incorrigible Zing, was nursing again. Silver growled . . . Then Sister . . . snuggled up to her mother, suckled two or three times, more for comfort than food" (George 1972, 51). Starving, Julie takes a cue from Zing and Sister: "She inched forward on her stomach and elbows until she was close to her mother . . . Slipping her hand beneath a nipple she caught several drops, keeping her eyes on Silver to discern her mood. Slowly Miyax [Julie] brought the milk to her mouth, lapped, and found it rich as butter" (ibid.). Like the pups, Julie is adolescent or near adolescent and too old to nurse. As with her pups, Silver stops Julie: "Silver closed her jaws on Miyax's shoulder and held her immobile" (ibid.). This sharing of milk expresses more than nurturing. An intimate act, it reinforces the mother–child bonds, and in these instances, the wolf–child bonds. As such, it serves as a tangible expression of their relationship. Further, by imbibing the wolf's milk, the child receives part of the wolf, becoming part wolf.

Although Messau and Mother Wolf represent the different worlds Mowgli must straddle, they are very much the same character. Both are foster mothers to Mowgli; both protect him—Mother Wolf from Shere Khan and the renegade wolves, Messau from a hunter and superstitious townspeople. In return, Mowgli repays Mother Wolf's kindness and love by killing Shere Khan. For Messau, he rescues her from the villagers who turn on her for having helped him, the wolf-child. They each provide him with a home, family, and foster brothers. They love Mowgli. Mother Wolf confesses to him that she loved him more than her other cubs; Messau also loves Mowgli, promising him marriage to a princess. Both oversee the education of Mowgli: Mother Wolf has Baloo and Bagheera teach Mowgli, along with her wolf cubs, the law and how to hunt while Messau teaches Mowgli human language and customs and how to work in a village. The jungle develops Mowgli's strength, stamina, and integrity and it is from Messau that Mowgli first hears of his physical beauty. Although the circumstances are different, the last words that Mother Wolf and Messau speak to Mowgli are pleas for him to return: "Come back!"

Wolf-Children

If wolves such as Stinkface, Timide, and Little One reflect human qualities and behaviors, what wolfish or wild qualities do children saved or raised by

wolves take on? For the most part, the wolfish traits are reflected in the physicality of the young protagonists' experiences and behaviors.

Although the source versions represent Romulus and Remus's contact with the wolf as limited and brief, references to their strength speak to their connection with Mars and the she-wolf. Anne Rockwell's beginning reader diverges from the source versions: the she-wolf raises the two boys. The physicality of the two brothers reflects their wolfish upbringing, and their strong, healthy bodies are a result of their active, outdoor rearing. Romulus and Remus play and wrestle each other and their wolf brothers. Spear in hand, they hunt alongside the wolves. In Rockwell's version, the twins eventually go their separate ways. Romulus, whom Rockwell characterizes as being slightly bigger and a better fighter, however, becomes more interested in building than in fighting, while Remus continues to hunt with his wolf siblings.

Raised as a wolf cub, Mowgli is socialized in the way of the jungle and educated in the language of the animals. In the jungle, he eats raw meat, sleeps under the open sky, swings from tree to tree, and until his first stay with humans, hunts without weapons. From his messy hair to his fierce eyes and naked or seminaked body, illustrators give Mowgli a wild appearance. His naked or seminaked state serves as an expression of his upbringing in and among the wild. Like the animals in the jungle, Mowgli wears no clothing and has no need of it. When Mowgli goes to stay in the village, his lack of clothing underscores the differences between him and the villagers. Significantly, after Mowgli's first stay in the village, most illustrators, such as William Bartlett, Inga Moore, and Kurt Weise, have dressed him in a loincloth, suggesting that his contact and stay with humans have changed him.* Yet even this scrap of clothing keeps him different from the villagers, who are depicted more fully clothed.

Because Mowgli's story covers the first seventeen years of his life, the illustrations feature images of him at different ages. Illustrators typically feature images of his arrival, a naked baby among a family of wolves. The opening illustration depicts the infant boy pushing aside the cubs to nurse. Reverses

* Since its publication in 1893, numerous illustrators have given visual dimension to *The Jungle Book*, including Kipling's father J. L. Kipling, Kurt Weise, Fritz Eichenberg, William Bartlett, Inga Moore, Jerry Pinkney, and Nicola Bayley. There are also at least two editions based on the images from Disney's movie. For the most part, illustrators depict such key scenes as Mowgli's arrival; Mother Wolf protecting Mowgli from Shere Khan; Mowgli's introduction at Council Rock; Mowgli brandishing a torch to threaten the renegade wolves and Shere Kahn; Mowgli, Bagheera, and Akela on Shere Khan's skin spread on Council Rock; and Mowgli's farewell. Mowgli is also depicted nursing on Mother Wolf, pulling thorns from a wolf's paw, and being licked by a wolf. He rides on Bagheera's back and sleeps next to him in the trees. He hugs Baloo and lies next to him. Even though Mowgli is raised in a wolf family, many of his adventures take place with Bagheera. The artwork reflects them, and the Disney animated film and books feature them too. Disney's version begins with Bagheera finding a baby washed ashore in a boat. Even though Bagheera leaves the baby with a wolf family and the wolf pack meets at Council Rock to decide Mowgli's fate, for the most part wolves are absent in the Disney versions.

in the relationship are also reflected in the images of an adolescent Mowgli waving a flaming torch, a technology all animals save humans fear, to drive away the rebellious young wolves and defend the aging Akela, a noble wolf and leader. The images of Mowgli and his wolf family, like those of him with Bagheera and Baloo, use the close physical proximity of the characters to express the familiarity and love between the boy and his wild family. Contrasted with these are scenes of Mowgli fighting Shere Kahn and the rebel wolves, attacking the village, and leading the wolves against the red dogs. As a whole, these images do more than highlight Mowgli's adventures: they underscore his role in the jungle and his relationships with its various inhabitants.

Unlike Mowgli, who is raised among animals and communicates easily with them, Julie must learn the language of the wolves. Much of George's text contains descriptions of the wolves' actions, which Julie interprets for us as she tries to decipher and imitate their gestures. Because of her need to survive, she becomes wolflike in her actions, mimicking their postures and movements. To disguise her humanness and allay the wolf pack's suspicions, Julie crawls on her hands and knees, bows before the alpha male, and looks at him adoringly. When Julie discovers how adult wolves returning from a hunt feed their pups—a young wolf sticks its nose into the corner of the adult wolf's mouth causing the adult to regurgitate its food—she attempts to do the same by sticking her hand into the corner of a wolf's mouth. Although she fails, the wolf pup Kapu understands what she needs and does it for her.

Wendell Minor's black-and-white illustrations feature images of Julie, the wolves, and the Arctic landscape. Minor's drawings provide glimpses of Julie's life before she ran away, but from the opening image of *Julie of the Wolves,* which shows Julie and the wolf pack standing on opposite hills to Julie turning away from her wolf friend Kapu, Minor's pictures capture the significant moments of their relationship: Julie submitting to Amaroq; Julie watching the pack take down a caribou; Julie fighting off Jello, the omega wolf; and Julie caring for the wounded wolf pack. Further, Julie loses her human shape inside her sealskin parka with wolverine fur trim. Indeed, when a plane full of hunters flies overhead, she fears that they will mistake her for a bear.

In Yolen's account of the wolf girls of Midnapore, Singh, the missionary who takes the girls in, uses the wolf girls' physical condition, movements, and inability to communicate as evidence of their feral state. Yolen summarizes Singh's journal entries, which depict the girls as being covered in mud, fleas, and scars thus: "The heels of their hands were callused from running on all fours. Their ears trembled like a dogs when they were excited. Their brows were bushy and long . . . Their teeth were close-set . . . the canines longer and more pointed than in humans" (Yolen 2001, 23). He describes them as eating raw meat, chewing bones, and lapping milk from a bowl. The girls also refuse to wear clothing and tolerate only loincloths. To communicate, they howl like dogs. After the youngest sister dies, the older one becomes less feral, learning to walk on two feet and gaining some human language skills.

Nature or Civilization: Straddling the Wolf–Human Divide

Romulus and Remus are noted for their strong and healthy appearances: "In their very infancy, the size and beauty of their bodies intimated their natural superiority; and when they grew up they both proved brave and manly . . . showing in them a courage altogether undaunted" (Plutarch 1952, 17). Yet the two serve as counterparts: the one representing civilization and the other, wild nature. Plutarch describes Romulus as preferring "to act by counsel," exhibiting "the sagacity of a statesmen" (ibid.). When the brothers decide to build a city, their choice of sites reflects their characters. According to Plutarch, Romulus chooses the square while Remus chooses an area on the Aventine Mount "well-fortified by nature" (ibid., 19). Rockwell's version demonstrates the difference in the two brothers by their different actions; Romulus founds a city while Remus continues to hunt with his wolf brothers. In Rockwell's story, the people of Rome decide to honor Romulus by naming him their king. Romulus throws a feast to celebrate, inviting both the she-wolf and his brother Remus. While the she-wolf joins in the festivities by dancing with Romulus and the other guests, Remus leaves and returns to his wolf brothers. Rockwell's endnote points out that the Italian expression used to indicate a wild or turbulent mob, *turbi remi*, derives from Remus's name, expressing the divide between the wild and civilized as represented by the two brothers.

Jungle life as proposed by Kipling is orderly and just. Its inhabitants live according to laws and conventions passed on to the young through teachers like the brown bear Baloo, the python Kaa, and the panther Bagheera. The laws ensure justice within the jungle but also refer to groups outside the jungle, particularly humans and their livestock: "The Law of the Jungle, which never orders anything without a reason, forbids every beast to eat Man except when he is killing to show his children how to kill, and then he must hunt outside the hunting grounds of his pack or tribe" (Kipling 1995, 4). Further, the animals who consume human flesh suffer visible and physical consequences: "Maneaters become mangy, and lose their teeth" (ibid.). As Kipling points out, even though the reason given for the proscription against eating humans is that "man is the weakest and defenseless of all living things," the real reason for this is that man-killing, sooner or later, brings "the arrival of white men on elephants, with guns, and hundreds of brown men with gongs and rockets and torches. Then everybody in the jungle suffers" (ibid.). So although the law of the jungle describes man as the weakest of all animals and has, except for specific circumstances, provisions against killing man, it makes clear that man is the most dangerous of all predators.

As Mowgli ages, his struggles as a human raised by wild animals increase. Mother and Father Wolf raise Mowgli with and as a wolf, and until the rebellion, Mowgli considers himself to be a wolf. He sleeps with, hunts with, and shares his kill with the other wolves. He picks thorns out of their paws and

burs off their coats. The scars on Mowgli's arms indicate that he wrestles and plays with his lupine siblings. With his wolf brothers he learns the laws and customs from Baloo and hunting from Bagheera. Being called a man or man's child angers him and he denies it.

Yet through his adventures, Mowgli remains a human, distinct from the other animals. Several times in the story, Bagheera makes the comment that Mowgli is behaving as a man—vengeful, arrogant, and careless. But it is his ability to look an animal in the eyes—to stare an animal down, making even his closest friend, Bagheera, uncomfortable—that marks him as a human. Kipling's descriptions suggest that even for a human, Mowgli is especially bold and fearless. When Father Wolf finds him, he looks at the wolf and laughs. Placed among the other wolf cubs, he pushes them aside to feed. While undergoing the identification ritual, Mowgli is more interested in playing with pebbles than in the proceedings.

After Shere Khan and his band of renegade wolves rise up, Mowgli leaves the jungle and returns to human society. But his time in the jungle has left him ill-prepared for life in a village. Although he can communicate with wolves, tigers, panthers, bears, and other wild animals, he does not speak or understand human language. To him, sleeping and living indoors is akin to being trapped. And though he knows how to hunt, he does not understand farming and disdains domesticated livestock. To the villagers the scars on his body are evidence of his wild upbringing, forever marking him as an outsider and an unnatural being. Mowgli's time in the village is short-lived. When Mowgli kills the tiger Shere Khan and refuses to give the carcass to the village hunter Buldeo, Buldeo attacks Mowgli by claiming that the boy can change into a beast. The villagers side with Buldeo, who, by playing on their fears and superstitions, convinces them that Mowgli's relationship with wild animals is a sign of sorcery.

After being ostracized by humans, Mowgli returns to the jungle. His perception of himself has changed. When invited to join the newly formed wolf pack, he refuses, saying he will hunt alone. But it is hard for Mowgli to change old habits. Not only does he continue to hunt with his four wolf brothers, but he also seeks the jungle's help in retaliating against the villagers who rejected him. In turn, he helps the new pack in its battle against the dholes or Red Dogs.

During his seventeenth year, in the spring when the jungle animals are busy seeking and being with their own kind, it becomes clear that Mowgli, no longer a boy, has outgrown the jungle. Unlike other springs, during which Mowgli mocked the New Talk—the cries, songs, and grunts of the animals—this time spring brings with it heaviness, sadness, and loneliness, suggesting his sexual maturation. When his friends and wolf brothers are slow to respond to his calls, he accuses them of being disloyal and disrespectful to their master. But as they point out to him, they have not changed—he has. While assuring Mowgli that the jungle will always be there to help him, Baloo tells him

"to take thine own trail; make thy lair with thine own blood and pack and people" (Kipling 1995, 229). Mowgli admits that although he wants to stay, he is drawn to the world of humans. Baloo reminds him that no words or will hold him, that except for Baloo and Bagheera those who raised him are long gone. Bagheera buys Mowgli his freedom with the body of a young bull: "Man goes back to Man" (ibid.).

In *Julie of the Wolves*, humans also are characterized as dangerous to wolves in particular and to nature in general. Yet George makes distinctions between different human cultures and groups. Whites or *gussaks* are particularly dangerous—they hunt for bounties, not for need. Whites also hunt in ways that are extravagant and unfair: shooting wolves from planes. When a group of aerial hunters attacks Amaroq's wolf pack, Julie looks up and sees "the belly of the plane. Bolts, doors, wheels, red, white silver, and black, the plane flashed before her eyes. In that instant she saw great cities, bridges, radios, school books . . . long highways, TV sets, telephones, and electric lights. Black exhaust enveloped her, and civilization became this monster that snarled across the sky" (George 1972, 141). White money, alcohol, technology, and values corrupt the Eskimo and destroy their culture as surely as the white hunters destroy the wolf. Throughout her novels, George equates the wolf with the Eskimo—both are nomadic, hunt to survive, and kill only what is needed.

Between human and wolf, white and Eskimo, modern and traditional, and cultural and economic, Julie must learn to negotiate different and competing worldviews, values, and ways of life. Like Mowgli, she has two names—Julie and Miyax—one English and one Inupiaq. Her time with the wolves requires her to draw on her knowledge gained from Kapugen, her Eskimo father, whom she remembers as equating Eskimo society with wolf society. Yet as Julie discovers, her father is the pilot who flew the aerial hunting party that killed Amaroq, injured the young wolf Kapu, and left the wolf pack leaderless. Even as she realizes that economic reasons compel her father and other Eskimos to relinquish their traditional attitudes and lifestyle for modern ones, Julies considers the change in her father's behavior and views it as a collapse of integrity that endangers the Eskimo as well as the wolf. As Julie sings in her final song to Amaroq: "The hour of the wolf and the Eskimo is over" (George 1972, 170).

Yet at the end of the book and in its sequel, *Julie*, Julie returns to live with her father. Although she loves her father and even at one point forgives him for killing Amaroq, it is clear that she disapproves of his decision to reject traditional ways in favor of more modern, white ways. Minor's illustrations for *Julie* highlight Julie's new life with her father, a world torn between traditional and modern ways expressed most strongly in the image of her father carrying a rifle. Yet Julie also compromises. When her father insists that she learn to shoot a gun to hunt foxes, Julie does, making the action more palatable by framing it within a more traditional view: the fox gives itself to her.

At first, Julie rejects her father's new way of life and his new American wife by pretending not to speak or understand English. Even though she allows her

father to call her by her Inupiaq name, Miyax, to others she remains Julie. At the same time, Julie reads and writes in English, reads her stepmother's books on the sly, and values education.

Julie moves between different worlds—that of the humans and that of the wolves, of the whites and the Eskimos, and of the modern and the traditional—and becomes the conduit between them. Her relationship with her father begins to change as she begins to slowly change him. When the caribou herds fail to return, both humans and wolves face starvation. Julie understands that a sighting of a wolf pack near her father's musk-oxen herd means her father will hunt them to protect his herd. As he explains to her, he now lives according to "Minnesota rules": in Minnesota, though the wolf cannot be hunted, "when a wolf comes onto a person's land and kills his cattle, then the government environmental officers come and shoot him. They shoot the ones that compete with humans. They think that is fair. That is how it is between humans and wolves in Minnesota" (George 1994, 113). Julie retorts by reminding him that the Eskimos are different and that "we know the wolf is from the earth and must live so we all can live" (ibid.). When he responds that they now live like white men, Julie stops her father from acting immediately by requesting a chance to move the pack to a different location, to an area where there is wild prey on which to feed.

Julie's attempts to move Kapu's pack to an area where food is plentiful almost fail because of the presence of a second wolf pack. The region she finds has plenty of moose, but the moose are in what George calls a "no wolf zone"—between the borders separating two packs. When Julie realizes that the second pack is led by Kapu's mother, Silver, she sets out to entice the she-wolf and her mate to unite with Kapu. Julie, with Kapu's scent on her, acts as envoy for Kapu and his pack. After some initial hesitation, Silver and her mate join Kapu.

In Julie's absence, her stepmother has given birth to Julie's brother. Her father tells her that the baby has a wolf spirit and that he will call the baby Amaroq: "By giving my son the name of your great wolf leader, I have said he will be like him. Little Amaroq will hunt for himself, he will hunt for his family, and he will defend his tribe against enemies, And like the wolf he will be integrated into the universe" (George 1994, 167). When Julie returns, Julie is surprised that her father wants to name the baby Amaroq after a wolf he "killed and did not like" (ibid., 168). She accepts his explanation that by killing Amaroq, a wolf who preyed on the town's musk oxen, he was protecting the town. He also explains that he would do it again, that killing wolves that attack his livestock comes under a different law, "Minnesota law." The breech between Julie and her father, however, is completely healed only when her father decides to release his musk-oxen herd and to share the land and coexist with the wolves as Eskimos do.

The illustrations of Kipling's and George's works highlight the different physical environments that make up Mowgli's and Julie's worlds. Mowgli's is a rich, verdant jungle filled with trees, vines, plants, and animals. It is a space

teeming with life. In contrast, the nature with which Julie must contend is the open, barren tundra of the Arctic. The ways in which the two protagonists live—Julie in heavy, thick clothing that reshapes her form and Mowgli, naked or seminaked—reflect the climate of each environment. Whereas Julie fears freezing to death, Mowgli fears heat and drought.

Changing Roles and Relationships

By reconfiguring the roles of the child and the wolf, authors reconfigure their relationships. Through visual and textual allusions, three stories in particular revise "Little Red Riding Hood" by recharacterizing either the child or the wolf. In Marie Coimont's *Marlaguette*, a young girl overcomes the predatory wolf who accosts her in the woods, while in Antoine Guillope's *Loup noir*, a young boy's lupine stalker turns out to be his rescuer. In Delphine Perret's *The Big Bad Wolf and Me*, a young boy helps a wolf, who is down and dejected because he has lost his edge, rediscover his big, bad ways. In each of these works, a friendship develops between the child and the wolf.

From the start, Marie Coimont's *Marlaguette* recalls "Little Red Riding Hood." The story begins with a little girl in a red skirt walking through a forest and carrying a picnic basket. When a big gray wolf attacks her, Marlaguette fights back, injuring the wolf. When she realizes that his injuries are serious, she nurses him with bandages, compresses, and, to the wolf's dismay, herbal tea. To help him recuperate, Marlaguette walks him in the woods. When the wolf chases and kills a bird, Marlaguette strikes him, calling him wicked, and threatens to leave him until he promises never to attack other animals. In return, Marlaguette feeds him vegetarian meals. But when the wolf grows lean and fails to thrive, a woodsman warns Marlaguette that she is killing the wolf—that being a wolf means he needs to eat meat—but that the wolf loves her so much that he is willing to die for her. The story ends with Marlaguette releasing the wolf from his promise and from their life together.

The story of Marlaguette is unusual for the time in which it was written. Not only does Coimont suggest the need to accept the wolf for what it is, but she rewrites more traditional encounters between a little girl and a wolf, in which the wolf's power and strength pose a danger to the child. In Coimont's story the wolf is no match for the young girl. Yet Marlaguette's strength in inflicting injuries on the wolf is matched by her concern for the wolf's physical well-being. From responding to the wolf's attack to nursing the wolf, reforming the wolf, and eventually letting the wolf go, control rests with Marlaguette.

A wolf rescues a young boy in Antoine Guillope's picture book *Loup noir*. Incorporating images of the woods, a wolf, a young person alone, and darkness descending, Guillope evokes the scenario from "Little Red Riding Hood." From the wolf's white eyes watching the young boy as he enters the woods to his white teeth within his black muzzle and his open-mouthed lunge towards

the youth, Guillope's black-and-white images create tension and underscore the potential danger. Yet this wordless story of a boy stalked by a wolf as he makes his way through the woods on a snowy night ends with a twist. The wolf lunges at the boy to push him out of the way of a falling tree. The wolf's action suggests that he senses impending danger—that he stalks the boy not to devour him but to watch over him. When the boy realizes what the wolf has done, he rewards him with a hug.

In *The Big Bad Wolf and Me*, a boy on his way home from school finds a wolf, whom he at first mistakes for a lost dog. When the wolf claims to be the Big Bad Wolf, the boy tells him he does not look scary and comments on his small stature. The wolf's response explains his state: "Nobody believes me anymore. I don't scare anyone. I'm done for" (Perret 2006, 7). From his name, Bernard, to his slight figure, the wolf is a shadow of his former self. His diminished image as a dangerous predator speaks to more contemporary and scientific understandings of the species. The boy takes the wolf home with him, renames him Zorro, feeds him chocolate-chip cookies, and retrains him in his role as the Big Bad Wolf. As the wolf practices and grows stronger, he begins to regain confidence, until one day he succeeds in scaring his friend. The story ends with the two sitting next to each other on a park bench, the boy giving the wolf a box of cookies and asking how it feels to be the Big Bad Wolf again.

Nurturing Children

While these works play off the image of the devouring wolf of traditional tales, other works replace the image of the nurturing wolf with that of the child as protector and the wolf as victim. As in Coimont's, Guillope's, and Perret's stories, the children and wolves form friendships with each other.

Although images of children saving or rescuing wolves are more common to contemporary fiction and nonfiction, one of Ernest Thompson Seton's stories from the late nineteenth century features a young boy who helps ease the plight of a captive wolf. "The Winnipeg Wolf" is an account of the relationship that develops between an orphaned wolf and a young boy, Little Jimmy. The wolf arrives in Jimmy's life when a hunter kills and scalps a she-wolf and her eleven pups, save one. After receiving his money for the scalps, the hunter gives the remaining wolf pup to a saloon owner, who keeps the wolf for the amusement of his drunken clientele and their dogs. In gratitude for killing a dog that bites him, the saloonkeeper's son Jimmy begins to feed the wolf, treating it like a pet. Further, the wolf is not the only one abused; when drunk, the saloonkeeper also beats his son, Little Jimmy: "One day, seeking safety in flight with his father behind him, he dashed into the wolf's kennel, and his grizzly chum thus unceremoniously awakened turned to the door, displayed a double row of ivories, and plainly said to the father: 'Don't you dare touch him'" (Seton 1905, 297). From that moment the wolf and the boy protect one

another: "Thus the friendship between Jim and his pet grew stronger, and the Wolf as he developed his splendid natural powers, gave daily evidence also of the mortal hatred he bore to men that smelt of whiskey and to all Dogs, the causes of his suffering. This peculiarity, coupled with his love for the child— and all children seemed to be included to some extent—grew with his growth and seemed to prove his ruling force in life" (ibid., 299). When his father allows a German nobleman to demonstrate the abilities of his hunting dogs by setting the dogs on the wolf, Jimmy stops the hunt by placing himself between the dogs and the wolf. Seton illustrates this scene with an image of Jimmy hugging the wolf.

When Jimmy gets sick and his visits to the wolf stop, the wolf suffers: "The Wolf howled miserably in the yard when he missed his little friend, and finally on the boy's demand was admitted to the sick room, and there was his great wild Dog—for that is all a Wolf is—continued faithfully watching by his friend's bedside" (ibid., 307). When Jimmy dies, Seton describes the wolf as the child's most "sincere mourner," howling along with the church bells. Even death does not sever the wolf's ties to the boy. When the wolf escapes from Jimmy's father, it takes up residence in the woods near the graveyard to remain close to Jimmy.

David McPhail's *A Wolf Story* also pits children against adults. When a wolf, captured and chained for a movie, escapes, a group of schoolchildren come to its aid by standing between the wolf and the marksmen sent to hunt it down. From the trapping and binding of the wolf to their pursuit of the fugitive wolf, McPhail contrasts the brutality of the adults with the children's compassion. In the alignment of the wolf and the children, adults represent the enemy; with the children's help the wolf is able to regain its liberty.

As we have seen, at the beginning of Jean Craighead George's *Julie of the Wolves*, Julie, lost and starving in the Alaskan wilderness, relies on a wolf pack to survive; at the end of the book, however, she helps the surviving pack members recover from an aerial attack by hunters. After Amaroq is killed, the young wolf Kapu runs to him: "Bullets showered the snow around him. He leaped, dodged . . . His wide eyes and open mouth told Miyax he was afraid for the first time in his life" (George 1972, 141). Kapu is injured in the attack, and Julie begins to nurse him. Building her tent around his fallen body, she takes him into her space. Using sinew as thread, she begins to stitch him, calming him with "the healing song of the old bent lady" (ibid., 145). Later, as Amaroq's pack mates howl mournfully, Julie bids farewell to Amaroq. Lacking a bladder to hold his spirit, she asks him to enter the wolf totem, which she has carved, and "to be with her forever" (ibid., 147).

Julie, upon discovering that her father is responsible for this attack on her wolf pack, reacts by fleeing from him. Her reaction to her father's new way of life reflects a message found across contemporary nonfiction and fiction featuring wolves: where before wolves were perceived as a threat and were used to represent behaviors threatening human society, now the humans, adult

humans in particular, threaten the existence of wolves. Further, the threat to individual wolves becomes a symbol for the threat to the species and to nature.

George's picture-book story *Nutik the Wolf Pup* takes place several years later, when Julie's brother Amaroq is about seven or eight years old.* In it, Kapu's wolf pack leaves two sickly pups for Julie to raise and nurture. Julie has her brother help her. She names her pup Uqaq, and Amaroq names his Nutik. Images of Nutik and Amaroq feature them running together, sleeping together, and interacting with one another. Like Mowgli, who, as he ages, eventually feels compelled to return to human society, Nutik, as he gains weight and strength, feels the need to return to his wolf family. Indeed, his family begins to call for his and his sister's return. Nutik tries to get Amaroq to accompany him, but the boy refuses: "You must go home alone" (George 2001, 29). We follow Amaroq as he flees, brokenhearted, Nutik and the wolf pack. Yet the next day, when Amaroq seeks comfort by hiding in his sleeping bag, he finds Nutik snuggled within it. At the end, Julie calls to the wolves and tells them that their pup has joined her family, assuring them that she will "take care of him as lovingly as you took care of me" (ibid., 33). And although the story focuses on Amaroq's relationship with his wolf pup, it also suggests that the bonds between Julie and the wolves are long lasting, that they remember her and trust her.

The most striking and poignant of these pictures is that of Amaroq, the young son of a hunter, bottle-feeding the "grandson" of the wolf killed by his father (see Figure 6.3). In part, the image reverses that of Lupa Romana, the she-wolf who nursed Romulus and Remus. Unlike Romulus and Remus's family, who sent the children away to kill them, Kapu and his pack bring the two wolf pups to Julie to save them. Where before a wolf saved the life of a human child, now a human child saves the life of a wolf pup. The image, however, does more than reverse the roles of the wolf and the child. Beyond breaking gender stereotypes—the nurturing male replacing the male hunter—the image offers hope as it underscores the power humans hold over the fate of other species, reinforcing the message that if the wolf is to survive, then humans must change.

* Kapu's request that Julie raise Nutik and his sister Uqaq originally appears in George's third Julie novel, *Julie's Wolf Pack* (1997). There are significant differences between the novel and the picture-book version. In the novel, Julie's brother Amaroq is a toddler raised along with the wolf pup Nutik. In the picture book, he is a boy of seven or eight who, at Julie's request, raises Nutik.

Chapter Seven
Transcending Literature

By condemning the European and Euro-American extermination of the wolf and stressing the need to preserve and restore the wolf to former habitats, authors of contemporary works encourage their young readers to do better by doing differently than past generations have done. In *There's a Wolf in the Classroom!* Weide and Tucker raise Koani to be a diplomat wolf, using Koani to help teach young people about wolves by giving them an opportunity to see and interact with a real wolf. Their experience with a wolf was intended to diminish children's fears and dismantle its evil reputation. Indeed, at the end of the book, Koani's success is measured by a girl's reaction to an anti-wolf agitator. At a town meeting in Montana, a girl speaks up for Koani, thereby silencing an adult protestor's voice. Informational books like this one align children with wolves while empowering young people to stand against closed-minded attitudes.

In addition to providing contact information for wolf and environmental organizations and resources for further reading, several contemporary works conclude by inviting young people to become involved in protecting. In *Face to Face with Wolves*, Brandenburg includes a section on "How You Can Help." In it, he provides a page of ideas suggesting how young people can make a difference, including being advocates for wolves, learning about different organizations that help wolves in the wild, donating money towards the support of a wolf (adopting a wolf), and writing to their congressional representatives. In addition to giving advice, Brandenburg reiterates the problems faced by wolves in the wild, specifically ranchers, hunters, and others who see wolves as a threat to their lives, livelihood, and game hunting (Brandenburg and Brandenburg 2008, 26). Similarly, Jonathan London, at the end of his work *The Eyes of Gray Wolf*, adds a page titled "What You Can Do." London suggests that young people become active in various wildlife organizations. While the messages of contemporary informational works and fictional picture books

advocate for wolves and for their protection and reintroduction by dispelling the myths and fears surrounding this animal, sidebars and addendums such as these explicitly promote environmental activism to young people.

Further, from Robert Baden-Powell's use of Kipling's Lone Wolf Akela to lead the Cub Scouts, to the recent video game Wolfquest in which children learn about wolves by creating wolf avatars, to a statue of three wolves at the entry of a children's zoo, images connecting wolves and children transcend the boundaries between the literary and the real. Although literary relationships between children and wolves are long-standing and repeated, these three images suggest an alliance between young people and wolves that contradicts the traditional use of the wolf as a metaphor for danger and an alliance that goes beyond the nurturing wolves in the legend of Romulus and Remus and Kipling's lupine characters in *The Jungle Book*.

Robert Baden-Powell, when looking for symbols to reflect his mission for his newly formed organization, the Boy Scouts, chose Kipling's Lone Wolf, Akela, to lead the youngest scouts, the Cub Scouts. Baden-Powell saw in Akela the wisdom, authority, and leadership that come with age and necessary requirements to mentor the boy cubs. Calling himself (and all the Cub Scout leaders) Old Wolf, Baden-Powell considered it his duty to guide young boys in the scouting ways. From the curious wolf cub to the majestic wolf standing proudly on a rocky cliff to today's Smokey Bear-like incarnation, images of Akela have graced the covers of the *Wolf Cub Scout Handbook* since 1916. Cub Scouts follow the "Law of the Pack":

> The Cub Scout follows Akela.
> The Cub Scout helps the pack go.
> The pack helps the Cub Scout grow.
> The Cub Scout gives goodwill. (*Wolf Cub Scout Book* 1959, 6)

The handbook explains that Akela* is the leader like a scout's mother, father, teacher, den chief, den mother, or cub master; that individual scouts must think of others in the pack; that the pack will teach the scout; and by being friendly and helpful, he will ensure that others are friendly and helpful to him.

In December 2007, the free video game for young people, Wolfquest, premiered. Developed by the Minnesota Zoo, eduweb, and the International Wolf Center and funded by the National Science Foundation, Wolfquest teaches players about wolf ecology and conservation. Set in Yellowstone National Park, the game involves players creating wolf avatars through which they learn about wolves by becoming wolves; each player learns different wolf survival skills including cooperation, competition, submission, and dominance. The Web site also hosts a chat room (where players correspond

* In the *Cub Scout Handbook* Akela is also an Indian Scout known as the Old Wolf.

with each other and with wolf biologists about wolves) and offers quizzes and prizes to participants. The game's producers describe their objectives as fostering "strong emotional connections between players and wolves, [and] changing player's attitudes towards wolves and habitat conservation in the real world" (www.wolfquest.org).

At the entrance to Chicago's Lincoln Park Children's Zoo is a statue of three wolves. The statue acts as a visual reminder of recent changes in our understanding of the wolf. Like contemporary informational books and several fictional picture books, the placement of the statue underscores the message that the long-term survival of the wolf depends on the ways in which young people perceive the species.

Indeed the story of the wolf remains unfinished. In 1990, it was estimated that fifty wild wolves remained in the western United States (Thiel and Ream 1995, 59). Less than twenty years later, scientists estimate the wolf populations in Wyoming, Idaho, and Montana at about twelve hundred (U.S. Fish and Wildlife Service 2007, "Factsheet"). These figures underscore the success of programs aimed at reintroducing the wolf to its former habitats along with the wolf's ability to adapt and thrive. Success, however, comes at a price.

As the number of wolves increases, so does the number of wolf attacks on livestock. This past year wolves were blamed for killing 170 cattle and 344 sheep. While these represent only a small percentage of the half million livestock in the region, government agents and authorized landowners killed more than 150 wolves blamed for killing or harassing livestock. Further, as recent research by wolf biologists David Mech and Luigi Boitani suggests, wolves do not require remote habitats to survive. Instead, wolves are proving that they can survive and thrive near human populations.

Not surprisingly, thriving wolf populations mean renewed efforts to remove the gray wolf from the Endangered Species List. On January 31, 2007, with the wolf populations in Minnesota, Wisconsin, and Michigan exceeding four thousand, the Department of the Interior's Deputy Secretary Lynn Scarlett announced the removal of the western Great Lakes population of gray wolves from the federal list of threatened and endangered species. The U.S. Fish and Wildlife Service also proposed removing the northern Rocky Mountain population of gray wolves from the list (U.S. Fish and Wildlife Service "Interior" 2007). Since the announcements of 2007, there have been appeals, lawsuits, and reversals concerning the wolf's status. In the waning days of the Bush administration, the acts removing the wolf from the Endangered Species List were once again announced and signed into law, turning over the federal protection and management of the wolf populations of Montana, Idaho, Minnesota, Wisconsin, and Michigan to the individual states. Environmental groups and wolf advocates looked to President Obama's new head of the Department of the Interior, Ken Salazar, for a reprieve. Yet on March 7, 2009, Secretary Salazar, a rancher from Colorado, approved removing the wolf from the list. On May 4, 2009, the wolf

was removed from the Endangered Species List, and federal protection in Montana, Idaho, Minnesota, Wisconsin, and Michigan, as well as portions of Washington, Oregon, and Utah, ceased.

Strong reactions on both sides—from promises to take wolf populations from eight hundred to one hundred to lawsuits filed on behalf of the wolves—along with the continued research, preservation, and restoration efforts of biologists, ecologists, and environmentalists suggest that neither the wolf's story nor its future is secure. As interactions between humans and wild wolves increase, the question "What is a wolf?" remains.

Bibliography

Primary Sources

Aesop. *Aesop's Fables.* Edited and illus. with wood engravings by Boris Artzybasheff. New York: The Viking Press, 1966.

————. *Aesop's Fables.* Illus. by Arthur Rackham. New York: Franklin Watts, 1912, 1967.

————. *Aesop's Fables.* Illus. by Jerry Pinkney. New York: SeaStar Books, 2000.

————. *Aesop's Fables.* Illus. with plates and decorations by Stephen Gooden and trans. by Sir Roger L'Estrange. London: Harrap, 1936.

————. *Aesop's Fables.* Retold, illus. and printed by Elfrieda Abbe. Ithaca, NY: Elfriede Abbe, 1950.

————. *Aesop's Fables.* Retold and illus. by Brad Sneed. New York: Dial Books for Young Readers, 2003.

————. *Aesop's Fables: Translated into English; With a Print Before Each Fable/Abridged for the Amusement & Instruction of Youth.* Illus. with woodcuts by Alexander Anderson. Cooperstown, NY: Stereotyped, printed and sold by H. & E. Phinney, 1829.

————. *Aesop's Fables: With Upwards of One Hundred and Fifty Emblematical Devices.* Illus. with woodcuts by Thomas Bewick. London: Printed for J. Booker; G. and W. B. Whittaker; Rodwell and Martin; and C. Whittingham, Chiswick, 1821.

————. *Aesop's Fables: With Upwards of One Hundred and Fifty Emblematical Devices.* Philadelphia: Thomas, Cowperthwait & Co., 1839.

————. *Aesop's Fables, With His Life: In English, French and Latin. Newly Translated. Illustrated With One Hundred and Twelve Sculptures. To This Edition Are Likewise Added, Thirty One New Figures Representing His Life.* Retold by Francis Barlow. London: Printed by H. Hills jun. for Francis Barlow, and are to be sold by Chr. Wilkinson [etc.], 1687.

————. *Fables from Aesop.* Retold by James Reeves and illus. by Maurice Wilson. New York: Bedrick Books, 1985.

————. *The Fables of Aesop.* Illus. by Edward Detmold. 1909. Reprint, London: The Folio Society, 1998.

————. *The Fables of Aesop: Printed from the Veronese Edition of MCCCCLXXIX in Latin Verses and the Italian Version.* 3 vol. Retold by Accio Zucco and illus. with the woodcuts newly engraved and coloured after a copy in the British Museum. Series: Editiones Officinae Bodoni. Verona: Officina Bodoni, 1973.

————. *The Fables of Aesop Paraphras'd in Verse and Adorn'd with Sculpture.* 4 vols. Retold by John Ogilby and illus. with engravings by Wenceslaus Hollar. London: Printed by Thomas Warren for Andrew Crook, at the Green Dragon in St. Paul's church-yard, 1651.

————. *The Fables of Esope, Translated Out of Frensshe into Englysshe by William Caxton.* Illus. with engravings on wood by Agnes Miller Parker. Newtown, Montgomeryshire, Wales: The Gregynog Press, 1931.

————. *The History and Fables of Aesop/Translated [from the French] . . . by William Caxton.* Facsimile from the copy in the Royal Library, Windsor Castle. Introd. by Edward Hodnett. London: Scolar Press, 1976.

————. *The Medici Aesop: Spencer MS 50 from the Spencer Collection of the New York Public Library.* Intro. by Everett Fahy. Trans. by Bernard McTigue. New York: Abrams, 1989.

Ahlberg, Janet, and Allan Ahlberg. *The Jolly Postman or Other People's Letters.* Written and illus. by Janet Ahlberg and Allan Ahlberg. New York: Little, Brown and Company, 1986.

Allard, Harry. *It's So Nice to Have a Wolf Around the House.* Written by Harry Allard and illus. by James Marshall. Garden City, NY: Doubleday & Company, 1977.

Amoss, Berthe. *The Three Little Cajun Pigs.* Retold and illus. by Berthe Amoss. New Orleans: TC Press, 1999.

Andres, Kristina. *Good Little Wolf.* Written and illus. by Kristina Andres. New York: North-South Books, 2008.

Aristotle. *The Works of Aristotle, The History of Animals*; volume II: Great Books of the Western World, Edited by Mortimer J. Adler. Chicago: William Benton Publishers and Encyclopaedia Britannica, Inc., 1952.

Artell, Mike. *Petit Rouge: A Cajun Red Riding Hood.* Retold by Mike Artell and illus. by Jim Harris. New York: Puffin Books, 2001.

Asch, Frank. *Ziggy Piggy and the Three Little Pigs.* Retold and illus. by Frank Asch. Toronto: Kids Can Press, 1998.

Auzary-Luton, Sylvie. *Noël chez Papy Loup.* Written and illus. by Sylvie Auzary-Luton. Saint-Germain-du-Puy, France: Kaléidoscope, 2001.

Aymé, Marcel. *Le loup.* Les Contes du Chat Perché. Written by Marcel Aymé and illus. by Perrain. Paris: Gallimard, 1941.

Bailey, Vernon. *Directions for the Destruction of Wolves and Coyotes* No. 55. USDA—Bureau of Biological Survey Circular, March 13, 1907.

Bannerman, Helen. *Little Black Sambo: Three Little Pigs.* Retold by Helen Bannerman. New York: Playette Corp., 1942.

Bedard, Michael. *The Wolf of Gubbio.* Retold by Michael Bedard and illus. by Murray Kimber. Toronto: Stoddart Kids, 2000.

Bidner, Jenni. *Is My Dog a Wolf?: How Your Pet Compares to Its Wild Cousin.* Illus. with photographs. New York: Lark Books, 2006.

Bonameau, Isabelle. *Amélie et le grand-méchant-loup.* Written and illus. by Isabelle Bonameau. Paris: L'Ecole des Loisirs, 2004.

Bouiller, Claire. *Un loup dans le potager.* Written by Claire Bouiller and illus. by Quentin Grebin. Namur, Belgium: Mijade, 2004.

Boujon, Claude. *La chaise bleue.* Written and illus. by Claude Boujon. Paris: Lutin Poche de l'Ecole des Loisirs, 2000.

———. *L'apprenti loup.* Written and illus. by Claude Boujon. Paris: Lutin Poche de l'Ecole des Loisirs, 1987.

Brandenburg, Jim. *Scruffy: A Wolf Finds His Place in the Pack.* Written and illus. with photographs by Jim Brandenburg. Edited by Joann Bren Guernsey. New York: Walker and Company, 1996.

———. *To the Top of the World: Adventures with Arctic Wolves.* Written and illus. with photographs by Jim Brandenburg. Edited by Joann Bren Guernsey. New York: Walker and Company, 1993.

Brandenburg, Jim, and Judy Brandenburg. *Face to Face with Wolves.* Face to Face with Animals. Washington, DC: National Geographic, 2008.

Bridgeman, John Vipon. *Little Red Riding Hood: Or, Harlequin and the Wolf in Granny's Clothing.* London: n.p., 1859.

Brimmer, Larry Dane. *The Littlest Wolf.* Illus. by Jose Aruego and Arian Dewey. New York: HarperCollins, 2002.

Browne, Anthony. *Into the Forest.* Retold and illus. by Anthony Browne. Cambridge: Candlewick, 2004.

———. *The Piggybook.* Written and illus. by Anthony Browne. New York: Knopf, 1986.

Buckingham, Leicester. *Little Red Riding Hood and the Fairies of the Rose, Shamrock, and Thistle: An Original Burlesque Extravaganza in One Act.* London: Thomas Hails Lacy, 1861.

Burgess, Thornton W. *The Burgess Animal Book for Children.* Illus. by Louise Agassiz Fuertes. 1920. Reprint, Mineola, NY: Dover Publications, Inc., 2004.

"Chèvre et le loup, La." *Contes de France.* Retold by Anne Rocard and illus. by Olivier Latyk. Paris: Editions Lito, 2001.

Chilsolm, Louey. "Red Riding Hood." *Red Riding Hood and Other Stories for the Four Year Old.* Retold by Louey Chilsolm and illus. by Katharine Cameron. London: T.C. & E.C. Jack, 1912.

Coimont, Marie. *Marlaguette.* Illus. by de Gerda. Paris: Flammarion, Albums du Père Castor, 1952.

"Come Santo Francesco libero la citta d'Agobbio da uno fiero lupo." *I Fioretti. Letteratura Italiana delle Origini.* Comp. by Gianfranco Contini. Florence: Sansoni, 1970.

Corentin, Philippe. *Patatras!*. Written and illus. by Philippe Corentin. Paris: Lutin Poche de l'Ecole des Loisirs, 1997.

———. *L'ogre, le loup, la petite fille et le gâteau*. Written and illus. by Philippe Corentin. Paris: Petite Bibliothèque L'Ecole des Loisirs, 1995.

———. *Plouf!* Written and illus. by Philippe Corentin. Paris: Petite Bibliothèque L'Ecole des Loisirs, 2005.

Cousseau, Alex, and Philippe-Henri Turin. *Les trois loups*. Written and illus. by Alex Cousseau and Philippe-Henri Turin. Paris: Matou L'Ecole des Loisirs, 2002.

Crane, Walter. *Walter Crane's Toybooks: Little Red Riding Hood*. Retold and illus. by Walter Crane. London: Routledge, 1866.

———. "Little Red Riding Hood." Retold and illus. by Walter Crane. *Red Riding Hood's Picture Book*. Walter Crane's Picture Books Volume IV. London and New York: John Lane, The Bodley Head, 1898.

Crossley-Holland, Kevin. *The Norse Myths*. New York: Pantheon Books, 1980.

D'Aulaire, Ingri, and Edgar D'Aulaire. *D'Aulaire's Book of Norse Myths*. 1967. Reprint, New York: New York Review Children's Collection, 2005.

Delarue, Paul. *The Borzoi Book of French Folk Tales*. Edited by Paul Delarue, illus. by Warren Chappell and trans. by Austin E. Fife. New York: Alfred A. Knopf, 1956.

———. *Le conte populaire français: Catalogue raisonné des versions de France et des pays de lange française d'Outre-Mer: Canada, Louisiane, Ilots Français des Etats-Unis, Antilles Françaises, Haïti, Ile Maurice, La Réunion*. Vol. I. Paris: Erasme, 1957.

DeLarue, Paul, and Marie-Louise Teneze. *Le conte populaire français : Catalogue raisonné des versions de France et des pays de langue française d'Outre-Mer : Canada, Louisiane, Ilots Français des Etats-Unis, Antilles Françaises, Haïti, Ile Maurice, La Réunion*. Vol. III. Paris: G.-P. Maisonneuve et Larose, 1976.

Denslow, Sharon Phillips. *Big Wolf and Little Wolf*. Illus. by Cathie Felstead. New York: Greenwillow Books, 2000.

Devernois, Elsa. *Grosse peur pour Bébé Loup*. Illus. by Savine Pied. In *Marlaguette et les 5 histoires de loups*. Paris : Père Castor Flammarion, 1998.

Dheron, Louis. *Ultime veillée (Souvenirs et contes creusois au temps des loups)*. Paris: Gueret, 1982.

"Domesticate." *Concise Oxford English Dictionary*. 11th ed. Oxford: Oxford University Press, 2004.

Egielski, Richard. *Saint Francis and the Wolf*. Retold and illus. by Richard Egielski. New York: Laura Geringer Books, 2005.

Evert, Laura. *Wolves*. Illus. with photographs by John F. McGee. Our Wild World Series. Minnetonka, MN: NorthWord, 2000.

Faulkner, Georgene. "The Three Little Pigs" *Old English Nursery Tales*. Retold by Georgene Faulkner and illus. by Milo Winter. Chicago: Daughday & Co., 1916.

Ferrier, Anne. *Les chaussettes d'Oskar*. Written by Anne Ferrier and illus. by Stibane. Paris: Pastel l'Ecole des Loisirs, 2004.

Forward, Toby. *The Wolf's Story: What Really Happened to Little Red Riding Hood*. Retold by Toby Forward and illus. by Izhar Cohen. Cambridge: Candlewick, 2005.

French, Vivian, and Korky Paul. *Aesop's Funky Fables*. London: H. Hamilton, 1997.

Gaiman, Neil. *The Wolves in the Wall*. Illus. by David McKean. New York: HarperCollins, 2003.

Galdone, Paul. *The Three Little Pigs*. Retold and illus. by Paul Galdone. New York: Houghton Mifflin, 1970.

George, Jean Craighead. *Julie*. Illus. by Wendell Minor. New York: HarperCollins, 1994.

———. *Julie's Wolf Pack*. Illus. by Wendell Minor. New York: HarperCollins, 1997.

———. *Julie of the Wolves*. Illus. by John Schoenherr. New York: Harper & Row, 1972.

———. *Look to the North: A Wolf Pup Diary*. Illus. by Lucia Washburn. New York: HarperCollins, 1997.

———. *Nutik the Wolf Pup*. Illus. by Ted Rand. New York: HarperCollins, 2001.

———. *The Wolves Are Back*. Illus. by Wendell Minor. New York: Dutton, 2008.

———. *The Wounded Wolf*. Illus. by John Schoenherr. New York: Harper & Row, 1978.

George W. Bush/Dick Cheney 2004 Campaign. *Wolves*. Videocassette, 2004.

Gibbons, Gail. *Wolves*. Written and illus. by Gail Gibbons. New York: Holiday House, 1994.

Grand livre du méchant loup, Le. Paris: Bayard Jeunesse, 2003.

Gravett, Emily. *Wolves*. Written and illus. by Emily Gravett. London: Macmillan Children's Books, 2005.

Grimm, Jacob. "Little Red Cap." *Household Stories from the Collection of the Bros. Grimm*. Illus. by Walter Crane and trans. by Lucy Crane. London: Macmillan, 1882.

———. "Little Red Cap." *The Great Fairy Tale Tradition*. Edited by Jack Zipes. New York: W. W. Norton & Company, 2001.

———. *Little Red Cap*. Illus. by Lisbeth Zwerger and trans. by Elizabeth D. Crawford. New York: William Morrow & Co., 1983.

———. *Little Red Cap*. Illus. by Monka Laimgruber and trans. by Anathea Bell. New York: North-South Books, 1993.

———. "Little Red Riding Hood." *English Fairy Tales*. Retold by Flora Annie Steel and illus. by Arthur Rackham. 1918. New York: Macmillan, 1924.

———. "Little Red Riding Hood." *Once Upon a Fairy Tale: Four Favorite Stories Retold by the Stars: Little Red Riding Hood, The Frog Prince, Goldilocks and The Three Bears, Rumpelstiltskin*. Retold by Glenn Close, Robin Williams, Bruce Willis, Oprah Winfrey, and Lisa Kudrow and illus. by Kevin Hawkes, Tony Di Terlizzi, Steve Johnson, Lou Fancher, Jerry Pinkney, and David Catrow. New York: Viking, 2001.

———. *Little Red Riding Hood*. Illus. by Bernadette. Cleveland: World Publishing Company, 1969.

———. *Little Red Riding Hood*. Illus. by Harriet Pincus. New York: Harcourt Brace & Jovanovich, 1968.

———. *Little Red Riding Hood*. Illus. by John Goodall. New York: M K McElderry Books, 1988.

———. *Little Red Riding Hood*. Retold and illus. by Paul Galdone. New York: McGraw Hill, 1974.

———. *Little Red Riding Hood*. Retold and illus. by Trina Schart Hyman. New York: Holiday House, 1983.

———. *Little Red Riding Hood*. Retold by Candice Ransom and illus. by Tammie Lyon. Columbus, OH: McGraw-Hill, 2002.

———. *Little Red Riding Hood*. Retold by Josephine Evetts-Secker and illus. by Nicoletta Ceccoli. Cambridge, MA: Barefoot Books, 2004.

———. *The Little Red Riding Hood Rebus Book*. Retold by Ann Morris and illus. by Ljiljana Rylands. New York: Orchard Books, 1987.

———. *Le loup et les sept chevreaux*. Illus. by Claudine Routiaux. Paris: Nathan, 1998.

———. *Nanny Goat and the Seven Little Kids*. Retold by Eric Kimmel and illus. by Janet Stevens. New York: Holiday House, 1990.

———. "Le Petit Chaperon Rouge." *Les contes du grand méchant loup*. Illus. by Rotraut Suzanne Berner and trans. by Dominique Autrand. Paris: Albin Michel Jeunesse, 2001.

———. *Le Petit Chaperon Rouge*. Retold and illus. by Jean-François Martin. Les Petits Cailloux. Paris: Editions Nathan, 2003.

———. *Le Petit Chaperon Rouge*. Retold and illus. by Kimiko. Paris: L'Ecole des Loisirs, 2001.

———. *Le Petit Chaperon Rouge*. Retold and illus. by Susanne Janssen. Paris: Editions Seuil, 2002.

———. "Red Riding Hood." *The Beautiful Book of Nursery Rhymes Stories and Pictures*. Retold and illus. by Frank Adams. London and Glasgow: Blackie & Son Co., ca. 20th century.

———. "Red Riding Hood." *Grimm's Fairy Tales*. Illus. by Fritz Kredel and trans. by Lucy Crane and Marian Edwardes. New York: Grosset & Dunlap, 1945.

———. "The Wolf and the Kids." *The Three Billy Goats*. Illus. with woodblocks. The Happy Hour Books. New York: Macmillan, 1927.

———. "The Wolf and the Seven Goats." *Grimm's Fairy Tales*. Illus. by Fritz Kredel and trans. by Lucy Crane and Marian Edwardes. New York: Grosset & Dunlap, 1945.

———. "The Wolf and the Seven Kids." *Household Stories from the Collection of the Bros. Grimm*. Illus. by Walter Crane and trans. by Lucy Crane. London: Macmillan, 1882.

———. *The Wolf and the Seven Little Kids*. Illus. by Bernadette Watts and trans. by Anathea Bell. New York: North-South Books, 1995.

———. *The Wolf and the Seven Little Goats*. Illus. by Claudine Routiaux and trans. by Molly Stevens. Little Pebbles. New York: Abbeville Kids, 2001.

———. *The Wolf and the Seven Kids*. Illus. by Felix Hoffmann and trans. by Oxford University Press. New York: Harcourt, Brace & World Inc., 1958.

———. *The Wolf and the Seven Little Kids*. Illus. by Kinuko Y. Craft. Mahwah, NJ: Troll Associates, 1979.

———. *The Wolf and the Seven Little Kids*. Illus. by Svend Otto S. and trans. by Anne Rogers. New York: Larousse & Co., 1977.

———. *The Wolf and the Seven Little Kids*. Retold and illus. by Ann Blades. Vancouver, British Columbia: Groundwood Books, 1999.

———. *Der Wolf und die Sieben Geisslein*. Mainz: Jos. Scholz, ca. 1912.

———. *Der Wolf und die Sieben Jungen Geisslein*. Illus. by Herbert Leupin. Zurich: Verlag, 1947.

———. *Der Wolf und die Sieben Jungen Geisslein*. Illus. by Josef Hegenbarth. Hamburg: Maximilian-Gesellschaft, 1984.

Guettier, Benedicte. *Le loup méchant*. Written and illus. by Benedicte Guettier. Paris: Petit POL, 2003.

Guilloppé, Antoine. *Loup noir*. Illus. by Antoine Guilloppé. Paris: Les Albums Casterman, 2004.

Gunzi, Christiane. *The Best Book of Wolves and Wild Dogs*. Illus. by Michael Rowe. Boston: Kingfisher, 2003.

Halliwell-Phillips, James Orchard. *Popular Rhymes and Nursery Tales*. London: John Russell Smith, 1849.

Hartman, Bob. *The Wolf Who Cried Boy*. Retold by Bob Hartman and illus. by Tim Raglin. New York: G. P. Putnam's Sons, 2002.

Havard, Christian. *The Wolf: Night Howler*. Written by Christian Havard and illus. with photographs by Jacana Agency. Animal Close-ups. Watertown, MA: Charlesbridge, 2003.

Hawkins, Colin, and Jacqui Hawkins. *Fairytale News*. Cambridge, MA: Candlewick, Press, 2004.

Hennessy, Barbara G. *The Boy Who Cried Wolf*. Retold by Barbara Hennessy and illus. by Boris Kulikov. New York: Simon & Schuster Books for Young Readers, 2006.

Holub, Joan. *Why Do Dogs Bark?* Illus. by Anna DiVito. New York: Dial Books for Young Readers, 2001.

Holy Bible: New International Version Containing the Old Testament and the New Testament. Grand Rapids, MI: Zondervan Bible Publishers, 1984.

Homer. *The Iliad of Homer*. Trans. by Samuel Butler. The University of Chicago: The Great Books 4. 1952. Chicago: Encyclopaedia Britannica, 1989.

Hooks, William H. *The Three Little Pigs and the Fox*. Retold by William H. Hooks and illus. S. D. Schindler. New York: Macmillan, 1989.

Hoover, Helen. *Great Wolf and the Good Woodsman*. Written by Helen Hoover and illus. by Betsy Bowen. Minneapolis: University of Minnesota Press, 2005.

Housman, Laurence. *The Wolf and the Seven Young Goslings*. Retold and illus. by Laurence Housman. London: Blackie & Son Limited, 1899.

"How Francis Tamed the Very Fierce Wolf of Gubbio." *St. Francis of Assisi Writings and Early Biographies: English Omnibus of the Sources for the Life of St. Francis*. Trans. by Raphael Brown and edited by Marion A. Habig. 4th rev. ed. Chicago: Franciscan Herald Press, 1983. Rpt. of *The Little Flowers of St. Francis*. Garden City, NY: Hanover House, 1958.

Howker, Janni. *Walk With a Wolf*. Illus. by Sarah Fox-Davies. Cambridge, MA: Candlewick Press, 2002.

Jacobs, Joseph. "The Three Little Pigs." *English Fairy Tales and More English Fairy Tales*. Retold by Joseph Jacobs and illus. by John D. Batten. 1890 and 1894. Reprint, Santa Barbara, CA: ABC-CLIO, Inc., 2002.

Jagtenberg, Yvonne. *Jack the Wolf*. Written and illus. by Yvonne Jagtenberg. New York: Roaring Brook Press, 2002.

Janovitz, Marilyn. *Is It Time?*. Written and illus. by Marilyn Janovitz. New York: Scholastic Inc., 1994.

Jerrard, Jane. *The Three Little Pigs*. Retold by Jane Jerrard and illus. by Susan Spellman. Fairy Tale Treasury. Lincolnwood, IL: Publications International, 1999.

Johnson, Sylvia A., and Alice Aamodt. *Wolf Pack: Tracking Wolves in the Wild*. Written by Sylvia A. Johnson and Alice Aamodt. Illus. with photographs. Minneapolis: Lerner Publications Company, 1985.

Kasza, Keiko. *The Dog Who Cried Wolf*. Written and illus. by Keiko Kasza. New York: G. P. Putnam, 2005.

———. *The Wolf's Chicken Stew*. Written and illus. by Keiko Kasza. New York: G. P. Putnam's Sons, 1987.

Kellog, Steven. *The Three Little Pigs*. Retold and illus. by Stephen Kellog. New York: Murrow Junior Books, 1997.

Kelly, Mij. *One More Sheep*. Illus. by Russell Ayto. London: Hodder, 2005.

Kipling, Rudyard. *All the Mowgli Stores*. Illus. by Kurt Weise. New York: Doubleday & Co., Inc., 1936.

———. *The Jungle Book*. Illus. by Alan Langford. New York: Puffin, 1994.

———. *The Jungle Book*. Illus. by Christian Broutin. New York: Viking, 1994.

———. *The Jungle Book*. Illus. by Earle Mayan. Companion Library. New York: Grosset & Dunlap Publishers, 1983.

———. *The Jungle Book*. Illus. by Fritz Eichenberg. Illustrated Junior Library. New York: Grosset & Dunlap Publishers, 1950.

———. *The Jungle Book*. Illus. by Jerry Pinkney with Afterword by Peter Glassman. New York: William Morrow & Co., 1995.

———. *The Jungle Book*. Illus. by John Lockwood Kipling. New York: The Century Co., 1914.

———. *The Jungle Book*. Illus. by William Dempster, cover art by Don Irwin. Chicago: Children's Press, 1968.

———. *The Jungle Books*. Vol.1. Illus. by Aldern Watson with Foreword by Nelson Doubleday. New York: Doubleday, 1948.

———. *The Jungle Books*. Illus. by Tibor Gergely. New York: Golden Press, 1963.

———. *The Second Jungle Book*. Illus. by John Lockwood Kipling. New York: Century, 1895.

———. *Tales from the Jungle Book*. Adapted by Robin McKinley and illus. by Jos. A. Smith. New York: Random House, 1985.

Kitamura, Sotashi. *Sheep in Wolves' Clothing*. Written and illus. by Sotashi Kitamura. New York: Farrar, Strauss & Giroux, 1995.

Kliros, Thea. *Three Little Pigs*. Retold by Raina Moore and illus. by Thea Kliros. New York: HarperFestival, 2003.

Krings, Antoon. *Jean-Loup*. Paris: L'École des Loisirs, 1992.

La Fontaine, Jean de. *Fables*. Introd. by Antoine Adam. Paris: Garnier-Flammarion, 1966.

———. *Fables de La Fontaine*. 4 vol. Illus. by Gustave Doré. Paris: Librairie de L. Hachette, 1867.

Laing, Frederick. *Why Heimdall Blew His Horn: Tales of the Norse Gods*. Retold by Frederick Laing and illus. by Leo and Diane Dillon. Morristown, NJ: Silver Burdett Co., 1969.

Lairla, Sergio. *Abel and the Wolf*. Illus. by Alessandra Roberti. New York: North-South Books, 2004.

Langton, Jane. *Francis and the Wolf*. Retold and illus. by Jane Langton. Boston: David R. Godin, 2007.

Lecaye, Olga. *Docteur Loup*. Written and illus. by Olga Lecaye. Paris: Lutin Poche de l'Ecole des Loisirs, 1996.

Levine, Gail Carson. *Betsy Who Cried Wolf*. Retold by Gail Carson Levine and illus. by Scott Nash. New York: HarperCollins, 2002.

Ling, Mary. *Amazing Wolves, Dogs, & Foxes*. Illus. with photographs by Jerry Young. Eyewitness Juniors. New York: Knopf, 1991.

Litchfield, Mary. E. *Nine Worlds: Stories from Norse Mythology*. Retold and illus. by Mary Litchfield. Boston: Ginn & Co., 1890.

London, Jack. *The Call of the Wild, White Fang, and Other Stories*. Edited by Andrew Sinclair with introduction by James Dickey. New York: Penguin Books, 1981.

London, Jonathan. *The Eyes of Gray Wolf*. Illus. by Jon Van Zyle. 1993. San Francisco: Chronicle Books, 1994.

Loup et la Chèvre, Le . France: n.p., ca. 1880.

Loup, la chèvre, et ses biquets, Le. France : n.p., ca. 1900.

Loup y es-tu?. Retold and illus. by Charlotte Mollet. Paris: Les Editions Didier, 1993.

———. Retold and illus. Mario Ramos. Paris: Pastel L'Ecole des Loisirs, 2006.

MacDonald, David. *Foxes*. Illus. with photographs. Stillwater, MN: Voyageur Press, 2000.

MacPhail, David. *A Wolf Story*. Written and illus. by David MacPhail. New York: Charles Scribner's Sons, 1981.

Markle, Sandra. *Animal Scavengers: Jackals*. Minneapolis: Lerner Publications Co., 2005

———. *Growing Up Wild: Wolves*. New York: Atheneum Books for Young Readers, 2001.

Marlaguette et les 5 histoires de loups. Paris: Père Castor Flammarion, 1998.

Marshall, James. *Red Riding Hood*. Retold and illus. by James Marshall. New York: Puffin Books, 1987.

———. *Swine Lake*. Retold by James Marshall and illus. by Maurice Sendak. New York: Harper Collins, 1999.

———. *The Three Little Pigs*. Retold and illus. by James Marshall. New York: Puffin, 1986.

Masurel, Claire, and Melissa Iwai. *Big Bad Wolf*. New York: Scholastic, 2002.

McCaughrean, Geraldine. *Roman Myths*. Retold by Geraldine McCaughrean and illus. by Emma Chichester Clark. New York: Margaret K. McEkderry Books, 2001.

McClintock, Barbara. *Animal Fables from Aesop*. Adapted and illus. by Barbara McClintock. Boston: David R. Godine, 1991.

Meddaugh, Susan. *The Best Place*. Written and illus. by Susan Meddaugh. Boston: Houghton Mifflin Co., 1999.

————. *Hog-eye.* Written and illus. by Susan Meddaugh. Boston: Houghton Mifflin, 1995.

Michalkow, Sergej. *Drei Kleine Ferkel.* Retold by Sergej Michalkow and illus. by Erich Gurtzig. Berlin, GDR: Kinderbuchverlag, 1968.

Mickey Mouse Presents Walt Disney's Silly Symphony: Big Bad Wolf. United Artist Picture, 1934. Animated Film.

————. *Three Little Pigs.* United Artist Picture, 1932. Animated Film.

————. *Three Little Wolves.* United Artist Picture, 1936. Animated Film.

Moore, Maggie. *Little Red Riding Hood.* Retold by Maggie Moore and illus. by Paula Knight. Leapfrog. London: Franklin, 2001.

————. *The Three Little Pigs.* Retold by Maggie Moore and illus. by Rob Hefferan. Leapfrog. London: Franklin Watts, 2001.

Morpurgo, Michael. *The McElderry Book of Aesop's Fables.* Retold by Michael Morpurgo and illus. by Emma Chichester Clark. New York: Margaret K. McElderry, 2004.

Moser, Barry. *The Three Little Pigs.* Retold and illus. by Barry Moser. Boston: Little, Brown & Company, 2001.

Mowat, Farley. *Never Cry Wolf.* New York: Little Brown, 1963.

Murie, Adolph. *The Wolves of Mount McKinley.* Fauna of the National Park, no. 5. 1944. Reprint, Seattle: University of Washington Press, 1985.

Murphy, Jim. *The Call of the Wolves.* Illus. by Mark Alan Weatherby. New York: Scholastic, Inc., 1989.

Murphy, Patricia. *Red Foxes.* Illus. with photographs. Mankato, MN: 2004.

Murphy, Yannick. *Ahwooooooo!* Illus. by Claudio Munoz. New York: Clarion Books, 2006.

Murray, Marjorie Dennis. *Little Wolf and the Moon.* Illus. by Stacey Schuett. New York: Marshall Cavendish, 2002.

Nadja. *Tout P'tit Loup.* Written and illus. by Nadja. Paris: Loulou & Compagnie, 1997.

Nickl, Peter. *The Story of the Kind Wolf.* Illus. by Jozef Wilkon and trans. by Marion Koenig. Mönchaltorf, Switzerland: North-South Books, 1988.

Noël, Geneviève, and Hervé Le Goff. *Timide le loup.* Written and illus. by Geneviève Noël and Hervé Le Goff. Paris: Matou Lutin Poche de l'Ecole des Loisirs, 2003.

Otto, Carolyn B. *Wolves.* Illus. with photographs. Scholastic Scientific Readers Level 2. New York: Scholastic, 2000.

Palatini, Margie. *Bad Boys.* Written by Margie Palatini and illus. by Henry Cole. New York: HarperCollins, 2003.

Patent, Dorothy Hinshaw. *Dogs: The Wolf Within.* Illus. with photographs William Munoz. Minneapolis: Carolrhoda Books, Inc., 1993.

————. *Gray Wolf, Red Wolf.* Written by Dorothy Hinshaw Patent and illus. with photographs by William Munoz. New York: Clarion Books, 1990.

————. *When the Wolves Returned: Restoring Nature's Balance in Yellowstone.* Illus. with photographs by Don Hartman and Cassie Hartman. New York: Walker Books, 2008.

Pennart, Geoffroy de. *Balthazar!* Written and illus. by Geoffroy de Pennart. Paris: Kaléidoscope Lutin Poche de l'Ecole des Loisirs, 2005.

————. *Chapeau rond rouge.* Retold and illus. by Geoffroy de Pennart. Paris: Kaléidoscope, 2004.

————. *Le déjeuner des loups.* Written and illus. by Geoffroy de Pennart. Paris: Kaléidoscope l'Ecole des Loisirs, 1998a.

————. *Je suis revenu!* Written and illus. by Geoffroy de Pennart. Paris: Kaléidoscope Lutin Poche de l'École des Loisirs, 2001.

————. *Le loup est revenu!* Written and illus. by Geoffroy de Pennart. Paris: Kaléidoscope Lutin Poche de l'Ecole des Loisirs, 1994.

————. *Le loup, la chèvre, et les 7 chevreaux.* Retold and illus. by Geoffroy de Pennart. Paris: Kaléidoscope, 2005.

————. *Le loup sentimental.* Written and illus. by Geoffroy de Pennart. Paris: Kaléidoscope Lutin Poche de l'Ecole des Loisirs, 1998b.

Perrault, Charles. "Le Petit Chaperon Rouge." *Contes.* Illus. by Mittis and G. Picard. Paris: Editions Dentu, 1894.

————. "Le Petit Chaperon Rouge." *Contes de ma mère loye Histoires ou contes du temps passé, et contes en vers.* Illus. with wood engravings by J. L. Perrichon. Paris: Claude Aveline, 1923.

————. "Le Petit Chaperon Rouge." *Contes et fables.* Illus. by Eva Frantova. Paris: Editions Grund, 2001.

————. "Le Petit Chaperon Rouge" *Les Contes de Perrault.* Illus. by Gustave Doré. Paris: J. Hetzel Librairie Firmin Didot Frère et Fils, 1862.

———. "Le Petit Chaperon Rouge." *Les Contes de Perrault*. Illus. with engravings. Paris: Librairie de Theodore Lefevre, ca. 1900.

———. "Le Petit Chaperon Rouge." *Les Contes de Perrault*. Retold by Marcel Aymé and illus. with seven colored images from the 1695 manuscript. Paris: Club des Libraires de France, 1964.

———. "Little Red Riding Hood." *Mother Goose's Nursery Tales*. Retold by L. Edna Walter and illus. by Charles Folkard. London: A&C. Black Ltd., 1923.

———. "Little Red Riding Hood." *Perrault's Tales*. Illus. by Gustave Doré and trans. by A. E. Johnson. New York: Dover Publications, Inc., 1969.

———. "Little Red Riding Hood." *The Great Fairy Tale Tradition*. Edited by Jack Zipes. New York: W. W. Norton & Company, 2001.

———. *Little Red Riding Hood*. Retold and illus. by Christopher Coady. London: ABC, 1991.

———. *Little Red Riding Hood*. Retold and illus. by Sarah Moon. Mankato, MN: Creative Editions, 2002.

Perret, Delphine. *The Big Bad Wolf and Me*. Trans. by Shannon Rowan. New York: Sterling Publishing, Co. Inc., 2006.

Perry, Phyllis J. *Crafty Canines: Coyotes, Foxes, and Wolves*. New York: Franklin Watts, 1999.

Philip, Neil. *Odin's Family: Myths of the Vikings*. Retold by Neil Philip and illus. by Maryclare Foa. New York: Orchard Books, 1996.

Pigweeney the Wise: Or the History of a Wolf & Three Pigs. Richmond, UK: J. Darnell Hill, 1830. Toronto, Canada: The Friends of the Osborne and Lillian H. Smith Collections, 1988.

Pineau, Léon. *Contes de Grand-Père*. Retold by Léon Pineau and illus. by C. V. Surreau. Paris: SFIL, 1959.

Pinkwater, Daniel. *Wolf Christmas*. Illus. by Jill Pinkwater. New York: Backpack Books, 2002.

Pittau and Gervais. *Le Noël du loup*. Written and illus. by Pittau and Gervais. Paris: Seuil Jeunesse, 1996.

Plutarch. *The Lives of Noble Grecians and Romans: The Dryden Translation*. Great Books of the Western World, vol. 14, Edited Mortimer J. Adler. Chicago: William Benton Publishers and Encyclopaedia Britannica, Inc., 1952.

Poetic Edda. Trans. by Carolyne Larrington. 1996. Oxford: Oxford University Press, 1999.

Priceman, Marjorie. *Little Red Riding Hood*. Retold by Marjorie Priceman and illus. by Brian Foster. A Classic Collectible Pop-up. New York: Little Simon/Simon Schuster, 2001.

Prokofiev, Sergei. *Peter and the Wolf*. Retold and illus. by Bono with Jordan and Eve. New York: Bloomsbury, 2003.

———. *Peter and the Wolf*. Retold by Selina Hastings and illus. by Reg Cartwright. London: Walker, 2002.

———. *Peter and the Wolf*. Retold by Janet Schulman and illus. by Peter Malone. New York: Alfred A. Knopf, 2004.

———. *Peter and the Wolf: From the Story of a Symphony by Sergei Prokofiev*. Retold and illus. by Vladmir Vagin. New York: Scholastic Press, 2000.

———. *Pierre et le loup*. Retold and illus. by Jiri Trnka. France: Editions la Farandole, 1964.

Le proprieta degli animali: Bestiario moralizzato di Gubbio; Libellus de natura animalium. Edited by Giorgio Celli. Genova: Costa & Nolan, 1983.

Puttock, Simon. *Big Bad Wolf Is Good*. Illus. by Lynne Chapman. New York: Sterling Publishing Co., 2001.

Ramos, Mario. *C'est moi le plus fort*. Written and illus. by Mario Ramos. Paris: Pastel et Lutin Poche de l'Ecole des Loisirs, 2002.

Rascal. *Ami-ami*. Illus. by Stéphane Girel. 2002. Paris: Pastel et Lutin Poche de l'Ecole des Loisirs, 2004.

———. *C'est l'histoire d'un loup et d'un cochon*. Illus. by Peter Elliot. Paris: Pastel L'Ecole des Loisirs, 2000.

———. *Loup blanc*. Illus. by Rene Hausman. Paris: Pastel L'Ecole des Loisirs, 1994

Recueil de contes de Perrault. Belgium: n.p., ca. 1903.

Reineke Fuchs, das ist ein Sehr Nützliches Lust-und Sinn-reiches Büchlein . . . Auff das Neüe Mit Allerhand Jetziger Zeit Ublichen Reim-arten . . . Aussgezieret; Mit Etzlichen Hundert Verssen Bereichet Mit Unterschiedlichen Sitten und Lehr-sätzen Verb. Rostock, Germany: J. Wilden Buchhändlern, 1650.

Robbins, Jim. "Gray Wolf Will Lose Protection in Part of U.S." *New York Times*, March 7, 2009, Science Section, p. 13A.

Roberts, Lynn. *Little Red: A Fizzingly Good Yarn*. Retold by Lynn Roberts and illus. by David Roberts. New York: Harry N. Abrams, 2005.

Rocard, Anne. "La chèvre et le loup." *Contes de France*. Retold by Anne Rocard and illus. by Olivier Latyk. Paris: Editions Lito, 2001.

Rockwell, Anne. *Romulus and Remus*. Retold and illus. by Anne Rockwell. Ready to Read. New York: Aladdin, 1997.

Roosevelt, Theodore, and Hermann Hagedorn. *The Works of Theodore Roosevelt*. Vol. 2. New York: C. Scribner's sons, 1927, quoted in Stephen R. Swinburne, *Once a Wolf: How Wildlife Biologists Fought to Bring Back the Gray Wolf*. Illus. with photographs by Jim Brandenburg. Boston: Houghton Mifflin Company, 1999.

Ross, Tony. *The Boy Who Cried Wolf*. Retold and illus. by Tony Ross. New York: Pied Piper, 1991.

———. *The Three Pigs*. Retold and illus. by Tony Ross. New York: Pantheon Books, 1983.

Saga of the Volsungs: The Norse Epic of Sigurd the Dragon Slayer. Trans. by Jesse L. Byock. Berkeley: University of California Press, 1990.

Santangelo, Colony Elliott. *Brother Wolf of Gubbio: A Legend of St. Francis*. Retold and illus. by Colony Elliott Santangelo. New York: Handprint Books, 2000.

Scieszka, Jon. *The Stinky Cheese Man*. Retold by Jon Scieszka and illus. by Lane Smith. New York: Viking, 1992.

———. *The True Story of the Three Little Pigs by A. Wolf*. Retold by Jon Scieszka and illus. by Lane Smith. New York: Viking-Penguin, 1989.

Seibert, Patricia. *The Three Little Pigs*. Retold by Patricia Seibert and illus. by Horacio Elena. Columbus, OH: McGraw-Hill Children's Publishing, 2002.

Sendak, Maurice. *Where the Wild Things Are*. Written and illus. by Maurice Sendak. 1963. New York: HarperCollins, 1991.

Seton, Ernest Thompson. *Animal Heroes: Being a History of a Cat, a Dog, a Pigeon, a Lynx, Two Wolves, & a Reindeer and in Elucidation of the Same Over 200 Drawings*. New York: Charles Scribner's Sons, 1905.

———. *Lobo, Rag, and Vixen: And Pictures*. New York: Scribner, 1899.

———. *Wild Animals I Have Known*. 1903. Reprint, Chapel Hill, SC: Univ. of South Carolina Press, 2007.

Sexton, Anne. "Red Riding Hood." *Trials and Tribulations of Little Red Riding Hood*. Edited by Jack Zipes. New York: Routledge, 1993.

Silverstein, Alvin, Virginia Silverstein, and Laura Silverstein. *Different Dogs*. Illus. with photographs. Brookfield, CT: Twenty-First Century Books, 2000.

Simon, Seymour. *Dogs*. Illus. with photographs. New York: HarperCollins, 2004.

———. *Wolves*. Illus. with photographs. New York: Scholastic, 1993.

Solotareff, Grégoire. *Le Masque*. Written and illus. by Grégoire Solotareff. Paris: L'Ecole des Loisirs, 2001.

———. *Le Petit Chaperon Vert*. Retold by Grégoire Solotareff and illus. by Nadja. Paris: L'Ecole des Loisirs, 1989.

———. *Loulou*. Written and illus. by Grégoire Solotareff. Paris: L'Ecole des Loisirs, 1994.

Sperring, Mark. *The Fairytale Cake*. Illus. by Jonathan Langley. Somerset, UK: Chicken House, 2005.

Stehr, Frédéric. *Les trois petites cochonnes*. Retold and illus. by Frédéric Stehr. Paris: L'Ecole des Loisirs, 1997.

"The Story of the Three Little Pigs." *A Book of Nursery Stories*. Comp. and illus. by Violet Macdonald. London: Jonathan Cape, 1929.

"The Story of the Three Little Pigs." *Mother Goose's Nursery Tales*. Retold by L. Edna Walter and illus. by Charles Folkard. London: A&C. Black Ltd, 1923.

Sturluson, Snorri. *Edda*. Trans. and edited by Anthony Faulkes. London: Everyman, 2002.

Sweet, Melissa. *Carmine: A Little More Red*. Retold and illus. by Melissa Sweet. Boston: Houghton Mifflin, 2005.

Swinburne, Stephen R. *Once a Wolf: How Wildlife Biologists Fought to Bring Back the Gray Wolf*. Illus. with photographs by Jim Brandenburg. Boston: Houghton Mifflin Company, 1999.

"Symbol." *American Heritage Dictionary*. 4th ed. New York: Bantam Dell, 2004.

"The Three Little Pigs." *English Fairy Tales*. Retold by Flora Annie Steel and illus. by Arthur Rackham. 1918. New York: Macmillan, 1924.

———. *Everyday Classics Primer*. Retold by Fannie Wyche Dunn et al. and illus. by Maud and Miska Petersham. New York: Macmillan, 1923.

———. *The Golden Goose Book: Being the Stories of the Golden Goose; The Three Bears; The 3 Little Pigs; Tom Thumb*. Retold and illus. by L. Leslie Brooke. London: Warne, 1900.

———. *The Jolly Jump-ups Favorite Nursery Stories*. Springfield, MA: McLaughlin 1942.

————. *Kellogg's Storybook of Games*. Battle Creek, MI: Kellogg Co. Home Economics Dept., 1931.

————. *Old Mother Goose's Rhymes & Tales*. Illus. by Constance Haslewood. London & New York: Frederick Warne & Co, 1889.

————. *Old Old Tales Retold: Eight Best-Loved Folk Tales For Children*. Illus. by Frederick Richardson. Chicago: Volland Co., 1923.

————. *The Wonder-Story Books Reading Foundation Series: It Happened One Day*. Illus. by Mary Royt and edited by Miriam Blanton Huber, Frank Seely Salisbury, and Mabel O'Donnell. New York: Row, Peterson & Co., 1938.

Three Tiny Pigs. Uncle Toby's Series. New York: McLoughlin Bros., ca. 1870.

Trivizas, Eugene. *The Three Little Wolves and the Big Bad Pig*. Retold by Eugene Trivizas and illus. by Helen Oxenbury. New York: Aladdin, 1993.

Trois Cochons. Illus. by Agnes Mathieu. Paris: Editions Nathan, 1997.

United States. Dept. of Interior. Fish & Wildlife Service. "Factsheet: Wolf Recovery in North America." January 2007. http://www.fws.gov/home/feature/2007/gray_wolf_factsheet-region2.pdf. (Accessed Nov. 29, 2009)

————. "Interior Department Announces Delisting of Western Great Lakes Wolves; Proposed Delisting of Northern Rocky Mountain Wolves." January 29, 2007. http://www.fws.gov/news/NewsReleases/showNews.cfm?newsId=6F1726CD-952D-6E23-9A79F5D-44DBC2637. (Accessed Nov. 29, 2009)

Urbigkit, Cat. *Brave Dogs, Gentle Dogs: How They Guard Sheep*. Honesdale, PA: Boyds Mills Press, 2005

Vaugelade, Anaïs. *Une soupe au caillou*. Retold and illus. by Anaïs Vaugelade. Paris: L'Ecole des Loisirs, 2000.

Virgil. *The Aeneid*. Trans. by David West. New York: Penguin Books, 1991.

Von Alkmar, Heinrich. *Reineke der Fuchs, Mit Schönen Kupfern; Nach der Ausgabe von 1498 ins Hochdeutsche Ubersetzet, und Mit einer Abhandlung, von dem Urheber, Wahren Alter und Grossen Werthe dieses Gedichtes Versehen*. Illus. by Johann Christoph Gottscheden. Leipzig und Amsterdam: P. Schenk, 1752.

Waechter, Friedrich Karl. *Le loup rouge*. Trans. by Svea Winkler. Paris: L'Ecole des Loisirs, 2003.

Ward, Nicholas. *A Wolf at the Door*. Written and illus. by Nicholas Ward. New York: Scholastic, 2001.

Weide, Bruce, and Patricia Tucker. *There's a Wolf in the Classroom!* Illus. with photographs. Minneapolis: Carolrhoda Books, 1995.

Wegman, William. *Fay's Fairy Tales: Little Red Riding Hood*. Retold and illus. by William Wegman. New York: Hyperion, 1993.

Wheeler, Lisa. *Fitch & Chip: New Pig in Town*. Illus. by Frank Ansley. Ready to Read. New York: Atheneum Books for Young Readers, 2003.

————. *Fitch & Chip: When Pigs Fly*. Illus. by Frank Ansley. Ready to Read. New York: Atheneum Books for Young Readers, 2003.

————. *Fitch & Chip: Who's Afraid of Granny Wolf?* Illus. by Frank Ansley. Ready to Read. New York: Atheneum Books for Young Readers, 2004.

Whybrow, Ian. *Dear Little Wolf*. Illus. by Tony Ross. Minneapolis: First Avenue Editions, 2002.

Wiesner, David. *The Three Pigs*. Retold and illus. by David Wiesner. New York: Clarion Books, 2001.

"Wild." *Concise Oxford English Dictionary*. 11th ed. Oxford: Oxford University Press, 2004.

Yolen, Jane, and Heidi Elisabet Yolen Stemple. *The Wolf Girls: An Unsolved Mystery from History*. Illus. by Roger Roth. New York: Simon & Schuster Books for Young Readers, 2001.

Zeaman, John. *How the Wolf Became the Dog*. New York: Franklin Watts, 1998.

Secondary Sources

Aarne, Antti. *The Types of the Folktale: A Classification and Bibliography*. Trans. and enl. by Stith Thompson. Helsinki: Academia Scientarum Fennica, 1961.

Aelian. *On the Characteristics of Animals*. Trans. by A. F. Scholfield and edited by E. H. Warmington. The Loeb Classical Library. Cambridge, MA: Harvard University Press, 1971.

Allen, Durward L. *Wolves of Minong: Isle Royale's Wild Community*. 1st paperback ed. Ann Arbor: Ann Arbor Paperback-University of Michigan Press, 1993.

Armstrong, Edward A. *St. Francis: Nature Mystic: The Derivation and Significance of Nature Stories in the Franciscan Legend*. Berkeley: University of California Press, 1973.

Arnold, Arthur. "Big Bad Wolf." *Children's Literature in Education*, 17.2 (1986): pp. 101–11.

Ashliman, D. L. *Folk and Fairy Tales: A Handbook*. Westport, CT: Greenwood Press, 2004.

Bader, Barbara. *American Picturebooks from Noah's Ark to the Beast Within.* New York: Macmillan Publishing Company, 1976.

Bang, Molly. *Picture This: How Pictures Work.* San Francisco: Seastar, 2000.

Barbour, Michael. "Ecological Fragmentation in the Fifties." *Uncommon Ground: Rethinking the Human Place in Nature.* Edited by William Cronon. New York: W. W. Norton & Company, 1983, pp. 233–55.

Barthes, Roland. *Camera Lucida: Reflections on Photography.* Trans. by Richard Howard. New York: Hills and Wang-Farrar, Strauss & Giroux, 1980.

———. *Mythologies.* Trans. by Annette Lavers. New York: Hills and Wang-Farrar, Strauss & Giroux, 1972.

Baxandall, Michael. *Patterns of Intention: On the Historical Explanation of Pictures.* New Haven, CT: Yale University Press, 1985.

Beckett, Sandra L. *Recycling Red Riding Hood.* New York: Routledge, 2002.

Bernard, Daniel. *La fin des loups en Bas-Berry : XIXe–XXe siècles histoires et traditions populaires.* Chateauroux, France: Badel, 1977.

———. *L'homme et le loup.* Paris: Berger-Levrault, 1981.

Bettelheim, Bruno. *The Uses of Enchantment: The Meaning and Importance of Fairy Tales.* New York: Vintage Books, 1989.

Black, Kathryn Norcross. "Animals in Picture Books for Children," manuscript; quoted in Gail F. Melson, *Why the Wild Things Are: Animals in the Lives of Children.* Cambridge, MA: Harvard University Press, 2001, p. 140.

Bland, David. *The Illustration of Books.* London: Faber & Faber, 1962.

Boitani, Luigi. *Dalla parte del lupo: La riscoperta scientifica e culturale del mitico predatore.* Milan: Mondadori, 1986.

———. "Ecological and Cultural Diversities in the Evolution of Wolf-Human Relationships." *Ecology and Conservation of Wolves in a Changing World.* Occasional Publication no. 35. Edited by Ludwig N. Carbyn, Steven H. Fritts, and Dale Seip. Edmonton, Alberta: Canadian Circumpolar Institute, 1995.

———. "Wolf Conservation and Recovery." *Wolves: Behavior, Ecology, and Conservation.* Edited by L. David Mech and Luigi Boitani. Chicago: University of Chicago Press, 2003, pp. 317–40.

Bottigheimer, Ruth B. *Grimms' Bad Girls & Bold Boys: The Moral and Social Vision of the Tales.* New Haven, CT: Yale University Press, 1987.

Brown, Raphael. *The Little Flowers of St. Francis.* 1958. Reprint, *St. Francis of Assisi Writings and Early Biographies: English Omnibus of the Sources for the Life of St. Francis.* Trans. by Raphael Brown and edited by Marion A. Habig. 4th rev. ed. Chicago: Franciscan Herald Press, 1983.

Brownmiller, Susan. *Against Our Will: Men, Women and Rape.* New York: Bantam, 1976.

Brunel, Pierre, ed. *Companion to Literary Myths, Heroes and Archetypes.* Trans. by Wendy Allatson, Judith Hayward, and Trista Selous. London: Routledge, 1988.

Bryson, Norman. *Word and Image: French Painters of the Ancien Regime.* Cambridge: Cambridge University Press, 1981.

Caprettini, Gian Paolo. *San Francesco. Il lupo, Il segno.* Turin: Giulo Einaudi, 1974.

Carbaugh, Donald. "Naturalizing Communication and Culture." *The Symbolic Earth: Discourse and Our Creation of the Environment.* Edited by James G. Cantrill and Christine L. Oravec. Lexington, KY: University Press of Kentucky, 1996, pp. 38–57.

Cohen, Michael. "Blues in the Green: Ecocriticism Under Critique." *Environmental History,* 9.1 (January 2004): 9–36.

Coleman, Jon Thomas. *Vicious: Wolves and Men in America.* New Haven, CT: Yale University, 2004.

Cook, Arthur Bernard. "God of the Bright Sky." *Zeus: A Study in Ancient Religion.* Vol. 1. Cambridge: Cambridge University Press, 1914.

Cronon, William. *Uncommon Ground: Rethinking the Human Place in Nature.* New York: W. W. Norton & Company, 1983.

Darnton, Robert. *The Great Cat Massacre.* New York: Vintage Books, 1985.

Darton, F. J. Harvey. *Children's Books in England.* 3rd ed. London: The British Library; New Castle, DE: Oak Knoll Press, 1999.

Davidson, H. R. Ellis. *Gods and Myths of Northern Europe.* 1946. Reprint, London: Penguin, 1990.

Davis, Susan. *Spectacular Nature: Corporate Culture and the Sea World Experience.* Berkeley: University of California Press, 1997.

Duliere, Cecile. *Lupa Romana: Recherches d'iconographie et essai d'interprétation.* 2 vols. Brussels and Rome: Institut Historique Belge de Rome, 1979.

Dundes, Alan. *Little Red Riding Hood: A Casebook*. Madison: University of Wisconsin Press, 1989.

Dunlap, Thomas. *Saving America's Wildlife: Ecology and the American Mind, 1850–1990*. Princeton, NJ: Princeton University Press, 1988.

Ernst, Alice Henson. *The Wolf Ritual of the Northwest Coast*. Eugene, OR: University of Oregon Press, 1952.

Flader, Susan L. *Thinking Like a Mountain: Aldo Leopold and the Evolution of an Ecological Attitude Toward Deer, Wolves, and Forests*. Columbia, MO: University of Missouri Press, 1974.

Francesco d'Assisi: Documenti e archivi codici e biblioteche minature. Edited by Francesco Porzio. Milan: Electa, 1982.

Freud, Sigmund. "The Occurrence in Dreams of Material from Fairy Tales." *Zeitschrift* 1 (1913). Trans. by James Strachey. Reprint, *On Creativity and the Unconsciousness: Papers on the Psychology of Art, Literature, Love, Religion*. Edited by Benjamin Nelson. New York: Harper & Row, 1958, pp. 76–83.

———. *Totem and Taboo: Some Points of Agreement between the Mental Lives of Savages and Neurotics*. Reprint. Trans. by James Strachey. New York: W. W. Norton & Company, 1950.

Fritts, Steven H., Robert O. Stephenson, Robert D. Hayes, and Luigi Boitani. "Wolves and Humans." *Wolves: Behavior, Ecology, and Conservation*. Edited by L. David Mech and Luigi Boitani. Chicago: University of Chicago Press, 2003, pp. 289–316.

Fromm, Erich. *The Forgotten Language: An Introduction to the Understanding of Dreams, Fairy Tales and Myths*. New York: Grove Press, 1951.

Genette, Gérard. *Palimpsestes: La littérature au second degré*. Paris: Editions du Seuil, 1982.

Gillespie, Angus K., and Jay Mechling, eds. *American Wildlife in Symbol and Story*. Knoxville, TN: University of Tennessee Press, 1987.

Glofelty, Cheryll. "Literary Studies in an Age of Environmental Crisis." Introduction. *The Ecocriticism Reader: Landmarks in Literary Ecology*. Edited by Cheryll Glofelty and Harold Fromm. Athens, GA, and London: University of Georgia Press, 1996.

Gombrich, E. H. *Art and Illusion: A Study in the Psychology of Pictorial Representation*. Millennium Edition with a new preface by the author. Princeton, NJ: Princeton University Press, 2000.

———. *The Story of Art*. 16th ed. London: Phaidon Press, 1995.

Grant, Michael. *Myths of the Greeks and Romans*. New York: Penguin, 1962.

Graves, Robert, ed. *The Greek Myths*. 2 vols. London: Penguin, 1955. London: The Folio Society Ltd., 1996.

Greenleaf, Sarah. "The Beast Within." *Children's Literature in Education*, 23.1 (1992): 49–56.

Grinnell, George Bird. *Pawnee Hero Stories and Folk-Tales with Notes on the Origin, Customs, and Characters of the Pawnee People*. 1889. Reprint, Lincoln: University of Nebraska Press, 1961.

Harrington, Fred H., and Cheryl S. Asa. "Wolf Communication." *Wolves: Behavior, Ecology, and Conservation*. Edited by L. David Mech and Luigi Boitani. Chicago: University of Chicago Press, 2003, pp. 66–103.

Hearne, Betsy. *Beauty and the Beast: Visions and Revisions of an Old Tale*. Chicago: University of Chicago Press, 1989.

Heise, Ursula. "Science and Ecocriticism." *The American Book Review*, 18.5 (July–August 1997): 4+.

Hines, Maude. "'He Made Us Very Much Like the Flowers': Human/Nature in Nineteenth Century Anglo-American Children's Literature." *Wild Things: Children's Culture and Ecocriticism*. Edited by Sidney I. Dobrin and Kenneth B. Kidd. Detroit: Wayne State University Press, 2004.

Hollindale, Peter. "Why the Wolves are Running." *The Lion and the Unicorn*, 23.1 (1999): 97–115.

Howells, Richard. *Visual Culture*. Cambridge: Polity Press; Malden, MA: Blackwell Publishers, Inc., 2003.

Ivins, William M., Jr. *Prints and Communication*. Cambridge, MA: Harvard University Press, 1953.

Jaffe, Aniela. "Symbolism in the Visual Arts." *Man and His Symbols*. Edited by Carl G. Jung. New York: Dell-Random House, 1968, pp. 255–322.

Jager, Hans-Wolf. "Is Little Red Riding Hood Wearing a Liberty Cap? On Presumable Connotations in Tieck and in Grimm." Edited by Alan Dundes. *Little Red Riding Hood: A Casebook*. Madison: University of Wisconsin Press, 1989, pp. 89–120.

Jung, Carl G. "Approaching the Unconscious." *Man and His Symbols*. Edited by Carl G. Jung. New York: Dell-Random House, 1968, pp. 1–94.

Kellert, Stephen R. "The Biological Basis for Human Values of Nature." *The Biophilia Hypothesis.* Edited by Stephen R. Kellert and Edward O. Wilson. Washington, DC: Island Press, 1993, pp. 42–69.

———. *The Value of Life: Biological Diversity and Human Society.* Washington, DC: Island Press, 1996.

Kellert, Stephen R., Matthew Black, Colleen Reid Rush, and Alistair J. Black. "Human Culture and Large Carnivore Conservation in North America." *Conservation Biology,* 10. 4 (August 1996): 977–90.

Lagier, Marie. *Le livre du loup.* Illus. by Serbe Bloch. Luçon, France: Nathan/VUEF, 2001.

Lawrence, Elizabeth Atwood. "The Sacred Bee, the Filthy Pig, and the Bat Out of Hell: Animal Symbolism as Cognitive Biophilia." *The Biophilia Hypothesis.* Edited by Stephen R. Kellert and Edward O. Wilson. Washington, DC: Island Press, 1993, pp. 301–41.

LeGuin, Ursula K. "Cheek by Jowl: Animals in Children's Literature." *Children and Libraries* (Summer/Fall 2004): 20–30.

Leonard, Jennifer A., et al. "Ancient DNA Evidence for Old World Origin of New World Dogs. (Cover story)." *Science* 298, no. 5598 (November 22, 2002): 1613.

Levalois, Charles. *Le symbolisme du loup.* Milano: Arche, 1986.

Lévi-Strauss, Claude. *La pensée sauvage.* Paris: Plon, 1962.

———. *Totemism.* Boston: Beacon Press, 1963.

Lewis, David. *Reading Contemporary Picturebooks: Picturing Text.* London and New York: Routledge Falmer, 2001.

Lexicon Iconographicum Mythologiae Classicae (LIMC). Vols. II & VI. Zurich: Artemis, 1981.

Little, A. G., ed. *Franciscan History and Legend in English Medieval Art.* British Society of Franciscan Studies. Vol. XIX. Manchester, UK: Manchester University Press, 1937.

Lopez, Barry Holstun. *Of Wolves and Men.* 1979. Illus. with photographs by John Bauguess. New York: Touchstone-Simon & Schuster, 1995.

Lukens, Rebecca, J. *A Critical Handbook of Children's Literature.* Boston: Pearson Education, 2003.

Luthi, Max. *European Folktale: Form and Nature.* Trans. by John D. Niles. Philadelphia: Institute for the Study of Human Issues, 1982.

———. *The Fairytale as Art Form and Portrait of Man.* Trans. by Jon Erickson. Bloomington: Indiana University Press, 1984.

———. *Once upon a Time: On the Nature of Fairy Tales.* Trans. by Lee Chadeayne and Paul Gottwald. Bloomington: Indiana University Press, 1976.

Manes, Christopher. "Nature and Silence." *The Ecocriticism Reader: Landmarks in Literary Ecology.* Edited by Cheryll Glotfelty and Harold Fromm. Athens, GA, and London: University of Georgia Press, 1996, pp. 15–29.

Marcus, Leonard S. "Picture Book Animals: How Natural a History?" *Lion and the Unicorn* Special Double Issue 7/8 (1983/1984): 127–39.

McIntyre, Rick, ed. *War against the Wolf: America's Campaign to Exterminate the Wolf; Over 100 Historical Documents and Modern Articles Documenting the Evolving Attitudes toward Wolves in America from 1630 to 1995.* Stillwater, MN: Voyageur, 1995.

McKendry, John, comp. *Aesop: Five Centuries of Illustrated Fables.* Greenwich, CT: Metropolitan Museum of Art, 1964.

Mech, L. David. "The Challenge and Opportunity of Recovering Wolf Populations." *Conservation Biology* 9.2 (April 1995): 270–78.

Mech, L. David, ed. *The Wolves of Minnesota: Howl in the Heartland.* Stillwater, MN: Voyageur Press, 2000.

Mech, L. David, and Luigi Boitani, eds. *Wolves: Behavior, Ecology, and Conservation.* Chicago: University of Chicago Press, 2003.

Melson, Gail. F. *Why the Wild Things Are: Animals in the Lives of Children.* Cambridge, MA: Harvard University Press, 2001.

Mercatante, Anthony. *Who's Who in Egyptian Mythology.* New York: Clarkson N. Potter, Inc., 1978.

Merchant, Carolyn. "Reinventing Eden: Western Culture as a Recovery Narrative." *Uncommon Ground: Rethinking the Human Place in Nature.* Edited by William Cronon. New York: W. W. Norton & Company, 1983, pp. 132–159.

Mirzeoff, Nicholas. *An Introduction to Visible Culture.* London: Routledge, 1999.

Mooney James. *Myths of the Cherokee.* New York: Dover, 1995.

Nash, Roderick Frazier. *Wilderness and the American Mind.* 4th ed. New Haven, CT: Yale University Press, 2001.

Nie, Martin A. *Beyond Wolves: The Politics of Wolf Recovery.* Minneapolis: University of Minnesota Press, 2003.

Nodelman, Perry. *Words about Pictures: The Narrative Art of Children's Picture Books*. Athens, GA: University of Georgia Press, 1988.

Nuzum, K. A. "The Monster's Sacrifice—Historic Time: The Uses of Mythic and Liminal Time in Monster Literature." *Children's Literature Association*, 29.3 (Fall 2004): 207–27.

Panofsky, Erwin. *Meaning in the Visual Arts*. Chicago: University of Chicago Press, 1995.

Pauls Realencyclopadie der Classischen Alterumswissenschaft. Suppl. 15. Edited by Wilhelm Kroll and Karl Mittelhaus. Munich: Alfred Druckenmuller, 1978.

Peterson, Rolf. O. *The Wolves of Isle Royale: A Broken Balance*. Ann Arbor: University of Michigan Press, 2007.

Phébus, Gaston III, Count of Foix. *Le livre de la chasse*. Reproduction Bibliothèque Nationale de France from MS. Fr. 616, *Le livre de la chasse*, Gaston Phébus Count de Foix (France, 1389). Reprint, *The Hunting Book of Gaston Phébus*. Trans. by Ian Monk. Dallas: Hackberry Press, 2002.

Propp, Vladmir. *Morphology of the Folktale*. Trans. by Laurence Scott. Publications of the American Folklore Society. Rev. and edited by Louis Wagner. Introd. by Alan Dundes. Austin: University of Texas Press, 1968.

Rabb, George. Foreword. *Wolves: Behavior, Ecology, and Conservation*. Edited by L. David Mech and Luigi Boitani. Chicago: University of Chicago Press, 2003, pp. ix–x.

Ragache, Gilles, and Claude-Catherine Ragache. *Les Loups en France: Légendes et Réalité*. Paris: Aubier, 1981.

Rahn, Suzanne. "Green Worlds for Children." *The Lion and the Unicorn*, 19.2 (1995): 149–70.

Reich, Susan, and David Walker. "Wild Life Photographers Debate Controversial New Practices." *Photo District News*, July 1998, pp. 28–31.

Reitz, Joan. *Online Dictionary of Library and Information Science*. http://lu.com/odlis.

Robisch, Sean Kipling. "Big Holy Dog: The Wolf in North American Literature." Diss. Purdue, 1998. Ann Arbor: UMI, 1998. AAT9953751.

Rodari, Gianni. *The Grammar of Fantasy*. Trans. by Jack Zipes. New York: Teachers & Writers Collaborative, 1996.

Roheim, Gheza. "Fairy Tale and Dream: 'Little Red Riding Hood.'" *The Little Red Riding Hood Casebook*. Edited by Alan Dundes. Madison: University of Wisconsin Press, 1989, pp. 159–67.

Ross, Jackie Leigh. *The Wherewolf?* Illus. by Steve K. San Jose, CA: All About Kids, 2002.

Saintyves, Paul. "Little Red Riding Hood or the Little May Queen." *The Little Red Riding Hood Casebook*. Edited by Alan Dundes. Madison: University of Wisconsin Press, 1989, pp. 71–88.

Shepard, Paul. "On Animal Friends." *The Biophilia Hypothesis*. Edited by Stephen R. Kellert and Edward O. Wilson. Washington, DC: Island Press, 1993, pp. 275–300.

Sontag, Susan. *On Photography*. New York: Farrar, Straus & Giroux, 1977.

Sorrell, Roger D. *St. Francis of Assisi and Nature: Tradition and Innovation in Western Christian Attitudes toward the Environment*. New York: Oxford University Press, 1988.

Steinhart, Peter. *The Company of Wolves*. New York: Vintage-Random, 1995.

Sutherland, Zena, and May Hill Arbuthnot. *Children and Books*. 7th ed. Glenview, IL: Scott Foresman and Company, 1986.

Tatar, Maria. "Introduction: Little Red Riding Hood." *The Classic Fairy Tales*. Edited by Maria Tatar. New York: W. W. Norton & Company, 1999, pp. 3–7.

Thiel, Richard P., and Robert Ream. "Status of the Gray Wolf in the Lower 48 United States to 1992." *Ecology and Conservation of Wolves in a Changing World*. Edited by Ludwig Carbyn, Stephen H. Fritts, and Dale Seip. Edmonton, Alberta: Canadian Circumpolar Institute and University of Alberta, 1995.

Thomas, Keith. *Man and the Natural World: A History of the Modern Sensibility*. New York: Pantheon Books, 1983.

Thompson, Stith. *The Folktale*. Berkeley: University of California Press, 1977.

Tolkien, J. R. R. *The Tolkien Reader*. New York: Ballantine Books, 1966.

Voisenet, Jacques. *Bêtes et hommes dans le monde médiéval: le bestiaire des Clers du Ve and XIIe siècle*. Turnhout, Belgium: Brepols, 2000.

Walker, Brett. *The Lost Wolves of Japan*. Seattle: University of Washington Press, 2005.

Warner, Marina. *From the Beast to the Blonde: On Fairy Tales and Their Tellers*. New York: Farrar, Strauss & Giroux, 1994.

Wheeler, Mark. "Shadow Wolves." *Smithsonian* 33, no. 10 (January 2003): 40. *Academic Search Premier*, EBSCOhost (accessed April 15, 2009).

Williams, Raymond. *The Country and the City*. New York: Oxford University Press, 1973.

Wilson, Edward O. "Biophilia and the Conservation Ethic." *The Biophilia Hypothesis.* Edited by Stephen R. Kellert and Edward O. Wilson. Washington, DC: Island Press, 1993, pp. 31–41.

Woods, Gioia. *ASLE Graduate Handbook: Literature and Environment in the Academy.* http://www.asle.umn.edu/pubs/handbook/lit.html. (Accessed May 15, 2005).

Young, Stanley Paul. *The Last of the Loners.* New York: Macmillan Company, 1970.

Young, Stanley Paul, and Edward A. Goldman. *Wolves of North America.* Washington, DC: The American Wildlife Institute, 1944.

Zimmer, Carl. "Evolutionary Biology—What Is a Species?—Biologists Still Struggle with That Fundamental but Scientifically Pivotal Question." *Scientific American* (2008): 298, no. 6, 48–55.

Zipes, Jack. "Reviewing and Re-Framing Little Red Riding Hood." Epilogue. *The Trials and Tribulations of Little Red Riding Hood.* Edited Jack Zipes. 2nd ed. New York: Routledge, 1993, pp. 343–83.

Index

Begbrook Kitchen Library

DOWNSIDE ABBEY PRESS
2017

First published in 2017 by Downside Abbey Press.
Stratton on the Fosse, Radstock, Bath, BA3 4RH, United Kingdom.
www.downside.co.uk

ISBN: 978-1-898-663-56-0

Designed by Frances Bircher.

Printed and bound by Biddles.

Dom Christopher

Acknowledgements

As with all works such as this, thanks are owed to many sources. Nothing about this publication would have happened without the hard work and contributions of so many.

It is probably best to thank people chronologically in the lifetime of the work. Firstly, thanks to Dom Leo Maidlow Davis and the community of St Gregory the Great at Downside for allowing us to use the book and for their continued support during the process of publication. Dom Christopher Calascione for his interest, support and involvement in our great 'Sally Lunn Bun adventure'. His love for cooking has been a vital part of the push to get published. To Dr Tim Hopkinson-Ball, archivist at Downside, thanks for discovering the cookbook in the collections and for his introduction and advice over the years. Dr Simon Johnson for his editorial advice and constant chivvying along, as bosses do, to get us over the line. Steve Parsons, for bringing the idea to life and keeping the momentum going.

Special thanks to Charis Stevenson who spent many an hour transcribing the cookbook and trying to decipher the handwriting. Frances Bircher for her tireless work to get the book in a state for publication. Hours of her typesetting, formatting, photography and making all the alterations suggested by many parties have seen us where we are today.

To Bobby Anderson and Simon Ball we are grateful for the loan of their family silver and crokery to help us bring the

food photographs alive. Without their generosity we could not have done justice to the wonderful food prepared for us by the Downside catering department. Particular thanks must go to Sarah Kieck, Oliver Iles, James Bancroft for their patience and time interpreting the receipes and turning them into something wonderful for us to photograph.

We are also indebted to Helga Muelneritsch, a placement student who spent many an hour poring over the cookbook analysing it and providing us with an early transcription and an idea of what much of the food was. Additionally thanks to Kirsten Elliot who answered many of our questions about what many of the ingredients were and what a modern day equivalent would be. Her input was invaluable.

Finally, in general thanks to anyone who has shown an interest in the cookbook, offered advice, criticism and opinions. All of them have been welcome in one way or another and have helped get us to print.

Downside Abbey

Monks and their Meals:
A word from the Prior

We monks were delighted when we discovered this Georgian cookery book in our archive. We are longing for the opportunity to try the *Fricasee Lobsters* that Dom Christopher, with his background in Mediterranean cuisine, can now prepare for us; there is, however, less enthusiasm for *Spinage Stewed Like Sambo*.

Delighted, but also surprised. Which of our monks could have put this book on our shelves, and when? There were Benedictines among the Catholic community in the Bath and Bristol area in the eighteenth century, but how often were they in a kitchen?

At Downside today we follow *The Rule* that was written in Italy in the sixth century by an abbot who had founded a number of monasteries around Rome. He is known as St Benedict and we are Benedictine monks. Before the Reformation and until the reign of Henry VIII the landscape was dotted with Benedictine monasteries and Bath, in particular, was a noted Benedictine centre with its abbey in which Edgar, the first king of all England, had been crowned by Dunstan, a Benedictine monk of Glastonbury, in 973.

Monks are expected to spend a lot of time in prayer, and not so much time sleeping late and eating long. During Lent, the period of fasting and penance that leads up to Easter and the celebration of Jesus Christ's resurrection from the dead, St Benedict wants his monks to have only one meal a day, towards evening. In Eastertide we rejoice and celebrate with two meals. St Benedict is doubtful about wine. He tells us: 'We do, indeed, read that wine is entirely

unsuitable as a drink for monks, but, since in our day they cannot all be brought to accept this, let us at least agree that we should drink in moderation and not till we are full.' His compromise is to recommend a 'hemina' or 'a half'; over the centuries there has been a lot of discussion in monasteries about what 'a half' means. I wonder whether St Benedict would have approved of the Georgian recipe for Gooseberry Wine you will find here.

There are plenty of signs that St Benedict took food and drink very seriously, as any civilised person should. He does not want his monks eating red meat, but he allows it when they are weak and need to build up their strength. He offers a choice of two cooked dishes at meals, catering for different tastes. He has a lot to say about guests to the monastery, who are 'never lacking'. They – especially the poor and pilgrims – must be welcomed like Christ himself. He wants a separate kitchen set up for them so that meals can be prepared whenever they arrive. A splendid example survives at Glastonbury Abbey. And whereas most chores in the monastery are parcelled out a week at a time, the guests' two cooks are appointed for a whole year to give them the opportunity of becoming experts.

When you next visit a monastery you probably won't find *Fricasee Lobsters* on the menu, though a *Famous Rice Pudding* might well appear. But who would not love to be on the shore of the Sea of Galilee on that Easter morning when Jesus, triumphant over death, had bread prepared and fish cooked on charcoal for his disciples after their cold night of unsuccessful fishing? When everything is ready he says, 'Come and have breakfast.'

Dom Leo Maidlow Davis
Downside Abbey Prior

Begbrook House Kitchen Cookbook: An Introduction

The Downside Abbey Archives are extensive and they encompass a surprisingly diverse array of materials. Not just papers belonging to the English Benedictine Congregation, but also collections gifted to the community by individuals with connections to the monastery.

One such donor was Daniel Parsons (1811-1887) of Stuart's Lodge, Malvern, Wells, Worcestershire. A catholic convert, Parsons married another catholic convert, the author Gertrude Parsons (née Hext), in 1845. Initially the Parsons family lived at Begbrook House in Frenchay near Bristol, from 1845 to 1847, before moving to Rome. They returned to Begbrook in 1852 and finally moved to Malvern in 1855.

The Begbrook Kitchen Library cookbook is part of the Parsons Collection. Consisting mainly of Daniel Parsons' heraldic and genealogical research notes, there is also a small, but significant assemblage of family papers and memorabilia, of which the cookbook is the most notable item. It came to light quite by chance. Separated from the Parsons Collection in the archive and long forgotten, it was discovered on a high shelf covered in dust, behind a box of papers relating to excavations at Glastonbury Abbey in Somerset. Its significance to social and culinary history was quickly realised, and this publication is the result.

The cookbook is bound in leather, seemingly a cheap sheep skin, and the pages are handmade paper with no visible watermarks. The recipes are initially written in a hand using a goose quill and then later a steel

pen. In the first instance the book seems to have been started as an inventory listing linen and bedding, but was quickly repurposed as a cookbook. The recipes are written in a number of hands and we can imagine that a succession of cooks added to the manuscript as new recipes were received, tried and approved for inclusion in the Begbrook House repertoire. Although the book concludes 'End of volume the first', sadly, the second volume is not present in the Parsons Collection.

Started at the end of the eighteenth century, the book seems to have been in use well into the second quarter of the nineteenth century. The cookbook contains some 142 recipes including three 'household' recipes for Lavender Water, Furniture Oil and a polish for cleaning marble. The rest of the recipes are for savoury or sweet baked goods, puddings, jellies, marmalades, jams and curds, sauces, pickles, soups, recipes for meat, poultry, fish, sea food and vegetables. The titles of a few of the recipes suggest Indian, Chinese, German and French sources. The recipe for the Sally Lunn bun is of particular note, being an early variation of Bath's authentic regional specialty.

Begbrook House was owned in the middle of the eighteenth century by one of Daniel Parson's ancestors. By the beginning of the twentieth century the house belonged to Augustine Birrell, Liberal MP for Bristol North. It was destroyed by fire in November 1913, deliberately started by Suffragettes targeting Birrell for his political inaction. Today, the site of Begbrook House is occupied by a nursing home. Sadly, no photographs or drawings of the kitchens of Begbrook House have come down to us – this cookbook is our only surviving link to what was clearly a vibrant and outward-looking kitchen, and possibly one of the first to serve curry in the South West.

Dr Tim Hopkinson-Ball
Downside Abbey Archivist

Downside Abbey Library

Begbrook House
1853

Begbrook Kitche[n]

Library

September 29th 1793

List of Table Linnen & Sheets

6 Pair of Sheets marked Suit
5 Do of Pillow Cases
5 Pair of good Sheets
5 Do of Pillow Cases
10 Pair of Sheets & 1 odd one
2 Pair of Small
17 Pillow Cases
6 Pair of Servants Sheets & 1 odd one

$$
\begin{array}{r}
4\ 3\ 2\ 7\ 2\ 4\ 9\ 6 \\
3\ 6\ 4\ 8\ 9\ 3\ 4\ 5 \\
\hline
0\ 6\ 7\ 8\ 3\ 1\ 5\ 1
\end{array}
$$

1 Large Damask Cloth old
9 Damask Table Cloth,
5 Diaper good
7 Do old
2 Damask Breakfast Cloths
3 Do ⸺ Do Do
3 Diaper ⸺ Do ⸺ Do

26 Damask Napkins
9 Towels
5 Towels
8 Towels

12 old Towels

9 Glass Cloths
6 Knife Do
2 Dusters ⸺
6 holland ones

1 Large Damask Table Cloth added to this

Contents

Plumb Loaf

Two pounds of flour

Two table spoon-fulls of Barm, a little warm milk and water

The yolks of two eggs, one pound of currants

Half a pound of Butter

To be mixed as stiff as possible.

To Cure Hams
Mrs Broughton

1 pound of common salt, half a pound of Bay Salt[1], ¼ pound of salt petre[5].

Two ounces of black pepper, one ounce of Juniper Berries.

These ingredients to be well mixed and rubbed on the meat which will take some days and after it is all used add one pound and a half treacle this is a sufficient quantity for 25lb of meat which should be first swiftly salted to drain the blood from it.

Plumb Loaf.

Two pounds of flour, two
table spoon fulls of Barm,
a little warm milk & water,
& the Yolks of two Eggs
one pound of Currants
half a pound of Butter
to be mixed as stiff as
possible ―

For a Ham of 18 – 20lb
Mrs Birdleigh

Rub the ham with a little common salt and let it lay 24 hours to drain it. Boil one quart of old foamy beer, with ½ lb of bay salt, ½ lb of common salt, ½ lb of juniper berries, 3oz of black pepper and 3oz of salt petre, all well bruised and pour it on the ham boiling hot

Baste the ham every day for a month with the liquor, the oftener the better. When the ham has been in the pickle one week add to it 1 ½ tb of treacle rubbing it thoroughly into the ham.

Orange Jelly

Grate the rinds of 2 oranges and 2 lemons, and the juice of 8 oranges and 4 lemons. Take four ounces of isinglass[2], boil it in a pint of water till it is melted, strain it in to the juice, boil it up altogether, sweeten it to your taste and strain it through a thin cloth and when almost cold put it into your shape. If the oranges should be small twelve will not be too many.

Orange Jelly

Grate the rinds of 2 Oranges, and
2 Lemons, and the juice of eight
Oranges, and four Lemons. Take
four Ounces of Isinglass, boil it
in a pint of Water till it
is melted, strain it to the
Juice. give it a Boil up
altogether, sweeten it to
your taste, and strain it thro'
a thin Cloth, and when
almost cold put it into
your shape. If the Orange

Parsnip Pudding

Four parsnips, two eggs, two large spoonfuls of milk and a little nutmeg: boil the parsnips very well, either scrape them very fine or beat them in a mortar.

To Cure Hams

One pound a half bay salt, one pound of common salt, two ounces of black pepper, four ounces of salt petre, pound these ingredients together and rub them well into the hams. Three days later add one pound and a half of treacle and let them remain a month in pickle turning them every day. Before you smoke them, let them lie twenty-four hours in water. They should hang to be smoked 4 weeks. There is no occasion to soak these hams before they are boiled.

Oyster Catchup

One hundred oz of Oysters with all the liquor, one pound of anchovies, one quart of white wine, one lemon with half the peel, boil them gently for half an hour, strain the liquor thro' muslin, add to it cloves and mace[3] of each a quarter of an ounce, boil it a quarter of an hour longer. When cold add 12 shallots, bottle it and add cayenne pepper to your taste.

Hambro Pickle[4]

4 gallons of water, 6 pounds of common salt, half a pound of brown sugar, 4 ounces of salt Petre[5]. Boil it well, strain it. When cold put in your Beef, Mutton, Pork or Tongue. Keep the meat covered with brine and in nine or ten days it will be fit for use or continue it longer. It will keep in pickle 2 or 3 months – The pickle should be boiled up and well-seasoned at the end of 6 weeks and this every three weeks. This pickle will keep good three months in Summer and in Winter much longer.

To Stew a Knuckle of Veal

Put a knuckle of Veal well washed and the bones broken into two quarts of water, with seasoning of pepper salt, to your taste. Add Juniper, Carrots, 2 or 3 Onions and Celery if you can get it. A bundle of sweet herbs, a piece of lean bacon and a couple of Anchovies. Cover them down close and stew them gently for 2 or 3 hours, taking out the Veal when done sufficiently. In the mean-time have about 2 handfuls of rice or Barley creed[6]. Strain the soup, then put the rice or Barley and let them boil together. When you take it off the fire have in readiness the yolks of two eggs, beaten up in half a pint of cream (or good new milk thickened with a little flour).

Orange Jelly

Plumb Pudding

To a pound of raisins stoned, a pound of suet chopped fine, eight eggs, four whites left out, four spoonfuls of flour, two of sugar, quarter of a pound of Citron cut very thin, one small nutmeg, sixteen cloves, two blades of mace, some china orange peel, one glug of brandy and as much milk as will make it of a proper thickness. To be boiled three hours and a half, or it will be heavy.

Nice Pancakes

Two ounces of sugar, two of fresh butter much beaten together, four eggs beat to a froth, a full pint of milk and half a pound of flour well mixed together. Fry them in good lard over a clear fire[26]. A full gill[7] of lard to each Pancake. Serve them up hot with cinnamon and sugar to eat with them.

Artificial Oyster Sauce

4 Anchovies boiled in half a pint of water till they are quite dissolved with two or three blades of mace and two pepper corns. Strain it, and add half a pint of cream and four ounces of butter thickened with flour.

Artificial Oyster Sauce

4 Anchovies boiled in half a pint
of Water till they are quite
dissolved with two or three Blades
of Mace and two pepper Corns
Strain it, and add half a pint
of Cream, and four Ounces of Butter
thickened with flour. —

Simolina Pudding

2 Ounces of Simolina to a quart
of Milk, cut some Lemon Peel
and let it Boil gently over a
slow fire till it begins to thicken,

Semolina Pudding

2 ounces of semolina to a quart of milk, cut some lemon peel and let it boil gently over a slow fire till it begins to thicken. Then take it off the fire, flour it well and when it is nearly cold, add to it 2 or 3 eggs and some sugar. The butter and sugar as soon as it is taken off from the fire should be put to it.

To Make a Trifle: Mrs Harris

Take a pound of macaroons, a quarter of a pound of ratafia[8] cakes, put them into a Deep Dish, and pour on them as much sweet wine as will soak them. Then take a quart of milk, boil it and when cold add the yolks of eight eggs, sweeten it to your taste, and set it over the fire to thicken stirring it all the while to prevent it burning, and when almost cold, pour it over the cakes – then take a quart of thick cream, half a pint of Mountain[63] made sweet with sugar, add to it the juice of a large lemon with the whites of four eggs – put it all into a deep pan and whisk it all one way, as the froth rises take it off and lay it on the custard as light as you can. Put a piece of very thin lemon peel and steep it in the wine an hour or two before you put it to the trifle.

To Make Custards

Take a quart of cream, and two eggs, leave out half the whites, sweeten it to your taste, add to it a spoonful of orange flavour water, with a laurel leaf, it must be stirred one way all the time it is on the fire. You must observe to beat the eggs <u>well</u> <u>before</u> you mix them with the cream.

Lavender Water

A quarter of a pint of best rectified spirits of wine, a shilling's worth of oil of lavender, six penny's worth of oil of Amber grease[9] – shake them well together - keep it 6 months

Cream Pancakes

A pint of cream, 6 eggs leaving out three whites, 2 ounces of melted butter, a little nutmeg and one spoonful of flour.

Jumbals

Three quarters of a pound of flour, half a pound of sugar, two ounces of butter, two eggs and a tea spoonful of ginger.

Carrot Soup

A knuckle of veal, some lean beef, one pound of ham, add to it 10 large carrots, 4 heads of celery, 6 onions, half pint of dry peas, herbs, pepper and salt. Boil them altogether for five hours, rub it through a sieve. It should not be thicker than a good white soup.

Cream Pancakes

A Pint of Cream, 6 Eggs leaving
out three Whites, 2 Ounces of melt=
=ed Butter, a little Nutmeg and
one spoonful of Flour. —

Jumbals

Three quarters of a pound of Flour
half a pound of Sugar, two Ounces
of Butter, two Eggs, and a Tea spoon
=ful of Ginger —

Carrot Soup

A Knuckle of Veal, some lean Beef
one pound of Ham, add to it 10 large
carrots 4 heads of celery, 6 Onions

Macaronie

Two ounces of macaronie boiled in water till quite tender. Then put it on a sieve to drain from the water, when done put it into a stone pan with half a pint of cream, three ounces of fresh butter, likewise half a teaspoonful of salt and the same quantity of white sugar candy[10] – add two ounces of mild cheese grated. Stirring it gently over a slow fire for five minutes preserving the macaronie as whole as you can then turn it out in a dish and grate a little cheese over it and brown it all over with a salamander[11].

White Pot

Three pints of milk

6 Eggs – leaving out 3 whites

Beat them very well with a little hot water

Add to it the milk, sweeten it: it will take ½ an hour to bake in a quick oven. Just before you put it in, lay some pieces that are thin of bread and butter nicely spread just before as we have said.

White Pot

Three Pints of Milk
6 Eggs. — leaving out 3 whites. I took my
 Beat them very well with a little rose water
add to it the milk: Sweeten it: it will take
½ an hour to bake in a quick oven
Just before you put it in
Lay some pieces that are thin
Of bread & butter nicely spread
Just before as we have said.

 Leeanthum Saffist.

Jumbals

A Recipe for Carachie[12]

Put into a quart bottle half a pint of good walnut catchup.

Add a desert spoonful of salt, one of whole garlic and the same quantity of horseradish cut an inch long – add a tea spoonful of cayan – then fill the bottle with common vinegar.

In a fortnight it will be fit for use.

Famous Rice Pudding

Take half a pint of whole rice. Wash and dry it well before the fire, then boil it gently in three pints of milk till tender with a small bit of cinnamon. Then beat the yolks of six eggs well and stir into it. Sweeten it to your taste then put it into your dish and when nearly cold, cover the top entirely with the following mixture.

Beat up the whites of two eggs to a froth with a little pounded sugar, half a doz. macaroons well pounded and stir'd in – you must be careful to lay this regularly over the top of your pudding and bake it of a light brown – it will take a little time to soak – put in a large spoonful of Nayan.

Bread and Butter Pudding

A penny French roll[13] cut in thin slices and buttered the same as for tea, and between every layer some currants strewed not too thick. Put this into your dish fill half full then take the yolks of five eggs, and the whites of three. Beat them thoroughly and mix them with as much milk as will fill the dish sweetening it to your taste and laying a slice or two of the bread and butter on the top.

To Make German Puffs[14]

Take not more than three spoonfuls of flour, four eggs, one pint of cream, four ounces of butter melted.

Stir them well together, add a little salt, and grated nutmeg, put them in teacups, a quarter of an hour is quite sufficient to bake them brown top and bottom. They will be more then as large again when baked. Let the right side be upwards when you send them up – for sauce melted butter, wine and sugar.

NB Half the quantity makes seven puffs. Be sure to beat your eggs well before you add your ingredients.

To preserve Barberries

Take double the weight of Sugar
to your Barberries, and dip your
Sugar into Water, boil it into
a Syrup — When boiled put your
Barberries in let them boil once
up then lay them up for 3
or 4 days, warm them and
put them into Glasses —

To Stew Green Pease

Rub your Pease well in Butter
put them in your Stew Pan with
a piece of lean ham, one large
Onion cut fine, Pepper Salt and
2 Tea Spoonfuls of fine Sugar some

To Preserve Barberries

Take double the weight of sugar to your Barberries[15] and dip your sugar into water, boil it into a syrup – when boiled put your Barberries[15] in. Let them boil once up then lay them up for 3 or 4 days, warm them and put them into glasses.

To Stew Green Pease[16]

Rub your Pease well in Butter. Put them in your stew pan with a piece of lean ham, one large onion cut fine, pepper salt and 2 tea spoonfuls of fine sugar, some good gravy without any fat upon it, 2 heads of lettuce chopped very fine – garnish with fried bread.

White Sauce for Boiled Chicken

The livers of the chickens and as many eggs as there are chickens must be boiled together – when they are hard the yolks and the livers must be rubbed thro' a sieve with a little gravy made of veal or the necks of the chickens – a full half pint of gravy will do them. Put in a little anchovy liquor[17] to your taste about three or four spoonfuls of cream and some slice of lemon. Shake all well together then thicken it with butter and flour as for a fricassee – cut two slices of lemon and lay them on the side of your dish that the sauce may mix with them then heat your sauce and pour over the chicken.

To Pickle Mushrooms Brown

A quarter of a Peck of Button mushrooms washed clean in water with a flannel, let them drain in a colander then put them into a stone pan with a handful of salt some mace, cloves, nutmeg, whole ginger, or pepper to your taste – Stir them slowly over a clear fire[26], till they are quite dry, then lay them in a dish till they are quite cold, put them into dry bottles and fill them up with vinegar that has been boiled and has gone cold – pepper is preferable to ginger.

White Pot

Three pints of milk not too good measure, 6 eggs leaving out three whites, beat them very well with a little rose water and a bit of cinnamon, add to it the milk and sweeten to your taste. It will take half an hour to bake in a quick oven. Just before you hand it in, lay some thin pieces of bread and butter on it.

Scotch Collops[8]

Cut your Veal from the fillets thin, beat it well with a rolling pin and grate a little nutmeg over them then dip them in the yolk of an egg and fry them in butter till they are of a light brown, pour all the butter from them and have ready half a pint of gravy or broth, a little piece of butter rolled in flour, a few mushrooms, the yolk of an egg and a small quantity of cream and salt to your taste when thick and quite hot it is enough.

To make Fish Sauce for keeping)

Two quarts of Beef Pickle clarified
Six Pints of Vinegar, 4 Ounces Garlick
4 Ounces Ginger, all boiled up together
then add 4 Ounces of flour of Mustard
and a handful of horseradish
scraped, a wine glass of Anchovies
and two of Walnut Catchup, half
a Nutmeg a little Clove and a
very small quantity of Mace, pound
=ed in a Mortar, when done
put it before the fire or Sun
and shake the Bottle before it
is used.—
2 Table Spoonfuls is sufficient for
a large Butter Boat—

Fillet Souffles a la Bachemel

Put a bit of butter into a stew pan with a slice of ham or bacon and two shallots cut into bits – a few basil or bay leaves and one sliced onion, soak all together upon a quick fire adding cream sufficient and boil it till the sauce is of a good consistence. Sift it in a sieve, add pepper and salt and then put it to the fillets of roasted meat as of poultry, rabbit, partridges and add with the whites of two eggs first well beaten mix all together and pour it into the dish you intend to use – lastly sprinkle bread crumbs over it, place very small pieces of butter close to each other upon the crumbs – give it colour and serve it while hot.

To Make Fish Sauce for Keeping

Two quarts of beef pickle[19] clarified, six pints of vinegar, 4 ounces garlich, 4 ounces ginger, all boiled up together then add 4 ounces of flour and mustard and a handful of horseradish scraped, a wine glass of anchovies and two walnut catchup, half a nutmeg, a little clove and a <u>very small</u> quantity of mace, pounded in a mortar when done and pour it before the fire or sun and shake the bottle before it is used. 2 tablespoonfuls is sufficient for a large butter boat.

Onion Soup

Onion Soup

Six large onions, cut thin and fried, pepper and salt to your taste, then pour three pints of boiling water, cover it close and let it stew gently till the onions are tender, keeping it supplied with boiling water as it wastes to be rather more than a quarter when done. Beat the yolks of two eggs with a little flour and vinegar and a few spoonfuls of the soup, keeping it stirring till you take it off the fire.

To Stew Golden Pippins

Pare them and nicely scoop out the core with a very small scoop, throw them into water to preserve their colour. To a pound of pippins thus prepared take half a pound of sugar and one pint of water, boil and scum the syrup before you put in the poppins. When in let them boil apace to make them clear and when they are so put in half a lemon peel and the juice of one to give it a flavour.

To Preserve Strawberries Whole

Before they are full ripe get the finest Carolina strawberries[20] with their stalks on, lay them separately on a dish, beat and sift twice their weight of double refined sugar[54] and strew over them, and let them remain all night. Then take some ripe Scarlet strawberries[21], mash them and put them into a jar with their weight of sugar beaten small, cover them close and let them stand in a kettle of boiling water till they are soft and the syrup is out of them then strain them into muslin into a toping pan[22], boil and strain it well. When it is cold, put in your whole strawberries and set them over the fire till they are milk warm, then take them off and let them stand till they are quite cold, then set them on again and make them a little hotter. Do so several times till they look clear, but never suffer them to boil for it will take off the stalks – when the strawberries are clear and cold put them into glasses or pots with the stalks downwards, then boil your syrup till it becomes almost a jelly and put over them.

NB. Cover them with papers dipt in Brandy

Calves Head – Rolled

Scald the hair off in the manner of a pig, and clean it well then rub in a little salt petre or common salt, let it lay 24 hours then boil it till the bones come easily out. Have ready a good force meat made of veal and lay it in the inside of your head, first washing it with an egg, slice the ears and tongue and lay them on the force meat then roll it as tight as you can, and tie it in a cloth them fillet it to make it still tighter, the next day you will find it a firm roll. Wash it with an egg. Strew on crumbs of bread and set it in the oven for an hour, then serve it with the following sauce.

Morells or Truffles with mushroom sweetbread and the yolk of hard eggs cut into pieces, put them into a strew pan with a little good gravy or broth, a lump of butter, a little flour, and a glass of white wine, shake all well together then add a little cream, the yolks of three eggs, and two anchovies all beat together with a little pepper and salt to your taste, adding two large spoonful's of cider or lemon vinegar.

White Sauce for Carp

Half a pint of white wine, a quarter of a pint of cider vinegar and half a pint of water, a handful of sweet herbs, an onion stuck with cloves – let it boil till the goodness is out of the ingredients, then thicken it with well melted butter, the yolk of an egg, and a pint of cream.

White Sauce for Carp

half a pint of White Wine a
quarter of a pint of Elder Vinagr
and half a Pint of Water, a
handful of sweet herbs, an
Onion stuck with Cloves — let it
boil till the goodness is out
of the Ingredients, then thicken
it with well melted Butter
the yolk of an Egg, and a Pint
of Cream: —

To Stew Spinage Like Sambo[24]

Take your spinage, pick and wash it in many water till it becomes quite free from grit. Put it on to boil with a handful or two of parsley to boil, with a small quantity of water, with ¾ lb of salt pork with little or no fat till nearly done, then take it off the fire and chop it fine with a large onion, a sprig of thyme, part of a green pepper, quarter of a pound of butter, and a little salt, with two large spoonfuls of vinegar, put all these together in a stew pan and let it stew for a full half hour, making some small suet dumplings, about the bigness[41] of a walnut to stew with it.

Browning[25] for Made Dishes

Beat fine a quarter of a pound of fine sugar, put it into a frying pan with an ounce of butter, sit it on a clear fire[26], keep stirring it all the time. When it begins to be frothy hold the pan up to prevent it burning. Have ready a pint of red wine. When the sugar and butter are of a good brown, put in a little of the wine and shake it about, then add the rest and be sure to continue to stir it all the time, adding a very small quantity of red pepper, 6 cloves, 4 shallots, some salt to your taste and the rind of a lemon, boil it altogether for ten minutes slowly then pour it into a basin, when cold bottle it for use – 2 table spoonfuls for a made dish – it will keep a long time.

White Soup

Take a knuckle of veal, boil it to a rich broth, put pepper, mace and a large onion, prepare your gravy over night, when cold take the fat off, then put it into a stew pan, take half a pound of Almonds blanched, and a handful of scalded rice[27], with a full half pound of lean ham, boil all these ingredients together with a few herbs, whole white pepper, it is to be all carefully strained thro' a sieve and before you send it to the table have ready a quart of good cream. First boiling it, then adding it boiling to your soup, with salt to your taste, and if you please a French roll.

Pea Soup without Meat or Water

Put in a stew pan eight or ten cos lettuces, six or eight cucumbers pared, scooped, and cut thin, five onions, and a handful of parsley, a handful of chervil, a little sorrel, pepper and salt, with a quarter of a pound of butter, stew them together slowly till the juice is out of the ingredients, and then strain off the liquor, have ready boiled a pint of old peas and squeeze them through a sieve into the liquor, afterwards boil tender by themselves four or five cucumbers scooped, pared and cut into quarters, two or three cabbage lettuces cut, and a pint of young peas, add these to the liquor and let them stew slowly till done enough – NB it takes much doing and like all soups better forwarded the night before.

Norfolk Batter Pudding

Take the yolks of three eggs and the whites very well beat, three spoonfuls of flour, half a pint of milk and a small quantity of salt. NB This pudding to be boiled twenty minutes half an hour.

Burnt Cream

To a pint of good cream add half a pint of milk, grate in the rind of half lemon, thicken the milk with a spoonful of flour and the yolks of six eggs, when the cream boils put in your milk and sugar it to your taste and stir it one way till it becomes thick then pour it out into your dish, when a little cold brown it all over with a hot salamander[11]. A little burnt sugar crushed over it gives it a flavour and adds to the effect.

Burnt Cream

To a Pint of good Cream add half
a Pint of Milk grate in the
rind of half Lemon thicken the
Milk with a spoonful of flour
and the yolks of six Eggs, when
the Cream boils put in your
Milk and sugar it to your taste
and stir it one way till it become
thick, then pour it out into your
Dish, when a little cold brown
it all over with a hot Saloman
=der, A little burnt Sugar
crossed over its gives it a flaor
and adds to the effect.—

Red Quince Marmalade

Scald your quinces[28] very tender then pare and quarter them and cut out the cores and all the hard parts – to every pound of quince put 3 quarters of a pound of sugar, boil the cores and skins in as much water as will allow to every pound of quince a pint. Cover them and let them stew very slowly, when they are red and clear take them out and chop them in pieces then put them in again and boil them very fast till it will cut when it is cold.

To Preserve Cherries

To three quarters of a pound of cherries stoned, a pound and quarter of sugar to stew on them. As they boil then take the cherries and put a layer of cherries and a layer of sugar in the pan till they are all in, boil them quickly keeping them close covered with paper and frequently taking them off and well scumming[29] them till quite clear and stewing sugar over them when they look transparent. Take them out of the syrup and strain the syrup thro' a fine sieve then put in a quarter of a pint of white currant juice into the pan again and boil it till it is hanging jelly just before you take it off put in your cherries, and give it just a boil up. Put them in Pots, 14 spoonfuls of water are enough to make your syrup with.

Currant Wine

To 14 pounds of currants put 12 quarts of cold water, squeeze the currants and let them stand two nights and two days, stirring them 3 or 4 times. Strain them through a sieve, and squeeze them with the stalks till quite dry – put in it 14 pounds of sugar, and then put it into a cask, letting it stand open 14 days then bung it up very close, and keep stirring it well before you do so – in six months you may bottle it off. NB: I put an equal number of white and red currants and I add a few Raspberries.

Furniture Oil

Four pennysworth of alkanet[30] root, two of Rose Pink[31], a pint of cold drawn linseed oil mixed in an earthen pot, let it stand all night and then rub it on your tables with a linen rag. A few hours after take it off – if your tables have been rubbed with wax it must be set off with hot vinegar before you use the above.

Apricot Jam

Take two pounds of apricots and a pint of codlin[32] jelly, boil them very fast together till the jelly is almost wasted, then put to it a pound and half of refined sugar and boil it very fast till it jellies, put it into your glasses – you may make clean cakes with this in the winter.

To Make White Hog Pudding

Take a quart of cream, and 12 eggs leaving out six whites, beat them just a little, and when the cream boils, put in the eggs keep stirring it on a gentle fire till it is a thick curd, when almost cold put to it a pound of grated bread, a pound and half of suet shred small and half a pound of almonds, well beat, one nutmeg, a little grated citron, a quarter of a pound cut small, with two spoonfuls of orange flower water – a little salt, and sugar to your taste.

Apricot Jam

Take two pounds of Apricots and a pint of Codlin Jelly, boil them very fast together till the Jelly is almost wasted, then put to it a pound and half of refined Sugar and boil it very fast till it Jellies, put it into y.r Glasses. — You may make clean Cakes with this in the Winter. —

Westphalia Ham[33]

Cut your legs of pork like hams and beat them well, to three hams take half a peck of salt 4 ounces of salt petre[5], and one pound of brown sugar, mix them altogether and then rub your hams and lay them together then put the rest of your salt over them and let them lay three days. Then hang them up one night to drain, on the morrow put as much water to your salt and sugar as will cover your hams and bear an egg, boil and strain it, when cold pack your hams close and put your pickle over them, they must be covered two inches above the hams. Let them lay a fortnight then hang them up one night, the next day rub them well with bran, dry them in a chimney where they burn wood, if small a fortnight will dry them, if large a few days longer then hang them against a wall not near the fire or in a damp place.

Lemon Curd

Take a pint of cream and when it boils, put in 6 whites of eggs, one lemons and a half, stir it till it comes to a tender curd, then put it into a bag to drain till all the whey is drained from it then beat the curd in a mortar with some lemon peel and sugar putting it in a mould and letting it stand till it is fit to turn out – then pour over it cream and sugar.

Gooseberry Wine

To every pound of gooseberries when picked and bruised put one
quart of cold string water, let it stand three days stirring it twice
a day then strain and pour it thro' a sieve and to every gallon of
liquor put three pounds of loaf sugar[52] and barrel it up. To every
five gallons add a bottle of good brandy – put a piece of isinglass
into the vessel and stop it up – In six months if the sweetness is
sufficiently gone off, bottle it, and cement the corks.

Calves Head Turtle Fashion[35]

Take a calves head, and scald off the skin, as you would that of a
pig. When cleaned, cut the horny part into thin slices with the lean,
have ready 3 pints of gravy (strong) put it on to stew for some time
then add cayenne and salt to your taste, with a large onion and the
rind of a lemon, shred as small as possible, likewise sweet herbs and
a very small proportion of spice. After stewing some time add a full
half pint of madeira, with the juice of 2 lemons, when the horn is
tender, take it off, fry your forcemeat balls, then put it in the dish
you intended to send to table, with 2 ounces of butter. Put in small
bits about it with a dozen large oysters and the liquor, hard eggs,
and balls and set it into the over to brown. Takes a full quarter of an
hour doing. NB: If a large head it will required a trifle more butter.

Sheep's Rump with Sauce Robert

To Preserve Peaches in Brandy

Gather your peaches before they are quite ripe, rub them well with a flannel, then boil a thin syrup and put them in and keep them hot for half an hour, continually turning them for half an hour, then take them off the fire, and put them into a large bowl covered close. The next day put them on a very gentle fire for half an hour, turning them as before, then lay them by till near cold, and put them into a stone jar with the syrup they were boiled in – to which add the same quantity of brandy observing that the peaches be all covered – to about forty peaches it will require 3 pound and a half of sugar.

Dried Cherries

Stew 10 pounds of cherries, put 3 pounds of sugar finely beaten to them, shake the sugar and cherries well together, and when the sugar is dissolved let them have a boil or two over a slow fire, then put them into an earthen pot. Next day scald them and when cold lay them on a sieve. Dry them in the sun or lay them in an oven not too hot and turn them till they are dry enough – when you lay them in a box put no paper between them.

To Dry Green Gages

Take your plumbs prick them all over with a pin, make water boiling hot and put them in immediately. Cover them close and when they are almost cold set them on the fire again but do not let them boil. Do so three or four times, when you see the skin crack, put in a small quantity of allium to green them. Then give them a boil up close covered, then put them into fresh hot water, and let them stand all night. The next day have ready as much clarified sugar as will cover them, drain the plumbs, and put them into the syrup, and give them two or three boils, repeat for two or three days, till they are green, let them stay in the syrup a week, then lay them out to dry on a hot stove – you may put some of them in codlin jelly first, boiling the jelly with the weight of Sugar. NB: The large plumbs answer much better to this recipe.

To Stew Soles

To a pair of soles put half a pint of white wine, sufficient water to cover them a little pepper, salt, spice, 2 anchovies, a large onion, some herbs with a tea cup of walnut catchup – put in a little butter to stew with them.

Orange Creams

Take the rind of 6 China oranges[37] and the juice of 8 with 2 lemons, mix the rinds with the juice, add a pint of cream and 3 ounces of isinglass well boiled, grate the rinds on. Sugar sufficient to sweeten it, strain it, and put it into your shape overnight.

To Salt Bacon

Sprinkle the flitches with common salt, the next day wipe them dry thin in done to fetch out the bloody brine, then take 6 ounces of salt petre[5], 3 ounces proper salt, 3 ounces of salt prunell[38], 1 pound of coarse sugar, beat the salt fine, and mix them with the sugar and rub it in well with your hands. Let the ingredients lay on two days then salt the flitches with common salt turning them every day for three weeks – this salts a pig of 12 stone.

To Salt Bacon

Sprinkle the Flitches with common Salt, the next day wipe them dry this is done to fetch out the bloody Brine, then take 6 ounces of salt petre 3 ounces Paper Salt 3 Ounces of Salt prunell, 1 pound of coarse Sugar, beat the salts fine, and mix them with the Sugar and rub it in well with your hands. let the Ingre =dients lay on two Days then salt the Flitches with common salt turning them every Day for three Weeks. — This Salts a Pig of 12 Stone

Beef a la Mode

Take the lean end of the Ropes eye of
Beef salt it in the usual way for 3 or 4
Days, then wash it clean from the
Salt — rub into it salt Brunell and
salt Petre of each one pennyworth
let it continue in this state five days,
then drain it for 24 hours in a coarse
cloth. — Take half a pound of fat
Bacon in stripes and roll them in
chopt herbs, Cloves Mace a Nutmeg and
a little allspice and pepper beat
very fine, and with them lard your
Beef, put it in a stew pan with
half a pint of boiling Water, and
a few small Onions — Cover it very

Beef a La Mode

Take the lean end of the Popes eye of Beef. Salt it in the normal way for 3 or 4 days, then wash it clean from the salt – rub into it salt prunell[38] and salt petre[5] of each one pennyworth. Let it continue in this state five days then drain it for 24 hours in a coarse cloth – take half a pound of salt Bacon in strips and roll them in chopped herbs, cloves, mace, a nutmeg and a little allspice and pepper beat very fine, and with them lard your beef, put it in a stew pan with half a pint of boiling water, and a few small onions – cover it very close, then set it on a slow fire for 4 or 5 hours.

To Pickle Onions

Take small onions, peel them and put them into spring water and salt very strong, let them be shifted for 6 days, then strain them off and wipe them very dry then boil your vinegar with salt, a little mace, whole pepper and a head of two of ginger – the vinegar must be quite cold before you put in your onions.

Orange Loaves

Take 5 or 6 sweet oranges rub them with a coarse cloth and salt, let them lay in water a day, then tie them up in a coarse cloth, boil them slowly in 3 or 4 waters till they are tender then cut a small hole at the tops. Take out all the insides with a scoop then make a syrup with a quart of water and pound of sugar boil and scum it well – then put in the oranges, boil them till they are quite clear, then drain them well and take small quantity of Naples Biscuits[39], 2 ounces of almonds blanched, and beat fine a little sugar butter and orange flower[40] water, the yolks of 3 eggs beat altogether then fill your oranges and grate some sugar over them and put them in a pan, and put them in the oven to bake, when done pour any white wine, sugar & butter over them, serve them for 2 course. –

NB: Lay your oranges for a night in the syrup before you fill them up.

Short Crust

1lb of flour, 1 ounces of loaf sugar[52] beat very fine, mix and make it into a stiff paste with a gill[7] of boiling cream and 3 ounces of butter in it work it well, roll it very thin when your tarts are made beat the white of an egg and do them over with a feather and sift a little sugar over them.

To Pickle Lemons

Cut your lemons thro' and thro' with 8 parts, then put them into a pan, a layer of salt and a layer of lemon so as not to touch each other. Set them in the chimney corner and be sure to turn them every day and pack them in the same manner as before. This you must keep doing 15 or 16 days, then take them out of the salt and lay them every day in the sun for a month if no sun before the fire then put them into your pickle and in 6 months they will be fit for use.

Pickle for the Lemons

Take 2 pounds of peeled garlic, 1 pound of ginger, 1 pound 4 ounces of mustard seed, ½ an ounce of turmeric. – every clove of the garlic must be split in half – the ginger must be cut very small and covered with salt which will do in weeks, by which means when you have occasion for it, you may use it. The mustard seed must be bruised not reduced to powder. Mix them well together – add 3 ounces of oil of mustard seed – put these ingredients in a gallon of the best white wine vinegar boiled then put all upon the lemons in a glazed jar, and tie it up for use – let your vinegar stand till cold before you put it to your lemons – your lemons must be quite dry before you put the pickle to them.

To make a Fricase of Pigs Feet & Ears

Take 3 or 4 Pigs Feet & Ears, according
to the size of your Dish, clean and
boil them very tender, cut them in
small Shreds the length of your
finger and about a quarter of an
inch broad. fry them with Butter
till they are quite brown, but not
hard then put them into a Stew Pan
with a little brown Gravy and a
small peice of Butter, 2 spoonfals.
of Vinegar a little Mustard and Salt
thickened with a little flour and
an Onion sliced very fine. then
take 2 or 3 Pigs feet boil them tender
fit for eating then split them thro

To Make a Fricassee of Pigs Feet and Ears

Take 3 or 4 pigs feet and ears, according to the size of your dish, clean and boil them very tender, cut them in small shreds the length of your finger and about a quarter of an inch broad. Fry them with butter till they are quite brown, but not hard then put them into a stew pan with a little brown gravy and a small piece of butter, 2 spoonfuls of vinegar, a little mustard and salt thickened with a little flour and an onion sliced very fine. Then take 2 or 3 pigs feet boil them tender fit for eating then split them thro' the middle and take out the broad bones and dip them in egg – strew over them a few bread crumbs and well season them with pepper and salt then fry them and lay them on your dish upon the fricassee. NB: They do taste well of mustard and vinegar.

Cakes

Take 1 pound of flour, half a pound of butter, half a pound of sugar, 8 eggs, and two spoonfuls of Brandy – mix it well together and put it in the shape of small cakes on tins to bake.

Sheeps Rump with Sauce Robert

Cut your rumps off as near to the mutton as you can. Four or five will do for a small dish. Cut each in two and put them boiling in a pot till tender, with a spoonful of pepper, handful of salt, a small quantity of cloves, 3 cut onions, a bay leaf, a spring of thyme, 3 spoonfuls of vinegar put in these ingredients after your pot is scummed. The salt and vinegar when your rumps are very tender and well-seasoned. Take them out and let them drain in a colander and dip them in brown butter and broil them well on a grid iron until of a light brown. Then prepare the sauce Robert as follows. –

Put into your pan the bigness of an egg[41] in butter, a handful of onions minced fine, fry them gently till they are brown and throw in half a spoonful of flour and fry it a little. Add a ladle full of gravy, a little pepper and salt, boil it up a quarter of an hour, scum off the fat. Put in half a spoonful of mustard and a little vinegar, the juice of half a lemon, put the sauce in the dish and lay the rumps upon it, garnish with fried parsley.

An Omelette

Take 8 or 9 eggs and beat them well, just as much pepper and salt as will make them taste relishing – add a tea spoonful of milk, a small onion, a little parsley chopped fine. Put a piece of butter the size of an egg into a small frying pan and when hot pour the egg in. When you see it harden put a little more butter to make it high in the pan – it must not be burned. When it is dry at the top, flip it on the back side of a plate, into a dish that you send to table.

Sally Lunns

Take 3 pound of the best flour, 6 eggs well beaten, 5 ounces of butter melted into a pint of milk to which add your eggs with half a pint of good yeast, then mix in the flour and let them stand to rise an hour and half. Make them into flat rolls that will handsomely fill the bottom of a plate. Pass the tops over with a feather dipt into the yolk of an egg. Bake them in a very quick oven. They will be of a very dark colour.

Brown Sauce for Carp

To the blood of your cap put thyme, parsley, onion and anchovies. Chop them small and put them in the saucepan with the blood. Add half a pint of white wine and a quarter of a pint of cider vinegar. Mix all these ingredients together and put it on the fire to boil then mix some melted butter with it and pour it on your fish when done.

Sorrell Sauce

Pound sorrel sufficient to draw 2 spoonfuls of juice, sift it and melt it with your butter rolled in flour, salt, nutmeg and pepper with two yolks of eggs, warm together without boiling.

Gingerbread

Take 1 pound and half of flour. Warm 3 quarters of a pound of butter, then add three quarters of a pound of treacle, 6 ounces of sugar, half an ounce of ginger to which add a little orange peel beaten and sifted.

Sorrel Sauce

Pound Sorrel sufficient to draw 2
Spoonfuls of Juice, sift it and melt
it with your Butter rolled in
flour, Salt, Nutmeg, and pepper,
with two Yolks of Eggs, warm
it together without boiling. —

Gingerbread

Take 1 pound and half of flour
work 3 quarters of a pound of
Butter, then add three quarters
of a pound of Treacle, 6 ounces
of Sugar, half an Ounce of Ginger,
to which add a little Orange

Orange or Lemon Pudding

Take the peel of three lemons, boil them till tender beat them fine in a mortar with a little rose water, half a pound of butter oyled, 8 eggs leaving out 6 whites, six ounces of sugar half pound of almonds beaten well adding and well mixing it – lay a crust at the bottom of your dish – half an hour will bake it.

To Pot Mackerel

Wash and clean 4 dozen mackerel. Cut off the heads tails and fins, dry them with a cloth, then put them in layers into a pan, putting between each layer, salt, pepper, bay leaves, allspice and 3 pennyworth of cochineal[42], cover them over with the best white wine vinegar and let them bake in an oven all night. NB: Put half water to your vinegar, pound the allspice and cochineal, let them be put in the oven 2 hours after the bread is in and remain all night.

To Pot Mackrel

Wash and clean 4 Dozen Mackrel
cut off the heads tails and fins, dry
them with a Cloth, then put them
in Layers into a Pan, putting
between each Layer, Salt pepper
Bay leaves ^{allspice} and 3 pennyworth
of Cochineal, cover them over
with the best white wine
Vinegar and let them bake in
an oven all Night. NB
Put half water to your Vinegar,
pound the Allspice and Cochineal,
let them be put in the oven
2 hours after the Bread is in,

Cocoa-nut Tarts

Grate a cocoa-nut very fine. Put some syrup to it, and boil it up for five minutes. Then take it off, and let it cool. Before you put the cocoa-nut into your crust, add the yolk of 2 eggs and a small quantity of orange flower and rose water putting it on the fire for a minute or two stirring it all the time – take it off and beat it up well. Just as you are going to put them in the oven sift a little fine sugar over them.

Green Pease Soup

Boil a quart of pease[16] in 5 pints of water till all the goodness is out. Then strain the liquor, take a quarter of a pound of butter and burn it not too high, then put a quart of your pease and let them stew till they begin to husk, put in as much grated bread as you think will thicken it, and keep it stirring till the butter is dried into the bread, then put in the liquor with a little thyme and 2 leeks. Then boil the herbs tender then take lettuces and French fennel chop them a little and put them into a pan and season it with salt and pepper to your taste. Let it boil sufficiently and to improve it <u>much</u> put in a very large spoonful of white sugar and a slice or two of lean ham or bacon.

Macaroni Soup

Take three quarts of broth, boil half a pound of small pipe macaroni in three quarts of water with a little butter in it till quite tender, then strain it thro' a sieve. Cut it into pieces of about two inches in length, put it into your soup, and boil it up few minutes.

Veal Olives

Cut collops from a leg or loin of veal, hack them with the back of a knife, and dip them in the yolk of an egg, season them with pepper, salt, nutmeg. Make forced meat of some of the veal, beef, just grated bread and herbs shred fine with a little onion and spice, make it up with the yolk of an egg and spread very thin on the collops[18], then lay 4 thin slices of bacon over each not too fat and roll it up in the form of an egg laying a little of the forced meat over the outside of them and put them into a pan with a little water. About half an hour will bake them. The sauce must be a good gravy and just some of the liquor it was baked in, first taking off the fat.

Cocoa-nut Tart

China Chilo

Take a loin of mutton, mince it very fine with very little fat and no skin, a large tea spoonful of salt, 1 of beaten pepper, 2 large onions, and half a pint of green pease, a bunch of thyme, 4 cucumbers cut in very small slices, one lettuce chopt, 4 spoonfuls of water and a quarter of a pound of clarified butter. Let all this stew for 4 hours in a pipkin[43] putting in 2 large spoonfuls of cider vinegar or lemon pickle then put it into the middle of half a pound of boiled rice.

Ramekins

Take a pound of mild cheese grate it very fine, put it in a stew pan. Take the yolks of 6 eggs and the whites of 2, mix them with a wooden spoon, clarifying half a pound of butter, beat them together till they are quite smooth, put them into paper cases that are made ready, sitting them in an oven (not too hot) to be of a light brown about ten minutes will bake them. A Dutch oven will answer if you have not another.

Indian Pickle

Take a pound of ginger, let it lay in salt and water one night then scrape and cut it, and put it in a bowl with dry salt and let it stand till the rest of the ingredients are ready – take a pound of garlich cut it in thin slices and salt it for 3 days, then wash it, and put it in a sieve to drain in the sun. Take cabbage and cut thin quarters and salt them for three days then squeeze all the water from them and put them in the sun to dry. So do Cauliflowers, Apples, Cucumbers, French bean or anything else.

Take long pepper and dry it not too much, a quarter of a pound of mustard seed and one ounce of tumerich bruised very fine – put all these Ingredients into a stone jar with one quart of the sharpest vinegar, 3 quarts of small – fill the jar three quarters full, look at it in a fortnight and if you see occasion fill it fuller adding the things that come in season, you need not empty but as things come in put them into your jar and replenish it with vinegar. The sun is better to dry the vegetables than the fire.

To Preserve Green Gages[36]

Gather your gages not too ripe. Take as much pump water as will cover them, put a quarter of a pound of double refined sugar[54] and boil and scum it very well, and let it be cold. Then prick your gages to the stones and cover them with vine leaves and set them over a slow fire to green – do so three days running, then let them drain putting to them a thick syrup.

Chocolate Almonds

Take a pound of chocolate grated a p^d
and half of sugar sifted, then soak
in orange flower Water, work
them into a stiff Paste make them
in what form you please and dry
them in a Stove. —

Black Cherry Brandy

8 pounds of small black Cherries to a
Gallon of Brandy half a pound of double
refined Sugar a peice of Cinnamon
a a few Cloves with 2 doz Apricot
Kernels. —

NB it will take a double quantity of.
Sugar —

Green Gage Cheese[36]

Green your gages in a thick syrup covered well with vine leaves, when you perceive them tender, and that the skin begins to peel from them take them out of the syrup and pulp them thro' a cullinder, then take a small quantity of the same syrup they are scalded in and put three quarters of a pound of sugar to three pounds of the green gages – crack some kernels and boil up with them till they are of a consistence sufficiently thick to stiffen into cheese, when done put it into saucers or any shallow to turn and cut out. NB: If the green gages are not quite green when done scalding they will turn more so in boiling.

Chocolate Almonds

Take a pound of chocolate grated, a pound and half of sugar sifted, then soak in orange flower[40] water, work them into a stiff paste, bake them in what form you please and dry them in a stove.

Black Cherry Brandy

8 pounds of small black cherries to a gallon of brandy, half a pound of double refined sugar[54], a piece of cinnamon and a few cloves with 2 dry apricots kernels. NB: It will take a double quantity of sugar.

Mince Pies

Take 6 pounds of Currants, 3 pounds of
Raisins: Stoned and chopt very fine
3 pounds of Apples, the peel of a lemon
both Shred very fine — Mace Nutmeg
and Cloves 2 ounces, one pound and half
of Sugar, and a Pint of white Wine
one pound of Orange Chips cut small
and some Citron cut in slices — you
must judge the quantity of Suet
mix alltogether putting in the Juice
of 6 seville Oranges. — N B The quant,
of Spice is too much 3 quarters of
an Ounce is quite sufficient. —

An Amlet of Asparagus

Take 6 eggs, beat them with some onion chopt fine – boil some asparagus. Cut off the green mix them with the egg, add pepper and salt – make your pan hot put in a slice of butter, then put in the eggs and fry them not too thin.

Almond Cream

Take half a pound of good almonds, blanch them with fine orange flower water – take a quart of cream boiled, cooled and sweetened to your taste. Put the almonds into it, pounded very fine, and do the top over with a salamander[11].

Mince Pies

Take 6 pounds of currants, 3 pounds of raisins: stoned and chopt very fine, 3 pounds of apples, the peel of a lemon both shred very fine – mace, nutmeg and cloves 2 ounces, one pound and half of sugar, and a pint of white wine. One pound of orange chips cut small and some citron cut in slices – you must judge the quantity of that. Mix altogether putting in the juice of 6 Seville oranges. – NB: The quantity of spice is <u>too much</u> 3 quarts of an ounce is quite sufficient.

Mince Pies

Pickle to keep Brawn

To two Gallons of Water, put one
quart of Wheat Bran and one
pound of Salt; let them boil one
hour — Strain it from the Bran
and let it stand till cold then
put the Brawn into this Pickle
and keep it in constantly —

N B
This Pickle will keep 10 or 12 days
according to the weather —

French Bances[44]

Take half a pint of water and a piece of lemon peel, a small piece of
butter the size of a walnut and a little orange flower water, let it boil
3 or 4 minutes then take out the lemon peel and put in half a pint of
flour, keep the water boiling and stirring it all the while till it is of a
stiff paste – then take it off the fire, and put in 6 eggs, leaving out 3
whites well beating them for half an hour together till they come to
a stiff paste – then take 1 pound of hogs lard and put it into a stew
pan and give it a boil up – then fry your Bances if they are of a nice
lightness keep them stirring all the time till they are of a light brown
– large dish will take 6 or 7 minutes boiling. When done put them in
a dish to drain – strew fine sugar over them when going to be fried
drop them thro' the handle of a tray.

Pickle to Keep Brawn

To two gallons of water, put one quart of wheat bran[34] and one
pound of salt, let them boil one hour – strain it from the bran and
let it stand till cold then put the Brown into thin pickle and keep it
in constantly. This pickle will keep 10 or 12 days according to the
weather.

To Preserve Apricots

Take apricots before they are quite ripe, pare them and cut them into middling pieces but not to the stone then weigh them and to their weight put the same quantity of sugar and make what haste you can that they may not lose their colour, so wet your sugar to make it a syrup and put your apricots into it, then boil them till the syrup thickens breaking the apricots as little as you can, then put it out into a basin. Then take a quarter of your weight of sugar which you must remember to leave out and boil it to a candy height and pour it to the other in the Basin and set it over the fire but let it not boil.

Cucharee[45]

Take the third of a pint of split pease boil them till they are better than half boiled, pour them into a sieve and when they are boiled chop them a little, then take a pound of rice well washed and picked clean and mix it with the pease, cut an onion small and take some whole pepper, cloves and mace with a very small quantity of tumerich. Fry the onions and spice in a little butter, then put it into the pot where the onions and spice were fried, the rice and pease, pour upon them with a full quart of good veal gravy seasoned with salt, cover the pot close and let it stew over a slow fire till the liquor is soaked up and the rice tender and fit to eat. You must have a cup of clarified butter to eat with it. Garnish it with egg, boiled hard and cut into quarters.

Camp Vinegar

A large head of garlich peeled and cut into slices, a quarter of an ounce of Cayan Pepper, 2 spoonfuls of soy, 2 of walnut pickle, 4 anchovies shred very small to be put in a pint of vinegar with Cochineal through to colour it. Shake it often then put it in a warm place for 6 weeks then pour to clear off.

Chicken Curry

Take an ounce of butter and make it hot in your stew pan, put to it about two spoonfuls of rice pounded fine, a tea spoonful of salt and 3 of curry powder. With a little veal gravy boil it up then take your chicken and cut them fricasee fashion and fry them in butter with two large onions thin. Put them to the other ingredients and let it all stew together till tender before you take it off put in the rind of a lemon rubbed in salt and the juice of a large one a small bit of Indian pickle will improve it. Do Lobster, Veal or Rabbit the same way.

Almond Faggots

Blanch and slice your almonds
very thin long ways, to one
pound of Almonds half a pound
of fine Sugar. beaten and sifted, and
the whites of two Eggs. well beaten,
and the peel of one Lemon shred
fine, mix all well together
and with a Spoon drop it on
papers which must be well
buttered. Bake them on Tins of
a light Brown. —

Rissoles a la Bechenel

Soak a Slice of Ham with a bit of Butter, chopt Parsley, Shallots and half a laurel loaf, simmer these on a slow fire about a quarter of an hour then add a good spoonful of cullis[46] as much cream and a little flour and pepper, reduce the liquor till quite thick and sift it in a sieve – cut the Breast of roast poultry or veal into little bits, put the meat into a saucepan with one yolk of an Egg and give them a boiling together – cut also bits of thin paste to what form you please. Put this Ragout between the pieces of paste, pinch it all round to secure the sauce fry Them in oil a light brown.

Almond Faggots

Blanch and slice your almonds very thin long ways, to one pound of almonds half a pound of fine sugar beaten and sifted, and the whites of two eggs well beaten and the peel of one lemon shred fine, mix all well together and with a spoon drop it on papers which must be well buttered. Bake them on fire of a light brown.

To Stew or Palates

Blanch your palates[47] till quite tender in a little weak broth then cut them in any shape you like, put them in a rich white sauce, garnish with fried bread.

To Stew a Rump of Beef

Rub your beef with garlich then lard it, and stew it four hours in a pint of water with onion, leeks, pepper, salt, mace and cloves, add a bay leaf then make a good brown sauce adding carrots, turnips, capers and gherkins letting it stew altogether till quite tender – garnish with carrots, turnips and beatroot in slices, one or the other paring the rims round, and sticking a sprig of parsley in the centre.

Charteuse[48]

Take the breast of a roast or boiled fowl layed in the bottom of your mold with a slice of tongue, with asparagus tops and French beans layed in form, then take lobster cut in slices, put it round the middle with forced meat, bake it and turn it out in your dish, add a good brown gravy, glaze the larded part and put bars of bacon round your mold before you put it in a pretty dish for 2 course.

Minced Chicken and Cucumber

Cut the white part of your fowl in thin slices, take 4 cucumbers, take out the seeds, put them to stew in butter. When tender put them on a sieve to drain, put to it a good white sauce and stew it a little time. Send it up in puff pastry the top not covered.

A Bread Cake

One pound of flour, a quarter of a pound of butter, three eggs, half a spoonful of good yeast, quarter of a pound of Lisbon sugar[49] the same quantity of raisins stoned and chopt fine, 2 ounces of currants, melt the butter and sugar in a pint of new milk, mix altogether and set it to rise over night, bake it in a tin in the morning.

To Pickle Large Cucumbers

Slice your cucumbers as thick as half a crown[50], an onion in the same manner, put a little salt and let them drain all night in a cullender, boil your vinegar with whole pepper and a blade or two of mace and pour it hot on your cucumber and stop them up.

An Amlet

Famous Gingerbread

Boil three pound of lump sugar[51] in a pint of water, till it becomes a syrup, stir in it two ounces of ginger beaten very fine and pass thro' a sieve with the same quantity of preserved cut fine. 2 ounces of orange peel, with two of citron, then work in while the syrup is warm as much flour as it will - make it a quarter of an inch thick, cut it in what shape you please and bake them of a light brown.

Lemon Cheesecake

Take the peel of two large lemons, boil them very tender then pound them in a mortar with a quarter of a pound or more of loaf sugar[52], the yolks of 6 eggs and not quite half a pound of butter, and a little curd beat fine, after well beating your eggs with a little orange flower water stir it well together and put it in your pastry pans first laying in the puff paste. NB: Orange cheese-cakes are done the same way only you boil the peel in several waters to take out the bitterness. You must not fill your pastry pan but a little more than half full.

To Pot Lobsters

Take 3 mackerel sized lobsters when boiled take off the tails and split them, cut the meat out as whole as you can. Pick the meat out of the Bloody cut if fine, and season it with pepper, salt, mustard and mace – the claws must be got as whole as possible and season with the tails separate from the rest – take a pound of butter, clarify and scum It very clean then put in the tails and claws with what you have beaten and let it boil a little while, stirring it all the time. Let it strain through a sieve but not too much, after which put it down close in your pot, when it is a little cold, pour the butter you drain from it, over it, but first bruise the berries of the lobsters[53], and well mix it with the butter, so as to give it a pretty look on your table.

To Make Wafers

Put nine large spoonfuls of flour to a pint of cream, a little rose water, sweeten it to your taste; make your wafer from very clean and heat them on a charcoal fire, when they are hot enough to dip in water, wrap up in a rag, as often as you perceive the iron to be dry, which will make the wafer difficult to be take off. A little fine sugar and cinnamon put over them when just in.

To Fricasee Lobsters

Cut the body in half and lay the other part in small slice around it, opening the claws as whole as you can, then stew it in a good white sauce, first well rubbing it with pepper, salt and a little clove, when done enough put a into a puff or raised paste. NB garnish with the eggs and berries.

To Stew Pigeons

Take the livers and heart of the pigeon and chop them with some crumbs of bread, some fat of bacon, thyme, parsley, a little sweet majoram. Some beaten pepper, nutmeg and salt, mix all with a bit of butter and stuff with it the bodies and craws of the pigeons, tye them up at both ends, cut off the pinions and feet and truss them as you would for potting, put them into a stew pan the breast downwards, then cover them with a little water, white wine, an onion stuck with clove, some white pepper, 2 anchovies and a little lemon peel, the giblets of the pigeons, stew all these together over a slow fire, take care to skim it well else they will be black, when done enough strain off the liquor and thicken it with butter and flour and the juice of a lemon.

To Fricassee Lobsters.

Cut the body in half and lay the
other part in small dice around it
picking the claws as whole as you
can, then stew it in a good white
sauce, first well rubing it with
pepper, salt & a little clove, when
done enough put it into a puff or
raised paste. NB. garnish with the
eggs & berries –

To stew Pigeons.

Take the livers & hearts of the Pi-
-geons and chop them with some
crumbs of bread, some fat of bacon

Raspberry Jam

Take to each pound of raspberries half a pint of jelly of Red Currants and a pound of double refined sugar[54] (short weight), stew the currants in a pot to get out the juice, beat the sugar very fine, then mix them all together and set it over a good fire and let it boil as fast as you can, till you see it with jelly. The juice of the currants must be half white and half red.

Pepper Pot

Take a knuckle of Veal and boil it down to a strong gravy, strain it off and put in six good handfuls of spinage well washed and chop'd, a hundred asparagus head 1 pint of green pease, 1 pound of East-India potatoes or Eddoes. 2 large onions, a few sprigs of thyme, cayan and salt to your taste. When boiled to the thickness of a good pease soup, then take a couple of boiled lobsters picked and chop'd fine with the berries bruised and mix them with the other ingredients and let it all boil for a full hour, a bit of salt pork gives it a flavour with a small piece of butter and some dumplins. A hundred of crayfish or prawns will do instead of lobster.

Fricandeau of Veal

Take the clean part of a leg of veal. Lard it with small slices of bacon, cut it any shape you please, then take some brown gravy add to it some white mustard seed, pepper, salt, cayan, then take some French sorrel and stew it till tender. Add it to your gravy and when stewed altogether put it in your dish and lay your veal on it, beat your veal very tender before you lard it. – NB sweetbreads make a better Fricandeau.

Macaroons

Take a pound of almonds, blanch them and beat them in a stone morter with eight spoonfuls of rose water. Mix them with a pound of fine loaf sugar[52] pounded and sifted, and the white of three eggs beat to a thick froth. Lay them on wafers to bake. When they are risen, and dry they are done enough.

Morels[23]

Beat up 6 eggs, 2 ounce of sugar pounded, a small quantity of cinnamon pounded, a wine glass of water, and as much flour as will make it a paste – roll it thin and work in a quarter of a pound a butter, grate in a little orange, put to be fried in lard, any shape you please.

Pickle Oysters

Take the largest Oysters you can get
and just plump them over the fire
in their own liquor, then strain it
from them and cover the Oysters very
close in a cloth and take an equal
measure of white Wine and Vinegar
and their own liquor with a little
Clove or mace pepper salt and the
peel of a Lemon pared very thin
when it boils put in your Oysters
to have one boil up, then put the
Pickle and the Oysters in a Pot
tied close in a cloth till the Pickle

Pickle Oysters

Take the largest oysters you can get and just plump them over the fire[55] in their own liqueur, then strain it from them and cover the oysters very close in a cloth and take an equal measure of white wine and vinegar and their own liquor with a little clove or mace pepper salt and then peel of a lemon pared very thin. When it boils put in your oysters to have one boil up, then put the pickle and the oysters in a pot tied close in a cloth till the pickle is quite cold, then put them in a pot for use.

To Dry Apples

Take some of the largest John apples[56], if not them the sharpest you can get and put them tight into a sieve and as soon as the bread is brown from the oven. Let them stay till the next day, then work them round with your fingers and thumb till soft, but be careful not to press too much the fruit for fear you should break the skin, then put them into the oven the same way repeating it till they are as dry as you can wish. NB Stone pippins will do as well.

Poiverade Sauce[57]

Take 12 pods of capsicum, split them down the side, but take out the seeds. 1 pint of nasturtium seeds, quarter of an ounce of mace, the same of ginger, put these ingredients together into a stone bottle then take a gallon of white wine vinegar, boil it and pour it hot on the ingredients, stop it and let it store for 4 days, then pour off the vinegar and boil it and put it hot as before. Do this three times and when fine bottle it off. After this you may add some more vinegar to these ingredients it will make a richer sauce. NB The mace and ginger must not be pounded when you use it for sauce, add water with a little eschalot shred fine, the middle of September is the best time for making it. A small quantity of cayan is quite as good as the capsicum and you will find this sauce very relishing with cold fowl, partridge etc.

To Preserve Cherries in Brandy

Gather your cherries dry when full ripe with a part of the stalk on. Rub them clean with flannel give them two or three pricks with a pin – let your bottles be perfectly dry – to a quart bottle of cherries you must allow 4 ounces of sugar putting a layer of sugar and one of cherries till the bottle is full – each bottle will require a dozen apricot kernels – then fill your bottles with good brandy. Cover them with white paper pricked full of holes, and set them to stand six weeks if you can in the sun – then stop them close. NB white sugar candy[10] is to be preferred.

Cabob[58] To Eat With Cucheree

Take small bits of veal or chickens bones, season it with salt, pepper and a little tumerick, slice some onions and bits of garlick thin, put the meat on small skewers, and mix the onion and garlick between the meat and fry them in butter to eat with cucharee[45]. NB We always bring the burnt butter which the cabob is fried in instead of the clarified it is more savoury.

A Baked Apple Pudding

Take 12 large apples, pare them, take out the cores, put them into a stew pan with four or five spoonfuls of water, boil them till they are soft and thick, then beat them well, stir in a quarter of a pound of butter and a pound of loaf sugar[52], beat the juice of three lemons and the rind of five in a mortar, the yolks of eight eggs, mix all well together and when it is baked sift over it a little fine sugar – bake it in a puff paste.

New College Pudding

For one dozen take two penny loafs[59] grated, ½ a lb of currants, ½ a lb of beef suet, minced small – half a nutmeg, a little salt a quarter of a lb of sugar, 4 eggs, orange or rose water, a little wine and cream, as much as will make it as stiff as paste, then mix it well together and make them up in the shape of an egg then put a ¼ of a lb of butter in a stew pan and lay them round the bottom, cover them and set them over a moderate fire, let them stew gently or fry them till they are entirely brown then dish them, melt butter with wine and sugar and pour over them.

Boiled Rice Pudding

One pint of milk, 2 spoonfuls of rice flour, a little mace, and a good deal of lemon peel boiled in it, when cold, beat up two eggs and sugar to your taste, and put it on to boil in a bason for an hour and a half.

Custards

1 pint of cream boil therein four or five laurel leaves. Strain it, and sweeten it to your taste when cold beat up four or five eggs with half the whites, strain them into it, mix it together and fill your cups to bake.

New College Puddings

For one Dozen take two penny loafs
grated, ½ a ℔ of Currants, ½ a ℔
of Beef Suet, minced small — half
a Nutmeg a little Salt a quarter
of a ℔ of Sugar, 4 Eggs, orange or
Rose Water, a little Wine & Cream
as much as will make it as stiff
as Paste then then mix it well
together and make them up in the
Shape of an Egg then put a ¼ of
a ℔ of Butter in a Stew Pan and
lay them round the Bottom, cover
them and set them over a moderate
fire let them stew gently or fry

Custard Pudding

1 pint of cream, 2 large spoonfuls of flour, 6 eggs, half a nutmeg, sugar to your taste – butter a cloth and put it in, when the pot boils, boil it half an hour – first mixing the flour and cream over the fire till it thickens then let it stand till cool before you put in the eggs.

Amlet

Beat 6 eggs, spread a handful of parsley, 4 or 5 tops of onions on a small onion into them, some pepper and salt, one anchovy chopped fine, fry it in butter.

Quince Marmalade

Pare, quarter and core your quinces[29], to every pound put almost a pound of sugar, clear your sugar in some water, boil the parings, cones and some of the worst quinces in some water, to every pound of sugar put ten spoonfuls of this water, instead of common water. Let them stew over a gentle fire till they are of a fine orange red, then mash them as fine as you like and boil them up as fast as you can, you must keep them covered when boiling to preserve their colour.

Mushroom Catchup

Take the large mushrooms, wipe them and cut off the dirt from the stalks, chop them very fine and salt them well to your directions. Let them stand all night then put them into a jug stopped close – infuse them an hour or more into a kettle of boiling water then strain the liquor thro' a hair sieve and to about two quarts put a pint of wine, a quarter of an ounce of mace, nutmeg, cloves and ginger, half an ounce of pepper, a handful of shallots, put them altogether in a ¼ of a lb of anchovies. Boil it together half an hour, pour it out to cool, when cold bottle.

To Stew Peas

½ a pack of peas, 1 lettuce, a bunch of parsley and young onions, put them in a stew pan stopped close and then put them on a slow fire – stew them tender – then take out the herbs and lettuce. Put in some cream or a piece of butter and a lump of sugar, give them a boil up and send them to table.

Pickle for Your Brawn

Put a sufficient quantity of water, more than will be enough to cover your brawn, add to it 4 or 5 handfuls of Bran, a few Bay Leaves and Salt to make it strongly relished of it. Let all boil together for an hour and a half then strain your brawn from the pickle and put in your brawn the following day. NB. Renew the same as often as required, once a fortnight if made strong.

Delicate Muffin Pudding

Boil in a pint of milk, a leaf of laurel and a little cinnamon with sugar also to palate, about eight or ten minutes. Having put 3 of the best muffins in a large bason, strain over them the hot milk and when cold mash them well with a wooden spoon. Then pounding an ounce of blanched almonds, mix them well in with about a quarter of a pound of any dry preserved fruit such as cherries, plums or apricots, 3 beaten eggs and a couple of table-spoonfuls each of brandy and orange flower water and bake it with puff quarter round the dish or boil it tied up in a bason – in either way it will prove delicious – it may be made plainer and very good by obvious omissions and substituting nicely picked currants for dry sweetmeat, muffins make a very delicious pudding without any fruit at all.

Delicate Muffin Pudding

Boil in a pint of milk, a leaf of lau[rel]
& a little cinnamon with sugar al[most]
to palate, about eight or ten minutes.
Having put 3 of the best muffins in a
large bason, strain over them the hot
milk & when quite cold mash
them well with a wooden spoon
then pounding an ounce of blanche[d]
almonds mix them well in with
about a quarter of a pound of any
dry preserved fruit such as cherries
plums or apricots, 3 beaten eggs
& a couple of Table-spoonfuls each
of Brandy & orange flower Water &

Quince

made plainer & very good by
obvious omissions, & substituting ni
=ly picked currants for dry sweetme
Muffins make a very delicate
Pudding without any fruit at all

Composition for cleaning Marble Hearts
Chimney pieces &c a

Mix finely pulverized pumice
stone with Verjuice somewhat mor
than sufficient to cover it & after it
has stood an hour or more, dip a
Sponge in the composition, rub it
well over the marble wash it off
with warm water & dry it with
clean cloths ———

Composition for Cleaning Marble Hearth Chimney Pieces etc

Mix finely pulverized pumice stone with verjuice[60] somewhat more than sufficient to cover it and after it has stood an hour or more, dip a sponge in the composition, rub it well over the marble, wash it off with warm water and dry it with clean cloths.

Pomade Divine

Steep clean-picked beef marrow in water for a week or ten days: strain the marrow and steep it in rose-water for twenty four hours – strain it through a thin cloth till it be dry. – With twelve ounces of marrow mix of flowers of Benjamin[61] pounded storax and Florentine orris, of each half an ounce of cinnamon two grams – of cloves and nutmeg, of each one gram; put the whole into a pewter vessel with a screw top or an earthen vessel with a close lid, which must lie further secured by paste, tied over with bladder, suspend then in a bottle of water, boil it for three hours, adding such boiling water as that in the kettle evaporates; strain the marrow through thick muslin into bottles which are to be corked close when cool.

Scotch Eggs

Boil 5 Eggs hard, & without removing
the white cover them compleating with
a Savoury force meat in which
let Scraped ham or Chopped Anchovy
bear a due proportion — fry them
of a light brown & serve them
up with a good gravey in a dish —

Pickle Walnuts

Add to as much ale Alligar as will
cover the Walnuts as much Salt as
will swim an Egg pack your
Walnuts in it & then throw the
alligar to them & cover them with
vine leaves tie them down & let
them remain Six Weeks then take
them from that Alligar & pack

Scotch Eggs

Boil 5 eggs hard and without removing the white cover them completely with a savoury force meat in which let scraped ham or chopped anchovies, bear a due proportion – fry them of a light brown and serve them up with a good gravy in a dish.

Pickle Walnuts

Add to as much ale vinegar as will cover the walnuts as much salt as will swim an egg, pack your walnuts in it and then throw the alleger to them and cover them with some leaves, tie them down and let them remain six weeks then take them from that alligar[62] and pack them in a jar with horseradish, mustard, cloves, ginger and pepper, cover them again with strong alligar.

Gooseberries Vinegar

Take a peck of gooseberries not quite ripe. Crunch them with your hands put to them 2 gallons of water, mix them well together, let it work 3 weeks, stir it 3 times a day then strain the liquor through a hair sieve and to every gallon put a pound of brown sugar and a pound of treacle. Toast a piece of bread and take a spoonful of fresh barm and let it work three or four days in the same tub. Put it into a cask and let it stand ten or twelve months.

To Cure Bacon
Mrs Broderick

Put the flitches with common salt on both sides, to get out the blood and juices and let them be a week on a board or in a tub set a little sloping – then clean them from that salt, and lay them separate with the sord downwards, half a peck of large bacon salt, 1 ½ lb of bay salt, 1 lb of salt pectre, ½ lb salt prunell?, let these three last be pounded very fine, and mixt well, with the salt over a chafing dish of coal till it is all a little warm, then rub the whole well into the flitches as they lie and let them remain in it a fortnight or three weeks, as soon as any pickle drains from them, begin to baste them well with it 3 or 4 times a day.

For a Ham of 18 or 20 lbs

Rub the ham with a little common salt and let it lie 24 hours to drain it. Boil one quart of old strong beer with half a pound of bay salt, half a pound of common salt, half a pound of juniper berries, two ounces of black pepper and three ounces of salt petre[5], all well bruised, and pour it on the ham boiling hot, baste the ham every day for a month with the liquor, the oftener the better, when the ham has been in this pickle one week, add to it 1lb and ½ of treacle rubbing it thoroughly into the ham.

Turtle Soup

Two calf's feet and one cow heel, boiled 'till tender – 2lb gravy beef, 1 anchovy, ½ pint white wine and half a spoonful of cayenne, a couple of lumps of sugar – the wine is to be added a quarter of an hour before it is taken up. NB. Skim it well.

A Rich Soup

A leg of beef with three pounds of gravy meat, 1 cow heel, 1 large onion with thin skins on, three large carrots, half an ounce of black pepper, a few all spice, 1 dry clove, 6 heads garlic, 1 doz shallots, the peel of 1 lemons, 1 head of celery, one bunch sweet herbs, all to be stewed together <u>very</u> slow for 12 hours, in eight quarts of water till it be reduced to six, strain the whole through a very fine sieve and when cold clean it from every particle of fat. Before it is served up for table, another cow heel is to be stewed in half of the soup til tender, then cut in small pieces and added with forced meat balls and two glasses of white wine to the whole quantity, three oz burnt sugar to be stirred in to add to the flavour and colour.

End of Volume the first.

Georgian Cooking

1. Bay salt is made in salt pans off the Atlantic coast of France – imported since the 13th century. Although it was cheaper, coarser and often grey in colour, it was favoured over table salt for preserving because it got into the meat better and this gave a better cure.

2. Isinglass is a kind of gelatin obtained from fish, especially sturgeon, and used in making jellies, glue, etc. and for fining real ale.

3. Mace is high quality nutmeg – obtained by grating the skin of the nutmeg rather than the interior.

4. Hambro is simply the the name of it – it is referred to as the famed Hambro pickle and was used for preserving meat.

5. Salt Petre is Potassium nitrate.

6. Creed is crushed barley.

7. 1 gill is 142.065 millilitres.

8. Ratafia Biscuits are small, round, light brown almond-flavoured biscuits.

9. Ambergris, which comes from some species of sperm whale, is one of the most valuable raw materials in perfumery.

10. White sugar candy is made of white Lisbon Sugar melted and boiled to a Candy thus: Dissolve your Sugar in pure Water then boil it to the Consistency of a Syrup which pour into Pots or Vessels Wherein little Sticks have been laid in order that the Sugar may stick to them during the fifteen Days that it is in the Stove but the great Care must be to keep the Stove Fire equal during these fifteen Days that it remains there; they afterwards take it out of the stove to drain and dry it and then put it up in Boxes for Use.

11. A number of utensils are called salamanders but in this case is likely to mean a metal plate which was heated and then held over a dish to brown it. A modern solution is probably to put under a low grill.

12. This is the old spelling of Karachi. Carachie is a sauce, and is one of the influences on Worcestershire Sauce.

13. A penny French roll is likely to be brioche.

14. German Puffs are still known by this name today. They are light fluffy cakes often served with jam or syrup.

15. The fruit of the European barberry, *Berberis vulgaris*.

16. Green Pease are green peas.

17. A modern day equivalent to anchovy liquor would be Worcestershire Sauce or Gentleman's Relish.

18. A collop is a slice of meat.

19. Beef pickle is likely to be the liquor that is left over after making salt beef.

20. A Carolina strawberry is what we would call a garden strawberry.

21. A Scarlett strawberry is what we would call a wild strawberry.

22. A toping pan is likely to be a bain marie.

23. Morels are a type of mushroom.

24. Sambo was common name for a slave. It is likely that the complier of the book met a black cook, who gave them the recipe.

25. Browning is similar to gravy.

26. A clear fire is an open fire with a bright flame

27. To make scalded rice, place rice in a sieve and pour boiling water over it.

28. Quince are a pear shaped fruit with a delicate flavour which are occasionally available in supermarkets in autumn.

29. 'Scumming' is removing the scum which forms on the surface.

30. An alkanet root is the root of the plant Alkanna tinctoria, which creates a red dye.

31. Rose pink is likely to be rose madder, a pink to red dye obtained from the madder plant.

32. Codlings are a type of cooking apple.

33. Westphalia is a part of Germany famous for its hams.

34. Bran is the hard outer layers of cereal grain.

35. Turtle fashion is another way of saying mock turtle.

36. Green gages are a kind of greeny-yellow plum.

37. China Oranges are so called because oranges first came from China.

38. Salt prunell, also known as *sal prunella*, it is a fused preparation of potassium nitrate in balls.

39. Naples biscuits are much like lady's fingers biscuits.

40. Orange flower is now known as orange blossom water, and is still widely available.

41. The bigness of an egg means a lump of butter the size of an egg.

42. Cochineal is a red colouring made from a South American scale insect. Worries about chemical colouring means it has recently returned to our grocery shelves. It's hard to know how much of it three pennies would have bought when the Begbrook House cookbook was written.

43. A pipkin is an earthenware cooking pot.

44. French Bances are like doughnuts without jam.

45. Cucharee is kedgeree.

46. Cullis is a clear meat broth.

47. Ox palates is the roof of a cow's mouth

48. Charteuse is likely to be a dish made in a mould using pieces of meat, game, vegetables, or (now most often) fruit in jelly.

49. Lisbon sugar is a soft, not so white, sugar that was considered inferior to sugar imported from Jamaica and Barbados. Golden granulated sounds like a good alternative.

50. A half a crown was a pre-decimal coin worth two shillings and sixpence (12½p). It was a little thicker than a 50p piece.

51. Most authorities say it is just lumps of sugar broken off from the sugar loaf (see below). However, some records exist of lump and loaf sugar both being sold, including in an act of Parliament. Lump sugar was refined into small moulds instead of the big loaf moulds to make it easy to take with tea. It was probably this sort of lump which was the secret of the Bath Bun.

52. Loaf sugar was sugar poured into a tall clay mould during refining, producing a large conical shape when cold. Bits were broken off with tongs.

53. Lobster berries are the roe (or eggs) carried by female lobsters.

54. Double refined sugar was a very high quality, very white sugar which had been refined twice, ensuring its purity.

55. To plump them over the fire means to cook them so that they plump up.

56. John apples are French crab apple, a green variety of cooking apple with spots of russet which was probably introduced commercially to England from France

in the late 18th Century. It has very good keeping properties and cooks down to a sharply flavoured purée. This late-season variety is harvested from mid-October in South-East England and is at its best from December to June the following year.

57. Poiverade Sauce is a peppery sauce.

58. A Cabob To Eat With Cucheree is a kebab to eat with kedgeree.

59. Penny loaves were small loaves.

60. Verjuice is the acid juice of green or unripe grapes, crab apples or other sour fruit, expressed, formed into liquor and used in place of vinegar.

61. Flowers of Benjamin is benzoic acid; pounded storax is styrax balsam, a benzoic resin. Florentine orris is the rhizome of the Iris florentina. Also known as orris root, it has a delicate Violet scent and is a popular ingredient because of its natural fragrance and its fixative properties (an ingredient that freezes or prolongs the scent of blends).

62. Alligar is a mixture of ale vinegar and salt.

63. 'Mountain' is sweet wine originating from Malaga, Spain.